Daughters of India

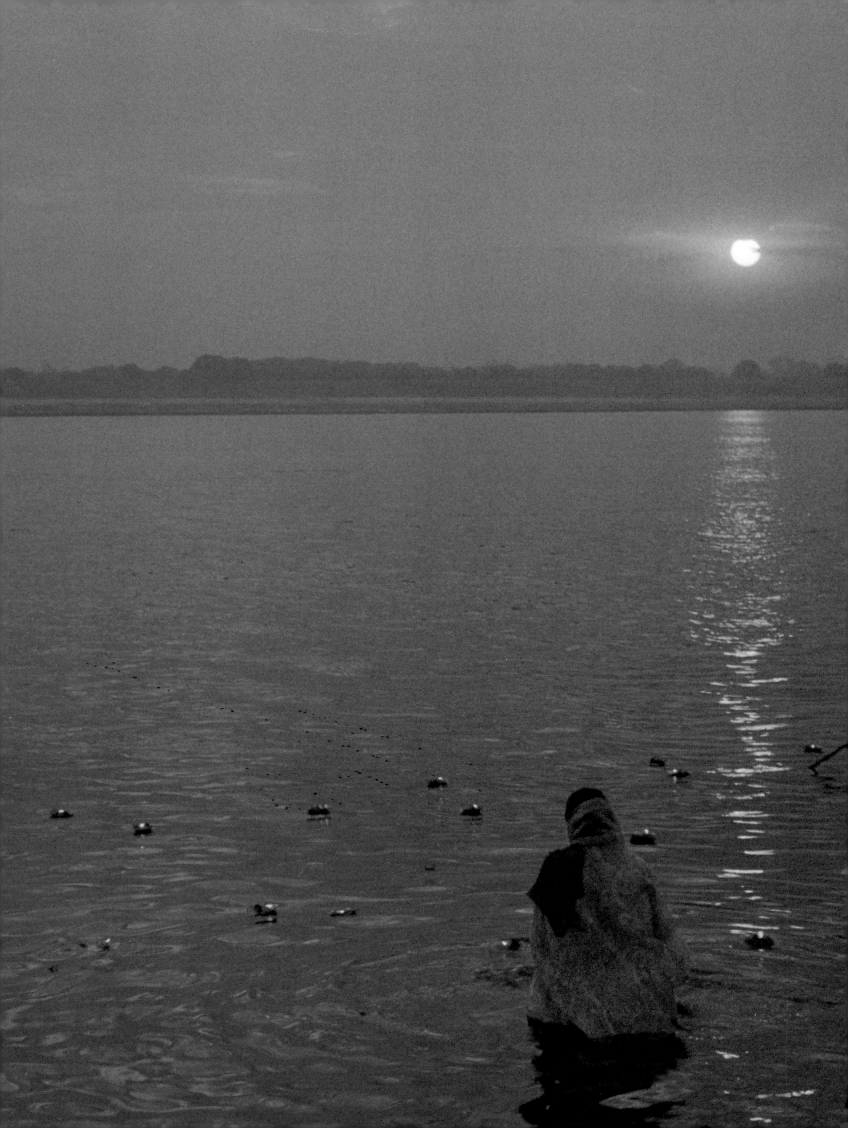

DAUGHTERS
OF
INDIA

ART

AND

IDENTITY

For Heidi,
whose thoughtful, sensitive work
has created & maintained by Daughters of India website.
gratefully,
Stephen Huyler
10.22.08

STEPHEN P. HUYLER

Abbeville Press Publishers
NEW YORK LONDON

Design concept: Joseph Guglietti
Editor: Mallika Sarabhai/Mapin Editorial
Production Editor: Megan Malta
Production Manager: Louise Kurtz

Jacket front: Expressing the close bond of sisterhood, women in Chhattisgarh wrap their arms around one another in their colourful harvest dance.

Jacket back: Achamma Joseph has leveraged her Kerala family's tradition of educating and empowering women. By using her acumen and insight in internet technology and program development, she has rapidly risen to become one of India's leading businesswomen.

Page 1: Smoothing a fresh ridge of clay with her tatooed hand, a Rabari woman in Western India creates bas-relief decorations on the wall of her home.

Page 2: As part of daily morning prayers, many women along the banks of the sacred Ganges River immerse themselves in water and light lamps to the rising sun.

Page 4: Water buffalo returning home in the Rajasthan evening dusk after grazing all day in the fields.

First published in India in 2008 by Mapin Publishing Pvt. Ltd., 10B Vidyanagar, Ahmdabad 380 014 India

First published in the United States of America by Abbeville Press, 137 Varick Street, New York, New York 10013

10 9 8 7 6 5 4 3 2 1

Text and photographs © Stephen P. Huyler

Printed and bound in Singapore.

For bulk and premium sales and for text adoption procedures, write to Customer Service Manager, Abbeville Press, 137 Varick Street, New York, NY 10013 or call 1-800-ARTBOOK.

Library of Congress Cataloging-in-Publication Data

Huyler, Stephen P., 1951–
 Daughters of India / Stephen P. Huyler.
 p. cm.
 Includes bibliographical references.
 ISBN 978-0-7892-1002-9 (hardcover : alk. paper)
 1. Women—India—Case studies. 2. Women artists—India—Case studies. I. Title.

HQ1742.H89 2008
305.48'800954—dc22
 2008014291

Visit Abbeville Press online at www.abbeville.com

To my mother

Margaret Noble Appenzeller Huyler,

who modeled the innate integrity, grace and power of women.

She had an infectious enthusiasm and fascination for all humanity.

I miss her greatly.

CONTENTS

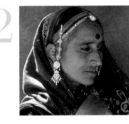
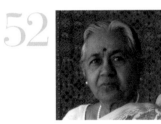

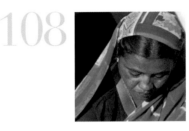

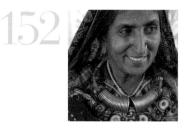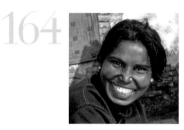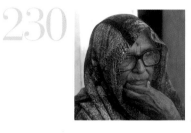

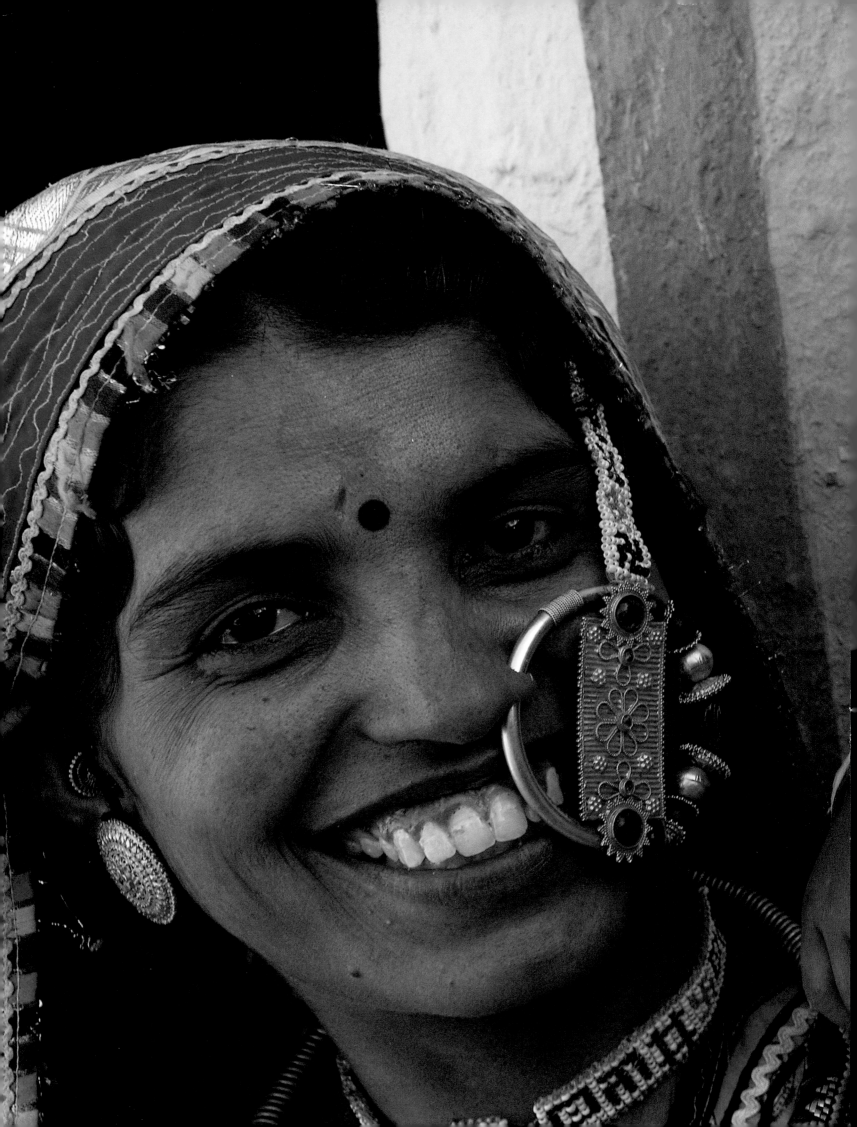

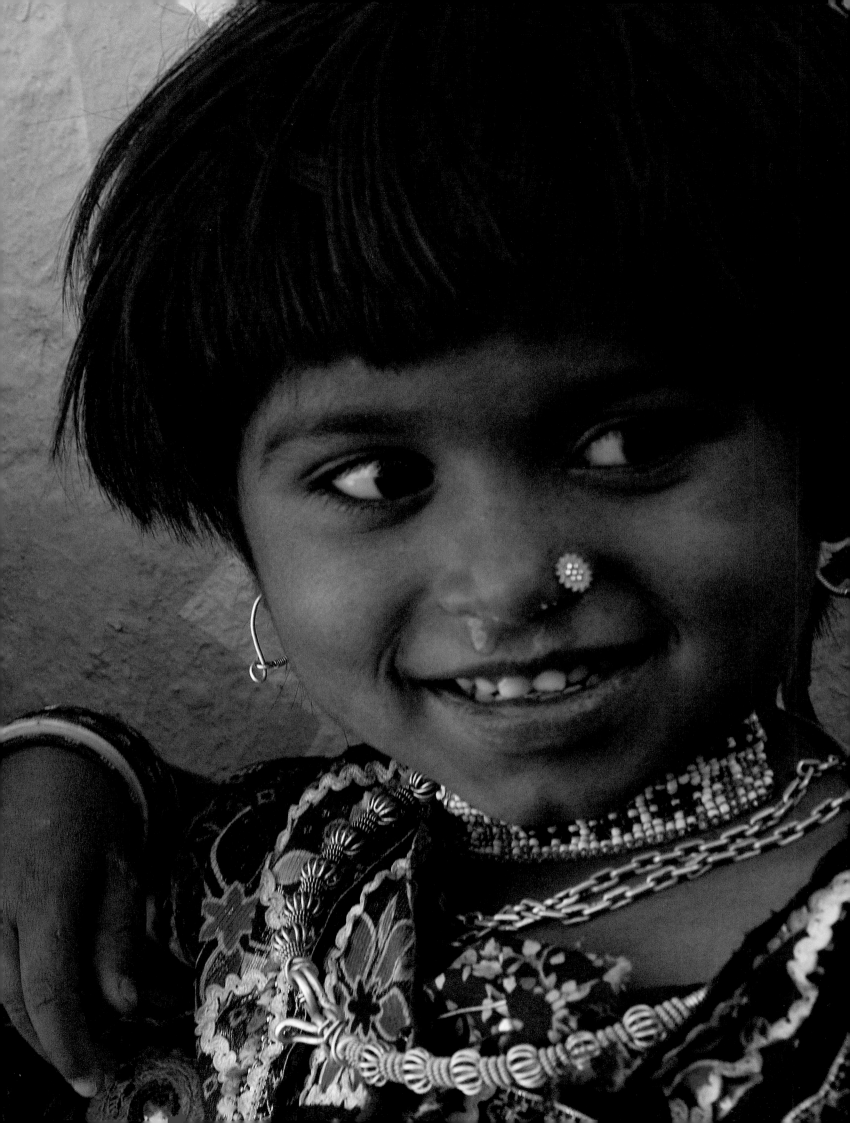

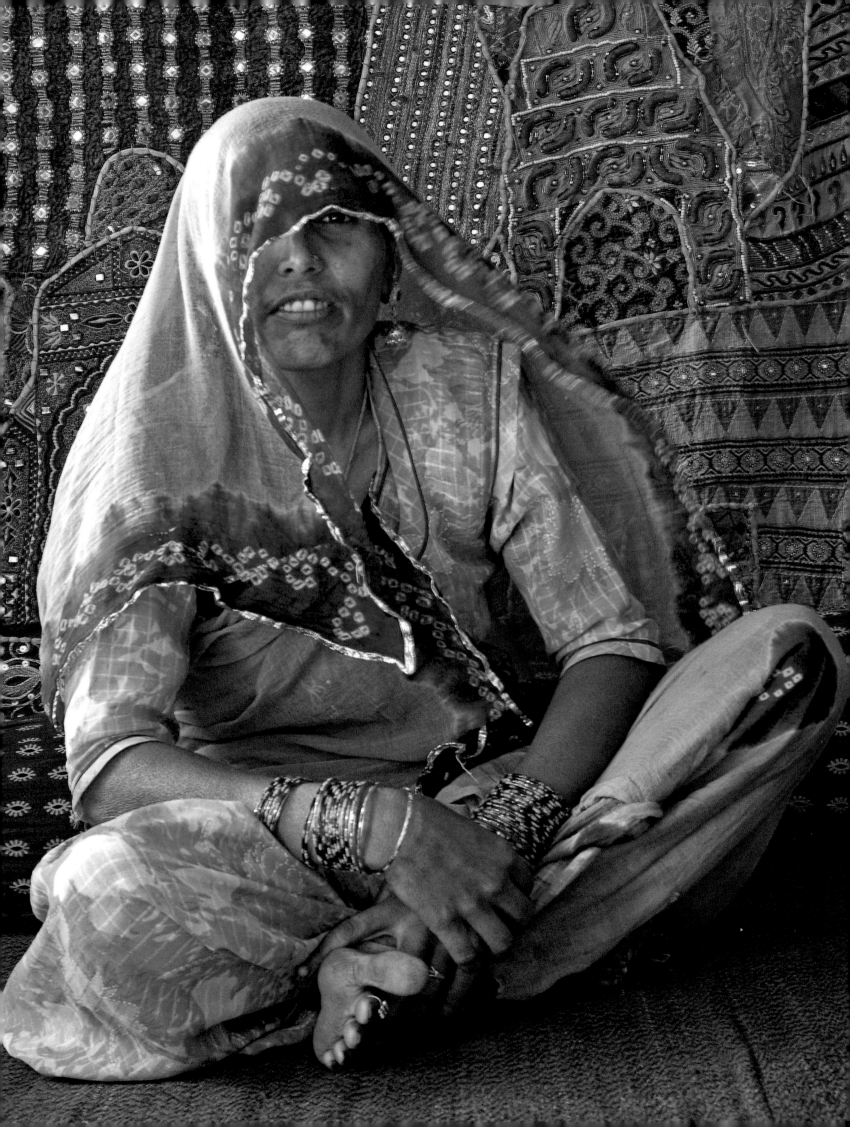

INTRODUCTION

ONE IN EVERY SIX WOMEN IN THE WORLD LIVES IN INDIA, more than the combined female populations of North America, the European Union and the Middle East. Yet most people outside India know little about Indian women, who often receive confusing and inaccurate press coverage.

THE WOMEN OF INDIA have long been misperceived in the West. Abuse towards women pervades Indian society, as it does in many parts of the world, but this abuse must be regarded within its own context. Much of Western reportage about Indian women is misinformed or misguided, depicting all or most of them as victims. Terrible inequities within Indian society must be addressed and changed, but it is essential that Indian women also be recognized for their strengths and for their phenomenal abilities to rise above adversity. India's cultures are contradictory—a fact epitomized by the conflicting attitudes towards women.

MOST WESTERNERS KNOW OF INDIRA GANDHI, a powerful leader on a global scale, but they believe that her position was an exception. The current president of India, Pratibha Patil, is a woman. It is true that there have been no other female politicians of equivalent stature to these two, but Indian business, politics, professions and society involve many outspoken, authoritative women. The voice of most Indian women is suppressed and it is often impossible to break free from the yoke of male oppression. But individual women have frequently been leaders during India's long history. Indian women from all walks of life possess phenomenal fortitude and a determination to improve their lives and the lives of their children. *Daughters of India* is a celebration of women in their diversity: their strengths, their challenges, and their many means for dealing with hardship and rising above it.

OUTSIDERS OFTEN VIEW INDIAN WOMEN as men's property, not valued for their own attributes. The actual situation is complex. Almost all societies in India are patriarchal. With some exceptions, men run businesses, religious and educational institutions and political parties. Most women are subservient to men. Even those who break out of the mould by working outside the household and publicly expressing their opinions are expected to continue their traditional activities at home by caring for their husbands and children. This situation often means an inhuman workload. Although far more women are now pursuing jobs and careers, househusbands are

PRECEDING PAGES: Girls in many of India's subcultures wear nose rings and earrings from a very early age. When they marry, they often replace this jewellery with much heavier and more valuable items.

LEFT: It is a rare honour to be able to glimpse Indra, one of the twenty women profiled in this book, as she normally lives behind a veil unseen by any outsiders.

11

INTRODUCTION

almost non-existent. India has some of the most favourable laws towards women in the world, but it is only in the last few years that the feminist movement has been pushing women to demand their rights. While millions of women vent their anger, express their opinions, petition the courts for inheritance rights, fight for political rights and strike for equal wages, the backlash is intense. Tens—perhaps hundreds—of millions of women are regularly abused. Many are thrown out of their homes for the slightest case of intransigence and others are burned alive for failing to meet the demands of their husbands' families.

PARADOXICALLY, THE WORD FOR BOTH "STRENGTH" AND "POWER" in most Indian languages is *shakti*, a term synonymous with the generic word for "Goddess." In Hinduism, *shakti* is the supreme feminine. Women are even feared for their power, and some of the cultural and religious restrictions that traditionally govern them result directly from that fear. For example, women in traditional Indian societies were separated from men during their menstrual cycles not because they were considered impure, but because they were considered so powerful during their menses that they could disrupt the balance of their families and communities. The original reason for menstrual segregation has been forgotten by most modern Indians, and menstruation is now viewed as dirty. A similar attitude in the West, that women are somehow contaminated, derives from the historical Christian precept that women are inherently tainted with sin. Western women were conventionally viewed as the weaker sex even though they worked as hard as or even harder than men. Although Indian women were not labelled as weaker or tainted, a strong patriarchy has encouraged millions to be treated as chattel (the possessions of their men). Paradoxically, the identification of strength as a feminine attribute has engendered the empowerment of many Indian women for centuries.

MEN AND WOMEN ARE CERTAINLY NOT TREATED EQUALLY IN INDIA. Each is believed to have his or her own specific functions. In general, women govern the private sphere while men rule in the public arena. As anyone who knows India will attest, however, all Indian societies revolve around the home. It is the centre of all existence. All Indian societies are deeply religious. The home is the true centre of Indian spirituality, and women are the keepers of the sacred. Beyond this, almost all of a family's major decisions are made in the home, usually by women. (Of course, in a subcontinent as

enormous, overpopulated and diverse as India, there are innumerable exceptions to this rule.) In many cases, a matriarch holds the family's purse strings, deciding what occupation her sons and grandsons will have, whom they will marry, and how they will lead their lives. The husband, who is so outspoken and dominating, may be subject to the power of his wife in all family matters. This private power cannot be overstated. It provides a natural transition into contemporary, forward-looking, 21st-century India.

CONSIDER ANOTHER ANOMALY: Several hundred million Hindus worship the Divine Feminine as the primary focus of their daily devotion. Western descriptions of Hinduism disregard this essential practise by emphasizing the male deities Shiva and Vishnu as the primary sects of the world's third largest religion. This bias reflects assumptions derived from male-dominated Western history and cultures, and needs to be set aside in considering Indian religion and culture.

IN THE THREE MAJOR WESTERN RELIGIONS (Judaism, Christianity and Islam), evil in mankind is considered the direct fault of woman (Eve), whereas within Hinduism, the primary Goddess, Durga, is regarded as the only deity who can truly destroy evil. Hindus believe that the universe is composed of the absolute balance of all opposites. Masculine and feminine forces are both essential and equal. It can be hard to understand how a culture that considers its major divine power to be feminine can also treat its women as inferior citizens. Ironically, the derogatory attitude of Indian males towards women has heightened during the past century-and-a-half of Western-influenced education and media in India, with increasing instances of violence and abuse everywhere. Feminists find it difficult to reverse the traditional attitude of the Indian women who still feel that they belong to men.

WESTERN NEGATIVE ATTITUDES TOWARDS INDIA were initially generated by the reports of early travellers who had little or no interest in understanding cultural habits so far removed from their own. Prejudices were compounded by 19th-century missionaries and imperial strategists who painted adverse pictures of a subcontinent they wished to convert and/or subjugate. The most notorious and inflammatory of these descriptions, one that persists in the Western consciousness to this day, is that of *sati* (or *suttee*): the immolation of a wife on her husband's funeral pyre. The ritual of *sati* was

INTRODUCTION

indeed practised in many parts of India, and there are documented cases of women being forced into it. However, it is important to realize that *sati* was always the exception and never the norm for broader Indian society. It is best understood within context in the traditional Hindu belief system where a strong code of honour governs all women's actions. Women who sacrificed their lives were taught that they were absolved from all future rebirths, instantly becoming one with the Divine. (It can be successfully argued, however, that as men do not also have this "privilege" of becoming *sati*, the entire custom was an act of convenient control by the patriarchy.) The disproportionate headlining and coverage by Western media of the horrors of *sati* was encouraged by the Christian church and by imperialist politicians. For them, it proved the obvious inferiority of Indian cultures and the need for extreme Western spiritual, educational and legislative reforms. Early 19th-century protests by socially aware Indians, combined with this European and American outrage, resulted in the illegalization of *sati* in 1829. Occasional instances of this ritual in the 20th century have given further fuel to negative attitudes regarding the treatment of women in India.

NEWSPAPERS, MAGAZINES AND TELEVISION DOCUMENTARIES regularly report cases of dowry murders and female infanticide in India. In the former, women are murdered if their natal families refuse to meet the negotiated terms of a marriage dowry. In the latter, female fetuses are increasingly aborted in India because families are afraid of not being able to pay the necessary dowries required to get their daughters married. In both situations, the cause is a societal condition that is technically illegal, but almost impossible to enforce: the pervasive maintenance of a dowry system. Some educated Indians refuse to participate, but for most there is no choice: dowry is an economic and social necessity. Families go into such crippling debt paying dowries for their daughters for generation after generation that they believe they must require large dowries from their sons' brides in the hope of balancing their beleaguered budgets.

ANOTHER FREQUENTLY MENTIONED INJUSTICE towards women in India is the attitude regarding widows. In traditional India, a woman retires from active life when her husband dies. She abdicates her power to her daughters-in-law. She gives away her jewellery and fine clothes, eats simple foods and spends her remaining years in quiet prayer.

ABOVE: Sonabai was widowed two decades ago, but she is still treasured by her family and community.

BELOW: Children in Samabai's very remote desert village have access to television daily and are very informed about the broader world.

14

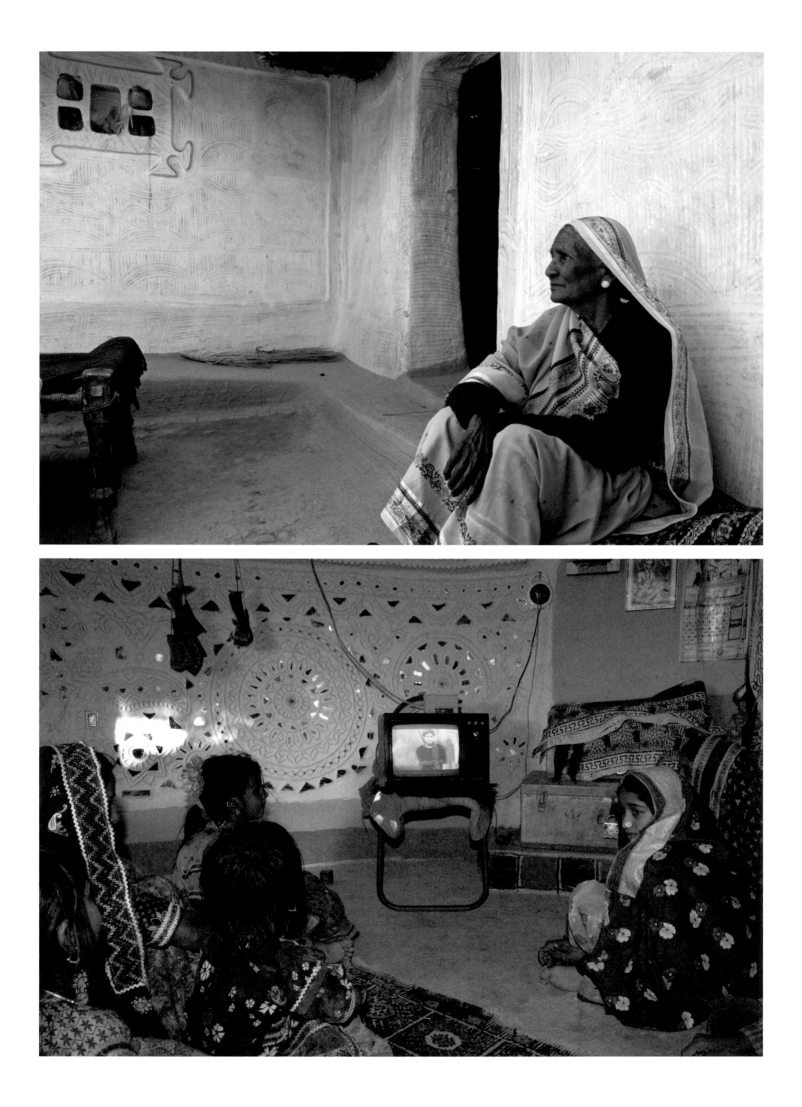

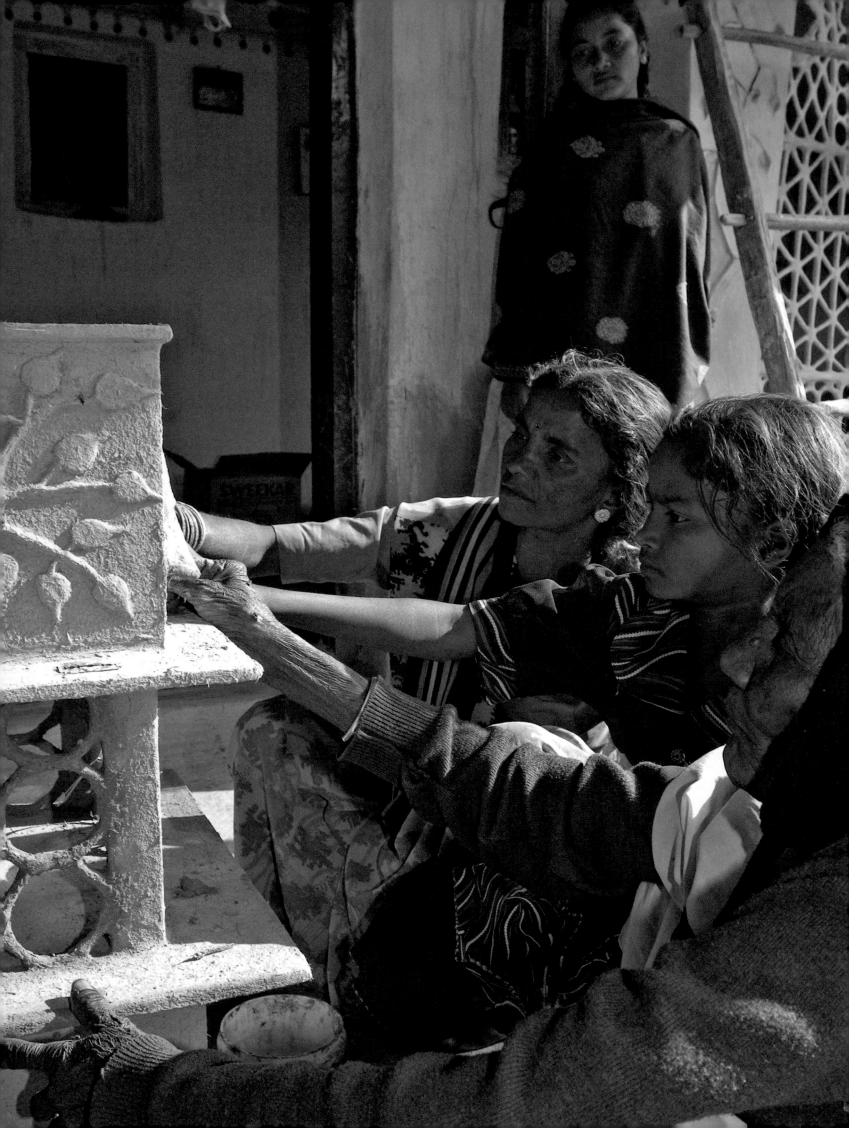

INTRODUCTION

In many families this transition is graceful, and an elderly widowed grandmother is loved and cared for. However, a common ancient superstition states that widows bring their families bad luck. Many widows are forcefully ejected from all human comforts, occasionally thrown onto the streets to fend for themselves. This situation is deplorable enough among the aged, but it is compounded in the case of young widows who may face decades of abysmal treatment.

THIS BOOK MAKES NO ATTEMPT to hide these inequalities. It conveys women's stories as they view them, in their own words. Some of the conditions these women have lived through are tragic. But they do not believe themselves to be victims. Each embodies *shakti* (power) in her own way. Each has found a means to express her own dignity and to lift her head above adversity. In this way they represent a vital characteristic common to all womankind.

DAUGHTERS OF INDIA: ART AND IDENTITY profiles 20 women from diverse communities ranging from the rice paddies of far southern India to the tea plantations of the Himalayas and from the dry western deserts to the verdant east coast. They represent everywoman: the traditional and the contemporary, the repressed and the highly innovative, the outcast and the entrepreneur. In their battles against adversity, their own words express their innate strength. All of these women are connected by a single thread: creative expression. Some view themselves as artists while others would be surprised to be identified in this manner, but each woman creatively embellishes her daily or seasonal life. Many traditional crafts and art styles are passed down from mother to daughter as part of sacred rituals or festivals. Creative Indian women are often completely unconscious of their artistry, and it is only recently that any attention has been drawn to them. In these chapters artistry is combined with individual women's words and stories to portray the empowerment of Indian women. *Daughters of India* is about change in the face of almost impossible odds, personal initiative that carves out a new identity, and implacable insistence on the recognition of human rights.

Artistic traditions and techniques have been passed down from mother to daughter for millennia in India. Here three generations of artisans work together to sculpt a clay storage vessel in Sonabai's home.

FOLLOWING PAGES: Communication and companionship between women is one of the vital foundations of Indian society, as expressed here in the gestures between Roopa and her friends.

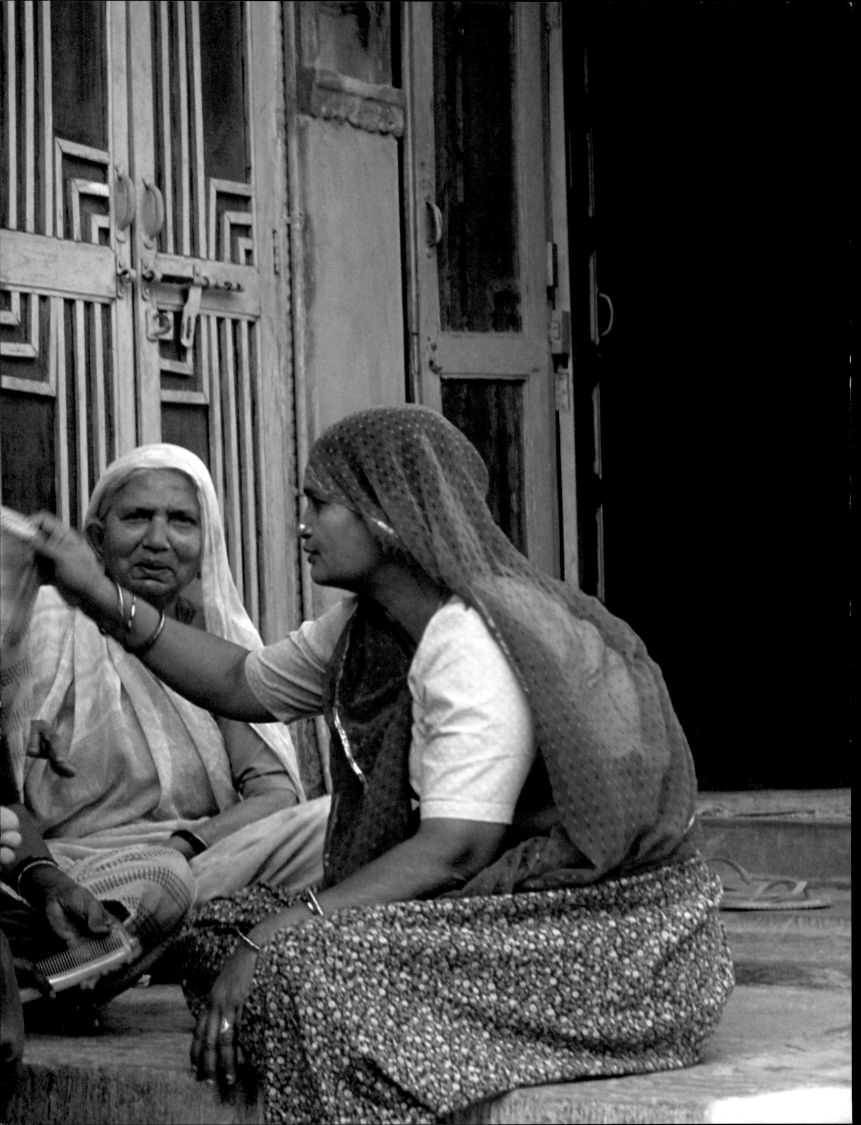

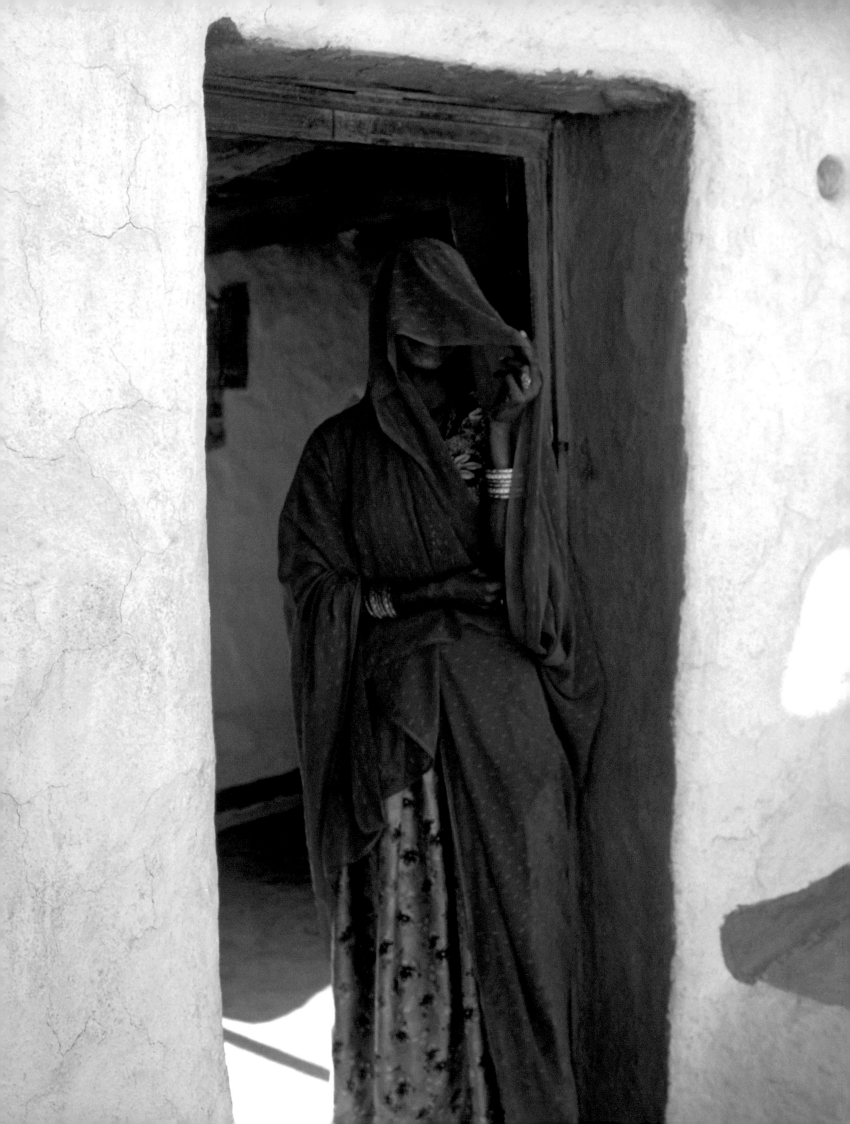

AUTHOR'S NOTE

°WOMEN'S ISSUES AND CONCERNS have always been deeply instilled in me. I was raised and have always been guided by strong, self-reliant, and self-aware women. My great-grandmother and great-aunt were both pioneers of women's rights in 19th and early 20th century Korea. Both my grandmothers were powerful and effective individuals. My father's mother was a transplanted southern belle who rose to become a compassionate but demanding matriarch. My mother's mother spent a life of service in Korea and, when she was widowed at 57, founded and ran an orphanage there. My mother, raised in Korea and trilingual in Korean, Mandarin and English, devoted her life to caring not only for my two siblings and me, but also for thousands of boys who passed through Thacher, the California boarding school on whose campus we lived. Her infectious love of humanity, her graceful, yet indomitable spirit, and her determination to instill in us her belief in the equal rights of all women and men, were invaluable lessons to help me open myself to the people and cultures of India.

BEATRICE WOOD, AN AMERICAN ARTIST AND POTTER who defied social taboos of the last century, befriended me just before I began college. As my mentor, Beatrice had a profound effect on my life, introducing me to India and arranging for me to be sponsored there by two particularly powerful Indian women—both members of India's first parliament. Kamaladevi Chattopadhyaya, a freedom fighter, had implemented Gandhi's program of cottage industries and women's craft cooperatives. Rukmini Devi Arundale was proclaimed by millions to be a Goddess when she was a child and went on to found India's pre-eminent school of classical Indian dance and music—as well as founding India's major parks and wildlife preserves. These two women were invaluable, introducing me to extraordinary people everywhere I chose to travel in the subcontinent.

All women in many regions of northwestern and central India, regardless of religion, must wear veils in the presence of any males other than those in their immediate families. This custom is the direct result of Muslim influence. In Lalita's village, a veiled Hindu woman stands in her doorway.

MY NETWORK OF FRIENDS AND CONTACTS IN INDIA has continued to spread over the past 35 years and I have been privileged to be a guest in the homes of countless Indian families. I have witnessed the rituals of daily devotion that women throughout India conduct to bring balance to their homes, families, and communities. On my first trip, I watched in fascination as the women in South India drew intricate *kolam*s (rice flour designs) on the ground outside their houses. I photographed them and wrote an illustrated paper for my undergraduate degree at the University of Denver, at the same time making a lifelong commitment to document their art.

21

AUTHOR'S NOTE

I pursued my doctorate from the University of London and, as a cultural anthropologist, I have noted and photographed hundreds of other styles of paintings created by women to decorate their homes. As I researched them, I realized that these artistic expressions are a valuable visual key that often link women from almost every diverse Indian subculture. My first book on the subject: *Painted Prayers: Women's Art in Village India*, was published in 1994 and, subsequently, a popular museum exhibition of these photographs travelled around the world to Washington, D.C., Denver, San Francisco, Lima, London, Munich, New Delhi and Madras, among other places. Many readers and viewers wanted to know more about the paintings and the women who created them. In response to this demand, *Daughters of India* was conceived.

I DECIDED TO WRITE PROFILES OF TWENTY WOMEN, each drawn from a separate part of the country and from varied walks of life and social settings. I was able to include Hindu, Muslim, Christian and Buddhist women, but not Jains, Sikhs or Parsis whose stories remain to be written. Each represents a vital facet of Indian life; while, in combination, they create a vivid portrait of Indian women.

I AM NATURALLY DRAWN TO documenting normal, everyday people. When I first began gathering material for these chapters, I was looking for individuals who led ordinary lives. I wanted to show that the story of each woman is fascinating no matter what her background or lifestyle. I began with women whom I knew well and whose lives I found appealing.

INITIALLY, I SEARCHED FOR WOMEN whose lives would richly complement the others. But, over the years, I have learned that one can never predict or control situations in India. They evolve at their own pace and often in a direction of which I had no previous intimation. India requires us to be constantly adaptable. In order to be able to change directions as circumstances dictate, I have always worked freelance. Consequently, my initial meetings with many of these women were entirely serendipitous.

AS THE PROJECT DEVELOPED, I realized that it was essential to include exceptional women who have made outstanding contributions to their world. Among those are Sunithi, Achamma, Chandaben, Minhazz, Shyamali and Sonabai; but truly each of the other women in this book also portrays phenomenal strengths and capabilities

The women whose stories are told in this book are from diverse regions, cultures, incomes and social statuses. Clockwise from top left are: Pushpa, Minhazz, Shyamali and Lalita.

22

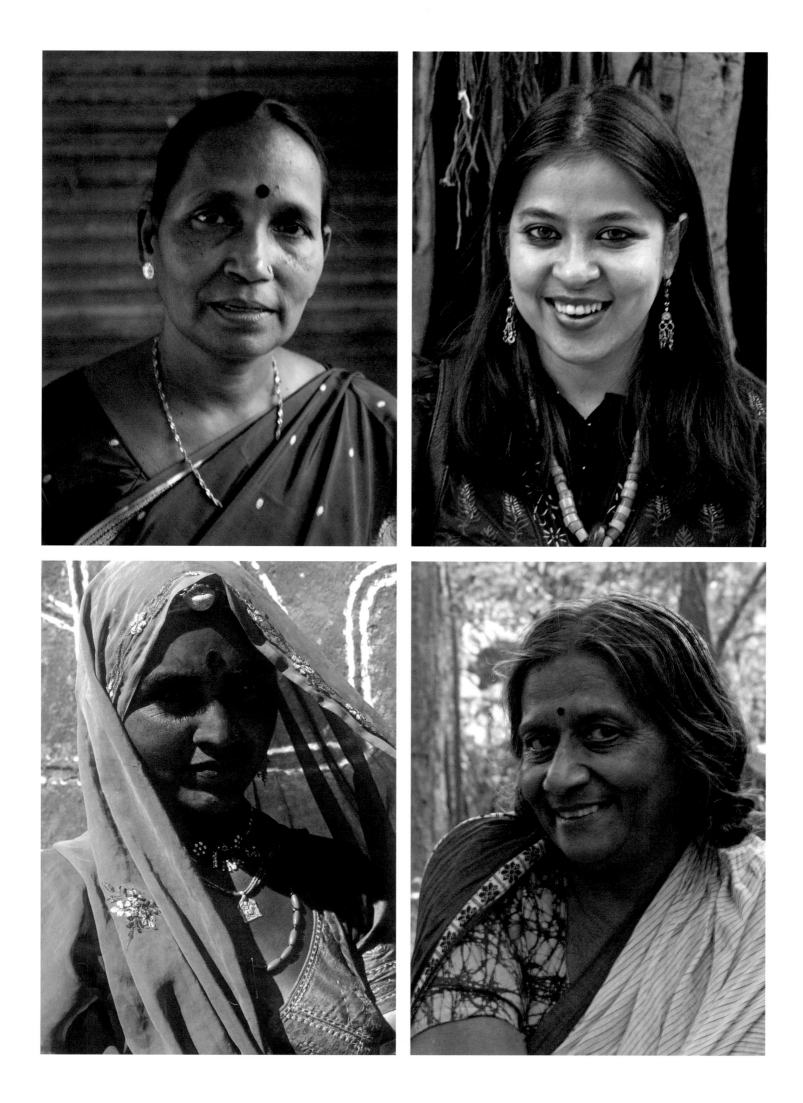

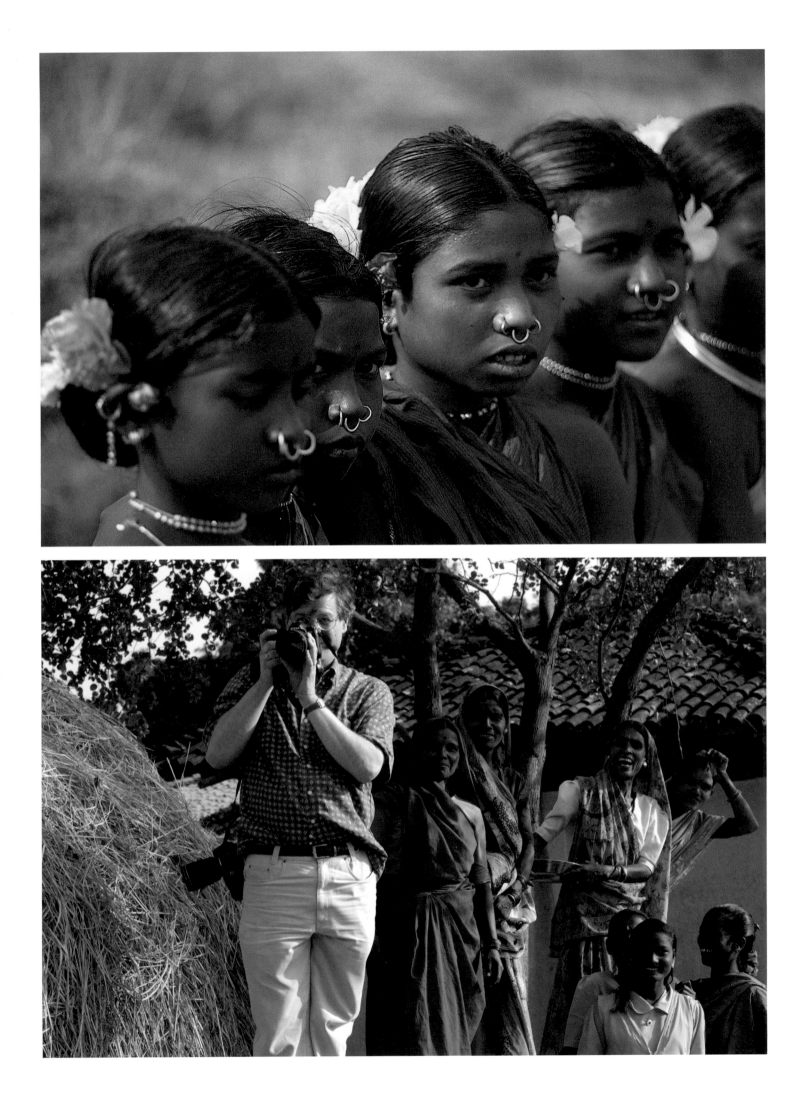

AUTHOR'S NOTE

that have been humbling to witness. They are all products of the great surge of change that enveloped India during the 20th century. I have been deeply honoured to be allowed to record their words and images. Five of the twenty women have requested that I change their names and a few incidental facts for their own protection. All twenty have been openly generous in sharing their lives with me.

I AM A WHITE, TALL, AMERICAN MALE and each of these qualities brings with it a cache of entitlement and indoctrinated socio/cultural position. As much as I try to leave it behind, I am always perceived through this lens. And yet, in India, I have been able to break through this initial barrier. I show respect for women and for their traditions and customs of appropriate behavior. I find that both women, and the men who generally protect them, open to me easily and, as I get to know them, I become emotionally involved with their lives. My primary ethic as a photographer is to always ask permission and respect their decision. First I try to connect with people without my camera, intending to establish an initial rapport and later to broach directly the subject of recording their lives.

WITHIN THE PAST TWO YEARS, India finally has been publicly recognized as a major world power. In order to deal with increasing dependence on Indian ingenuity, manpower, and products, it is crucial to raise our awareness of its peoples and cultures. Without feeling the pulse of India's women, we miss its central heartbeat. Since India's 550 million women are so diverse, it would be impossible to write a book that gives a complete picture of them. The approach of most articles and books about Indian women's social and cultural conditions has been either academic or fictionalized. Even though I have conducted my research professionally, I have chosen to compose this book of simple, evocative non-fiction stories that I hope will appeal as much to the general public as to my fellow scholars.

I HOPE THAT THIS BOOK WILL HELP WESTERNERS re-evaluate their opinions of Indian women and recognize the negative bias of most of our media. Some of the women portrayed here are involved in organizations whose direct aim is to improve women's rights and contemporary conditions. At the end of the book is a list of some of these organizations and the means for contacting them. All the royalties resulting from the sale of *Daughters of India* will be given to their aid.

ABOVE: In India, ancient traditions and cultural systems meld with innovative contemporary ones. Even though these tribal girls in Koraput District, Orissa, still wear the jewellery and clothing distinct to their tribe, they no longer live isolated from their progressive 21st century neighbours.

BELOW: Anonymity is impossible for a foreigner in India. Here author Stephen Huyler photographs Sonabai for her chapter.

FOLLOWING PAGES: Carrying a garland of flowers in a plastic bag, Bidulata walks from her home to give an offering to her local temple.

25

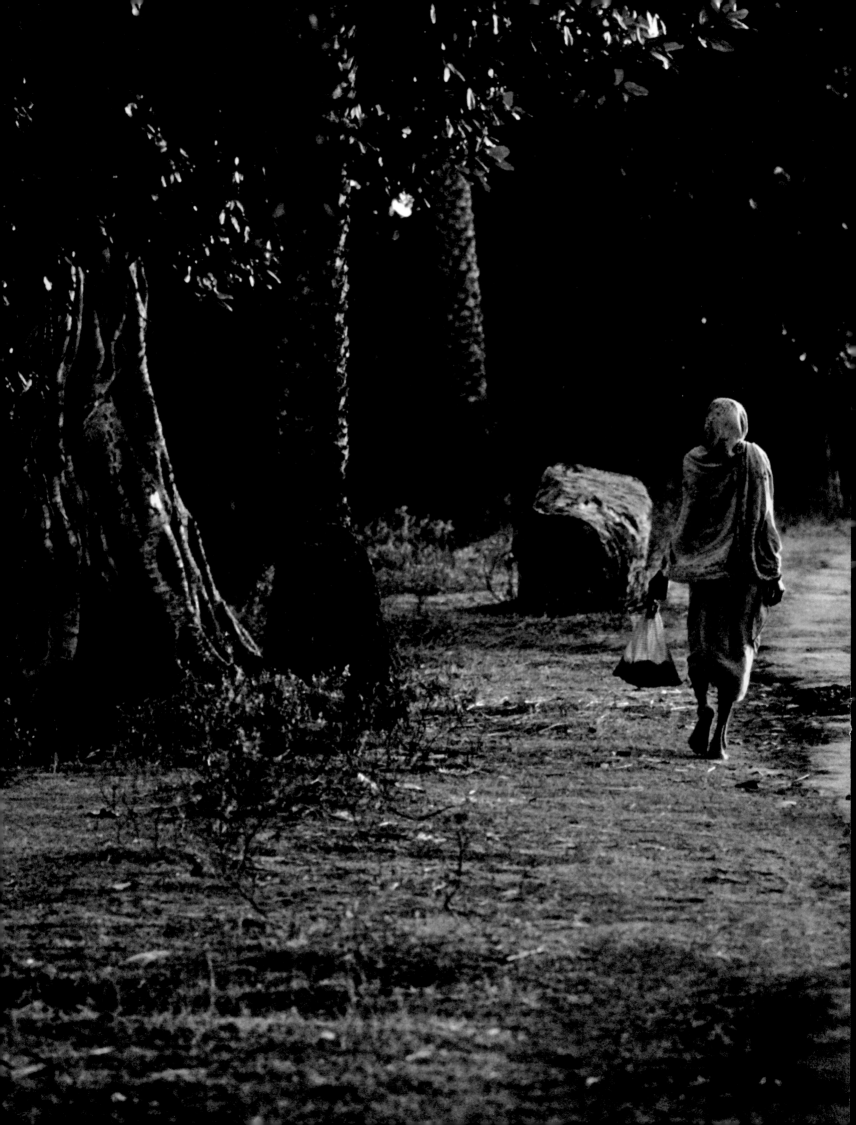

PUSHPA Unsettling the Slums

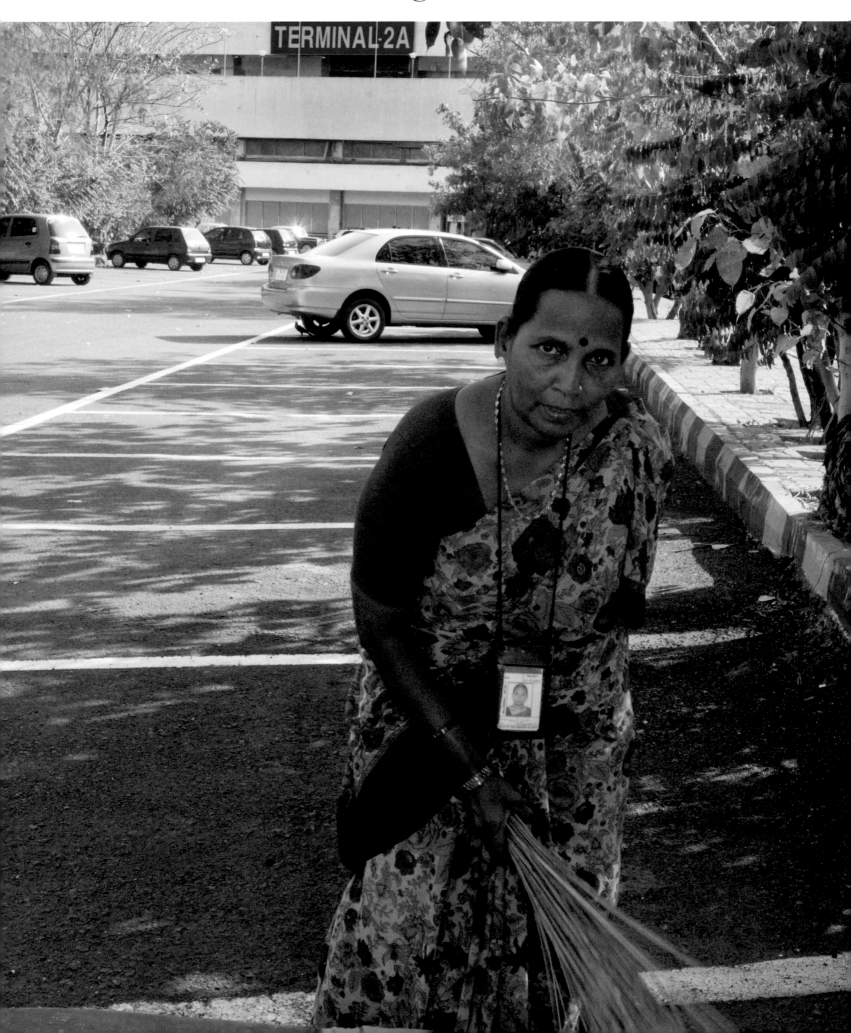

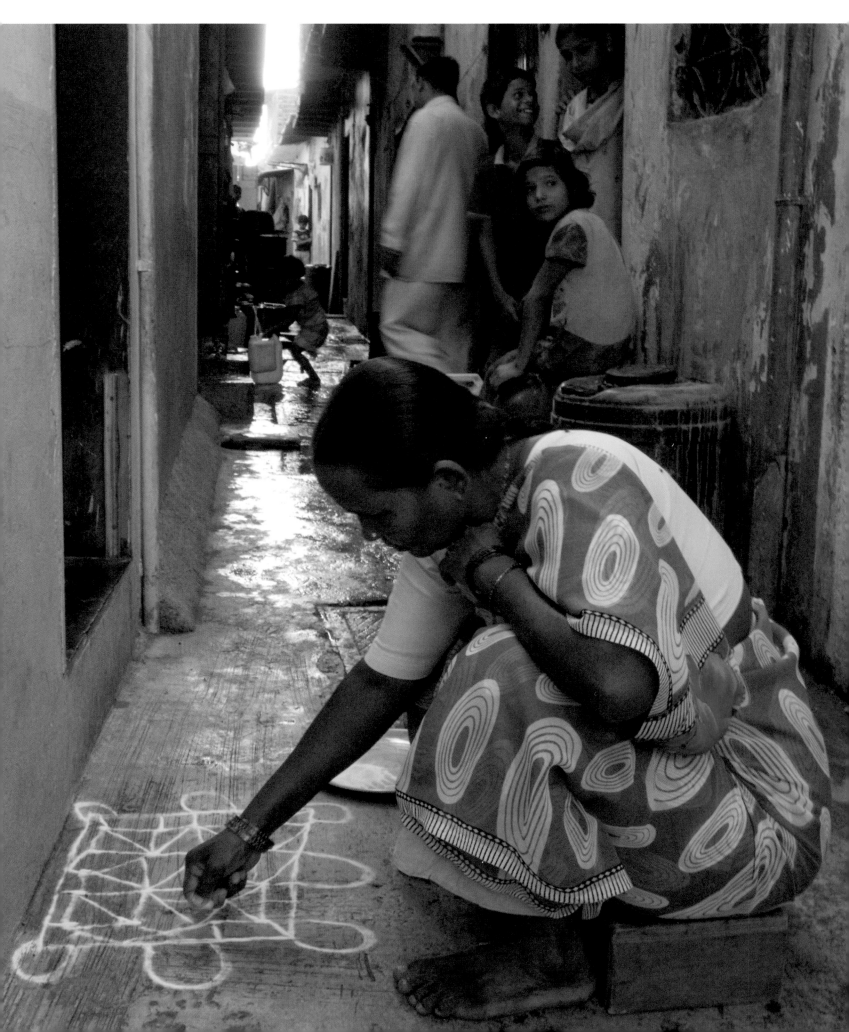

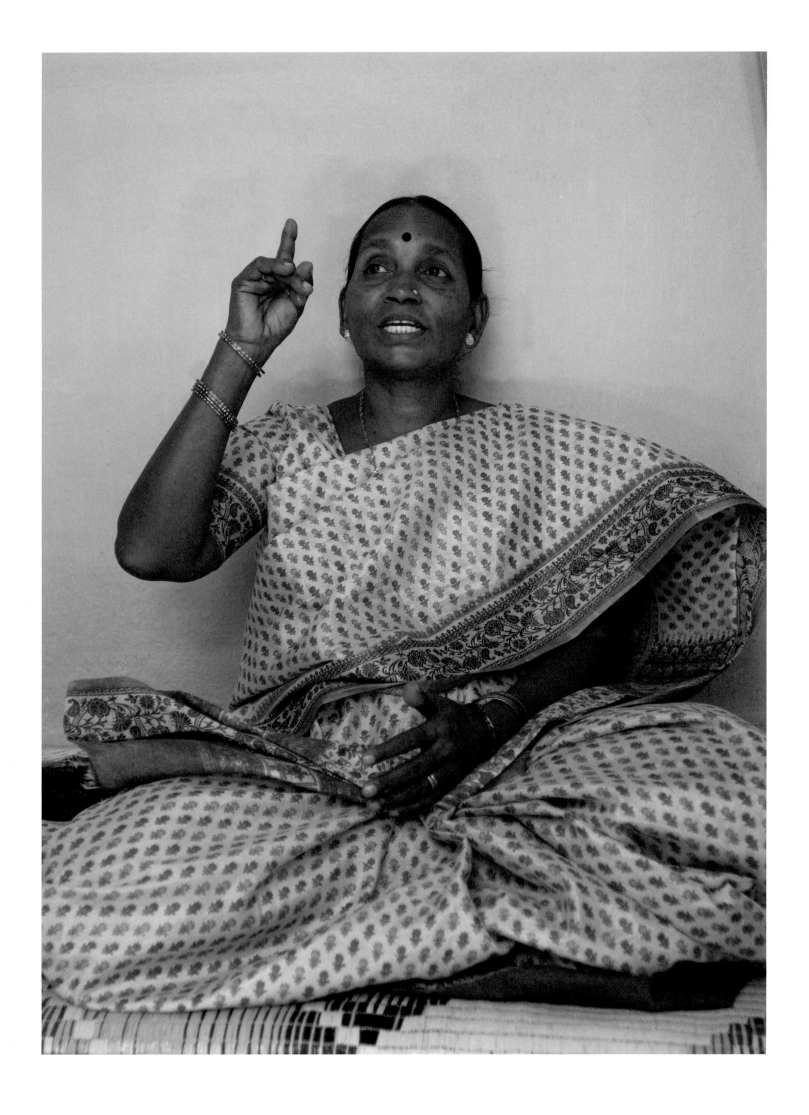

PUSHPA

"If my community is bulldozed, it will be very difficult. I will feel sad because I gave my blood and my money and my time to build this house and to help make this community. These are all my friends here. We are all like a large family. But it will happen some day, perhaps soon. I hope they will give me another home, but I am not sure. I have no money to buy land in Mumbai."

WHETHER TRAVELLERS ENTER MUMBAI BY AIR, rail or road, their first view is usually of endless slums and inconceivable poverty. This impression is enough to make some tourists turn around immediately and head elsewhere. It requires a dogged determination to look further and discover a metropolis that is culturally fascinating and, ironically, very beautiful. Mumbai, previously known as Bombay, is India's financial capital, the centre of many of its industries, one of the world's largest deep-water ports, and the home of Bollywood, where thousands of Hindi films are produced every year. It is also India's most expensive city. Property values have escalated 40 per cent in the past year and compete with those of London, Paris, New York and Tokyo. An average of 400 families move into Mumbai every day of the year and most of them simply cannot afford accommodation.

CONTEMPORARY ESTIMATES OF MUMBAI'S POPULATION vary between 12 and 22 million. The lowest end of this scale qualifies Mumbai as the world's third largest city after Seoul and San Paolo, but unofficial calculations make it the most populous. Over 50 per cent of Mumbai's inhabitants are either homeless or poorly housed. They live in slums that occupy one-tenth of a crowded urban space of 107,000 acres. If the entire population is indeed 22 million, more than 11 million people live on less than 11,000 acres: 24 times the population density of New York City. Sanitation is minimal in the slums: there is an average of one toilet for every 1,400 people. And city water is available for only two hours each day in those areas where it is provided. Even then, 15 families have to share one spigot! The result is barely controlled chaos.

ALTHOUGH POVERTY IS STILL PERVASIVE IN MUCH OF INDIA, the rapid growth of India's middle class, the burgeoning of its cyber-industry and the increase of multinational investments have combined to make India one of the most powerful nations in the world. Estimates for the fiscal year 2007 indicate a phenomenal economic growth rate of 9.2 per cent! The consequent change is epidemic,

PRECEDING PAGES, LEFT: Pushpa works as a sweeper at Mumbai's Chattrapati Shivaji International Airport.

RIGHT: To honour special guests visiting her tiny home, Pushpa draws a rice flour *kolam*, or sacred design, outside her front door in the narrow alleyway that serves as her street.

OPPOSITE: Pushpa is forthright in her determination to provide a good future for her daughter and son.

31

PUSHPA

altering the form and substance of many of India's regions so dramatically that they have become almost unrecognizable during the past 10 years. Foreign corporations are actively seeking to benefit from India's growing consumerism. For example, Walmart is building large outlets in 30 urban centres. Most of India's potential investors and many of her tourists enter the country through Mumbai's Chattrapati Shivaji International Airport, which adjoins Santa Cruz Domestic Airport. A top national and local government priority is to improve the facilities at both airports, thereby creating a far more positive image. Over the past decades, slums containing 60,000 households have encroached upon airport land. They inhibit the necessary expansion of runways and are an embarrassment to those Indians trying to impress foreigners. Mumbai's two airports now process 18 million passengers every year—a number that could grow to 90 million by the middle of this century!

IN AN EFFORT TO FACILITATE RAPID CHANGE, both airports were privatized in a 2006 bid won by a consortium of Indian and South African businesses. Billions of dollars have been allocated for this transformation. Eradication of the slums is imperative.

PUSHPA PAWAR LIVES IN A TINY HOUSE just 30 metres (33 yards) from Santa Cruz Airport's principal runway. After years of extreme hardship, this home is the culmination of her dreams. When she was born, the entire population of Pushpa's remote village belonged to the lowest rung of Hindu society, historically referred to by the pejorative term "untouchables" and now known as Dalits. When Pushpa was still an infant, everyone in her community converted to Buddhism, a casteless religion. Referring to her improved condition, she remarks: "Those who accepted Buddhism perfectly truly changed and left their old ways behind. My family changed a lot. We accepted Buddha as our only god and we did not continue to practise any Hindu rituals. Because of this full conversion, we are much better accepted now as Buddhists than we ever were as Hindu Dalits."

PUSHPA FIRST MOVED TO MUMBAI from her remote Maharashtrian village when she was just 15. Since her father worked as a military driver at the Mumbai airport, her family was given government-owned accommodations on the airport land. A few months after moving to Mumbai, Pushpa was married to a man five years her senior. Her husband, Ramesh, worked as a peon for the Indian Oil

Pushpa and her family lived for years under a plastic sheet shelter just 30 metres from the edge of Mumbai airport's major runway. In recent years she has been able to build a solid house on the same spot. The municipality has finally provided water and electricity, but the neighbourhood latrines and open sewers remain foul.

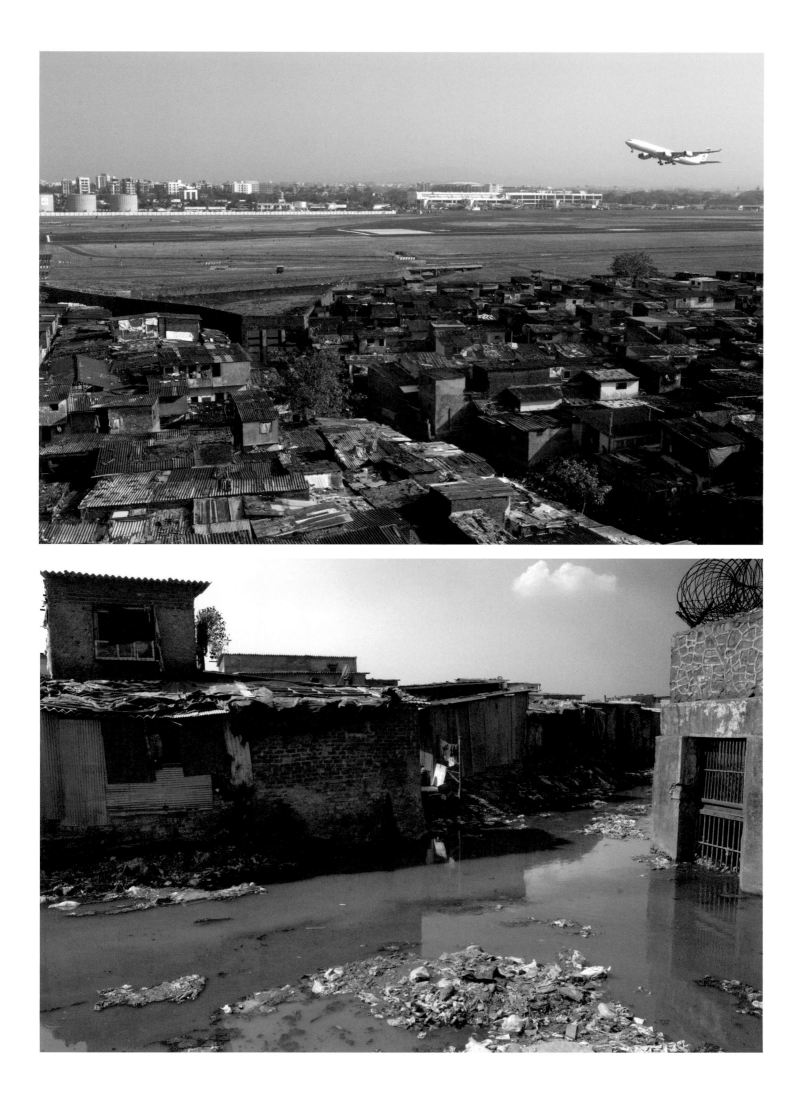

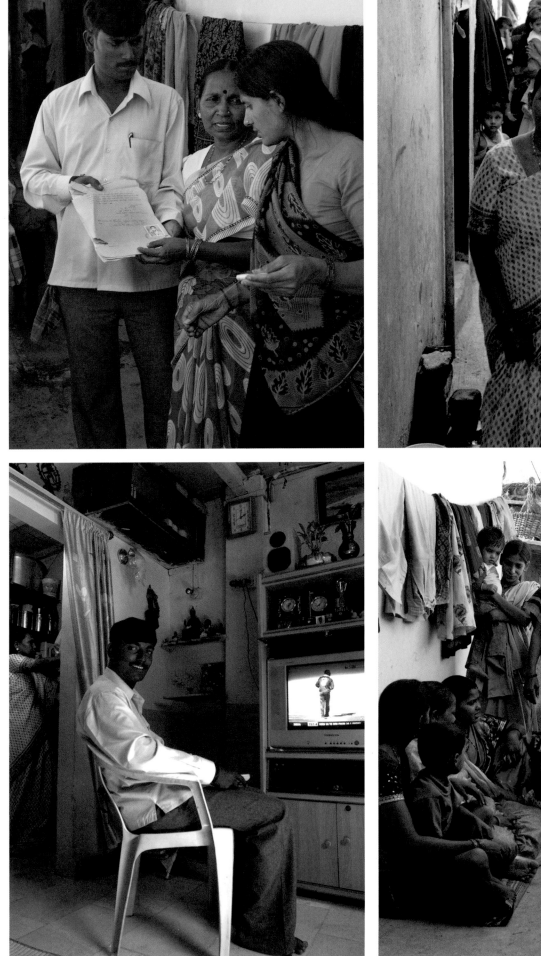

PUSHPA

Corporation, and his family treated Pushpa well. However, she soon discovered that Ramesh was an alcoholic. She states: "My husband's father was also a drunkard. They would go off and drink together regularly. After my daughter was born, I found him drinking more and more and working less and less. Finally, he just drank and didn't work at all. For three or four months he did not attend his job and, at last, his corporation suspended him. He was occasionally violent to me, but never to the children... I took a job cleaning rooms and serving tea. Three months after giving birth to my daughter, Gita, I got a government job, cleaning at the airport... One day, Ramesh had a big fight with his mother. It was terrible! And the result was that she demanded that we leave her house—all of us: Ramesh, Gita, my son, Mahesh, who was still in my belly, and I."

THE YOUNG FAMILY HAD NOWHERE TO GO. "During the monsoon, we lived for three months in an open space on the edge of Santa Cruz Airport. We had nothing, no shelter at all, nothing to cover ourselves! During the heavy rains, we would try to run under the overhang at the airport; but the police would chase us off each time. Luckily, I was earning Rs 210 (US$13) each month, so at least we had enough money for food, usually just *puri bhaji* (puffed bread with a simple potato/vegetable curry), if we were lucky." While homeless and without any medical care, Pushpa gave birth to their second child. Her husband, Ramesh, became very ill during those three months and was diagnosed with severe tuberculosis. Fearing death, he completely stopped drinking; but he was never able to work again. Accordingly, Pushpa recalls: "I supported my family completely. After three months of living out in the open air and rain, we found a house on the opposite side of the airport, with a rent of Rs 20 per month (US$2.20). We lived there for one and a half years."

ALTHOUGH HER BABY, MAHESH, WAS BORN HEALTHY, Pushpa discovered a few months later that he was completely deaf. She now believes the cause was viral, but over the following years, Pushpa says, "I spent a lot of money on my son to find out what was wrong with him and to help him: doctors, priests, temples, even those who practise *tantra* and witchcraft. Nothing helped..." Pushpa spent all her income on food and clothing for her small children and expensive medicines for Ramesh. It soon became apparent that they could not afford even the minimal rent they paid. Pushpa heard about some

CLOCKWISE FROM TOP LEFT:
When she moved here, Pushpa signed a document promising to vacate her home if the city ever required her property.

Pushpa is respected by all her neighbours.

She frequently meets with her neighbours to discuss the problems they face.

With her union job, she has been able to improve her home, adding a television for her son, Mahesh, to watch cricket.

35

PUSHPA

municipal land that was available for settling. "When we first moved near the airport gate, I built a simple room of bamboo and plastic. Ramesh could not help me and my children were too small to help. We lived there for five years, more or less. It was not easy. We had to purchase everything to build the house with: the bamboo sticks and the plastic sheeting. Every strong wind that came would rip the plastic and the water would pour in. I had to buy new plastic every few months. In the strong monsoons, we would be flooded and the sticks would wash away. We had so little, but we had each other. My husband became more and more sick."

PUSHPA AND HER FAMILY were evicted from this first plot to make room for expanding parking lots. She quickly seized the opportunity to move to the Vakola Pipeline field, on the other side of Santa Cruz Airport, when the Mumbai Municipal Corporation offered undeveloped acreage for free settlement. The government only stipulated that each tenant had to sign a legal document proclaiming that they would move without resistance if and when the property was required for any reason. Pushpa willingly signed. "We were given a slightly larger lot than the others (13 by 15 feet) because there was no house on one side. My son, daughter, husband and I all worked together to build this house. We started with a *gobar mitti* floor (a mixture of cow dung and mud). Our walls were about eight feet high and covered with colourful plastic: green, black, white and blue. ...We were very miserable, especially during the monsoon. We had no drainage and such bad flooding. Sometimes we would have to rebuild our house every fifteen days! It would all wash away."

WHEN THEY FIRST MOVED TO THE NEW SLUM, there were only about 200 families living there. "At that time there was no water and no sanitary facilities at all. We had to go all the way to Dhobi Ghat, a distance of about 500 metres (547 yards), to carry water that we had to buy for two rupees for each bucket! We had no electricity, only a gas lantern and a cooking stove. There was only open sewage—we all went into the field next door or to the edge of the creek to relieve ourselves.

"IN SO MUCH OF MY LIFE, I WAS DEPRESSED, suppressed and oppressed; sometimes I had no food left for myself. I could not take a bath because there was no bathroom and no water, and that would last for a week and more. ...I would hide behind my sari held on one side by my husband and on the other side by my daughter and I

ABOVE: Pushpa cooks dinner in her narrow modern kitchen. Behind her spice jars and utensils declare her relative prosperity.

BELOW: She looks at a photo album of her deaf son Mahesh's recent wedding and discusses it with him in sign language.

36

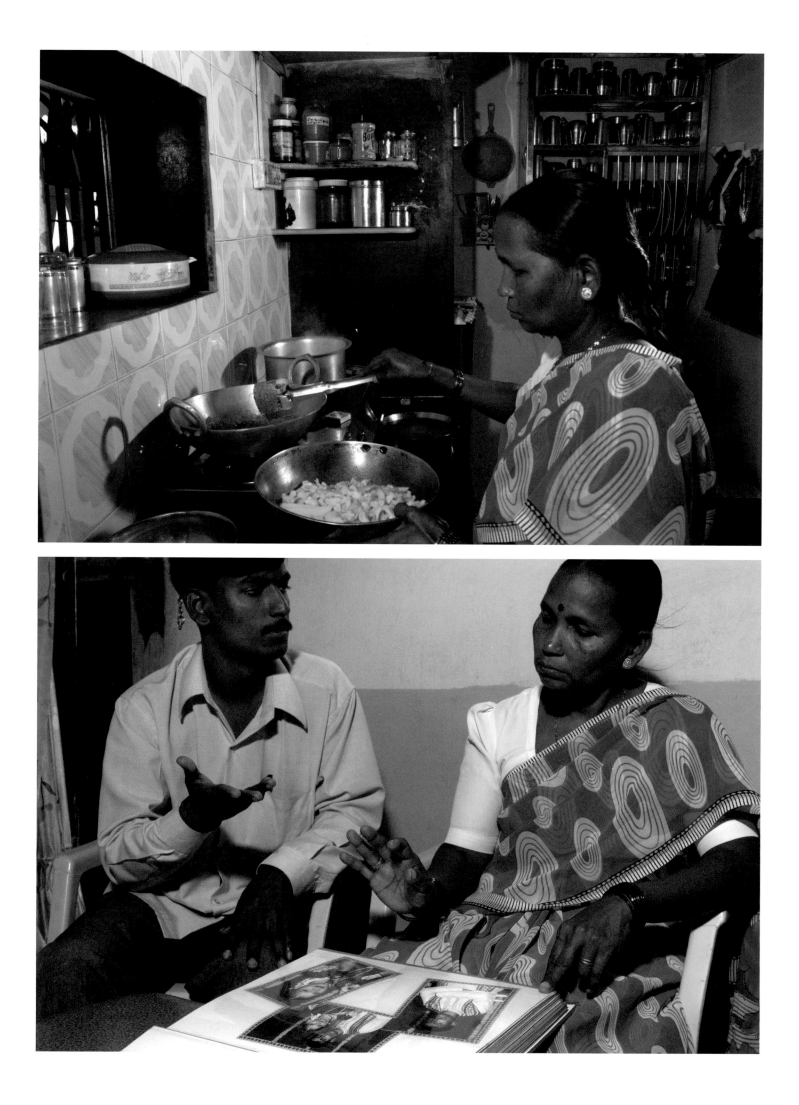

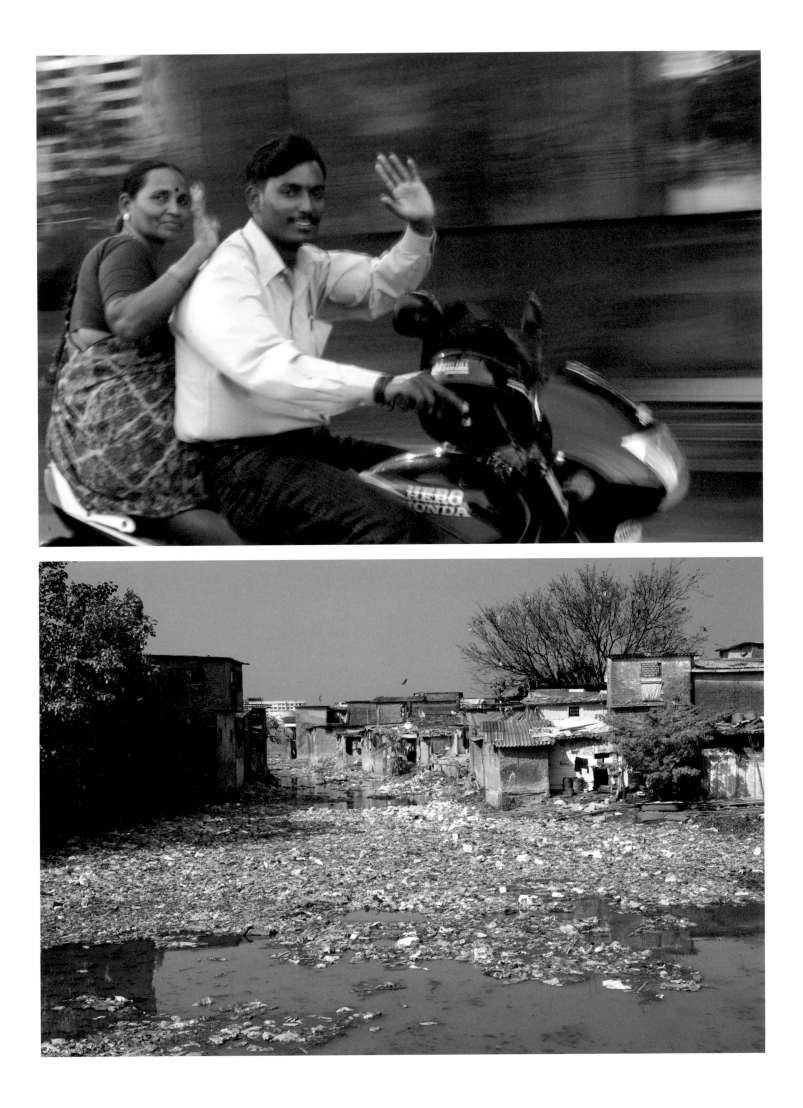

PUSHPA

would bathe that way, hoping that no one would see me. When I remember my past life, I can never sleep. It gives me nightmares. I try to forget, but it is not possible. ...Ramesh lived only two years in this house before he died."

WHEN PUSHPA WAS WIDOWED in 1991, at the age of 34, she had already been the sole support of three dependants for nine years. She was determined to provide a future for her nine-year-old deaf son, Mahesh, and struggled to pay his tuition and board at a special school for the hearing-impaired. She comments: "However many hairs I have on my head, I have spent more than that on my children. ...After the death of my husband, I worked in the airport for eight hours a day and, afterwards, I also had jobs as a house cleaner and I carried food for the owners of these houses to their children in school and also to the offices of their husbands. I received Rs 150 (US$6) per month per family for four families. ...Between my airport job and these small jobs, I was working 14 hours every day. I woke up at 3:30–4:00 every morning to prepare food and get ready for the day."

IN 1997, PUSHPA SECURED UNION EMPLOYMENT as a sweeper for the Airports Authority of India. This new job guaranteed her a much larger salary, unlimited medical care, a free lunch every day and bus fare to and from work. With her employment as collateral, Pushpa took out a bank loan in order to finally build a permanent structure on her lot. She and her teenage children mortared concrete brick walls into two stories with a tin roof. The Bombay Municipal Corporation began to supply electricity and limited water. Pushpa's house has a tiny kitchen with a gas stove and a small bathing cubicle (no toilet). The entire neighbourhood was similarly transformed. Two thousand families now live there—an average of 470 people per acre, with no dwelling taller than two floors! And although the shared latrines and the open sewers are foul, each home is remarkably clean. The members of this community are proud of their achievement, and their morale was high until a recent threat of airport expansion. Pushpa's honesty and vitality are well-respected. "I am very poor, but everyone in the neighbourhood comes to me for help. I am like their mother. I help where and when I can. I enjoy this. I never lock my house because our neighbourhood is safe. Anyone can come inside and rest. My son is strong and no one will cause problems for us."

ABOVE: Pushpa went into debt to purchase this motorbike for her son Mahesh in order to secure him a job as a courier. His income is still minimal.

BELOW: Pushpa's slum is an embarrassment to Mumbai's municipal developers and they want to bulldoze it. Her future is once again thrown into jeopardy by the threat of losing her home and employment.

PUSHPA

PUSHPA ALSO BORROWED RS 150,000 (US$3,300) to pay for her daughter Gita's wedding in 2004. In 2006, she paid a further Rs 200,000 for Mahesh to get married. In a normal situation, the bride would bring a dowry into her husband's family, but Mahesh's disability reversed the equation. Pushpa bought him a motorcycle as a wedding gift and he uses it for his work as a courier, earning Rs 550 (US$12) per month. This meagre income is clearly not enough to support a family. At present Komal, his young wife, has no job and Pushpa remains their sole support. Financial pressures are great, especially considering Pushpa's large bank debts. She has had three heart attacks in the past 10 years. In each case, her medical expenses were paid by her government employers. She comments: "I was given a prescription to take every day. I stopped about a month ago. It is too expensive! The pills make me sleepy and I cannot work, so I only take them on my day off, once a week. But I do have regular scans."

IN 2005, VILASRAO DESHMUKH, Maharashtra's chief minister (the Indian equivalent of a US state governor) submitted to the national government an ambitious eight billion dollar plan to modernize Mumbai in four years. His vision includes bulldozing all major slums—including those that now impinge upon airport development. Taking direct action, Deshmukh's administration removed Mumbai's airport management from the government-run Airports Authority of India and gave the contract to the private South African–Indian consortium, GVK-SA. Concerned that privitization might mean that her job benefits would be slashed, Pushpa joined an unsuccessful strike of airport employees in early 2006. At present her salary and benefits are assured for another three years, but Pushpa worries about her future. "I have to work another 10 years. If I have to stop work before then, I lose all my benefits. I am afraid of losing my job because I am already 50 years old. I do not exactly know what will happen in three years, but I am afraid that maybe they will tell me to leave my job and take all my benefits from me."

LOCAL AND NATIONAL MEDIA are filled with speculations about what will happen to the slums and their occupants, but neither GVK nor the municipal government have made any official statements. For all its problems, India is still a democracy. Chief Minister Deshmukh's pledge to obliterate the slums has been temporarily stymied because local politicians are worried about the voter base

represented by this huge population. In the meantime, Pushpa and her neighbours are concerned for her her future. One newspaper article suggested that they might be moved to uninhabited land far north of Mumbai. But this would put Pushpa too far from the airport to maintain her job, and she would have no collateral with which to build another house. Her future seems bleak.

"THE PAST IS PAST," she states. "I try to look to the future, but because of my son's disability, my future is not secure. It is a difficulty. I am worried about my son and his inability to support his family; and now as I get older, I may lose my job and my home. My belief teaches me to live in the present and I try to do that. Who knows what the future will bring?"

Pushpa prays to the Buddha in her household shrine that also contains a photograph of her late husband.

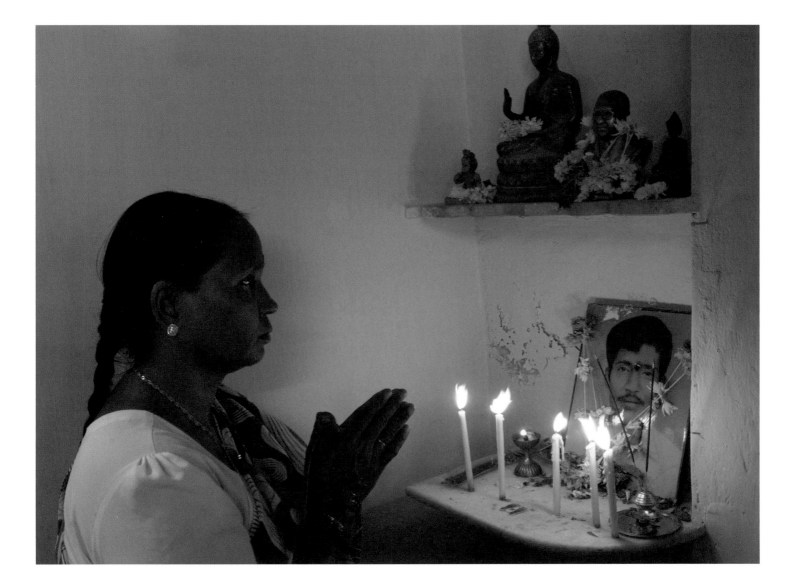

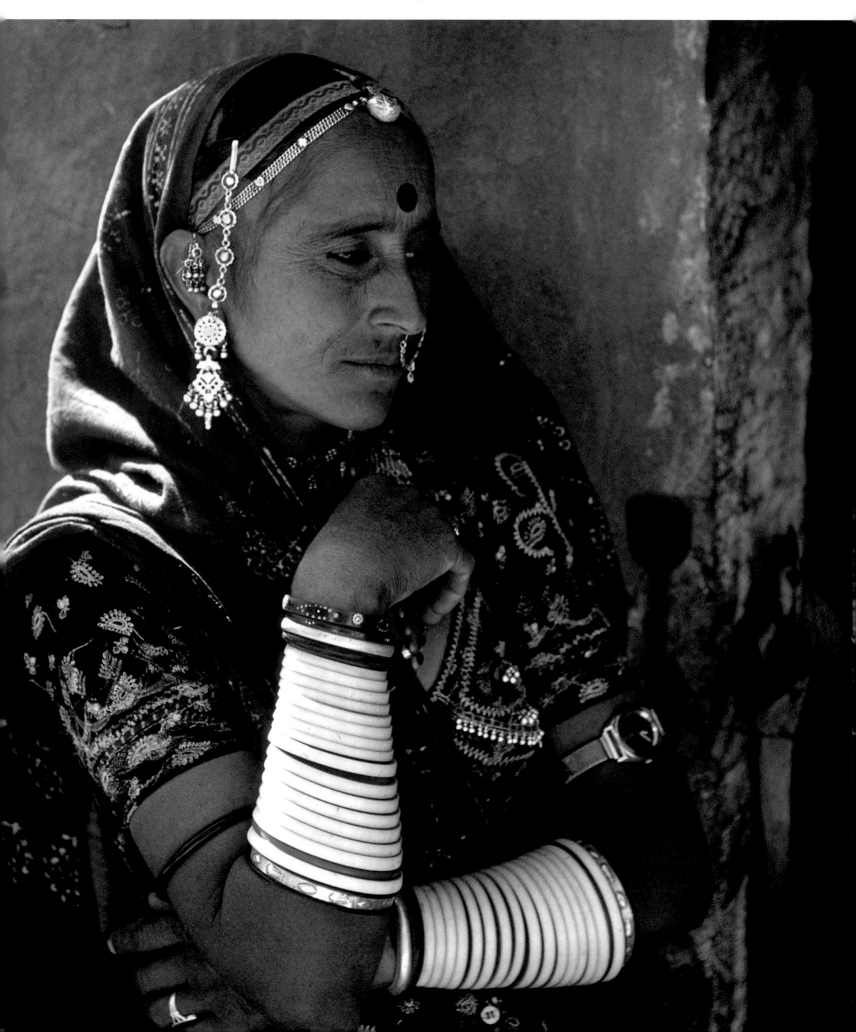

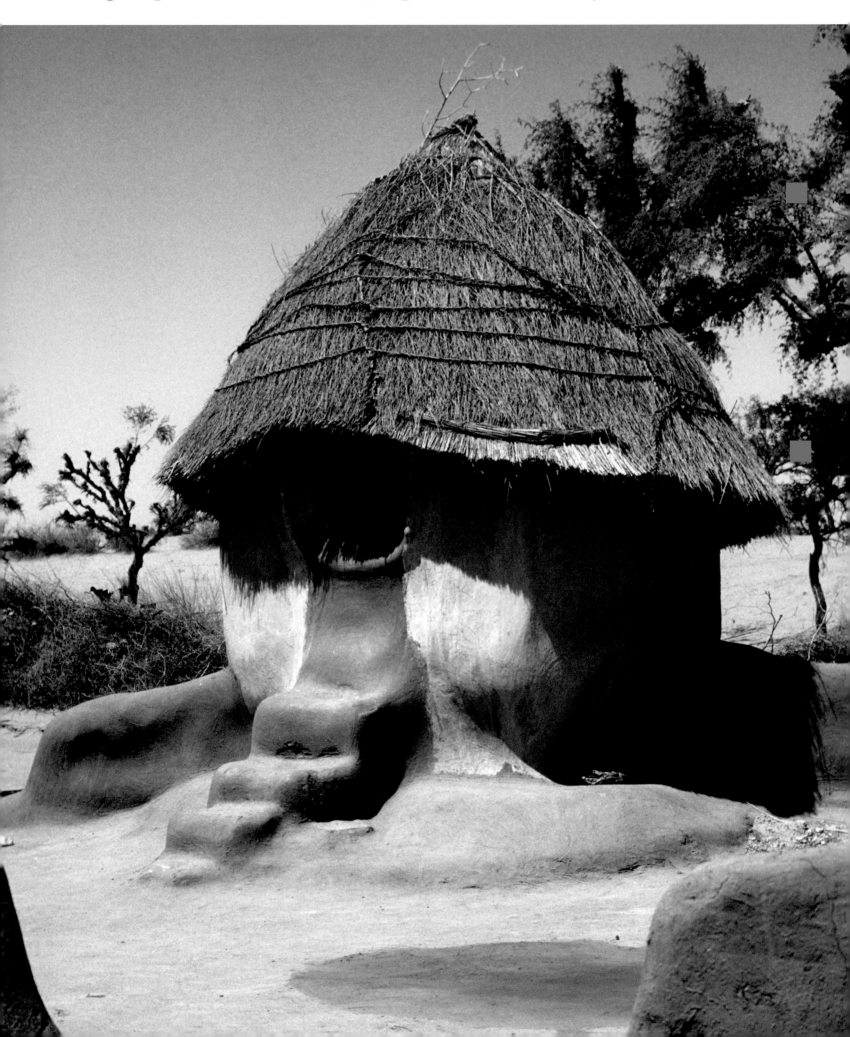

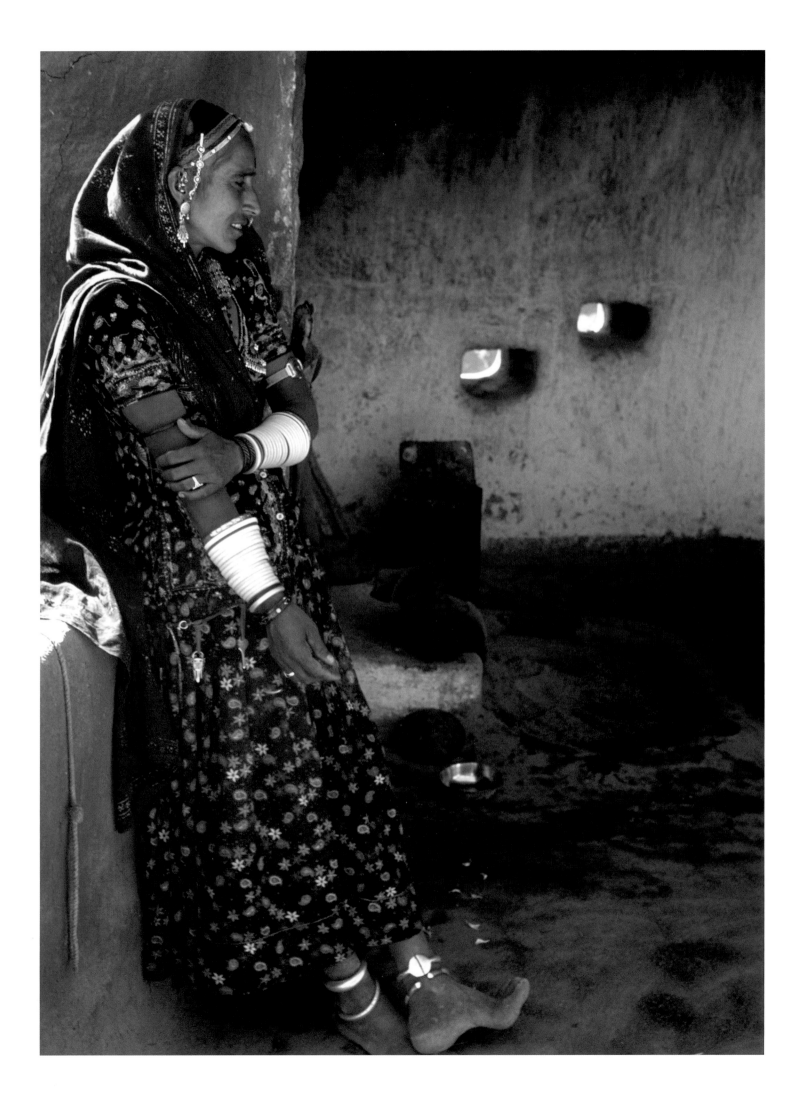

LALITA

"So many changes since I was a young girl. I cannot even remember them all. My mother and aunties—it is as if they are from a different India. And my grandmother before her—she could almost not leave the home, only for temple and some festivals; but then she must be fully veiled. Look how I am living! Look at my work! Can you even imagine how it was before?"

LALITA IS CONTENT. HER LIFE IS GOOD. She is happy in her marriage to Yadav, and they have two children: a boy, Sanjay, who is eight, and a girl, Mina, who is five. They believe that their immediate family is large enough. In accordance with popular opinion, Lalita and Yadav practise birth control, a custom that would have been unthinkable a few decades ago. However, most Indian families still believe it is essential to have at least one son. Lalita and Yadav's daughter, Mina, will move away when she marries, but a responsible son will ensure that his parents are properly cared for in their old age and that their funerary rites are properly observed. The old tradition of having many children is no longer necessary. Available medicines and a good local hospital have made unsuccessful pregnancies and the deaths of young children increasingly rare. At any rate, the two youngsters have plenty of cousins to play with. Yadav's two brothers live in attached houses in the same compound. Each has his own family; together, the three brothers have seven children ranging in age from ten to one.

YADAV IS IN GOVERNMENT SERVICE. He works as a guard at the local district headquarters for agricultural management. It is a respected job with a steady salary: an important asset for assuring a good marriage contract for Mina when she comes of age. Although Lalita was only able to attend school up until the fourth standard (grade), she was a quick learner and her literacy has enabled her to add to her family's income. Apart from cooking and caring for her immediate family and sharing in the joint responsibilities for the entire compound, Lalita works two afternoons a week as a receptionist in the office of a nearby motor scooter factory. This job exposes her to the broad outside world and to people from every walk of life.

THE LIVES OF LALITA'S MOTHER AND GRANDMOTHERS were entirely different. Although historically almost all Indian societies have been governed patriarchally, ancient Hindu customs did espouse a relative equality of men and women. Beginning in the seventh

45

LALITA

century, the advent and influence of Islam caused an imbalance in this relationship as Indian women were increasingly treated as chattel by the men in their families. This trend continued under British rule. Until recently, all women in this area—Muslim and Hindu—had to remain veiled at all times in front of any non-family males. The lives of most women, except the very poor, were confined to caring for their families within their compounds and courtyards. Activities outside the home were forbidden. Public unveiling was considered scandalous, bringing shame upon a woman's husband and children. Traditions have changed rapidly in contemporary India. Lalita's work and the income she generates are welcomed by the extended family. Her own experiences have convinced her of the need to educate both her children well. Every week she puts aside money to guarantee their schooling at a level much higher than she or Yadav were able to pursue. Education and literacy are highly valued in modern India. By these actions, she hopes to ensure good future employment for Sanjay and a good marriage for Mina.

YADAV AND LALITA LIVE IN THE SMALL VILLAGE of Begumpura, not far from the large town of Sawai Madhopur in Eastern Rajasthan. Most of their neighbours are farmers and dairymen, although, in common with others in India's burgeoning new economy, many are now taking jobs that differ from their hereditary professions. Both Yadav's and Lalita's fathers were farmers, and the two brothers that live with them continue to manage the family lands and animals. But Yadav's brother has a satellite-fed television in the main room of his section of the compound. The television offers constant views of new possibilities, and insights into the lives of people elsewhere in India, Asia, and wealthy countries overseas. "We see so much nowadays," Lalita says. "With this telly, always the world is coming right here into our house. Our choices are so different now. Perhaps Sanjay will be a computer programmer when he grows up. Maybe Mina will marry someone who travels to other states or other countries. I just do not know." For Lalita, the horizons are now open, the future unknown—but exciting.

AS LALITA STEPS INTO THIS NEW WORLD, she is also deeply rooted in community traditions. Her village, Begumpura, is still largely composed of mud-walled, tiled-roof houses. This compound, like all the others, has a central courtyard around which all the rooms of the extended family are built. The four members of Lalita's little

For many different festivals and celebrations, Lalita and the other women in her household paint their walls and floors with sacred designs. Red and yellow pigments come from locally mined ochre, while white is made from limestone.

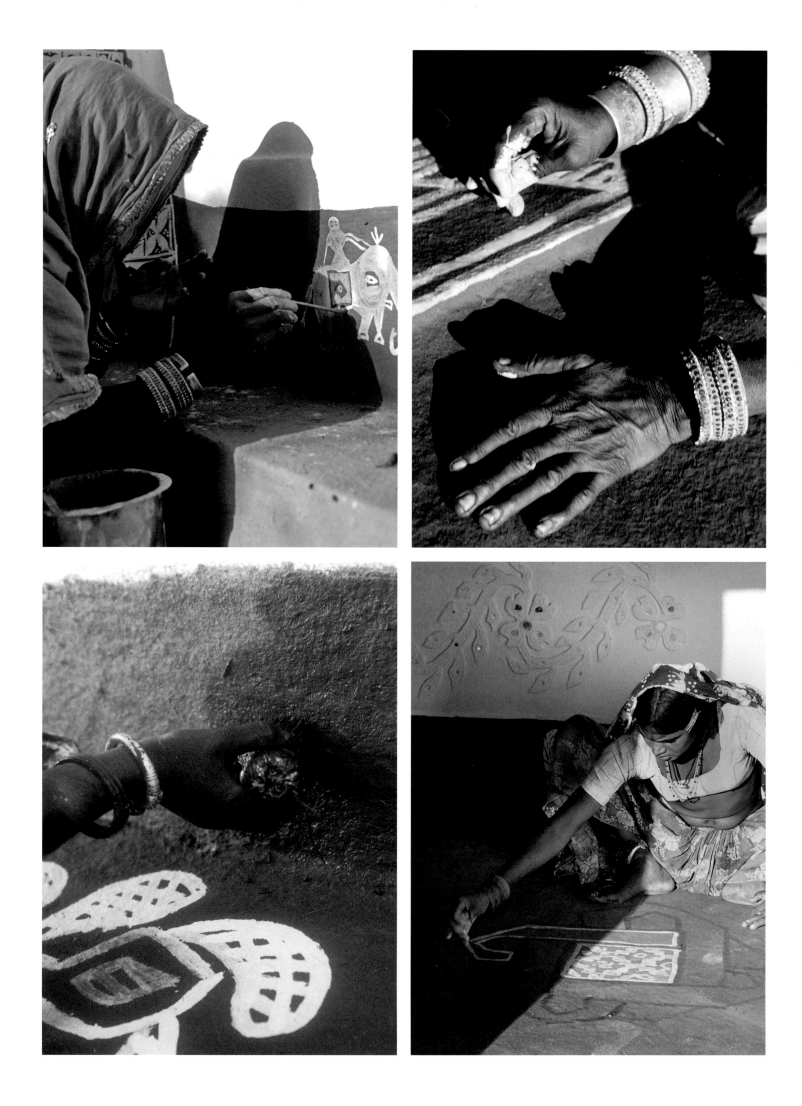

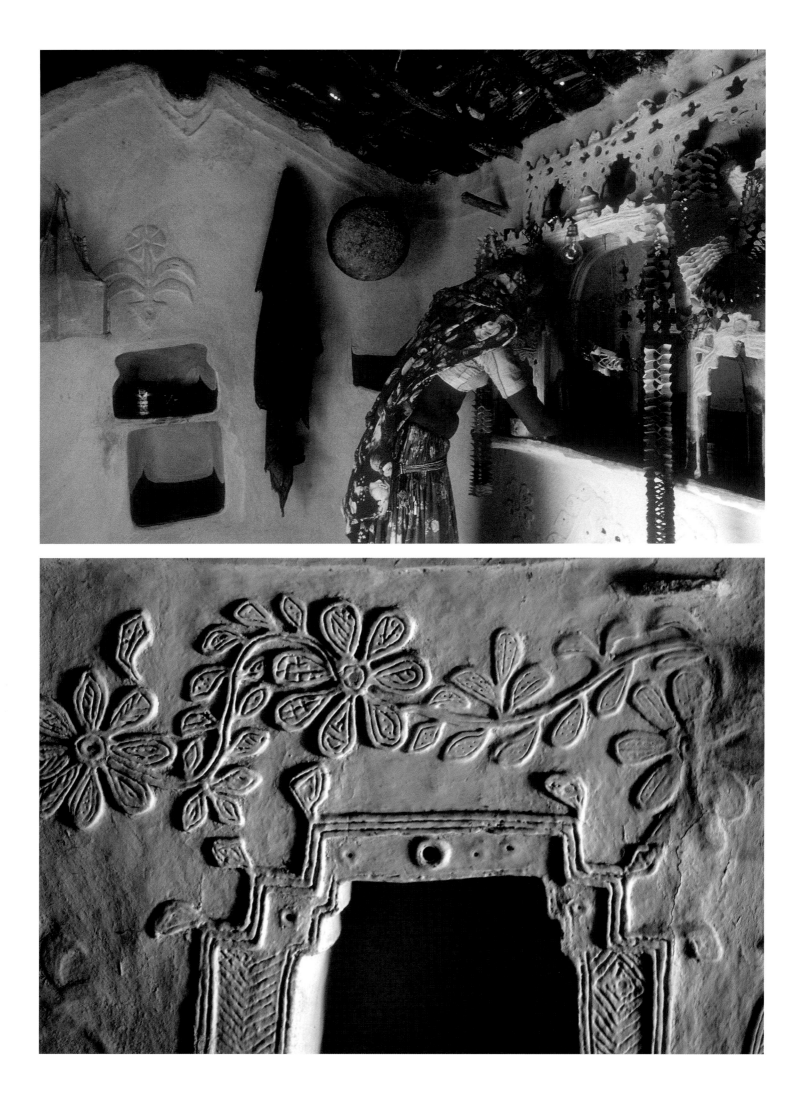

LALITA

family have two rooms of their own, as well as a small kitchen where they can cook meals for themselves if they like. However, the entire large family usually eats together. When the house was built, the inside walls of all the rooms were delicately sculpted by Yadav's grandmother. Now, when one of the mud walls begins to crumble due to the moisture of the wet monsoon or the wear and tear of family life, Lalita resculpts the walls in mud bas-relief inset with bright mirrors. The mirrors reflect the lamplight during the frequent electrical blackouts, making the entire room glow at night.

TODAY, LALITA IS TEACHING MINA TO PAINT. It is an age-old tradition of women, an art that Mina will need to know when she marries and moves into her new family. On special occasions like the many annual sacred festivals celebrated during the Hindu year, the women of the household use locally-mined red ochre to paint all the walls facing the courtyard and the outside walls on the street. Over this dark red base they use a paint made from white lime to cover the surfaces with fanciful decorations. They pride themselves in the variety of their designs: peacocks, camels, elephants, tigers, people, gods and goddesses, trees, flowers, and even bullock carts, cars and trucks. As they paint, they sing verses of the stories of the gods. Together, these women continue techniques that have been passed down for generations. Their intention: to bring balance to family and community. Yet their art is also innovative and creative, allowing for individual expression. Lalita comments: "We hope by these decorations the Gods and Goddesses will be pleased. We hope they will notice our home and want to help us." Lalita feels that the deities have already been very kind to her, although she would never say so for fear it might tempt fate. She views her life as good and can envision a positive future for her family. She exemplifies change within balance, and her art expresses her contentment.

OPPOSITE: When the interior walls of her home were first built, Lalita sculpted the clay surfaces with bas-relief designs, giving special attention to the niches that frame the family's household shrine.

FOLLOWING PAGES: Some of the wide variety of motifs that Lalita paints on the exterior walls of her house. The front wall, top right, is ornamented with two peacocks, a dog scratching fleas, a bullock, a camel cart, a lion, several birds and even a motor scooter.

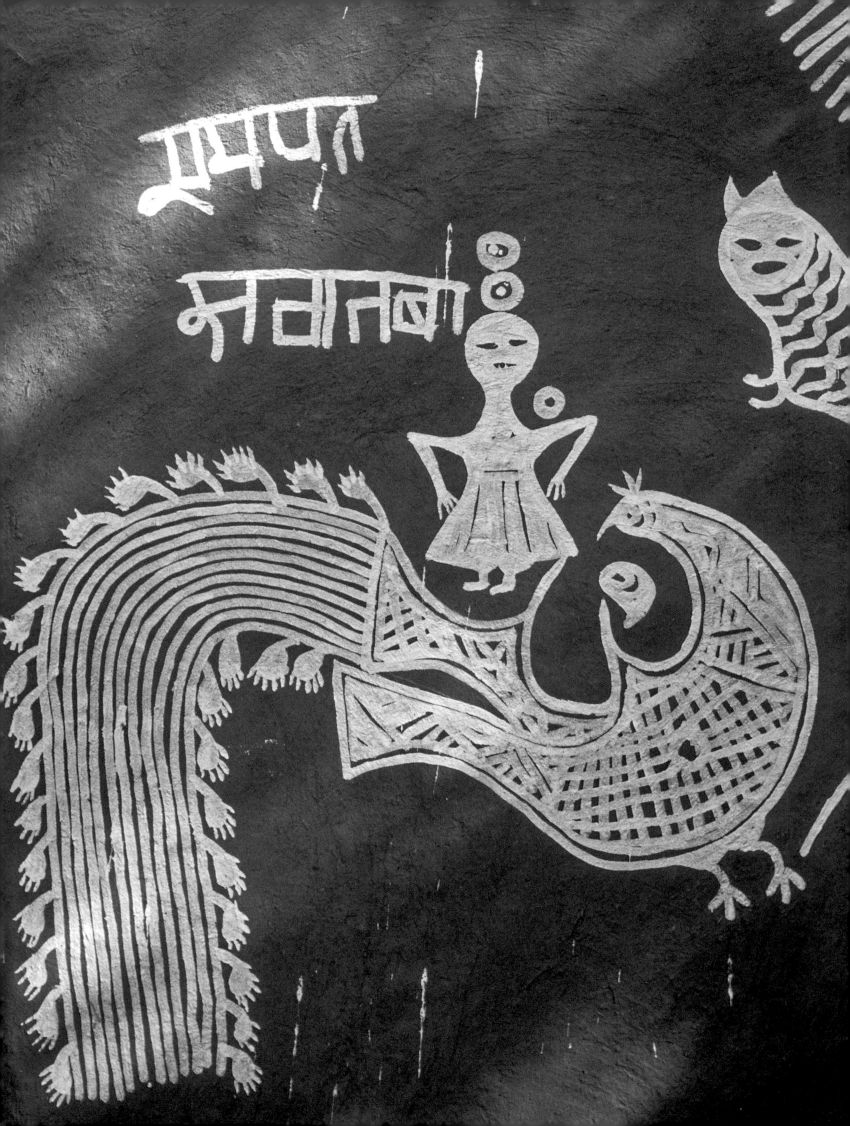

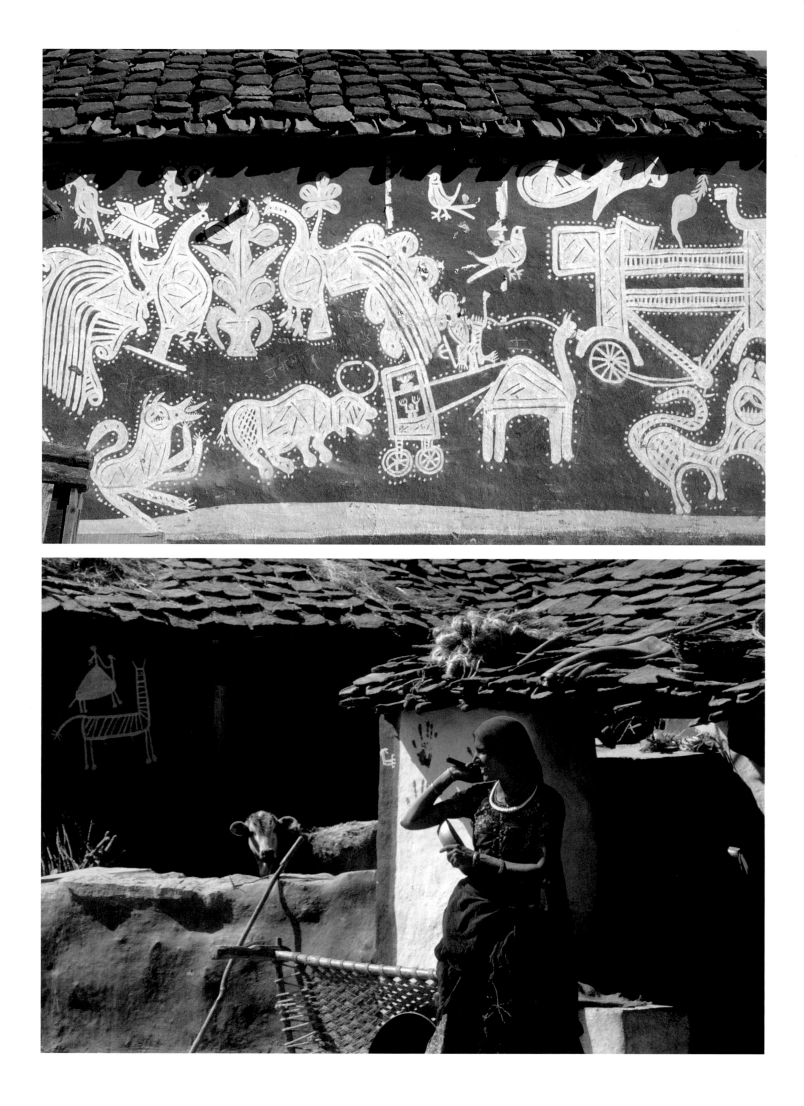

CHANDABEN Sewing Threads of Hope

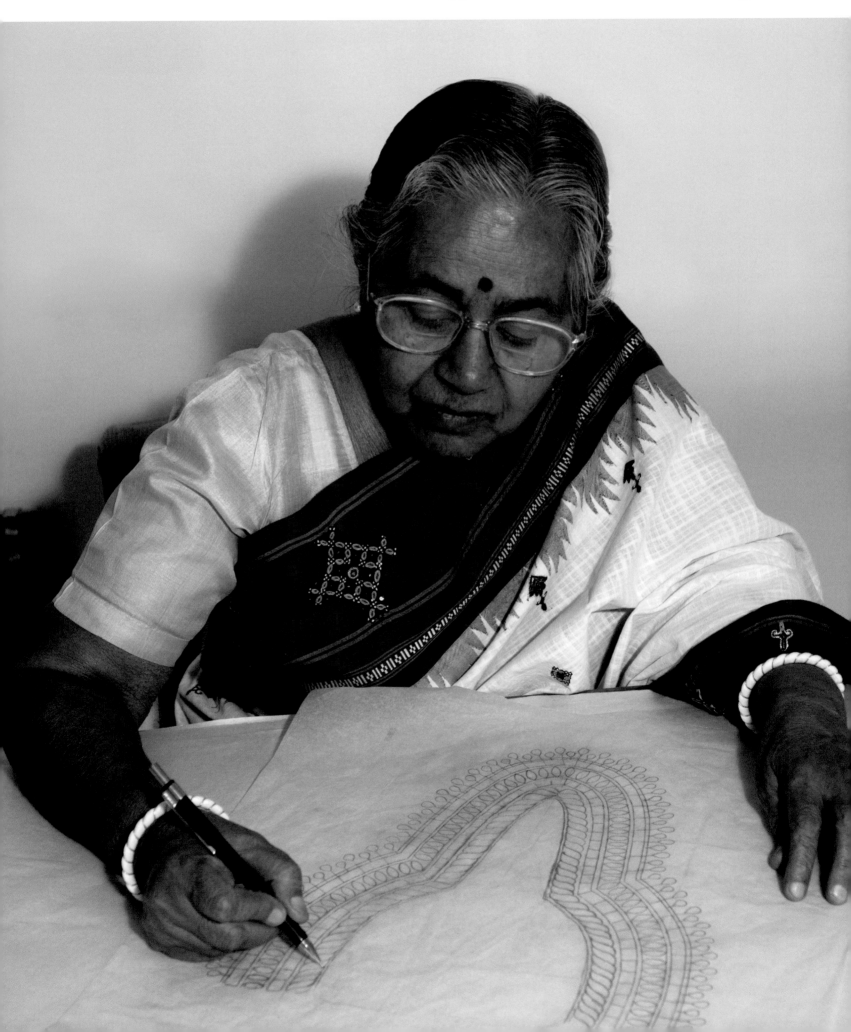

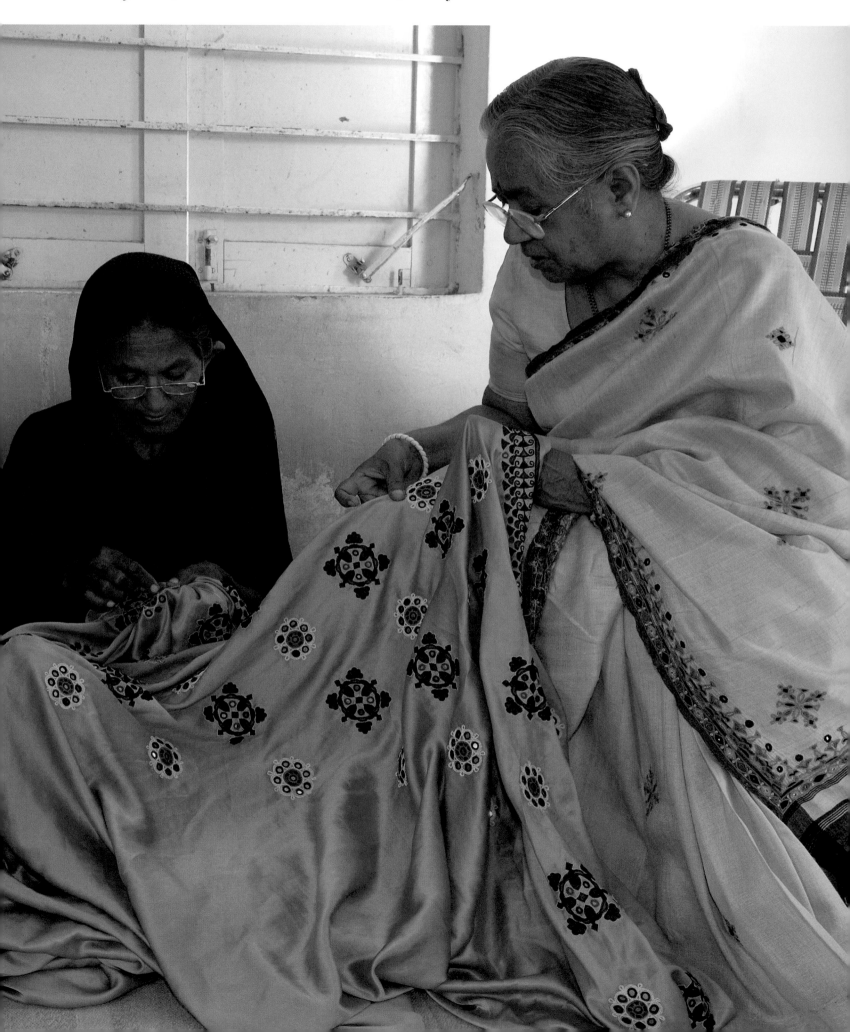

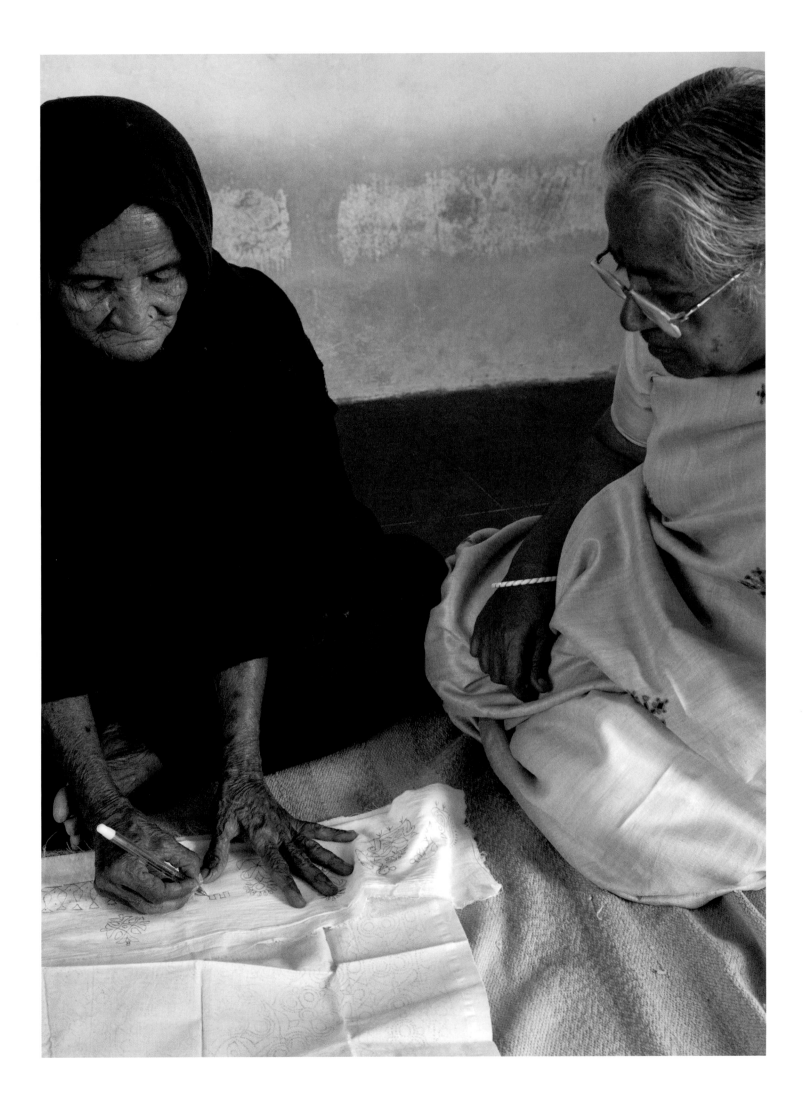

CHANDABEN

"When I first came to Kachchh, all government aid was based upon hiring the impoverished for manual labour: low wages for back-breaking and often demeaning jobs. My project allowed women their natural dignity, they received good wages and were still able to maintain their traditions by working at home while caring for their families."

CHANDABEN SHROFF ARRIVED IN KACHCHH IN 1969 as a volunteer for the Ramakrishna Mission to provide drought relief. She was the wife of a prominent, wealthy chemical industrialist living in Mumbai and she wanted to do something productive and meaningful with her life. The Kachchhi people had suffered from a major drought for several years and many were starving, but they were too proud to accept charity. In her first days there, Chandaben noticed the remarkable embroidery ornamenting the blouses, skirts and veils of local village women. For thousands of years, Gujarat—and Kachchh in particular—had been famous for remarkably refined textiles. These fabrics, traditionally manufactured by male artisans, were among the most highly valued by the courts and gentry of the Middle East and Europe. The fabrics' rarity fostered overland and nautical trade and influenced styles and fashions for centuries. Since the late 19th century, changes in trade routes, politics and fashions had diminished the demand for these exquisite weavings and embroideries. Communities had become more inward looking; the only remaining ornamented textiles were those that had always been created by the women as emblems of identity and as parts of their trousseaux. In Kachchh, these ornamented clothes were still worn every day by all the women that Chandaben met. As she began to question them about their craft, she had an epiphany.

SINCE INDEPENDENCE IN 1947, the greatest social priority in India had been to modernize and raise the lifestyles of its many cultures to a standard commensurate with Western 20th-century values. As part of that effort, it became fashionable among the upper and middle classes to purchase and wear machine-made synthetic textiles. Many now regarded the efforts of the earlier, Gandhian age to support traditional, hand-spun, hand-woven cloth as misguided idealism. In the textiles she saw in Kachchh, Chandaben recognized a creative talent that could be redirected into new and innovative products for the urban fashion market. This vision was remarkably ambitious: it would require re-educating urban sophisticates and redesigning traditional Kachchhi textiles to fit urban tastes and styles.

CHANDABEN

CHANDABEN HAD BEEN TRAINED AS AN ARTIST and had good business acumen. But she realized that she needed someone from within the community to facilitate her vision: a close liaison with village women. She sought a person who could understand her goals, find craftswomen, help train them, and reinterpret traditional designs for a contemporary market. She found her perfect partner in Parmaben, an older woman of the Ahir (cowherd) caste, who showed insight and originality in the beautiful embroideries she created. Other village women would often come to Parmaben for advice on how to lay out and design a textile and which embroidery techniques to use. Although illiterate, Parmaben had a highly trained mind and a capacity for understanding an innovative market. Chandaben took her to Mumbai and exposed her to the world of high fashion and then hired her as site supervisor, teacher and design manager. Back in Kachchh, they set up their first workshop, hiring and training 30 women in Parmaben's own village, Dhaneti. Their organization, Shrujan, was born.

CHANDABEN NEEDED TO CONTINUE LIVING IN MUMBAI with her husband, Kantisen, and raise their three children at home. Her dedication to her family meant that she could only travel the hundreds of kilometres to Kachchh three or four times a year, bringing new orders, consulting with Parmaben, and returning to the city with new products. Initially, as is typical in India, she relied upon her family and friends to help publicize and expand her business. Together, Chandaben and Parmaben designed clothes that combined traditional designs and techniques with contemporary fashions. Chandaben states: "It was my intention right from the start to make sure that these embroideries were essential to the future of women's fashion. My first priority was to make them a respectable part of Indian dress and identity. At a time when polyester and nylon were so popular, I wanted to make Indian women feel great in these embroidered cotton and silk garments."

When Chandaben's husband retired in 1996, the couple was finally able to move permanently to Kachchh where they live in a home composed of three small village-style buildings and surrounded by a large organic farm.

GRADUALLY, THE BUSINESS GREW and began employing more women. Its reputation expanded in Kachchh and the message spread that women were beginning to make good incomes. Parmaben set up training workshops in other villages. As each community in Kachchh was known for its own style of textile ornamentation, Shrujan took care to incorporate an embroiderer's hereditary designs into her new work. But in order to meet the demands of sophisticated clients, it was essential that Shrujan monitor quality

56

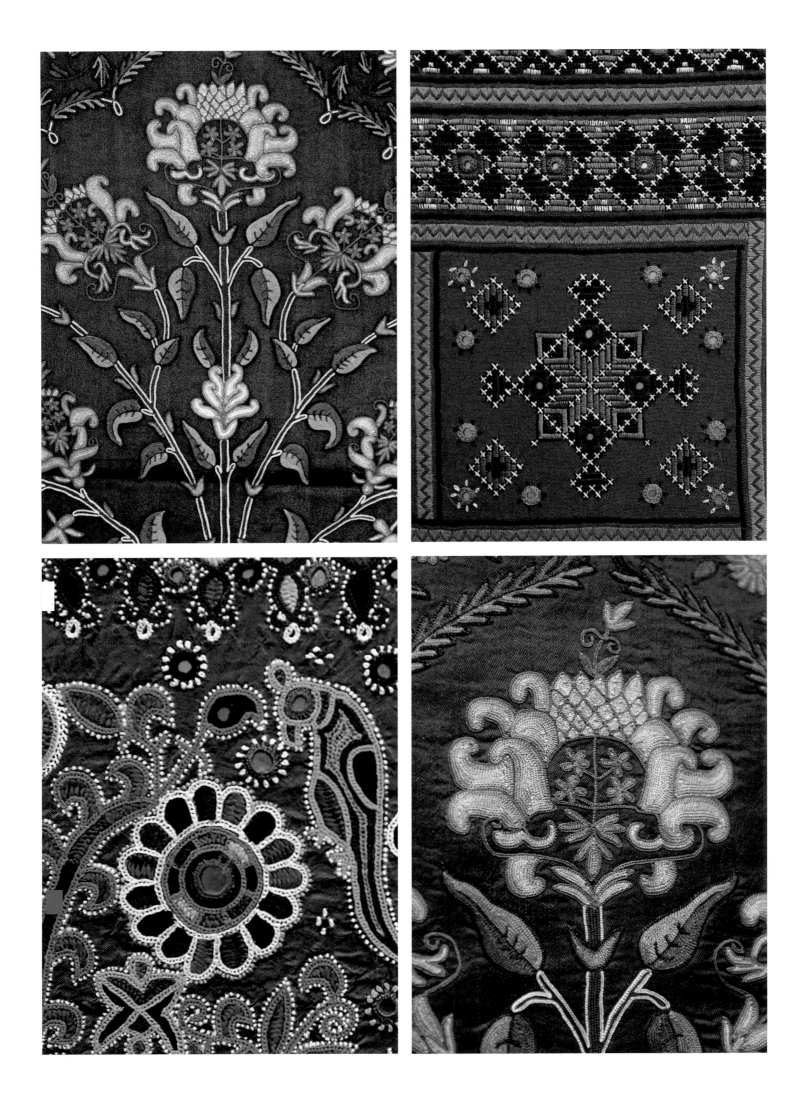

CHANDABEN

control. Most traditional folk textiles vary greatly in their adherence to pattern repetition and technical refinement. Quality control produced a relative uniformity of design. Chandaben comments: "Each area has its own unique style of embroidery. We always employ the women to recreate their own traditional designs, except where experienced artists wish to suggest and create a new motif. In order to ensure a uniform quality, Shrujan provides the base fabric with these designs already stencilled upon them. We have been consistent in providing the highest quality colour-fast fabrics, preferably handloom, so that the purchaser will know that these exquisite embroideries are durable and will not bleed in the wash…. We have, in fact, been trying to not only keep their individual creativity alive, but also to encourage more and more women to choose the career of becoming a traditional artist/designer." At Shrujan, a loss of individual creativity was counterbalanced by a fine, reliable product for urban couturiers and designers. That high standard of craft production was rare in the India of the 1970s and 80s. According to Chandaben: "Shrujan functioned as a bridge between the rural and urban, not just transferring money as donations to aid the poor. Urban women were happy paying for this high quality and rural women were getting the opportunity to earn. It was a natural symbiosis."

BY THE EARLY EIGHTIES, Shrujan had expanded to provide work for 400 women in 22 villages. Workshops were set up in Ahir communities surrounding Dhaneti, throughout the Banni Region (*see* Samabai, pp. 152–163) and in camps for Pakistani refugees. Chandaben established the Shrujan Trust in 1982, creating a board of trustees and receiving charitable trust status. The Trust enabled her to raise funds to expand the project into a broader network that could benefit more women. By 1990, Shrujan employed 800 women in 63 villages. She comments: "Because Shrujan was behind them, and the women knew this, they could manage their homes with self-respect. A woman whose husband was ill could take a loan with confidence that she could repay. We taught the women that tangible goods such as livestock, property and useful equipment might have more value for them than money in a bank and they began to spend their incomes more wisely. Gradually, they became more and more economically resourceful, and the gender balance began to shift. If a daughter required money to create a trousseau, she could now turn to her mother, not only her father, for help." Shrujan's emphasis on letting artisans work at

Many historical European fashions were based upon fine textiles imported from Kachchh. In the early 20th century, most of the techniques of superlative craftsmanship were lost. Here are four examples of the exquisite embroideries now created through Shrujan's influence.

59

home meant that the transfer of power was much more graceful and less threatening to men than the alternative of women working outside their traditional environment. This approval might simply illustrate the fact that women are expected to continue their traditional household work while endeavouring to bring in a large proportion of the family's income. However, as noted earlier, India has a long history of *shakti*: the identification of strength and power as feminine attributes. Even though it might be hard to understand from a Western perspective, Indian men are much more accepting of the natural power of women than Western men. Chandaben notes how heartening it is to see the increased respect Shrujan's employees have gained from their husbands and from the broader society.

IN 1996, CHANDABEN WAS FINALLY ABLE TO ENACT the next stage of her dream. First, she and her husband, Kantisen, were able to move permanently to Kachchh. They purchased a large tract of land on the outskirts of the village of Bhujodi, near the capital of Bhuj. There, they built a home designed to resemble three small village huts. Their successful, verdant farm blends traditional and innovative organic farming techniques. Right next door to the farm is Shrujan's new centre, housing administrative offices, design and production workshops and classrooms. In her work with contemporary Kachchhi women, Chandaben realized that they did not lack in creative talent but did need training and incentives. "I decided to accept responsibility for change and to try to make a difference. I realized that it was essential to build a design bank for posterity."

Over the past decade, Chandaben has assembled 1100 embroidered textile panels, each unique piece created by a master craftswoman. Together they form a design bank that is taken from village to village to demonstrate to local women their textile history and to encourage them to participate in this endangered and lucrative craft.

SHRUJAN'S NEW CENTRE — A COLLABORATIVE EFFORT by traditional artisans, university-trained artists and professional designers—has created a remarkable legacy. The new design bank is built around a unique collection of masterpiece prototypes, panels of a uniform size, each of which represents the very finest examples of specific styles in the most intricate embroidery. Over the past decade, this collection has grown to include 1100 pieces representing 10 different cultural groups and 15 different stitch types! It has become an invaluable resource for the future of Kachchh. The panels are exhibited in village halls throughout the district. As women examine them, they understand more clearly their heritage and the potential of their craft. It can be honestly stated that prior to the work of Shrujan and a few other far-sighted non-governmental organizations, the quality of Kachchhi embroidery was disintegrating. Thanks to

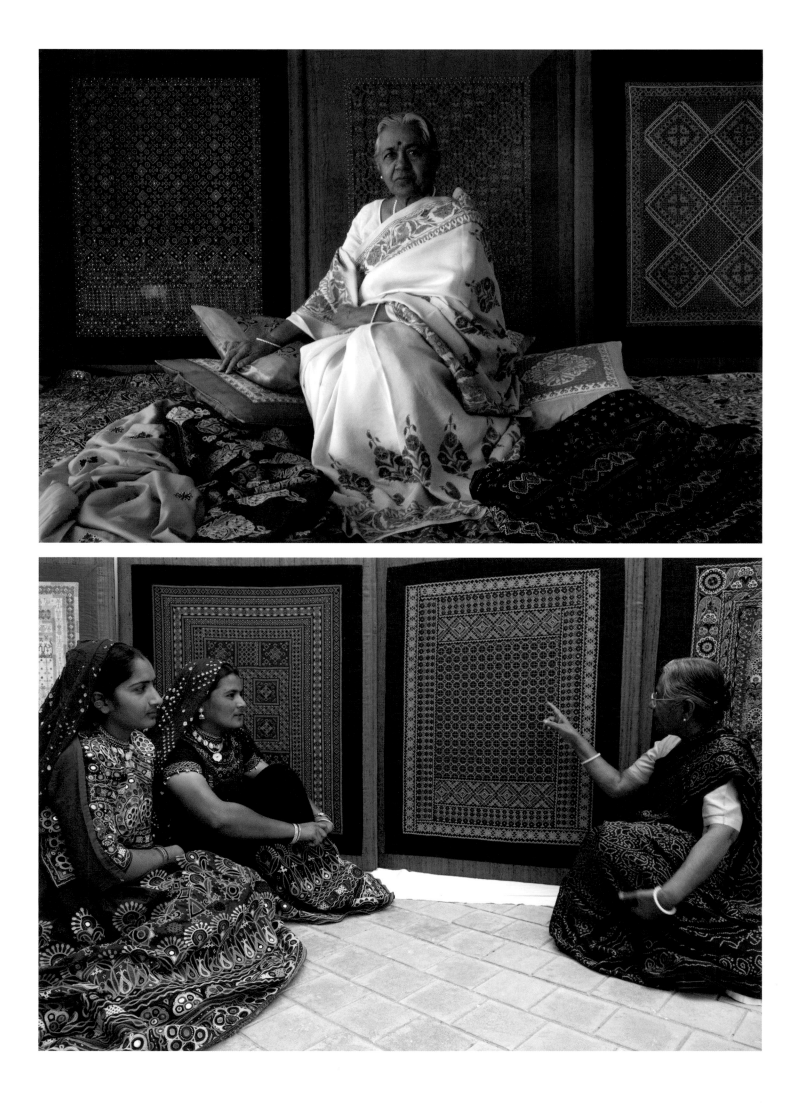

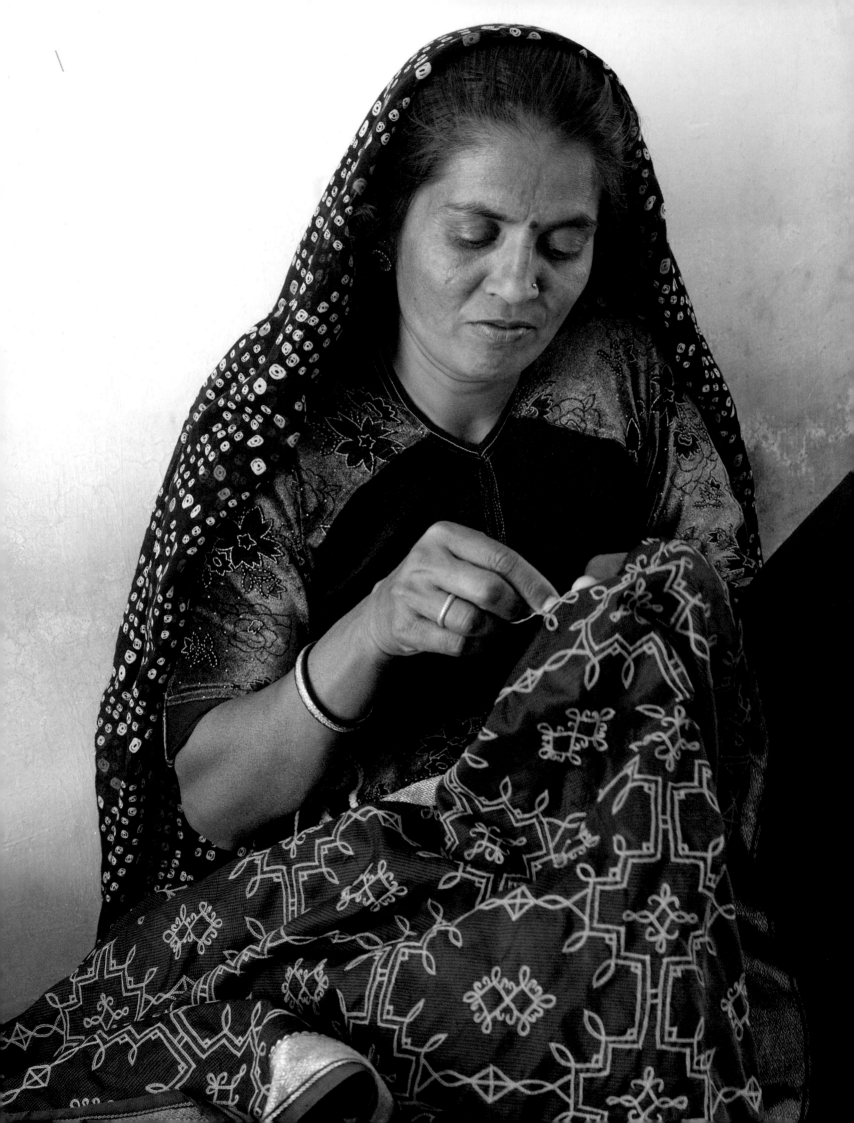

CHANDABEN

them, many of these textiles are now as fine as they have ever been. This superior quality is in demand among fashion markets and decorators throughout India and abroad. And customers are willing to pay high prices.

ON JANUARY 26, 2001, the massive Gujarat earthquake totally destroyed Shrujan's new centre. Luckily, all the panels were stored in humidity-controlled steel cupboards in the basement, and none of them was damaged. The disaster became a springboard for major changes. The Government of Gujarat Handicraft Board loaned Shrujan 10 million rupees at a very low interest rate to rebuild and expand its employees to 3000, and to further develop the textile training programme. Today, a normal training class consists of 20 trainees spending six months under the tutelage of a master craftswoman of their own village. They learn to make the very finest textiles using their own hereditary stitches and designs within a precisely dictated format that will meet the requirements of the fashion world. In their first years, they have limited design choices, but as individuals prove their competency and their understanding of the market, they are given greater freedom to incorporate their own choices in colour and design. Today, an average embroiderer working for Shrujan makes about Rs 18,000 (US$450) per year, double the income of a labourer. A master craftswoman can make as much as Rs 25,000 to Rs 30,000 (US$620 to 750) annually.

NOW IN HER SEVENTIES, Chandaben is still bursting with ideas and ways to further develop Shrujan and benefit women. She remains fit by walking every day to and from her farm, and by eating only nourishing home-grown produce. She is actively involved in designing textiles and regularly meets with Parmaben (now in her eighties) to discuss ways to teach this craft to a broader spectrum of women. In October 2006, Chandaben received the Rolex Award for Enterprise. She is one of only 55 laureates singled out during the past three decades for their innovative efforts to improve human conditions and the world economy. Summing up these last few years, Chandaben states, "The most important part of my work, my life, is to keep this art and these artisans alive." Through insight and determination, she is succeeding.

OPPOSITE: In the final stages of her tutelage under Chandaben and Parmaben, a village woman uses tiny stitches to create a masterpiece.

FOLLOWING PAGES: In this selection of embroideries for sale in one of Shrujan's stores, the mirrors, held in place by buttonhole stitches, are as small as the head of a pin.

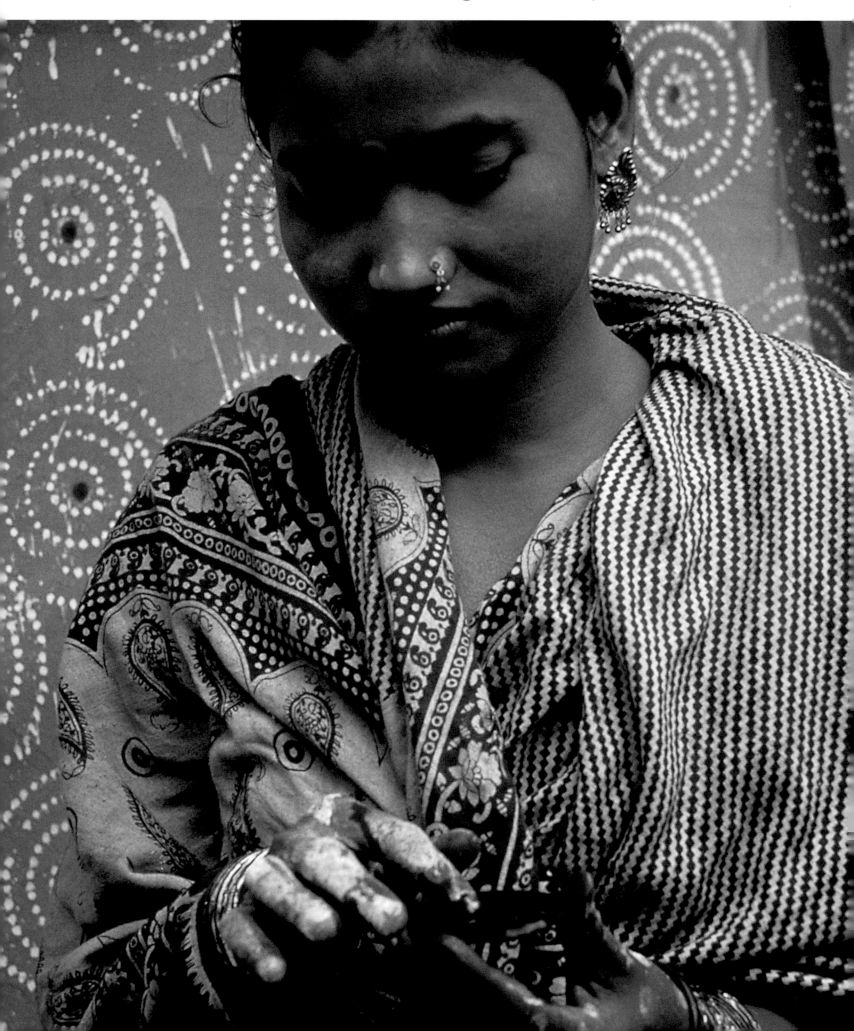

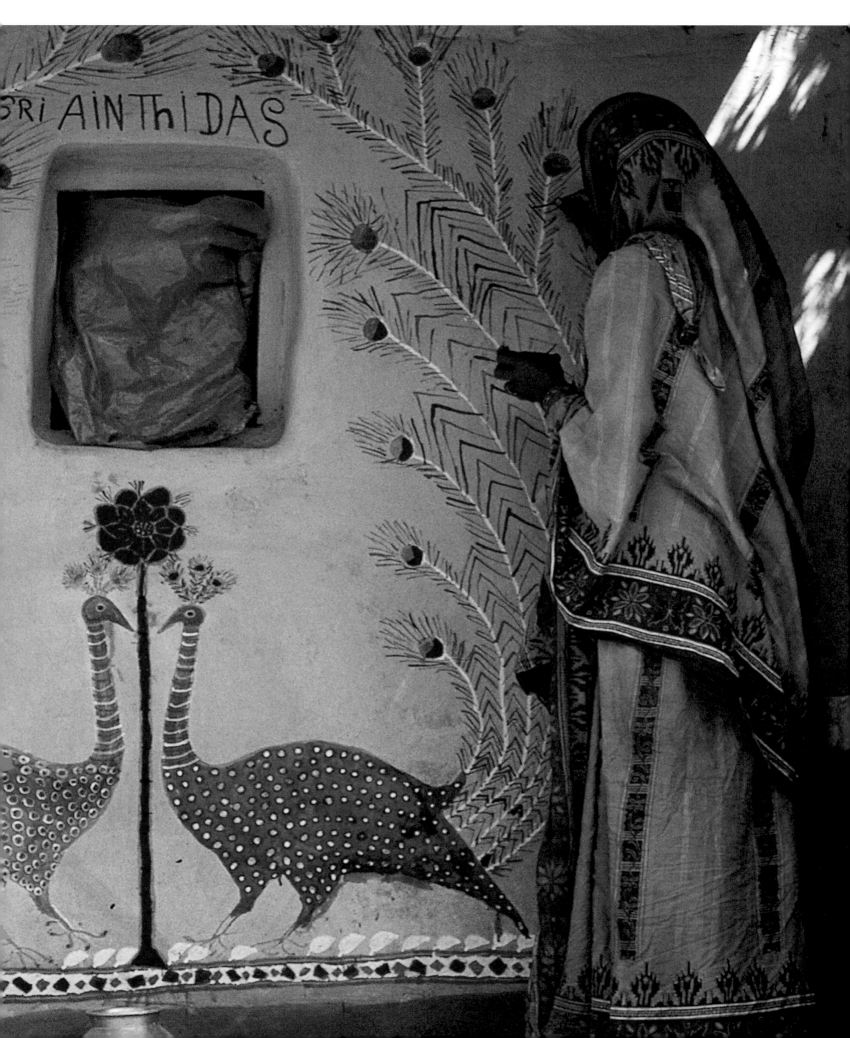

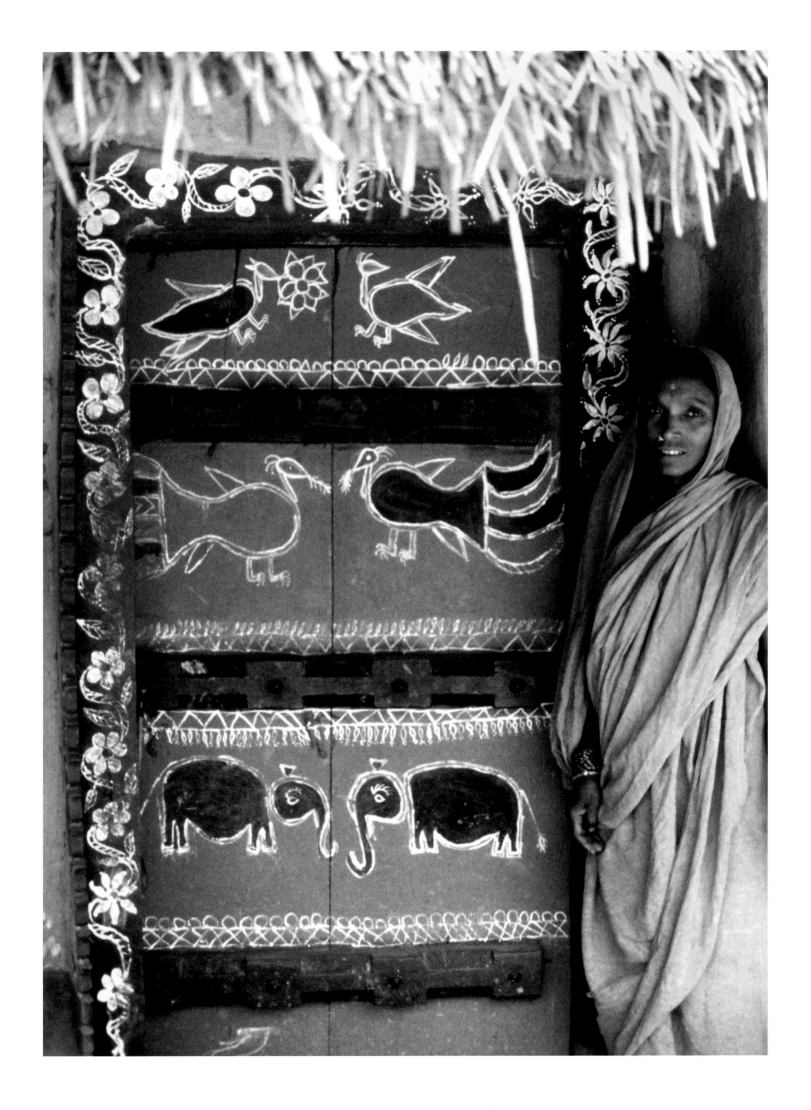

SAVITRI

"Every time I want to do something, to have some new clothes or bangles, or if I want to go on an outing with my friends, my parents say, 'No! Wait until it is your turn. Wait until Gita is married. Then you will have your own things.' Wait! Wait! Wait! Always, I am waiting..."

SAVITRI BEGINS HER PAINTING by sketching the outlines of two facing peacocks and then the long swooping curves that will be their tail feathers. She loves to paint. In this region of coastal Orissa, near Chilka Lake, it is customary to paint homes only for Diwali, the Hindu Festival of Lights dedicated to the Goddess Lakshmi. This decoration is usually limited solely to the front doors of a house and usually that is all Savitri is allowed to do. She is good at painting lotuses of many types: large abstract pinwheels or more graceful buds and petalled blossoms. Very often, she paints the elephants that are associated with the Goddess Lakshmi, the provider of abundance and good luck. But there is one other principal reason that women paint their homes in this region: to prepare for weddings. In just a few days Savitri's elder sister, Gita, is going to be married. Gita's fiancé, Narayan, will be coming here with his family for the initial celebrations. In honour of this special occasion, Savitri is painting the entire mud-plastered brick front wall of her parents' house. It is very exciting.

IT SEEMS AS IF SAVITRI'S ENTIRE LIFE has been hinged on this betrothal. For how long have her parents been getting ready for it? They have been saving money constantly for years just to get Gita and her married. Of course, Gita, older by two years, has to be married first. There has never really been any discussion about what Savitri wants. She is only 16. Any time she has asked to do something special—to go on a school outing or to buy some pretty bangles or a poster of her favourite film star—her mother has told her: "No, we have to wait until after Gita is married. We have nothing for extras." Every night when her father comes in from plowing or sowing seeds, he spends hours with his ledgers, counting out his savings, figuring out debts, scheming ways to get loans. Her parents are so frugal! It doesn't seem fair!

BUT HER MOTHER KEEPS TELLING HER that this is the system—that they have no choice. Even though dowry was outlawed by Parliament in the Prohibition Act of 1964, it is still an essential part of almost all Indian marriages. The only way that most girls can marry is if

69

SAVITRI

they bring with them a sizeable dowry, usually in the form of money and possessions. Aside from these expenses, the bride's family must pay for the wedding itself, for all the various festivities associated with the occasion, and for several days of meals for all the assembled guests. These celebrations can involve from several hundred to several thousand people, depending upon the means and status of the groom. All of these costs are the responsibility of the bride's family. The dowry itself is the property of the groom, not the bride. If her family wishes her to have any possessions of her own, they need to provide her with separate gifts that are part of a different negotiation.

UNTIL RECENTLY, THE AMOUNT OF A DOWRY depended entirely upon the means and the economic position of the groom. Most families marry their daughters into families of similar status. For example, farmers' daughters of a certain income would expect to marry farmers' sons in the same bracket; the son of a doctor expects to marry a well-educated girl from a similar family background. Theoretically, the economy balances out with each family having both sons and daughters, trading dowries and wedding expenses between them. However, the balance may shift for three major reasons. First, some parents have no sons or have more daughters than sons. Second, some families want to improve their social and material status. (If, for example, a tailor wants his daughter to marry the son of a shopkeeper, he may well have to provide her with a much larger dowry to meet the improved economic status.) The third—and increasingly common—cause of disproportionate dowry debts is the growing greed of young men and their families. Advertising and brand-name marketing in contemporary media have had a profound effect upon Indian consciousness in the past few decades. The publicity hype of multinational businesses is now felt everywhere, even in the most remote villages. These influences intentionally produce the desire to acquire more and more possessions, most of them far beyond the means of average Indians. Grooms and their families now demand these products as part of their marriage contracts, and the brides' families have no choice but to go into debt to afford them. Prestige is calibrated by social position and material wealth. The results can be crippling. As sons inherit both the wealth and the debts of their parents, it is common in India for large dowry debts to be carried on for several generations. There is no way to pay them off. Consequently, daughters are an enormous liability. Most of the cases of murder in

ABOVE: Standing next to a door painted by Savitri, her mother gazes out into the street.

BELOW: Houses are transformed in preparation for weddings. The circular image beneath the family name represents Lord Jagannath, a favoured form of the deity Vishnu.

70

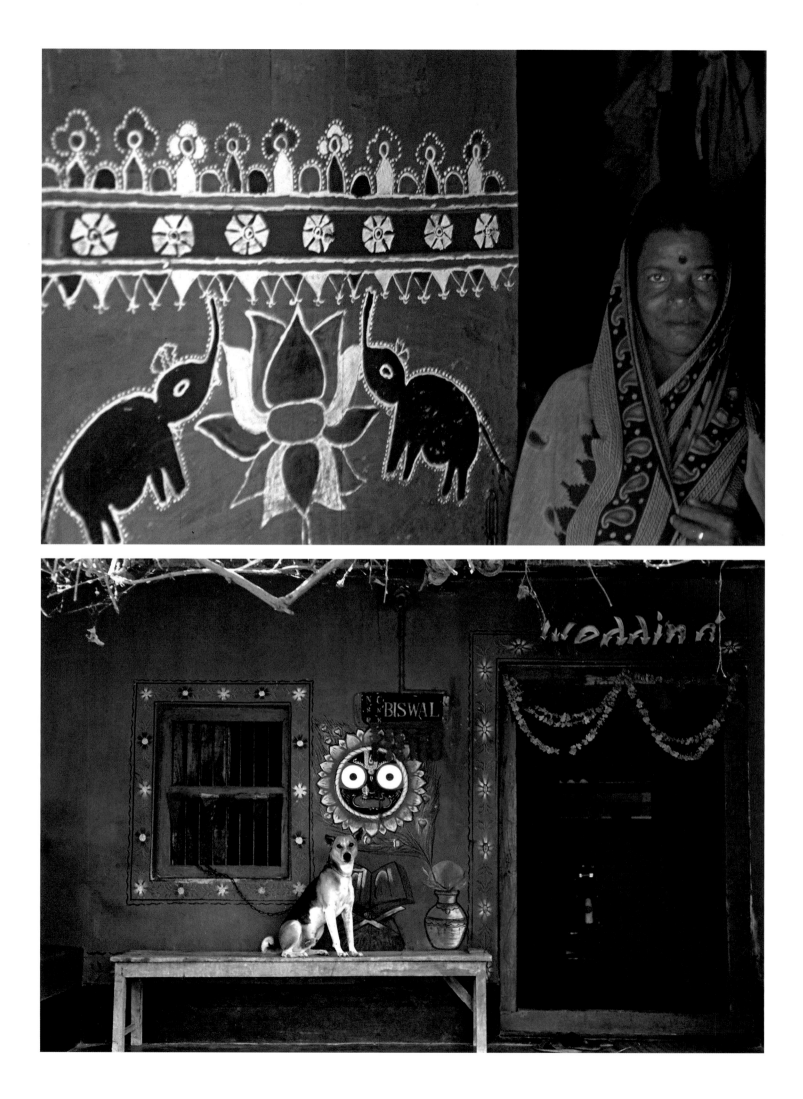

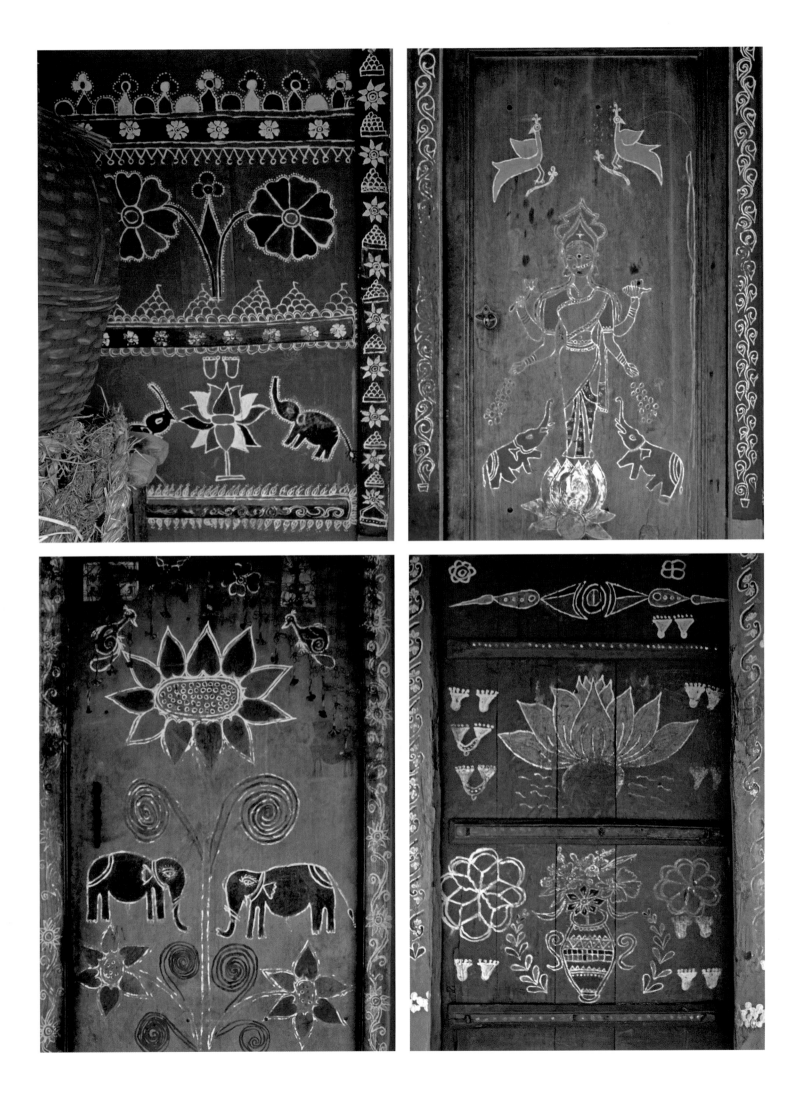

SAVITRI

India have to do with women or other family members killed for their inability to keep up dowry payments. Ninety-five per cent of all abortions in India are of female fetuses!

THERE ARE NO RELIABLE PUBLISHED STATISTICS about violence towards and murders of women. In a male-dominated, closed society, it is well known that many incidents go unreported. (One document states that 16 cases of various types of violence towards women are reported in India every hour of every day!) Even though the conditions that cause female infanticide and brutality towards women are deplorable, it is important to view them in perspective. When reading news and statistics, we must remember the extraordinary mass of the Indian population: more than one billion people (three times that of the United States in just one-third the area!). Of course, countless proud parents everywhere in the subcontinent love their daughters. Nevertheless, the statistics of female foeticide and abuse of girl children are pervasive and must be acknowledged and changed.

SAVITRI'S PARENTS, FOR ALL THEIR DOUR CONCENTRATION on frugality, have always shown deep and equal affection for all three of their children. Babu, her brother and the eldest, has been working with them for years to help save. Certainly, the income that they received as dowry from Bini, his wife, helped to offset the family debts and contributed towards the savings for Gita. Their mother made sure that both girls went to school through the sixth standard, even though she is still illiterate herself. She has assiduously been buying beautiful saris and special pieces of jewellery for the two girls ever since they were born, packing them away in camphor-scented trunks until they can be worn at their own weddings and taken as possessions into their new homes. The children all enjoy a close relationship with their parents.

BUT SO MUCH ENERGY IN THE PAST FEW YEARS has been spent on Gita's marriage! First, the best astrologers had to be consulted in order to know what appropriate signs would purport a good match. Then, all the relatives and neighbours suggested possible candidates. It had to be the right boy from just the right family and income and from a community not too far away, so that her parents and brother would still be able to see Gita upon occasion. Contacts were made and dowries discussed forever! The joint annual income of Babu and his father is Rs 93,000 (US$2,000). Narayan's parents

The front door of each house in Savitri's village of Dhunlo is painted with sacred designs for Diwali. In a common depiction of Lakshmi, the Hindu Goddess of Abundance and Prosperity, She stands on a lotus with an elephant on each side (shown on the upper right corner of the door). Two of the other doors depict different versions of these same elephants and lotus blossoms, while the bottom right corner of the door representes her through pairs of footprints.

73

demanded a payment of Rs 450,000 (US$9,782), plus a new refrigerator, a motor scooter, and two bullocks. Savitri's father had to take out another loan to cover this new debt. Arrangements were made to pay part of the debt just before the wedding, and the rest in installments during the following four years. All these negotiations were based upon one single meeting between Gita and Narayan. The two said that they found each other attractive, but not much more could be ascertained in such a brief visit.

NOW THE WEDDING IS FINALLY AT HAND. Narayan will arrive tomorrow night for the first of the long wedding festivities. Savitri is just about to finish her painting. She carefully adds all of the wispy plumes to the pinions before creating the luxuriant eye at each tip. Just as she is completing her final strokes, Babu comes out to add his name above the entire picture. It is an unusual act, but he wants his future in-laws and their guests to know that it is his house. In traditional India, women do not sign their paintings. Their art is considered a form of personal communication between artist and deity. But as she stands back and looks at the entire wall, Savitri is pleased. It is the largest painting she has ever made and it is a fitting gift to her elder sister at the time when she is moving away.

A painting on the outside wall of Savitri's house proclaims her sister's wedding.

OPPOSITE: This is a detail of a painting by Savitri that represents Lakshmi's lotus.

FOLLOWING PAGES: Much of the farming in this region of costal Orissa is devoted to the wet crop of rice.

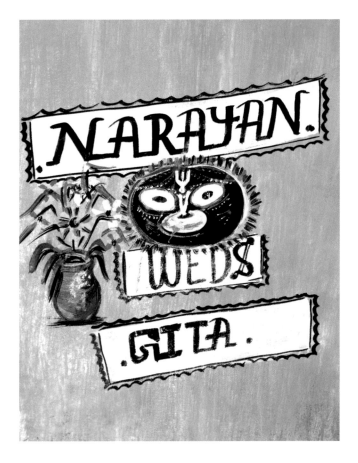

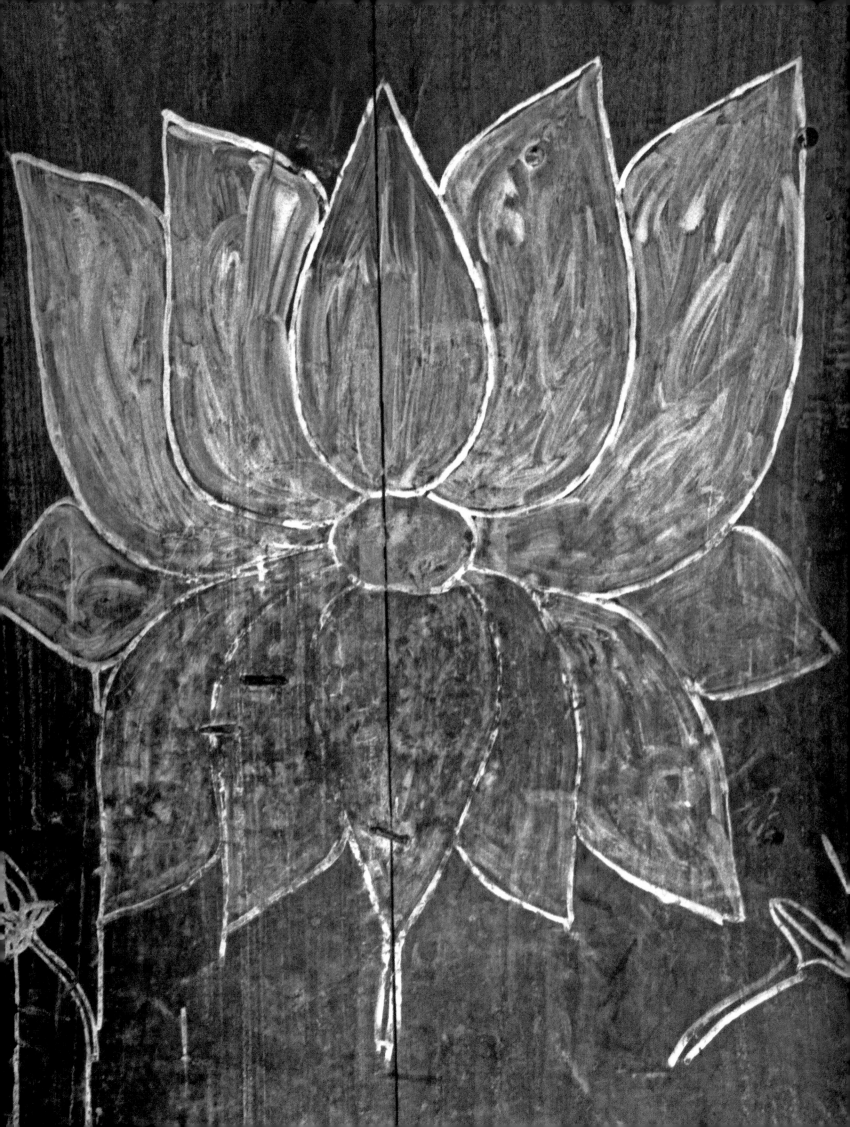

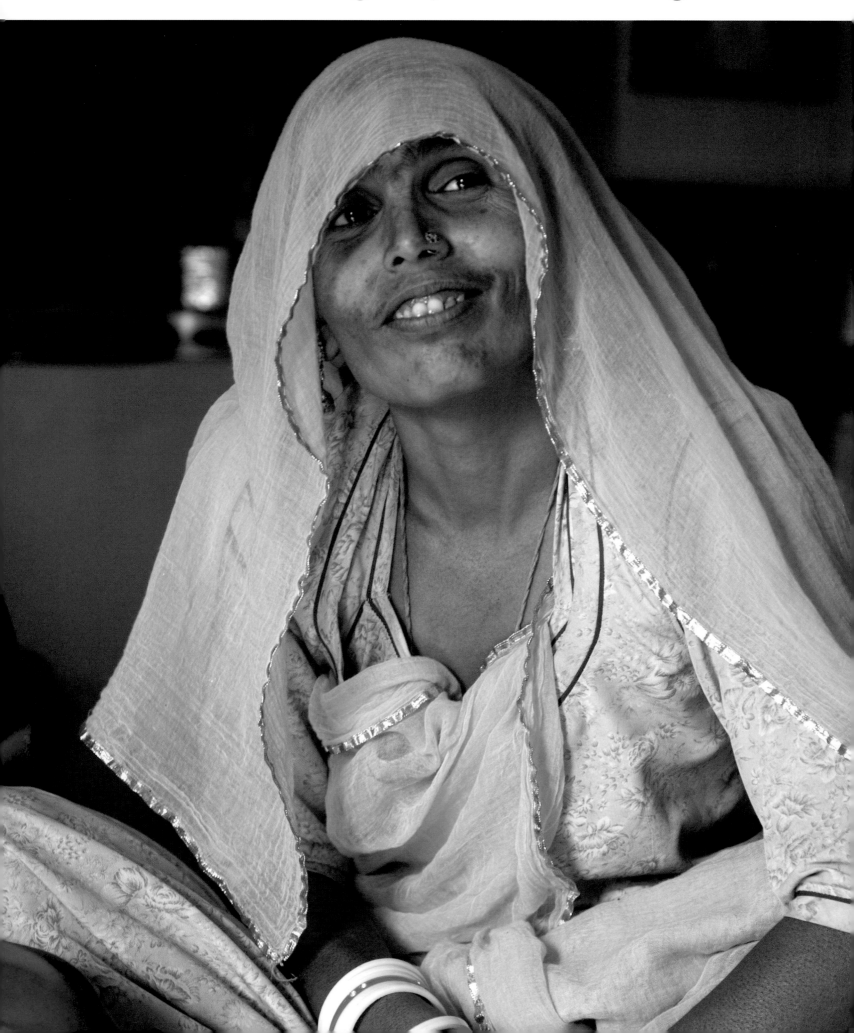

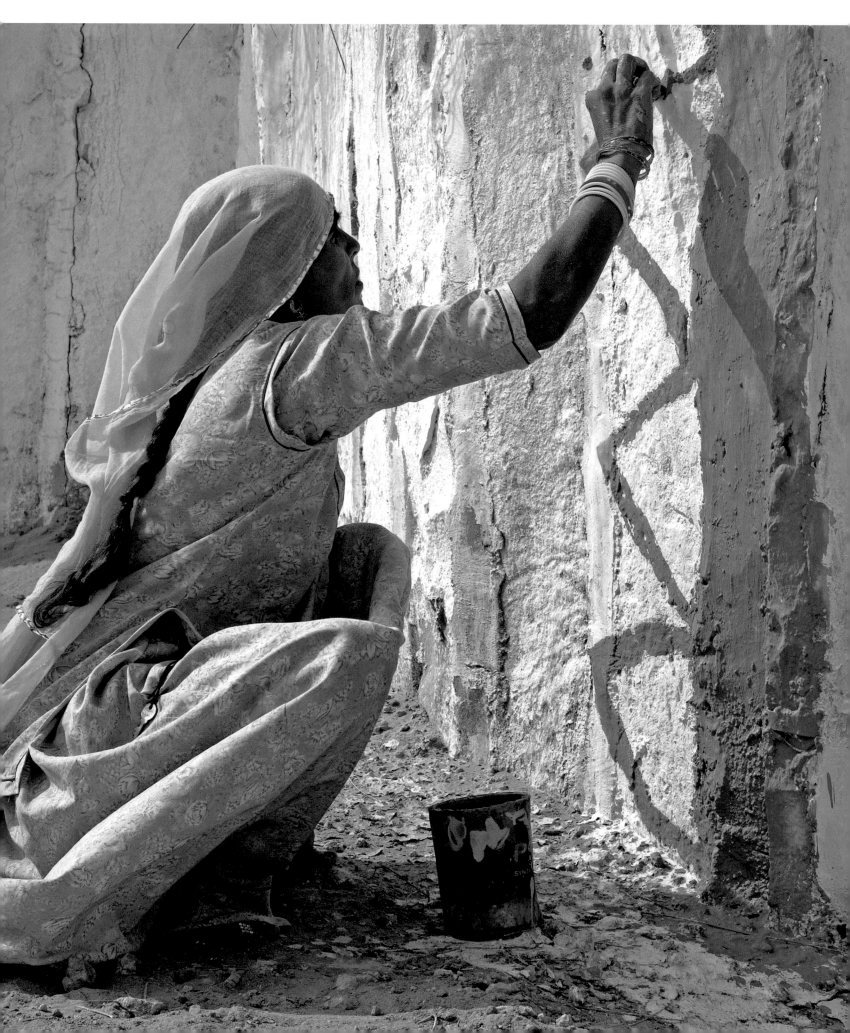

Jaisalmer, Rajasthan

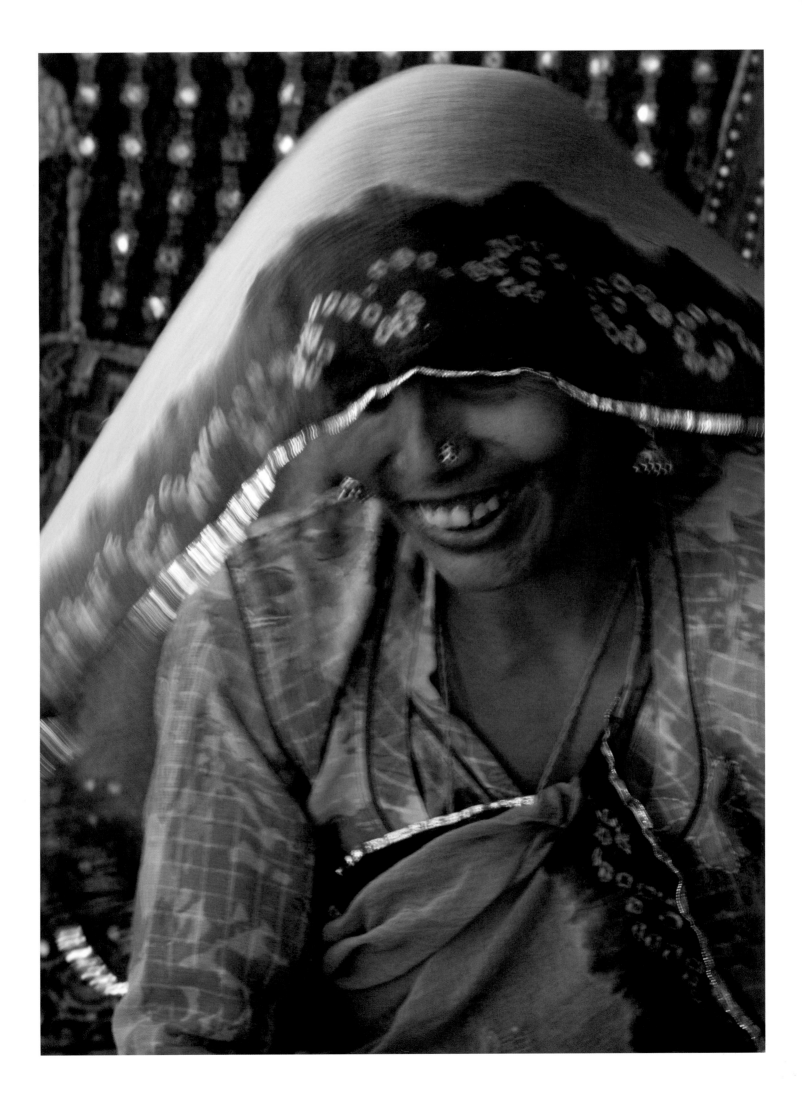

INDRA

"I feel good about painting. Earlier I had nothing I could do of my own. I only took care of my family: my parents, my husband, my children. Now, this is a way I can make a change in my life." Indra looks embarrassed and shy as she says: "And I feel proud that people seem to like my art."

INDRA BANU IS A MUSLIM WOMAN living in the Western Indian desert city of Jaisalmer, Rajasthan. Although Islam is technically a casteless society, Indra's inherited social position as a Merasi means that she is marginalized by her local culture. All Merasi are raised to observe the Muslim rituals of birth, betrothal, marriage and death. Nevertheless, the male members of Indra's family have been musicians to the local Hindu royalty and to a Goddess temple for the past 37 generations! Indra daily worships the Hindu Goddess Bhati Rani, in a small shrine in her home. In fact, her own brother is a priest at the Goddess temple in his remote village! This Merasi custom of honouring sacred aspects of two often incompatible religions has incurred the wrath and disdain of many in Jaisalmer. Indra and her people are ostracized in similar ways to those outcastes that were known elsewhere in India as "untouchables." Merasi women have few rights, and many are abused, even raped, with little or no recourse to legal or societal protection.

AN INTERNAL MOVEMENT TO IMPROVE THEIR CONDITIONS has grown among the Merasi during the past two decades. Sarwar Khan is a young Merasi man. As a boy, he grew up illiterate but wily. His natural curiosity put him in contact with Western tourists whose influence encouraged his own will to change. Working as an unofficial guide, he became fluent in several languages. His honest, open demeanour gained him many foreign friends, among them Karen Lukas, an American decorative painter who came to Jaisalmer in the early 1990s to study women's traditional art. When Karen was invited to stay with Sarwar's family, she met Indra, the wife of Sarwar's elder brother. During the months and years that Karen lived with the family, she became aware of the severe abuse that the Merasi receive on a daily basis. In 1996, Sarwar registered Lok Kala Sagar Sansthan, a non-governmental organization devoted to protecting the Merasi and facilitating their improvement. In 2005, Karen founded Folk Arts Rajasthan, a non-profit affiliate based in New York City. Together, the two organizations constructed a stone building in Jaisalmer's outskirts that serves as a safe house, a small folk museum, rehearsal and practise space, a school for women, and

PRECEDING PAGES, LEFT:

A life filled with strife and hardships has given Indra the determination to try to make a difference for her children.

RIGHT: Until a few years ago, her ability to paint was restricted to the simple household decorations she created to celebrate various festivals.

OPPOSITE: As a woman in a very conservative Muslim community, Indra has spent her entire life behind a veil. It is unprecedented that her husband allowed her to be photographed here.

79

INDRA

a women's crafts cooperative: Lugai for Lugai (meaning "woman for woman"). Indra, who lives with her family of five in a single room in the adjoining building, is an integral part of the new centre.

INDRA IS PROBABLY ABOUT 32 YEARS OLD. "I do not know my age," she says. "There are no records." She was raised in a tiny hamlet deep in the roadless desert, 160 kilometres (100 miles) from Jaisalmer. As Muslims, Merasi women are always veiled and isolated from any men but those in their immediate families. Indra's father and uncles were itinerant musicians who left home for weeks at a time to perform at distant festivals and weddings. The women's camaraderie within those cloistered walls was strong. They sang, told stories, and painted their floors with sacred designs for the rituals and festivals that marked every important occasion. Indra recalls: "In my house we made *chowk* (a local word for paintings made in a square) for the celebration of weddings and festivals such as Diwali and Holi. And when we have newborn baby boys in the family, then we do *chowk* for them. *Chowk* is always done on the floor. We paint all sorts of *phul* (flowers): lotuses, sunflowers many different other kinds." (It is interesting to note that the reason that *chowk* are only made for boys is that girl babies are considered to be inauspicious. In this culture, women are taught not to want them. Daughters are believed to be only a burden on the family's income and future.) Indra was taught to paint by her grandmother and mother, learning skills and a lexicon of motifs that have become an essential resource for her new profession as an artist.

In the past few years, Indra has been given the freedom to paint on paper and has poured out her emotions into visual explosions of colour. She has also begun building and painting her own versions of the wooden decorations (*torans*) that are traditionally placed above front doors in her region (above right).

WHEN INDRA WAS JUST 14 she was married to Yakob, Sarwar's brother. She had never seen him before their wedding and was terrified when she had to move from her village. Yakob is a stone carver in the quarries in the desert beyond Jaisalmer, yet he seldom works. Merasi women work hard in the home, but their traditions prohibit any other profession. Yakob brought almost no income into the family; but, living in a communal house with his parents, two brothers and their families, the young couple did not starve. Until Indra met Karen, there was no joy in her life. She comments: "One good thing now is that my husband does not beat me any more. Before, he beat me every day. One time I told Keri (Karen) about my problems and she came and had a fight with my husband and told him if he continued to beat me, she would bring the police. And he was afraid of this." Yakob and Indra have had three children, a girl, Farida, and two boys, Motilal and Asis. Farida, the eldest, is mentally challenged, perhaps as a result of her father's violence.

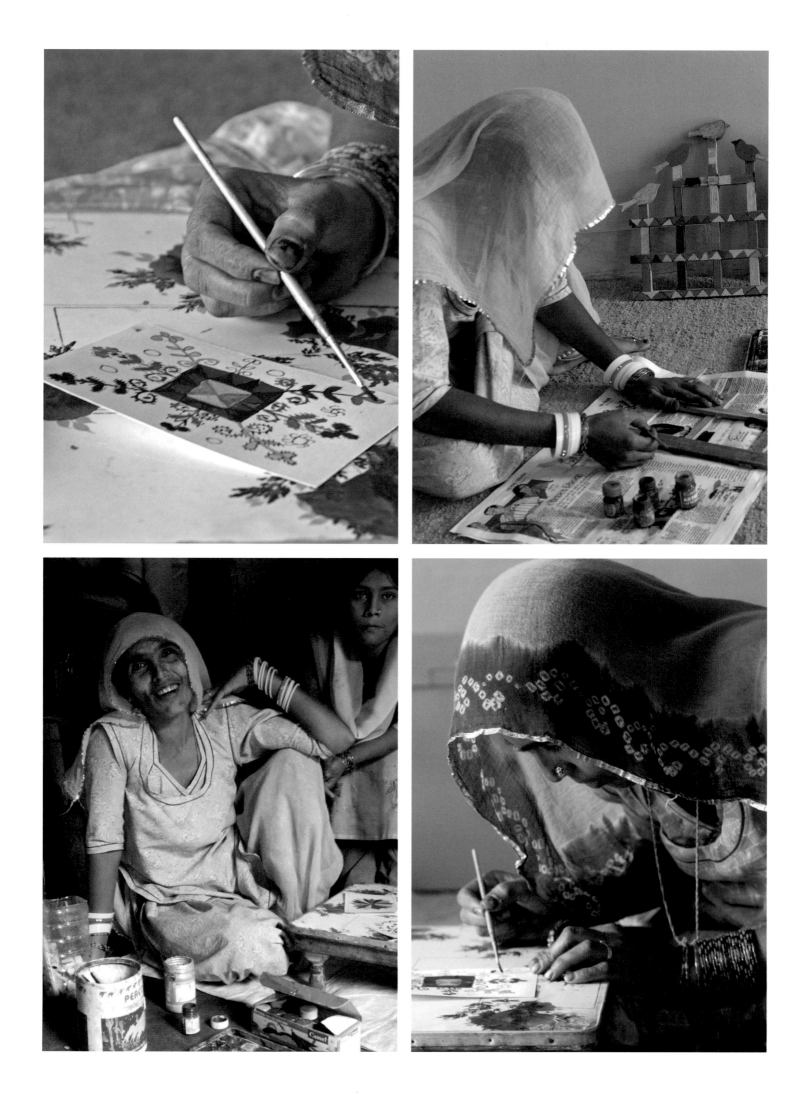

INDRA

ALL OF INDRA'S TIME WAS SPENT ON THE MENIAL TASKS of caring for her husband, children and in-laws, until she suddenly took a chance to change her life. "About 12 years ago," she says, "I started painting because of Keri. One day, Sarwar and Keri were talking about hiring someone to come in and do some (decorative) painting in our house. I said to Keri: 'Why do you need to hire someone from outside? I can do the painting! We don't need another woman.' So I started doing the designs for the doorways and windows, and Keri saw what I was doing and began talking to me about it. Then there was another woman who painted on paper. Keri had asked her to come to our house and was photographing her painting. But, one day, this woman had a headache and did not come; so I took the paper and started painting myself. And Keri told me that my work was much better than that other woman's. She gave me paper and small brushes and paint and said to try painting on that—small (translating large traditional wall designs into a small paper format). And so I tried. I am still trying."

IN HER YEARS OF LIVING WITH MERASI WOMEN, Karen realized that she was their lifeline. No one had ever shown them positive attention before. Abused and constantly neglected, these women had low self-esteem and no way to improve their conditions. The establishment of Lok Kala Sagar Sansthan provided a physical centre that was safe. There, the women have created for themselves two startling changes. For the first time in the history of this community, four adult women and 23 girls are attending school, learning to read and write and to add and subtract! Their minds are active and challenged and they are excited with and proud of what they are learning. Thirty local women have joined Lugai for Lugai. With no money for resources, the women use recycled tobacco, candy and food wrappers to weave intricate place mats and scavenge old fabrics to stitch colourful quilts. They have started making charming, whimsical dolls that are miniature caricatures of themselves. These women earn an income for themselves and are no longer only their fathers', brothers' or husbands' chattel with no value of their own. The effect is profound.

THROUGH HER INVOLVEMENT WITH LUGAI FOR LUGAI and with Karen's encouragement, Indra has created many series of small paintings on paper to be sold in exhibition. One series is being used to illustrate a counting book for Merasi children. Employing a brilliant palette, Indra paints intricate designs with tiny strokes, interpreting the

Many of Indra's paintings depict desert flowers— symbols of hope in a dry, desolate world. They also usually contain triangular figures of women that represent the sisterhood she has recently found through her fair trade organization: Lugai for Lugai.

motifs of her childhood into a new medium and adding her own personal touches. She almost always puts one or more women into her art to show, as she says, "that we women can also be seen." Indra's painting is the most important thing in her life, apart from her children. Whenever she is finished with a household chore, she turns to her paper and adds fresh designs. "I take care of my children and cook and wash the clothes," Indra remarks, "and then I get so tired. So I take some time out for painting and I heal myself. My headaches go away." For her, this creativity is a divine blessing that must be acknowledged: "Just before I start painting each day, I pray to all the Gods and Goddesses, asking for their help in my work. If God cripples my hands, how can I work? I must acknowledge Him and ask His blessing. So I say to God, 'Please help me so I can do this painting.'"

INDRA'S PRIORITY IS MAKING MONEY. In her society, it is essential that her daughter, Farida, is married soon, but Farida's mental disadvantage means that a good alliance will be difficult to find. Indra is slowly putting money aside to raise Farida's dowry. She states: "I am trying to work hard, to do this every day, whenever I can, so that I can improve and so that I can make some money from this art.... Still, I am not selling many paintings. Keri is helping to underwrite me and I keep making them. But this money is enough to help my family. There are five people in my family and my husband does not work very much, so I need to bring in money. Without it, how can I feed my family? And my children are getting bigger every day. Their hands, their feet are growing so big! Now I have to cook twice as much! They eat so much! That is why this Lugai for Lugai is so good, because we women can start earning our own money."

WHEN ASKED ABOUT HOW SHE SEES HER FUTURE, Indra comments: "What God has given me, this is my life. Until now, I have seen nothing but headaches and tensions. Desire is finished now that I am married. I cannot hope for anything. I have no dreams for my future. I have had a lot of hard times in my life. It has not been good. So this painting is my only joy. I cannot let myself think of what I cannot have. I do not think further than this painting right now."

ABOVE: As many as 20 women have joined Lugai for Lugai to make crafts and small folk art items by recycling materials.

BELOW: Despite her pleasure in her new creative endeavours, Indra's life is still bleak. She and her family of five live in this one small room. Here she is shown accompanied by her eldest daughter, Farida.

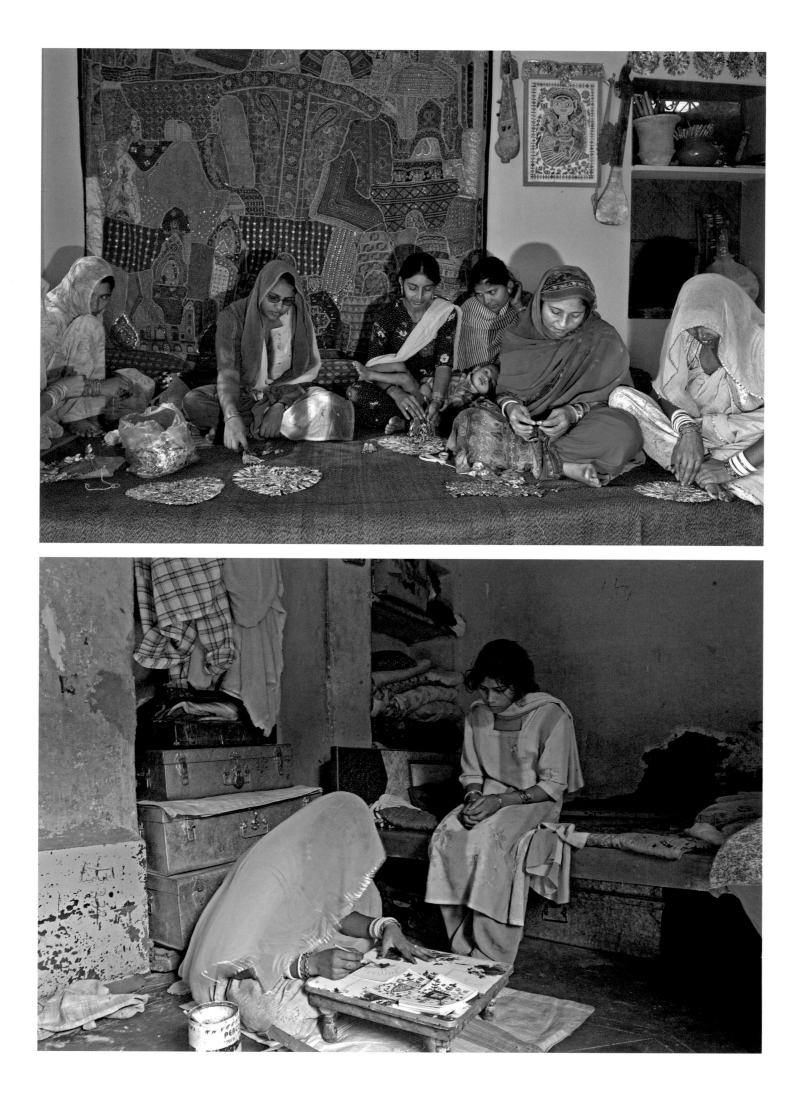

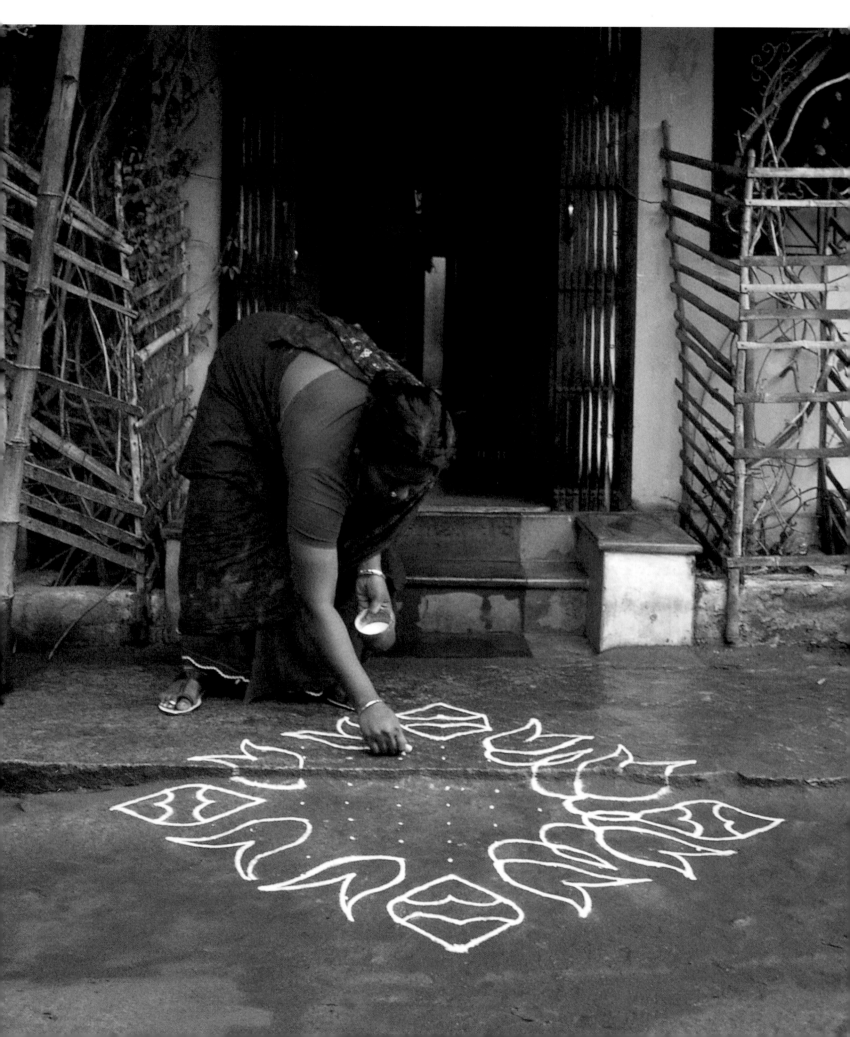

Madurai, Tamil Nadu

PADMA

PADMA IS SO EXCITED. She has been waiting for this day her entire life. She is finally about to draw her first complete *kolam* (sacred design drawn using rice flour). Padma is six years old. As long as she can remember, Amma ("Mother" in Tamil) has created a fresh *kolam* every morning, except during the annual rains. Padma has always watched the process intently. By the time she was three, she was copying the designs in the dirt with her finger or a stick. When Padma was four, Amma began giving her lessons in drawing with rice flour. It took Padma weeks to be able to take a pinch of the white powder between her little fingers and draw a simple, even, straight line. Only when she was able to draw lines with little effort did Amma let her begin curves. Those were so much more difficult. It seemed to take her forever, but finally, she was proficient.

AT FIVE, PADMA BEGAN HELPING Amma with the morning *kolam*s. Every night, Amma would create new designs in her notebook, graphing them carefully so she would be able to repeat the form on the ground the next morning. Her artwork was always so beautiful, the lines complex. Padma still did not know how she did it. But Amma would draw out a grid of white dots and then instruct Padma on which ones to connect and with what sort of lines: straight or curved. Amma always did the more intricate loops and spirals, and on special festival days filled in the spaces between the lines with a palette of brightly coloured powders. Padma enjoyed the process, clenching her tongue between her lips as she drew, although Amma always told her that it was a bad habit. Every morning, the two of them drew together to produce a fresh work of art. Padma never ceased to be amazed when she stood up and stepped back to see the finished *kolam*. The lines were so delicate, the forms geometric or sinuous—together creating a large lotus, or a group of interlacing stars, or the flowers and fruit of a banana plant, or pots brimming with sweet rice and surrounded by coconuts. Some days they fashioned birds (peacocks, parrots, mynahs and even chickens) or elephants, monkeys, horses or the winged *apsaras* that are like Christian angels. Each *kolam* is symmetrical, a concentric explosion of lines and, occasionally, colour. They usually finished just after the sun rose up over the village roofs. When they were done, they always walked hand in

PRECEDING PAGES, LEFT: Padma is an engaging young girl on her sixth birthday.

RIGHT: Every morning of her life she has watched her mother lay out a grid of dots and then connect them into a variety of beautiful designs.

OPPOSITE: Padma has been excited for weeks as she has planned the design she wants to draw for her birthday.

89

hand down the street to admire the *kolam*s in front of all the other houses. Each was different, and Amma would study them carefully to use as ideas for that night's creation. Then, they would return home, skirting that morning's fresh powder design, and go inside for breakfast. Although their art was different each day, the routine was always the same—and Padma loved it.

THE WOMEN AND GIRLS of more than a million Hindu households in this South Indian state create new *kolam*s every day of the year. The only exception is during the heavy rains of the monsoon season, when drawing outside is impossible. *Kolam*s are made as invocations to the gods and goddesses that are believed to protect the home. Always placed on the ground before the front door of a house, these drawings are believed to prevent evil and to encourage good spirits to enter the home. The designs have been passed down from mother to daughter for untold centuries, although there is a premium placed upon innovation and experimentation with new concepts. Once she has created a *kolam*, each woman prides herself in never precisely repeating that design. The breadth of this art is truly inconceivable! As they are all made of powder, the finished *kolam*s last only a short time, sometimes only minutes, before they blow away or are trod under feet or under the wheels of a passing vehicle. While the production of *kolam*s is definitely lessening as more and more women work outside their homes, that change is far more noticeable in large urban centres such as Chennai. For some, drawing *kolam*s is a feminine skill they must know in order to be seriously considered for marriage. But others claim that it is a deeply enjoyable and sustaining practise. Many women, when asked how they have time to create these daily works of art, state that these are the only moments in each over-burdened day when they can take the time to be quietly creative. They maintain that, for them, drawing *kolam*s is similar to practising yoga or meditation. It satisfies their souls.

The women in more than one million homes in this south Indian state create new *kolam*s (designs drawn with powder) every morning of the year. Girls learn from their mothers and often practise their designs together.

TODAY, PADMA IS BEING ALLOWED to create her first complete *kolam*. Every night for weeks she has been working on the design, filling dozens of pages with different attempts. It is so difficult! *Kolam*s have to be perfectly balanced. She tried to draw elephants and peacocks, but they were never good enough. For days she worked on a lotus, but it seemed impossible to keep all those curved petals and leaves from looking lopsided and smashed in. She finally decided to draw a simple interlacing star. It was still not easy to work out the grid: a pattern of five, six and seven dots that form the template.

90

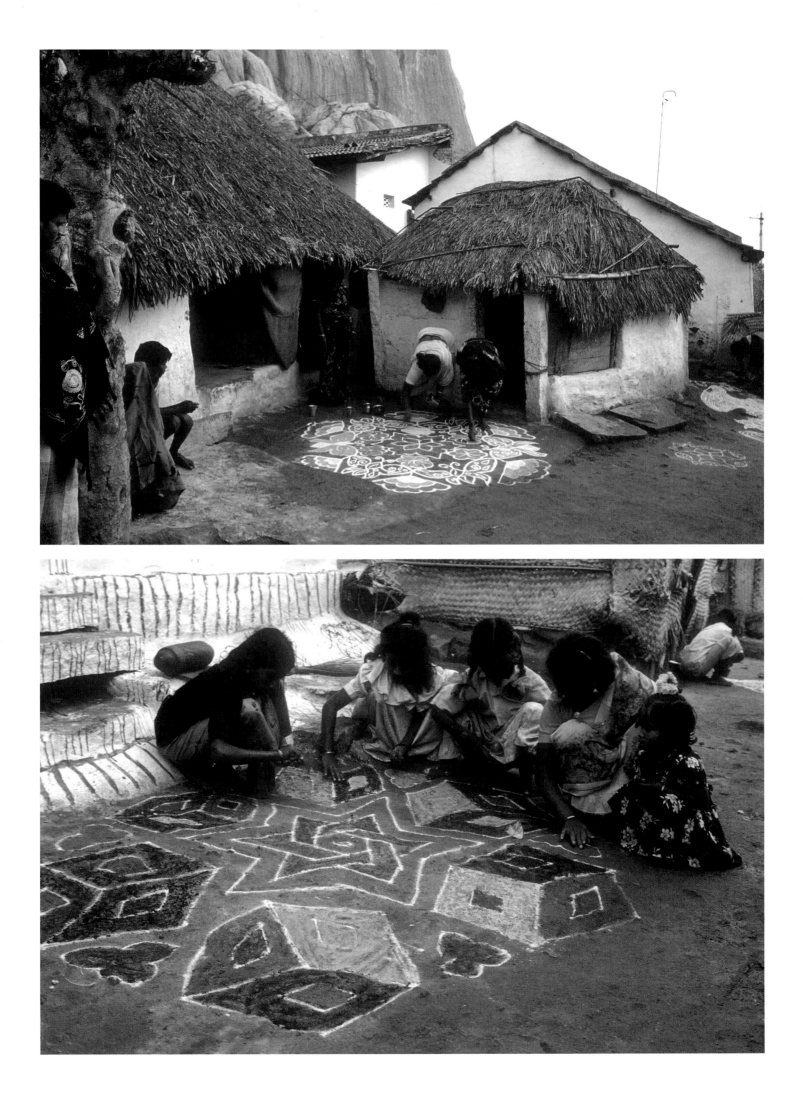

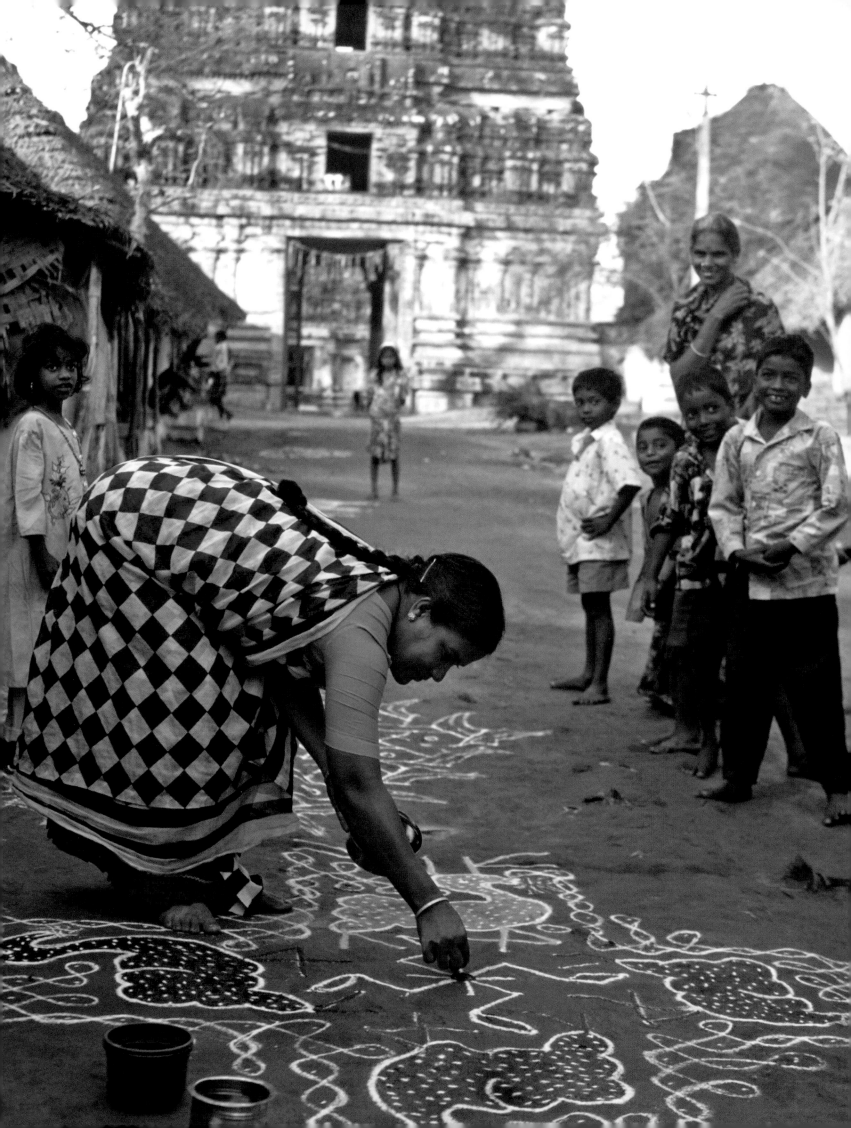

PADMA

PADMA IS AWAKE LONG BEFORE DAWN to turn on the tap in the
courtyard of their little house and bathe. *Kolam*s, after all, are
offerings to the Gods and it would not be respectful to make them
without being completely clean first. Then, she dresses in her
favourite white dress, the one with the lace collar. Amma, hearing
the noises of Padma's preparations, gets up and goes into the
kitchen to light the stove. Together they share small cups of sweet
coffee heavily diluted with milk. Amma kisses and hugs Padma and
then gives her a small brass pot to fill with water. Padma carries the
brimming vessel out the front door and uses her fingers to sprinkle
drops all over the dusty road in front of the house, dampening the
earth to use as a canvas on which to draw. As is the custom, Padma
has memorized the pattern and left it inside. This *kolam* will not be
as big as many of the ones that Amma designs, but Amma has
agreed that it is a good start. Padma runs back inside to retrieve a
bowl of rice flour from the kitchen and returns to mark out her grid
of dots. Evenly spaced, they cover an area of about nine square feet.
Then she begins to connect the dots with straight lines, making a
series of triangles and parallelograms that form her star. She works
intently for over an hour, although Amma can draw a complex
kolam in half that time. Finally the star is finished, its intersecting
forms radiating outward. Padma runs in to call Amma from the
kitchen, dragging her by the hand to see what she has made. Amma
looks so proud! She hugs Padma tightly and tells her that she is a
good artist. She says that this is just the beginning: every year
Padma will get better and better. As a teenager, she can compete
with all the other girls in school and maybe get an award! If she is
good enough, she might even travel to the state capital of Chennai!
A good *kolam* artist is greatly respected in Tamil Nadu.

NOW, IT IS TIME FOR PADMA TO GO TO SCHOOL. All the children in her
neighbourhood are literate. Education is highly valued in this state
and an educated woman is a great asset to the family. Many Tamil
women work outside the home. Although the social system has
never been matrilineal, as it was in the neighbouring state of Kerala,
women are still more powerful than in most other parts of India.
Even the head of the government of Tamil Nadu for many years was
a woman! Femininity is an important aspect of Tamil womanhood
and Padma is already being taught the appropriate manners and
etiquette. Without question she will marry when she is in her
twenties—single women are definitely disapproved of. As elsewhere
in India, religion permeates everyone's life and Padma is being

As women pride themselves
in never repeating a design,
the breadth of their artistic
variety is unimaginable.

93

PADMA

trained by Amma and her grandmother in the appropriate rituals of *puja* (worship) and the strict protocol of the local temple. Yet many aspects of society are rapidly changing. In school, Padma is taught about other lands and cultures. At home, on television, she watches Chennai films and programmes that seem to challenge almost all the traditions that her grandmother observes. Even at six years old she knows that this new millennium is bringing an unimaginable future.

FOR NOW, PADMA CAN HARDLY WAIT to tell all her friends at school about her new *kolam*. She is the first of them to be allowed to make one from scratch. Although Amma will design tomorrow's *kolam* and perhaps those for the rest of the week, Padma knows that it will not be too long before she is allowed to draw another. She hugs herself in delight that her life as an older girl has already begun.

Padma watches closely as her mother draws a flower and then adds coloured powder to fill in the petals.

OPPOSITE: Winged *apsaras* (legendary beings, somewhat like angels) hold hands to form a complex *kolam* for a special festival. A small mound of real blossoms and a little oil lamp laid at its centre indicate that this *kolam* is an invocation to the Divine.

FOLLOWING PAGES: On festival days, women purchase powdered pigments to colour their *kolams*.

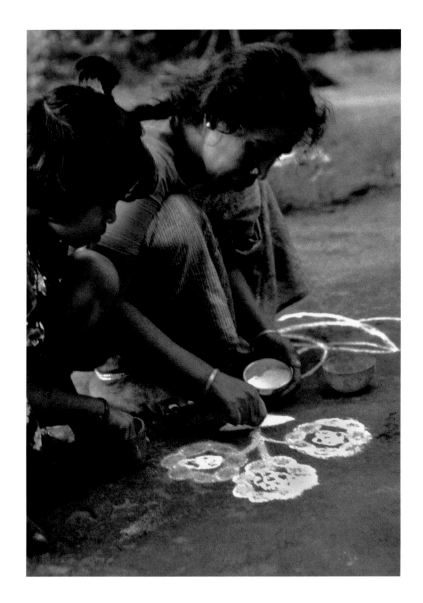

ACHAMMA Programming the Future

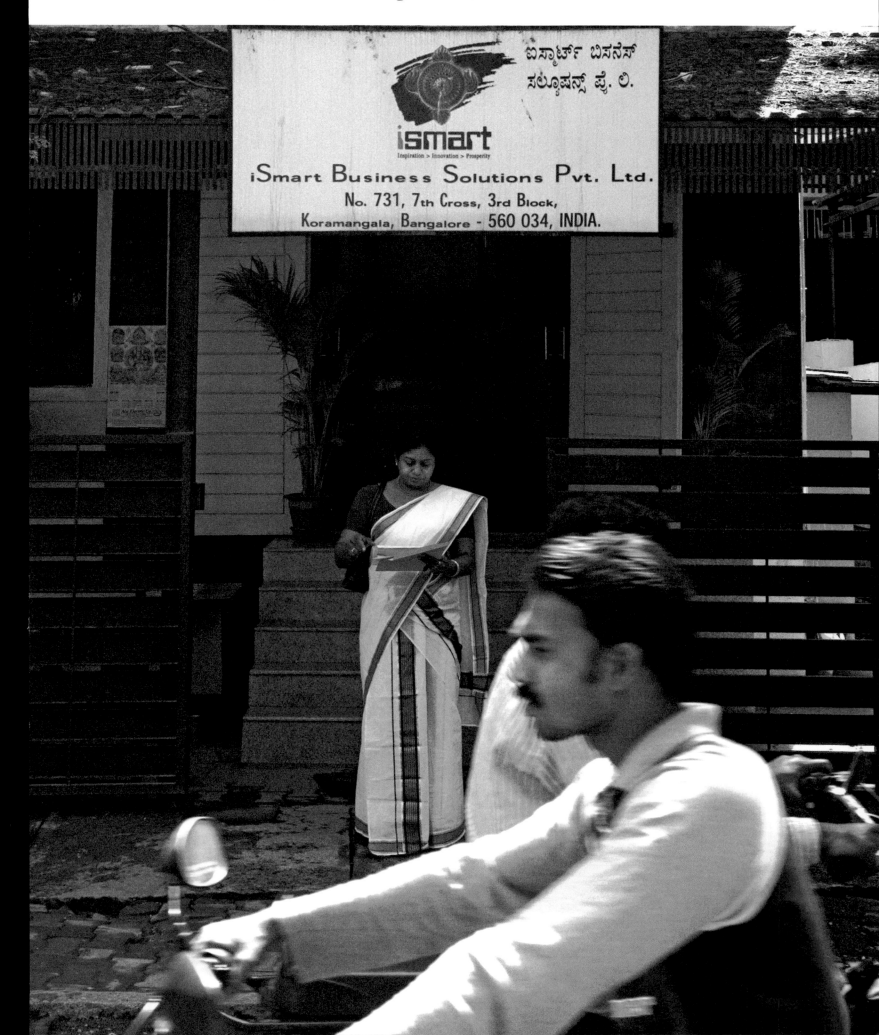

ACHAMMA

"My experience in business has been so difficult that I want to mentor other women. I do not want fame and attention. I want to give other women the chance to benefit from my mistakes and to have a better chance in this male-dominated business world."

ACHAMMA IS SITTING IN FRONT OF HER COMPUTER, running one of her own well-known programs: Harvest IT. Next to the monitor and on the nearby shelves and walls are some of her many trophies and awards for IT (information technology) entrepreneurship. Just outside the door, hundreds of her employees are busy at their own stations developing and programming software for an important niche market. In between answering almost continuous mobile and landline calls and attending to a constant flow of internet demands, she outlines her life.

ACHAMMA JOSEPH IS RECOGNIZED as one of India's leading women entrepreneurs. Raised as the daughter and granddaughter of Christian businessmen in the far south-western state of Kerala, Achamma was taught at an early age to think for herself. Her own mother managed 600 employees and the family business for several years before her untimely death, when Achamma was just 14. "They all say I am just like my mother," Achamma comments wistfully. When she was growing up, Achamma was recognized for her strong independence by her school friends in southern Kerala. She states: "All my gang was very intelligent, but they all settled down close to where we grew up: no change. I was shocked when I realized that many of them remained to become teachers at the same school. They never looked outside! For a person who travels so much like me, the outlook opens up."

KERALA IS UNIQUE IN INDIA FOR MANY REASONS, one of which is the high priority placed upon education. The state has maintained a 100 per cent literacy rate for many years! Historically, it fostered one of the few cultures in the world that was successfully matrilineal. Possessions and position were passed down from mother to daughter. While in other parts of India religious and intercultural violence were historically common, this region sustained a peaceful balance between its Hindu, Muslim, Christian and Jewish populations. Paradoxically, it was also one of India's most conservative, ritual-bound societies, where social mobility and even discourse between classes were almost impossible. Since Indian Independence in 1947, Kerala has possibly exhibited more dramatic changes than any other Indian state. It had a communist

PRECEDING PAGES, LEFT: Achamma Joseph is a brilliant woman whose acumen, perception and persistence have blended to produce a phenomenal business.

RIGHT: She has already created, developed, managed and sold one huge software enterprise and is now moving on to new horizons.

OPPOSITE: Achamma is a Christian from Kerala, a state in south-western India that sustains 100% literacy, an unusual form of government, and a history of matrilineal societies.

99

ACHAMMA

administration even before that of the USSR, and this government has been democratically voted in and out several times since then! Kerala is home to some of India's most advanced and progressive citizens, as well as to some of its most unyieldingly conservative.

ACHAMMA'S FAMILY ARE ORTHODOX CHRISTIANS who have practised their faith for nearly two millennia. As was common in her society, her marriage was arranged by her parents. In 1978, when she was just 21, she married a young man of a similar Orthodox background. He joined the merchant navy as a ship's officer. She received her postgraduate degree in chemistry and soon gave birth to their first child, a son. The following year, the small family moved to Mumbai. Achamma comments: "I never wanted to be a professional, but I got bored when my husband was always away. Computer education was the new buzzword and I took a computer software applications course at a local college for eighteen months and found that I was good at it. I was hired as a systems analyst by HCL (one of India's leading IT and software development companies) in 1982, and worked in banking automation, but gave up my post in 1986 when I returned to Kochi (Cochin) when I became pregnant again. The pregnancy was not successful and I decided I did not want to move back to Mumbai. Stuck at home with my little son and bored, I thought that I might be able to have a small household business. I was asked by a large plantation in Kerala to develop some software for them to manage their business and I bought my first PC." It was a step into the future from which Achamma has never returned. Through a combination of creativity, sharp wits, fine business acumen, good intuition and serendipity, her initial investment of Rs 25,000 (US$1000) has mushroomed over the past two decades into businesses worth well over 30 million dollars! In 2002, *Business World*, India's preeminent business journal, labelled Achamma as the "poster girl of Kerala's IT success... and of its entrepreneurial spirit."

"IT'S NOT EASY TO DO ALL THIS: to raise a family and start a business. Especially when you consider how fast it grew!" Achamma was quick to realize in 1986 that the new programs she was writing were unique and filled an important void. She remarks: "I began to realize that there was no other software designed for agriculture available in the market." She created a product that would manage plantations, from sowing seeds through cultivation to packaging and sales. Starting on her own and then hiring more and more staff each year, she worked for the first seven years out of her home.

Achamma multi-tasks constantly, developing software, networking by phone or Internet, and travelling almost constantly both inside and outside India. She has always maintained a good relationship with her many employees, making sure that they feel they can come to her with any questions or problems.

100

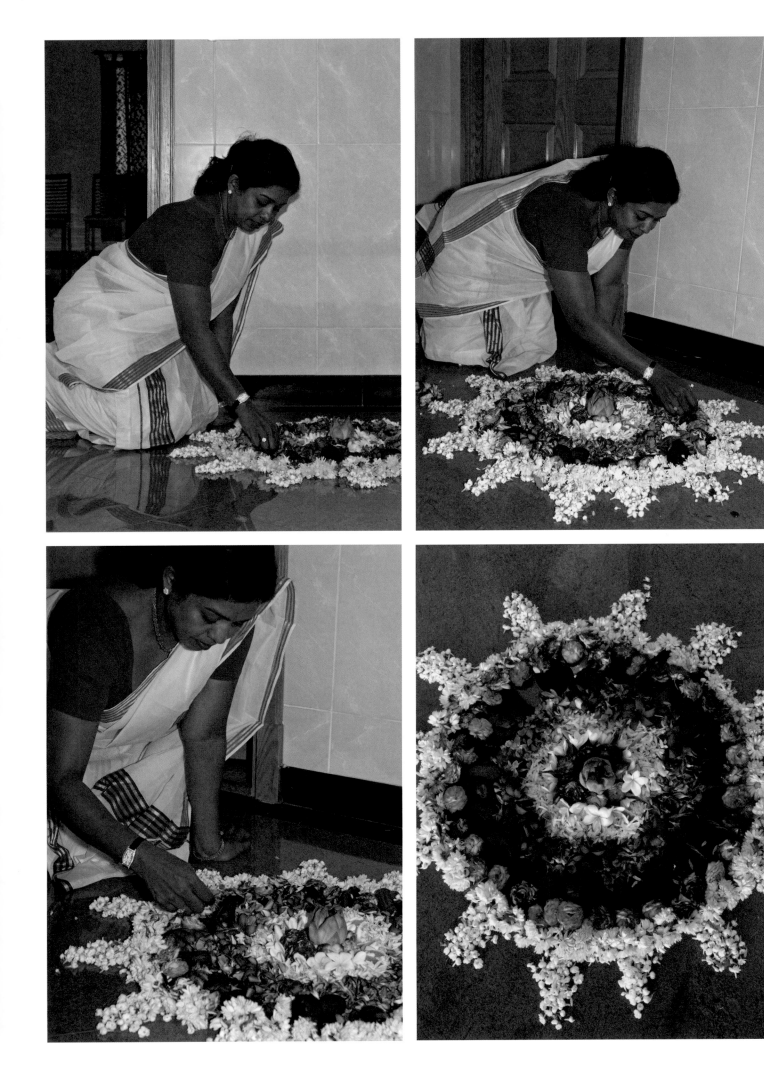

ACHAMMA

"My daughter, Kavya, was born prematurely in 1990. The doctors said I was just so tense with work that she was forced out early. I never stopped work for my pregnancies and I continued right after she was born, balancing her upon my lap while managing the business and designing software."

RAPID EXPANSION OF ACHAMMA'S COMPANY required that she move into her first office in 1993. "I have always been careful to pay my employees well. When my business began to truly succeed, I doubled the wages of my staff. I am a mother to my company. Yes, all my employees look up to me. I know them all. I am involved with their families. They come to me with their personal problems." Her growing business began to be more and more demanding. "I was the creator, designer and developer of these new plantation management systems and although it was difficult to leave my young family behind, I travelled regularly, meeting with clients, growing the business. I travelled to Kenya and East Africa, the length and breadth of India, to Southeast Asia and Sri Lanka. My customers were very satisfied. I was able to guarantee them a product that would improve efficiency as much as 20 per cent and return their investment within two years."

IN THE NEW MILLENNIUM, Achamma's business profile has rocketed. It began with a major award from Microsoft and meetings with Bill Gates. By 2001, her business was valued at 109 crores of rupees (US$27 million) and in 2002, Achamma was featured in a cover article of *Business World* magazine. In some ways, she has received more attention than she would have liked. She lost her privacy and was increasingly besieged by competition and even industrial espionage! In 2004, her original company was underwritten by a group of Mumbai investors who gradually made her position untenable and she was bought out. "I embodied the threat of a woman trying to succeed in business at a high level in a male business world. I was forced out under pressure from the jealousy of male egos. That is what I experience, being a female entrepreneur. My personal life is also threatened. All my effort in creating a world-class product has created bitter rivals."

ALWAYS INVENTIVE AND LURED by new potentials for software development, Achamma moved from Kochi, her home for so many years, to the large metropolis of Bengalooru (previously known as Bangalore), hub of India's lucrative internet industry. There she

For her daughter Kavya's 16th birthday, Achamma purchases flowers at a nearby temple market. Laying the blooms and leaves in concentric circles on the marble floor outside her apartment door, she creates an *athapoovidal*, the traditional Kerala symbol of celebration.

103

ACHAMMA

began to painstakingly set up new, independent offices. It was a difficult change and Achamma felt her life wrenched apart; among other things, she lost her family of loyal staff. (Ironically, she was later rehired by her Kochi company as a consultant.) Gazing at her computer monitor upon which she has opened her own beloved Harvest IT software, Achamma reflects: "This was my dream. It is the same pain as a mother letting go of her daughter into marriage. And then you find out she is having problems! It is so hard!"

BUT ACHAMMA CANNOT BE KEPT DOWN FOR LONG. She has an irrepressible joy in creativity and is constantly at work on innovative programs and new ways to expand her client base. She comments: "One of the reasons I gave up my initial business is to save my family life." Raising her family while conducting her high-paced business has been demanding for Achamma. Her husband, VK Joseph, decided to remain in Kochi with his friends and business when Achamma moved to Bangalore. Their son Vinay, now 25, has always exhibited his own natural acumen for internet technology and, inspired by his mother's success, now works in the computer business in Australia. "We have always been close," Achamma proudly notes. "It is like we are cut from the same mould. He is doing well down under." In order to be near him, Achamma has actively sought to expand her client base in Australia and is now providing successful management software for that continent's burgeoning wine industry.

REGARDING HER 16-YEAR-OLD DAUGHTER, Kavya, Achamma expresses the same concerns that beleaguer businesswomen throughout the world. She feels she does not have enough time to spend with Kavya and as a result their mother-daughter relationship is challenged. Kavya boards at an English-medium preparatory high school some distance from Bangalore; Achamma and Kavya are together for only a few days a month on weekends, when Achamma is at home. Like many mothers with teenage daughters, they do not seem to share the same interests, although Kavya exhibits the strong-minded independence that so characterizes her mother: "She is always reading. She loves all kinds of books and she paints well too. I love her so much, but Kavya resents my work and my travel… We like to do things together, but then she has to go back to school and I have to fly to Kenya or to China or maybe to Indonesia or Australia… It is never enough." Kavya comments: "Our relationship is improving and I am sure that it will continue to improve as I get older."

ABOVE: Achamma stands in front of the working harbour of her native city of Kochi.

BELOW: She looks at one of the many magazine articles written about her remarkable business success. In 2002, *Business World Magazine* labelled her the "poster girl of Kerala's IT success".

104

ACHAMMA

TODAY IS KAVYA'S 16TH BIRTHDAY. Just after dawn, Achamma drives down to purchase leaves and blossoms at the local flower market. Back at their new high-rise apartment, she begins cooking curries in preparation for the mid-day party, filling their modern apartment with delicious smells. While the food is simmering, she kneels in the hallway outside her door and chalks out a concentric design on the polished marble surface. She then fills in the mandala with patterns of brightly coloured petals and leaves, creating an *athapoovidal*, the traditional Kerala symbol of welcome used for special festivals. At noon, eight of Kavya's school friends arrive: six girls and two boys. While they help themselves to the meal, they jabber excitedly to one another in English about their plans for the next holiday, where they want to travel, and the latest music and films. They are virtually indistinguishable from any groups of teenagers in the Western world.

ACHAMMA PUTS THE LAST CANDLES ON THE CAKE in the kitchen and, when lunch is finished, lights the candles, and carries out the cake while everyone sings the "Happy Birthday" song. She is delighted to see her daughter happy. It reassures her in their relationship. After Kavya's friends leave, the two spend a few hours shopping together before Kavya returns to school and Achamma boards a jet for Australia. Theirs is a 21st-century relationship, and Achamma is again on the move.

Achamma proudly shows off her successful software: Harvest IT.

OPPOSITE, ABOVE: In 2005, Achamma moved from Kochi to India's cyber-industry capital, Bangalore. There she purchased an apartment in a new high-rise.

BELOW: Kavya blows out the candles on her birthday cake as her mother and all her friends sing in English the "Happy Birthday" song.

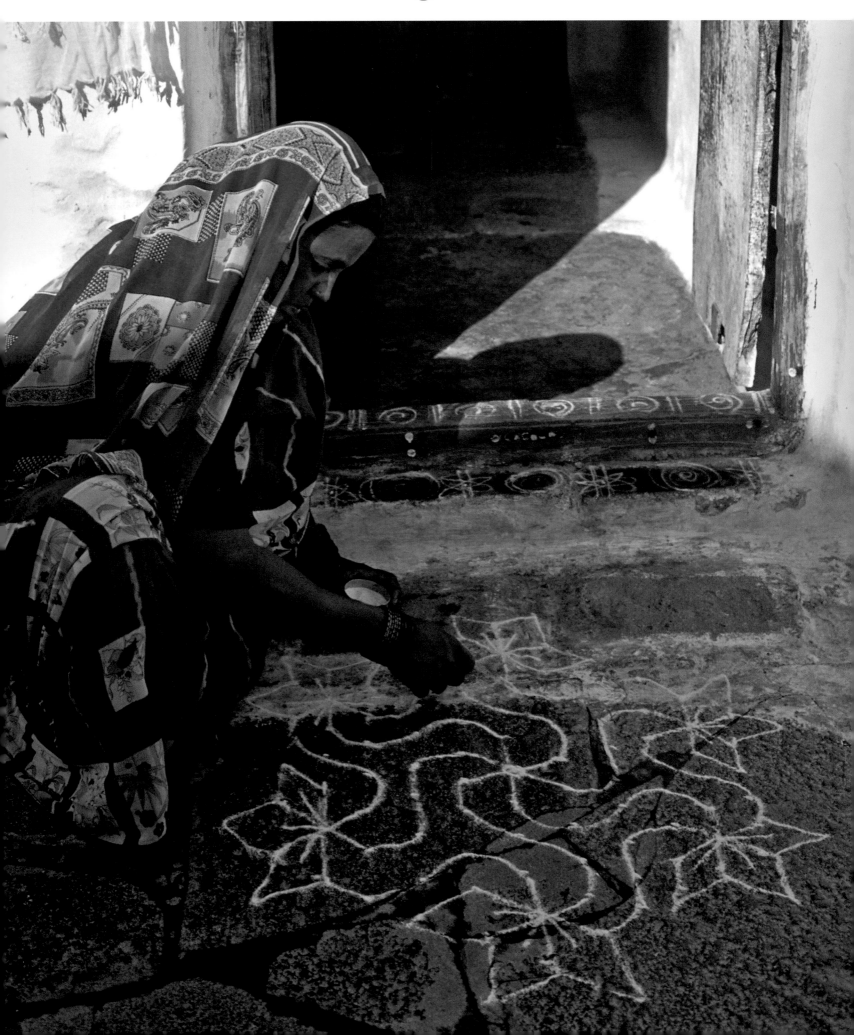

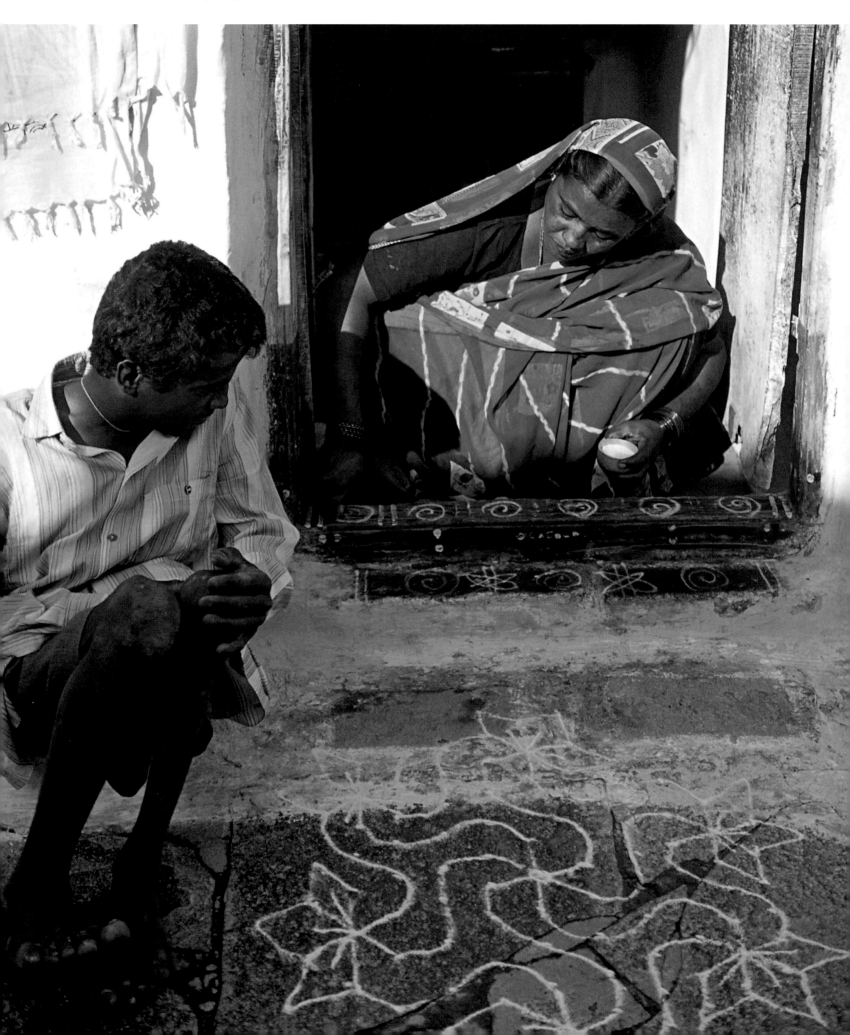

KUSIMA

"Why do they treat him this way? He was such a beautiful baby and now, because of this mistake, his life is ruined. Who will marry him? And what happens after I die?"

KUSIMA'S HUSBAND, A TAILOR NAMED SRIDHAR, died six years ago. She was already a widow by the time she was 37. Widows in many parts of India have a hard existence. Remarriage is discouraged, and they are treated as subordinates by their offspring and may even be blamed for their husbands' and families' misfortunes. But in this regard, Kusima is lucky. She is fully accepted, even cherished, by her brothers and their wives (who live right next door) and by her children, who often express their love for her. She still wears bright clothes and jewellery—not the plain white sari that is the standard uniform for widows elsewhere. Her appearance and social acceptance are rare in India. Most widows are forced by custom and their families to give away all their possessions, including their adornments and colourful apparel, to cut their hair short, and live extremely frugal and neglected lives. Women are taught that their sole value lies in their selfless dedication to their husbands and sons. When their spouses die, they remain only as burdens to their families and are expected to live the rest of their lives quietly in the background. Many are thrown out of their homes and left destitute to fend for themselves. There are countless exceptions to this rule in India, but its pervasiveness should never be underestimated. As a loved and respected member of her society, Kusima is blessed. Her great misfortune lies elsewhere.

KUSIMA AND HER ELDEST SON GOPAL (AGED 23) are both good tailors, making and mending clothes for all their neighbours. Her 19-year-old daughter Yellubai is a bright student in her final year at the local high school. Yellubai helps in the afternoons by collecting clothes that need to be repaired and by working in the sari shop run by her paternal grandmother. The family lives in a small but adequately furnished two-room stone house in the midst of town. They are surrounded by relatives and other friends in the closely-packed community. Shops are nearby and so is the lake with its ancient steps leading to the water for bathing and washing clothes and utensils. Kusima married Sridhar for love and she still speaks tenderly of him, even though she says that he was an alcoholic who spent 25 per cent of their income on liquor. He was never abusive to her or their children and he was always affectionate even when drunk.

PRECEDING PAGES, LEFT: Kusima draws a *kolam* on the ground in front of her door as an invocation for the Gods to protect her family from adversity.

RIGHT: Her youngest son, Ramesh, looks on as she adds finishing touches to the doorway.

OPPOSITE: While standing in the green brackish water of the local reservoir, Kusima washes clothes by pounding them against the stone steps.

111

KUSIMA

As Kusima creates her *kolam* outside, her eldest son Gopal uses their treadle sewing machine to tailor clothes. Ramesh sits idly by. His polio deformity has made their community shun him for having "the evil eye". He cannot go to school, play with any other children, or get a job.

FOLLOWING PAGES: The small town of Badami is one of the prettiest in the Deccan Plateau of central south India. Temples were built in the 7th century on the tops of cliffs that enclose the town and in caves deep within them. Ancient stone steps separate the town from a large reservoir that provides water for all purposes: watering and washing livestock, drinking, bathing, brushing teeth, and washing clothes.

KUSIMA'S LIFE HERE IN BADAMI might even be sweet if it were not for her youngest child: her son Ramesh. When Ramesh was just a one-year-old baby, happy and perfectly healthy, he was given a free polio vaccination by a government medical employee. Polio has long been a problem in India and national vaccination schemes have radically improved the lives of hundreds of thousands of children and secured the future health of millions of others. However, Ramesh was carelessly administered too much serum and, rather than being inoculated against polio, he caught it. He almost succumbed to the disease. When he recovered, his poor emaciated body was left deformed. Now, at 15, Ramesh still has a withered left leg. It will not support his weight and he has to use crutches to walk. This situation is tragic enough, but that is not all. Because of his deformity, Ramesh is treated as a pariah by almost all of his community. They believe he has the evil eye and that simply being in his presence will bring misfortune and even disaster!

SUPERSTITION AND FEAR OF THE "ABNORMAL" are common in India. Although there are innumerable exceptions such as Kusima, who give loving care to family members suffering from physical, mental and spiritual inequalities, most of India's handicapped and disadvantaged people are still ostracized. Their only hope of sustenance is from begging and, although Indian ethics mandate that beggars be given alms, their condition is deplorable. Here, in the beautiful town of Badami, prejudice is destroying the life of a good and capable boy. Ramesh dropped out of school because of the pressure. No one would talk to him. He had no counselling. He worked for a while in a local hardware shop, but he was fired when it was obvious that none of the customers would be served by him. Kusima states: "He is a good boy but he has no will power. He just gives up. He will not do anything. Perhaps his brother and I will have to support him all his life."

AND SO RAMESH SITS IDLY IN THE HOUSE WATCHING GOPAL use his good feet to pump the treadle of the family sewing machine. He observes his mother every morning as she draws out the intricate rice powder designs on the home's threshold as protection against evil. He encourages Yellubai as she learns how to cook and manage a home in preparation for her own marriage. Through the doorway he wistfully watches the gangs of other boys running through the streets yelling to one another. And he knows that he has no future. He will always be the one who, by his very presence, is believed to bring bad luck.

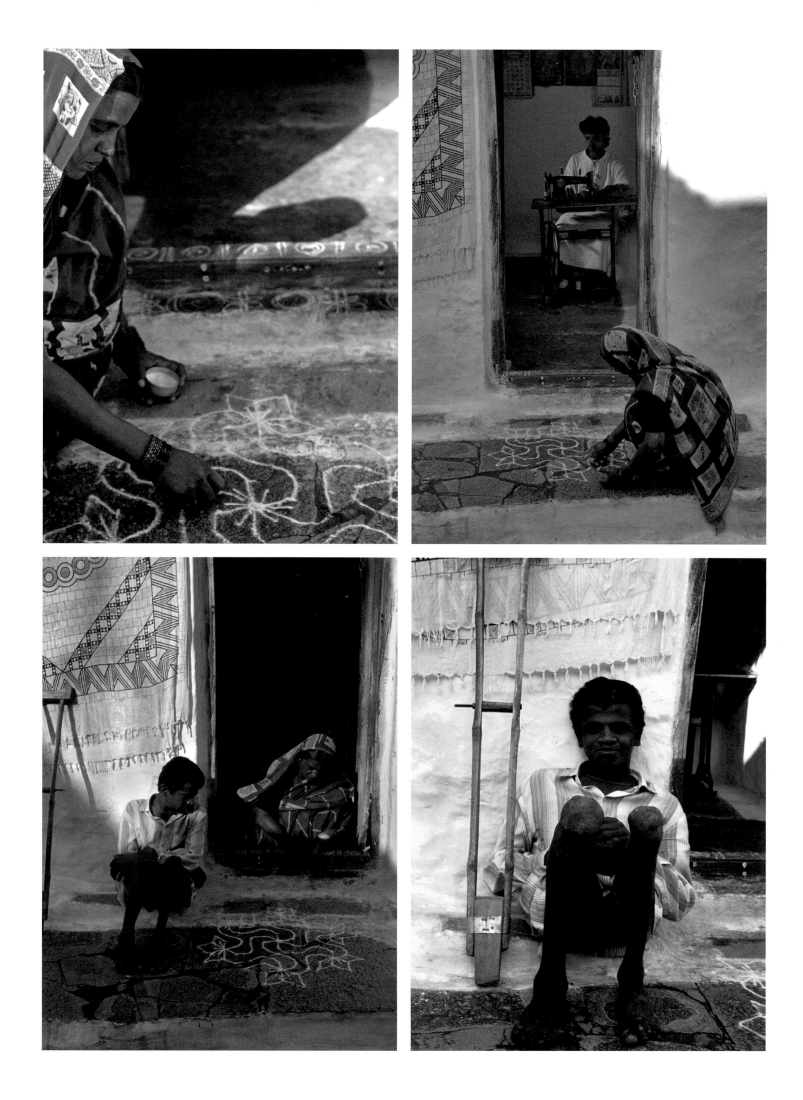

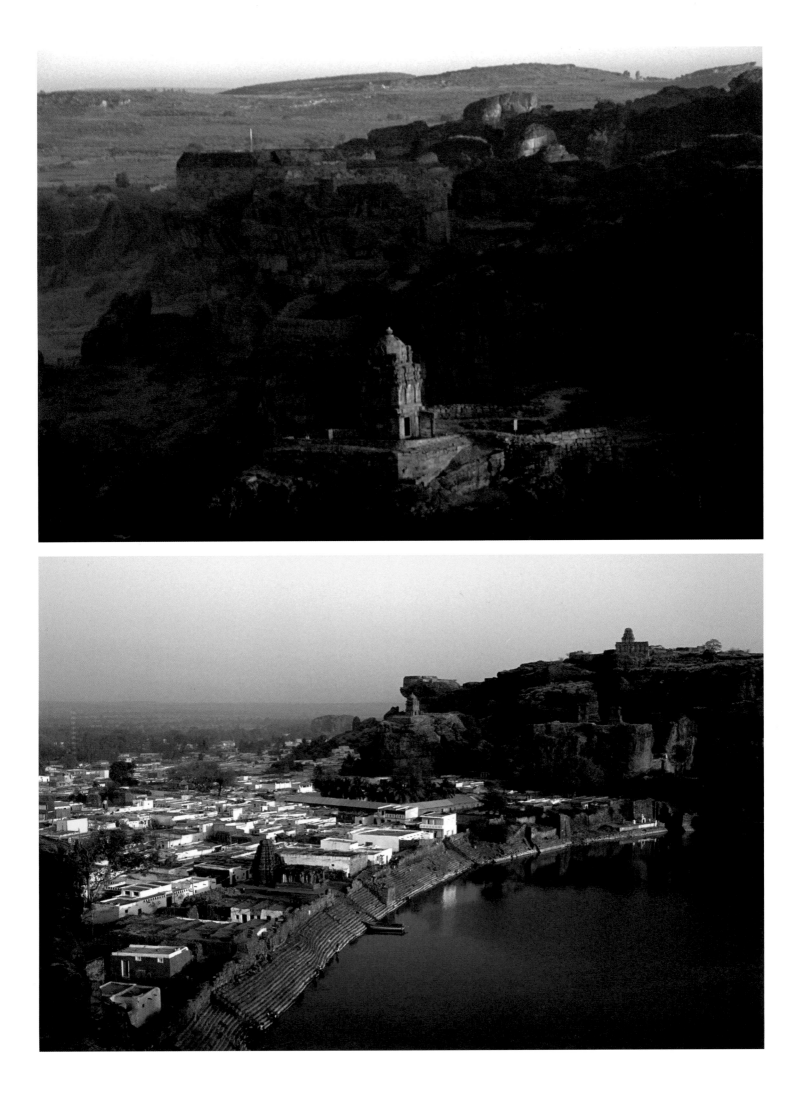

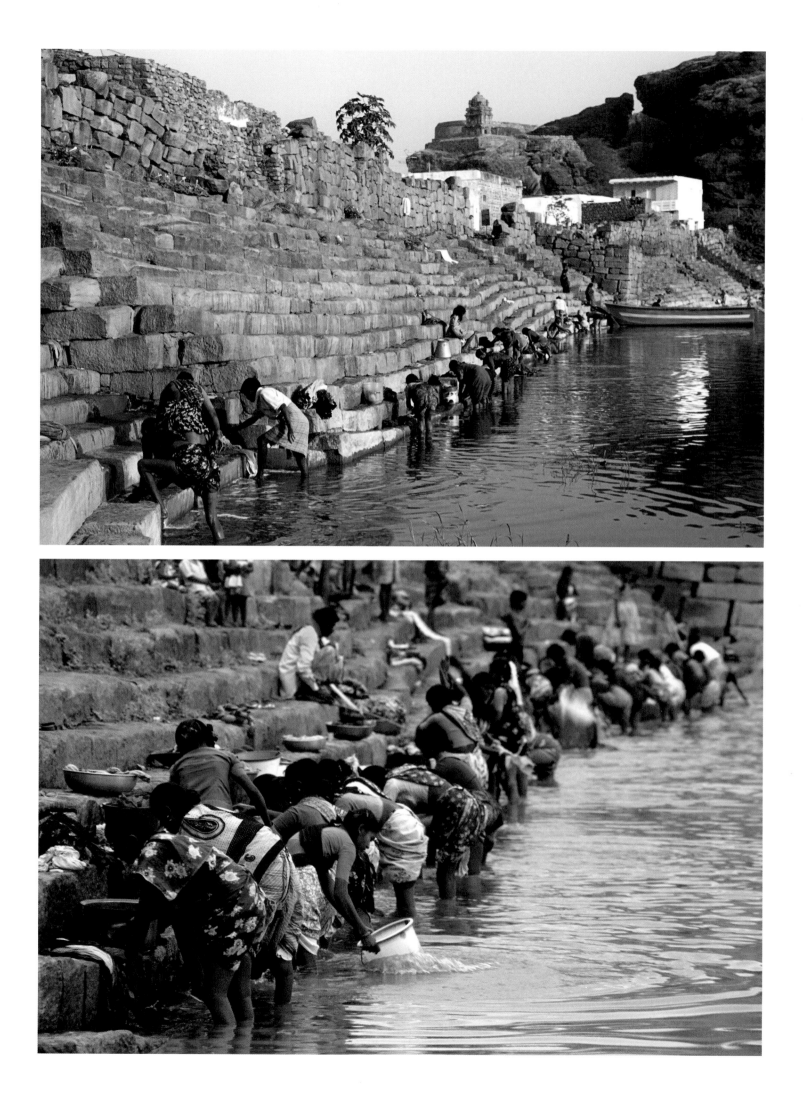

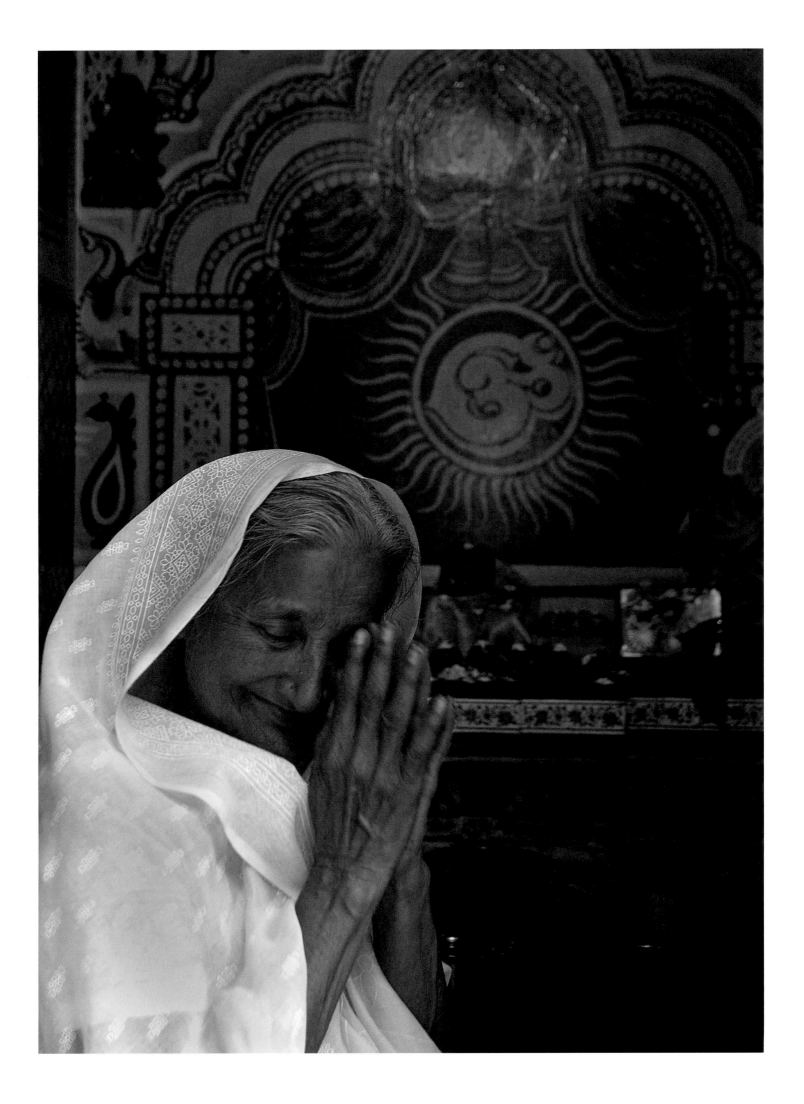

BIDULATA

"I am so happy! All year long I wait for this day and finally it is here. Look! We are transforming our entire home! All is becoming an invocation to Lakshmi. Isn't it beautiful? See the chita *(paintings) my daughters-in-law are making? And my young granddaughters there? And how we will welcome Her into our home! You must come and celebrate with us. You too will see how glorious She is…"*

IT IS THAT SPECIAL TIME OF THE YEAR when the Goddess Lakshmi is invited into the home as a guest. The dates vary throughout India, but here in the Puri District, Orissa, the first day is annually set during the month that spans from mid-January until mid-February. The women of every Hindu home in the area participate in the festival. Each household performs rituals that are unique to its particular heritage. In this home, Bidulata, known as "Maushi" (Auntie) by scores of relatives and neighbours, is in charge of the elaborate preparations. It is a celebration in which she has been involved for all but the first few of her 72 years.

JOINING HER IN HER WORK are her two daughters-in-law and five granddaughters. Although the labour is intense, the atmosphere is one of laughter and good spirits. After all, Lakshmi is the Goddess of Abundance and Prosperity. The act of welcoming her into the home is a joyous experience. First the entire house is elaborately cleaned: floors swept, bedding aired, and cooking and eating vessels scrubbed. Old clay pots are broken and thrown away and new terracotta vessels are purchased from the local potter. The farm animals (two milk cows and two bullocks) are taken out of the attached barn and washed in the nearby river. They are left outside while their space is fully cleaned and allowed to dry overnight. Then, when everything is finished, all the women begin to resurface the floors and walls of the entire compound, inside and out, using cotton cloths dipped in a mixture of clay and cow manure. The manure acts as both an astringent cleanser and an adhesive that keeps the clay surfaces from cracking. Only when all the walls and floors are completely covered with an even surface of fresh brown swirls can the most pleasurable part of the preparation begin.

ALL THE GIRLS AND WOMEN ARE INVOLVED in transforming their simple farmhouse into a temple for the Goddess. Rice recently harvested from their paddies is ground under a granite rolling pin and mixed with water to form a paste. Then each female takes a small bowl

PRECEDING PAGES:
Bidulata Hota is a widowed schoolteacher who lives with the families of her two sons in a remote village of Orissa. Bidulata does not suffer from the rejection experienced by many Indian widows. She is treasured by her family and neighbours.

OPPOSITE: Bidulata is a devout Hindu who speaks affectionately of her relationship with the Goddess Lakshmi and the God Vishnu as if they are old and close friends. Her face is often infused with a glow of deep inner peace.

119

of the mixture and begins to paint. They have discussed the subject of their painting ahead of time (a complex design of auspicious symbols for Lakshmi). Except for the two youngest girls, they are all accomplished artists and never have to sketch out their designs on the walls first. Maushi actively paints and also oversees everything: she whispers suggestions to one granddaughter and helps another to design a complex vine with lotus blossoms. The entire exterior of the home is painted first: walls, veranda, steps and even the clay planter that holds the sacred basil bush worshipped daily as an incarnation of Lakshmi. Soon, the surface is transformed into a pattern of rice sheaves and rice mounds, lotuses, elephants and peacocks. Then Maushi paints a set of footprints symbolizing the imminent arrival of the Goddess—beginning at the front door and leading through the courtyard to the principal room. The greatest efforts of all the females in the extended family are focused upon this final chamber which is intended to be Lakshmi's sanctum.

MAUSHI IS A WIDOW. She was married when she was just 16 to a farmer who also served as a primary schoolteacher. They were poor as they raised their family of two sons and two daughters. Coastal Orissa experiences frequent tornadoes and flooding rains, and periodically their farmlands were decimated. It was always hard to make ends meet. Their village of Bantaligram is remote and was without electricity until just 12 years ago. Maushi and her husband were able to find good wives for their sons and, with difficulty, to arrange dowries and consequent marriages for both of their daughters. Then Maushi's husband died when she was in her mid-fifties, and she followed the local custom of giving away all her jewellery and her colourful saris. For the past 16 years she has been wearing only white. Their small home was divided into two portions, one for the family of each son. But many activities are still conducted together, such as this festival for Lakshmi.

MAUSHI'S FAMILY IS UNUSUALLY PROGRESSIVE in this conservative Indian state. Most Indian widows have little of value in their lives after their husbands die. But Hota, Maushi's son, encouraged her to take over his father's classes after a suitable period of mourning. Hota's own teaching schedule was full and teachers are always in demand. Maushi loved learning and reading and she found that she was a natural teacher. She remarks: "For 10 years I taught the children. Often I would tell them the old stories from the

For many different annual festivals, the women of this region cover the exterior walls of their homes with a fresh surface of clay and then paint them with fresh sacred designs. All of these paintings contain symbols associated with the Goddess Lakshmi.

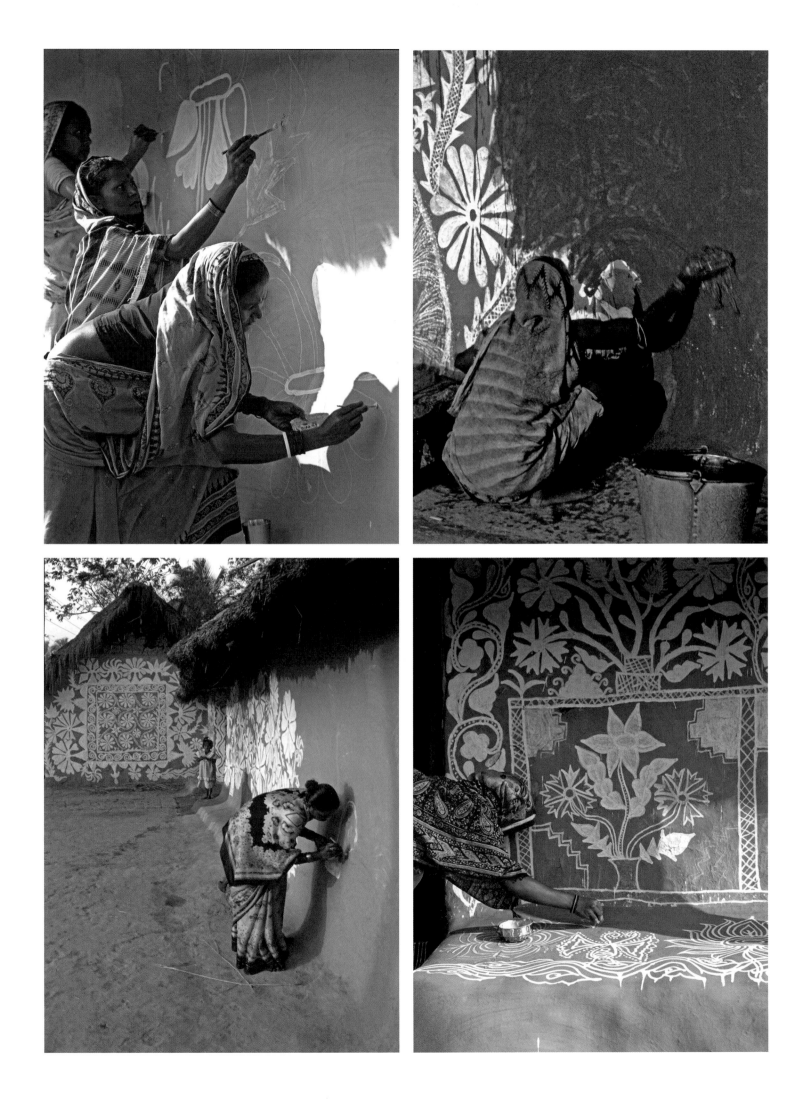

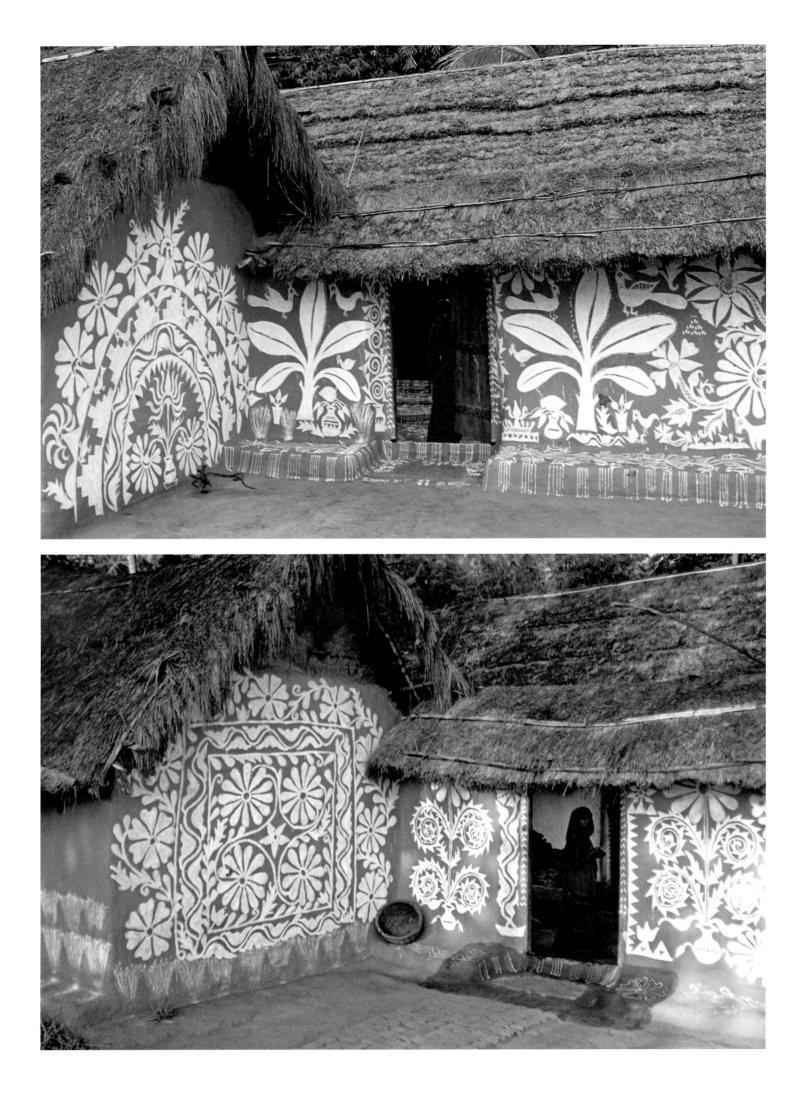

BIDULATA

Ramayana and the *Mahabharata* (the Hindu epics) and many from the *Puranas* (Hindu philosophical texts). I found I could always relate the lessons to these stories—the geography and history and mathematics, even spelling—and while they learned these, they also learned the importance of the way our grandfathers and grandmothers lived. They could understand our values. I only stopped teaching when I became too tired. But I still miss those children. Sometimes they come and see me, some even with families of their own. And then we remember."

NOW THE FAMILY HAS CLEARED THE ROOM of everything that is not needed for Lakshmi. They do not have much furniture. A large wooden bed and a couple of chests have been moved into other rooms. First the women begin by painting the walls with the huge arched forms that represent mounds of rice. Then they draw the shape of a shrine on the floor and fill in the area surrounding it with lotuses. From the rafters, they have pulled down a small wooden altar which they paint with simple stripes and dots. On normal days, Maushi conducts *puja*s (worship rituals) in a small room dedicated solely to prayer. From this *puja* room, Maushi lovingly retrieves an ancient black stone the size of an apricot. Its burnished surfaces reflect centuries of adoration to the Goddess. The stone is placed on top of a large black terracotta pot daubed with red spots and filled with unhusked rice. Then a piece of red silk is wrapped around the vessel and adorned with garlands of marigolds. Finally, Maushi chants an invocation to Lakshmi, inviting her to enter the vessel, while all of the other women and girls ululate in high piercing voices.

"RIGHT NOW LAKSHMI MATA (Mother Lakshmi) is here in our home. She is our guest and we are so honoured by Her presence!" They all prostrate themselves in prayer before the pot image asking for Lakshmi's help with whatever needs they have. Maushi, with a radiant smile on her face, whispers her prayers close to the shrine. When asked to explain, she says: "I have requested that all my granddaughters be healthy during this coming year and that Lakshmi Mata help us find a good husband for Trupti (the eldest). You should ask her for what you need. As you are doing this good work, She will surely help you." Now it is time to feed the Goddess. All the women have been cooking for days, making Lakshmi's favourite sweet and salty food. Platters and bowls brimming with delicacies are placed on the floor before her. Once Lakshmi has

As elsewhere in India, Orissan women pride themselves in never repeating the exact same design on their walls. These two photographs depict the same house on two different days. In the lower picture, two stylized lotus plants flank the door; while in the upper one they are replaced by banana trees and *kalasha*s (the Hindu welcome symbol portrayed by a pot surmounted by leaves and coconut).

123

symbolically sampled each one, the food is considered blessed and is passed among the women to eat. The initial ritual is now over, and Maushi's two sons are finally allowed into the room to make their own *pujas* to the Goddess. While Lakshmi remains in the home, the next two days will be filled with celebration, songs and feasting. Then, in a ceremony that acknowledges all her many responsibilities throughout the universe, the Goddess will be politely asked if She wants to leave. Her altar will be dismantled and Maushi will carefully carry Her black stone back to the household shrine. In this celebration that is clearly the highpoint of their year, their home has become a temple for a divine visitor and Maushi is confident that every aspect of her family's existence has been enhanced by the experience.

As they paint their walls so frequently, many of these women are very adept artists who take great joy in their personal creative expression.

OPPOSITE: Maushi loves the process of transforming her home for the Goddess Lakshmi. From the outside door through the courtyard and into the main room, she paints a series of paired feet to represent the entrance of the Goddess. Inside, she paints the floors and walls to transform the entire room

FOLLOWING PAGES: Using a brush that she made herself, Bidulata paints a fluid flower vine using paste made from ground rice. The rice paste is translucent when first applied, but quickly dries to an opaque white into Lakshmi's own temple.

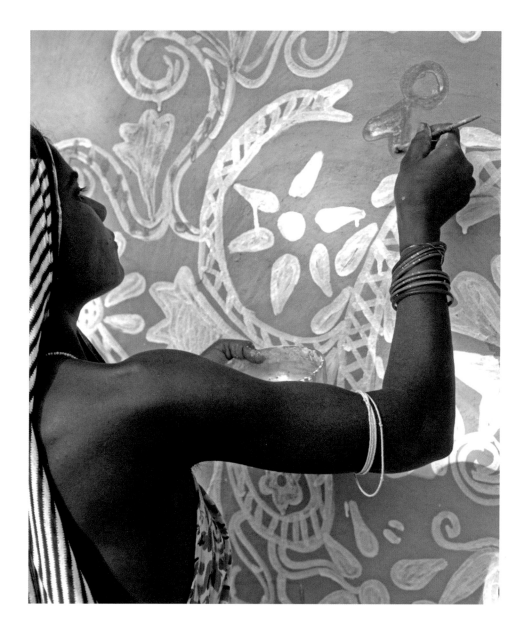

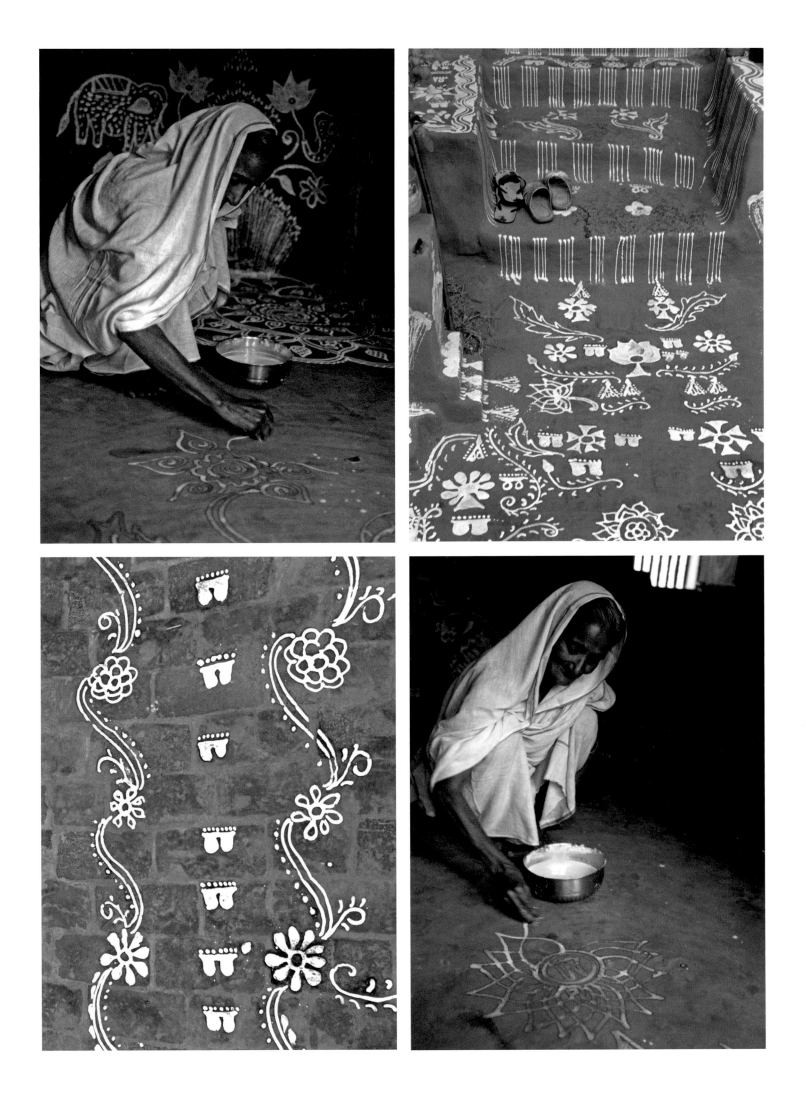

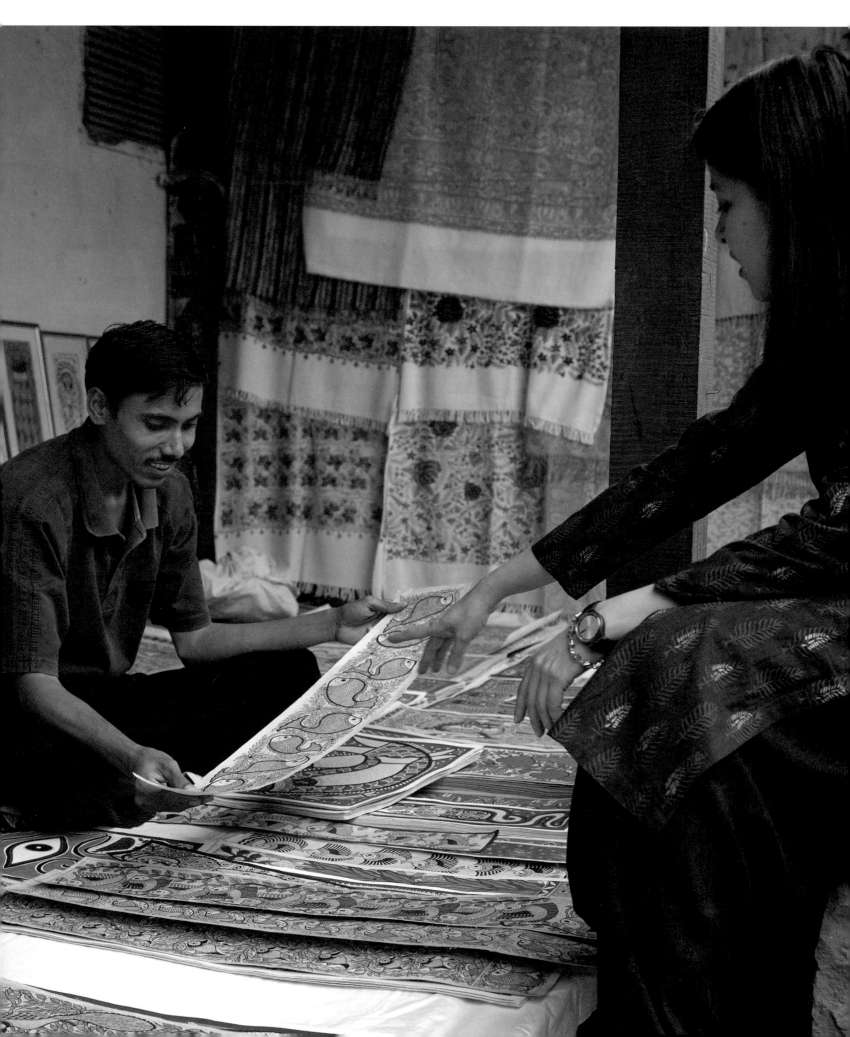

MINHAZZ

"I do not fit people's stereotypes of what a Muslim or a northeasterner should look or behave like. Having been born to very liberal-minded parents, naturally casteless as a Muslim, the rigid notions of casteism in India, in particular those relating to professional identity, fascinate me. I empathize with traditional artisans and artists as they struggle to find a place in Indian society for I, too, am trying to find my own meaningful place..."

PRECEDING PAGES, LEFT:
Minhazz Majumdar does
not fit most people's
concept of a Muslim
woman. From a modern
progressive family, she is
never veiled. She is focused
on the communication with
and understanding of other
cultures.

RIGHT: Minhazz is
passionate about protecting
the rights of the folk artists
with whom she works. She
represents artists from
many different fields and
regions of India.

OPPOSITE: She is a well-
informed urbanite who
deplores the condescension
that she finds expressed by
most educated Indians
towards the people living in
rural cultures.

MINHAZZ MAJUMDAR WAS BORN IN ASSAM, in the remote northeastern corner of India. She travelled about 1450 kilometres (900 miles) to attend university in New Delhi, remaining there to marry Shahriyar, an Assamese with similar values. She was employed as a journalist by the well-respected *The India Magazine*, which featured contemporary literature and reviews of innovative and traditional art. She credits this professional experience with opening her to the broader sphere of Indian arts and crafts. She comments: *"The India Magazine* really made me learn so much about our culture. It was at a point of time when things were disappearing and more was being reported about crafts and arts that were dying than about the crafts and arts that were still vibrant. I read in *The India Magazine* that crafts and arts were dying because of lack of patronage. That's when I decided that I was really positioned in a way to make patronage happen for other artisans."

CONSEQUENTLY, MINHAZZ AND HER HUSBAND, Shahriyar, began to research and market traditional crafts. Initially they focused on the land of their origins: India's northeast. In the early nineties, that region was identified with insurgency and political violence. They hoped that their work would provide income to the threatened northeastern artisans and offer the urbanites of New Delhi a means for better understanding these remote peoples' cultural values. Minhazz states passionately: "I wanted to just, sort of, wake people up and say: 'Don't judge or have these preconceived notions! There is much more than you know!'" Their initial focus was on crafts woven and constructed from bamboo, and their efforts helped to improve the general awareness of that valuable resource. "We come from the northeast, which is one of the last areas where the tropical jungles still exist. In the rest of India you don't see jungles anymore.... For 14 years we have been involved with this crusade for bamboo. It represents the northeast and the jungle for us, and it is an ecologically better choice than wood because it grows so easily and fast. When we started, many people were very pejorative and

131

very derogatory about bamboo. But today they are, like: 'Oh! This is so eco-friendly; this is a green medium!' So I've spent a lot of time developing manuals, writing articles, just pushing bamboo to be more than poor man's timber, because that is what it was seen as." In 1991, Minhazz and Shariyar co-founded The Earth & Grass Workshop, a non-governmental organization whose goal is to preserve Indian artistic and cultural heritage and to promote the cause of craftspeople. They gradually brought their focus to include regions other than the northeast, working with many fine artisans including quilt-makers in Bengal, hemp weavers in Himachal Pradesh, and potters in Delhi.

ALTHOUGH SOME TRADITIONAL CRAFTS are still endangered, many areas in India have seen a resurgence of quality production in the past two decades thanks to the work of scholars, visionaries and entrepreneurs. The new homes and wardrobes of the rapidly growing middle class are far more likely now than in previous years to feature handmade items. Sensing this change, and while still supporting craft production, Minhazz realized that her priorities were beginning to shift to fine art. "With television, the whole education/entertainment role that folk painting has fulfilled (like, say, the scroll paintings of West Bengal) has been taken over. That whole audience is gone because people would rather switch on their televisions." As part of her research, Minhazz scouts an area and chooses those painters, most often unrecognized, whose works stand out from the rest. Minhazz is truly a mentor to these artists. She patronizes their production while encouraging them to create their finest works and then helps them to find good collectors, galleries and museums that guarantee top prices for these pieces. Minhazz will accept no percentage of the artists' intake. She underwrites this endeavour as a journalist in India and abroad and as a communications strategist for international development organizations and private companies.

ONE OF THE ARTISTS who has captivated Minhazz's attention in the past couple of years is Joba Chitrakar. Joba is 30 years old, the mother of three children and married to Mantu, a fine painter in his own right. They both descend from generations of Chitrakars (painter/bards) from West Bengal and they continue their hereditary profession with adaptations to the 21st century. For hundreds of years, their ancestors have painted elaborate scrolls that depict through consecutive panels ancient myths, legends, local lore and topical events. The painters were also entertainers—storytelling

Joba Chitrakar is one of the artists that Minhazz represents. Joba uses vegetable and mineral pigments to paint on elaborate paper scrolls that depict legends, myths and topical events.

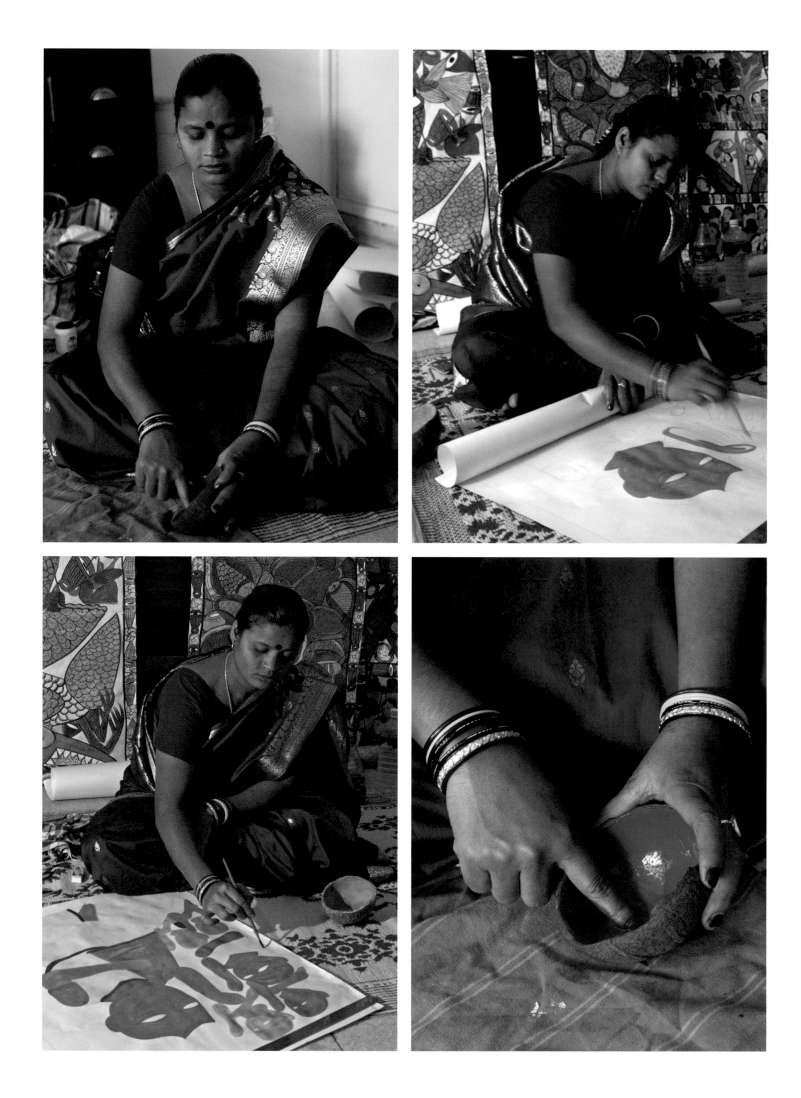

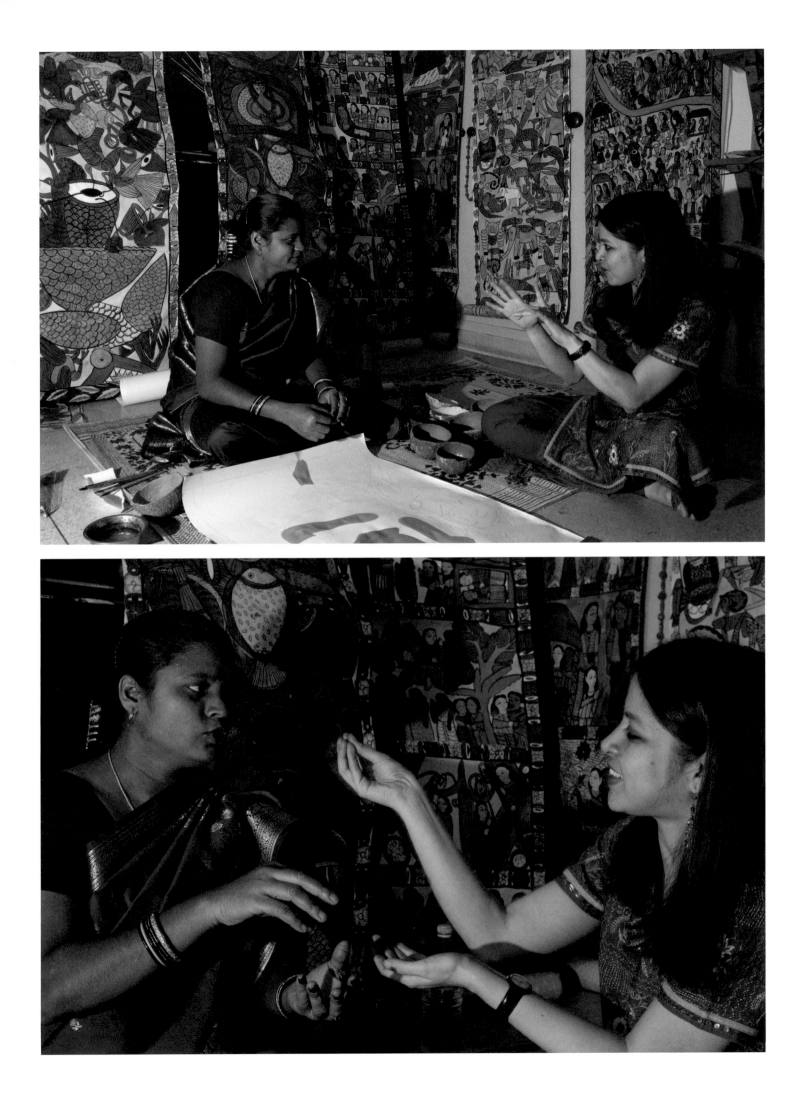

bards who travelled from town to village. In each community, they would unroll their scrolls to sing, panel by panel, their repertoire of stories, providing a vital source of historical and current information. Scroll painting was traditionally a male art. Chitrakar women generally sculpted small clay images that were sold in markets for use in festivals and as offerings to deities. Only within the past few decades have women in this region begun to paint.

MINHAZZ RECOGNIZED JOBA'S CREATIVE TALENT and, in the past two years, has been encouraging her to paint. At first Joba worked by helping her husband, Mantu, to decorate his paintings' borders and some of the simpler figures. The scrolls they created together are excitingly relevant to current events. Mantu painted his interpretation of the World Trade Centre disaster, Osama Bin Laden, the Iraq War and the ever-present threat of AIDS. His pure tenor voice complements his poignant lyrics as he sings about these tragic events. Learning from him, Joba has begun to express her own personal response to life. According to Minhazz: "She had not done any sort of painting before she married Mantu. She started off by painting birds and little fish and she really didn't have the confidence to express herself. But, as time has gone on, she has done a scroll on Bin Laden, and one on the tsunami, and the next thing she is thinking of doing is something on women's lives. You know, what is a woman's life like from the moment she is born? So there is definitely a sense of confidence that has come into her—that she can feel she can depict all these things through art. She does not have to restrict herself to making birds or animals, but can actually make a social comment herself. So that has been rewarding for her and for me."

MINHAZZ'S MENTORSHIP HAS REVERBERATED throughout Joba's life. She now travels with Mantu, composing her own songs and singing them. Although naturally shy, she conveys her message with forthright power in performance. Wily dealers and unscrupulous collectors have tried to bargain down her paintings but, under Minhazz's tutelage, she now insists that they be valued for what they are. Joba remarks: "I can't disembowel myself for my art."

MINHAZZ IS THRILLED WITH JOBA'S CREATIVE GROWTH and her sense of personal integrity and has found it rewarding to work with both artists in this wife-husband team. She acknowledges: "This has been totally a two-way process, because I have grown in my interaction with them. In giving them the space, I have found a new confidence in

Minhazz works with artists by engaging them in conversations to discover their own particular views and by encouraging them to use their highest creative potential.

135

what I can do. This is where I have found that I am really comfortable —in being this bridge between them and a larger audience."

ANOTHER REASON UNDERLIES MINHAZZ'S FASCINATION with Joba and Mantu. Like her, they are caught between two worlds. Their identity is unclear. Raised as Muslims, Joba and Mantu have both Hindu and Muslim names. Joba is also Jourun and Mantu is Samruddhin. In Hindu-dominant India, they have chosen to go by their Hindu names, hiding their Muslim identities. All Bengali Chitrakars have a similar identity conflict. As Minhazz states: "My research has shown me that actually the Chitrakars live between the Hindus and the Muslims. Why? Because they were probably low-caste Hindus who converted to Islam in full scale when the Mughals went eastwards. But the Muslims don't really think very highly of them because they paint figures. You know, a lot of the things that they are doing are not really what purists like to interpret as Islam. And, secondly, the interesting fact to me personally is that, as Muslims, they sing and perpetuate so many Hindu ideas and beliefs—episodes of the *Ramayana* as well as the *Mahabharata*. And Mantu himself has done a very beautiful scroll on the birth of Ganesha! So though they practise Islam, they are very well-versed in Hindu stories and beliefs. They are an example of how Islam and Hinduism coexist. To me, they are interesting because of this. How do you live with yourself? What skin are you comfortable in? My whole journey has been like that! I don't look like an Assamese. I don't fit people's stereotypes of what a Muslim woman should be. So as I find myself trying to be my own person and also fit what the other person's perception of me is, I find them to be absolutely fascinating."

FOR MINHAZZ, LIVING IN INDIA'S CAPITAL CITY is a constant challenge. She, Shahriyar and their 10-year-old daughter, Zahra, share their narrow three-storey house with her retired parents. They run their business from their home, with all sorts of concurrent problems. In 2006–07, Delhi's municipal legislation attempted to close down all household businesses, resulting in large-scale riots throughout the city. After some stressful months of not knowing if their work could survive, Minhazz and Shahriyar were relieved when the ban was lifted from all non-profit and non-governmental organizations, although it was implemented again a short time later. Minhazz feels more than ever that she is working in a field essential to India's future. As she says: "I am interested in ensuring cultural continuity. That is something very important to me because of my daughter,

As Joba unrolls a scroll portraying her interpretation of the devastation caused by the 2004 tsunami, she sings its story in a beautiful voice. Joba's daughter, Sona, helps Minhazz support the bottom of the scroll.

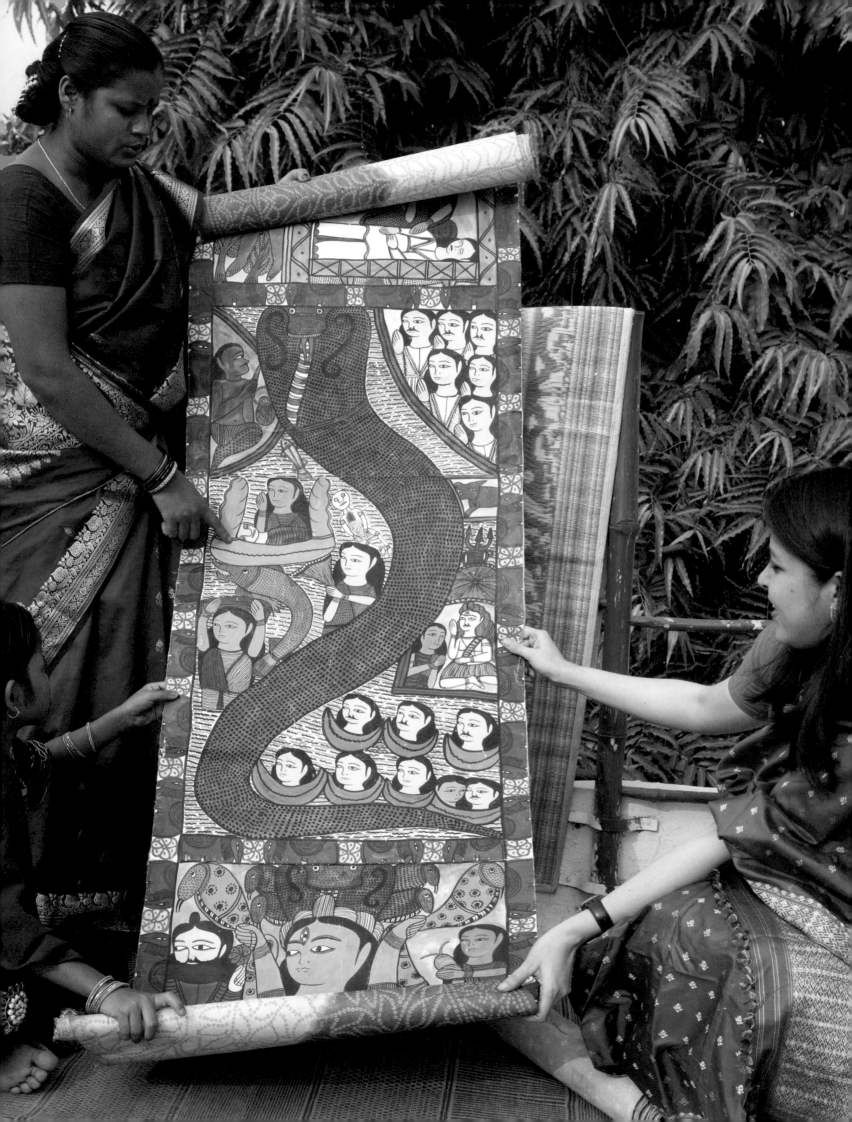

MINHAZZ

Zahra. Her world is more Barbies and video games than all this! But I don't see them (these artists) as carriers of a dead tradition. They are in the 21st century. Mantu has a mobile phone now. He has to live in this world. And he is dealing with the same things I am, to bring up his three children. How does he do it? For me, they are just like anybody else except that they work in this (painting and bardic) tradition. So I think that maybe I see them differently than most people do, who think that they just carry on something that their grandfathers did. They are not only carrying on, but they are bringing in new concepts like ... Bin Laden ... or this one that Mantu has done on religious harmony. They are responding to their time! We in India tend to lump these artists into 'them and us,' but there is no difference."

MINHAZZ IS A CONTEMPORARY WOMAN whose vibrant energy clearly reflects the mandate of many young educated Indian women to speak out and make a difference to India's future. For Minhazz it is essential that India embrace both the modern world and many of its traditional values. In a century that promises to be increasingly polarized, her particular niche is helping to bridge that gap for folk artists. She states: "Folk art became much more important to me, more important even than promoting and preserving crafts. To be able to give these artists space where they could keep creating. More than anything, it is important that they value what they are doing, that they don't think of getting a government job or of diluting their art just to make it saleable in the market. It became critical that it is not important to just sell a few paintings. It would be easy for them to sell by doing cheaper works or bad commercial pieces. But what I wanted to do was to retain the fine status. Because these folk artists are the carriers of cultural traditions which make India what it is. If we all become similar, there would be nothing special about India as a country. I am concerned that Indian society is losing its depth. Every cultural tradition that you look at, any folk art, any craft, they all have knowledge; but we in India are not valuing these knowledge systems. For instance, I could spend a lifetime studying these arts, but I could never know what one of these artists knows instinctively from growing up in her tradition. Because from the time of her or his birth, anyone who is born into a particular community absorbs it, maybe through their skin, maybe through conversations that are going on when they are small babies. And I am still an outsider. Even though I am an Indian and have always been deeply interested, I will always be an outsider."

GANI DEVI Preparing for a Wedding

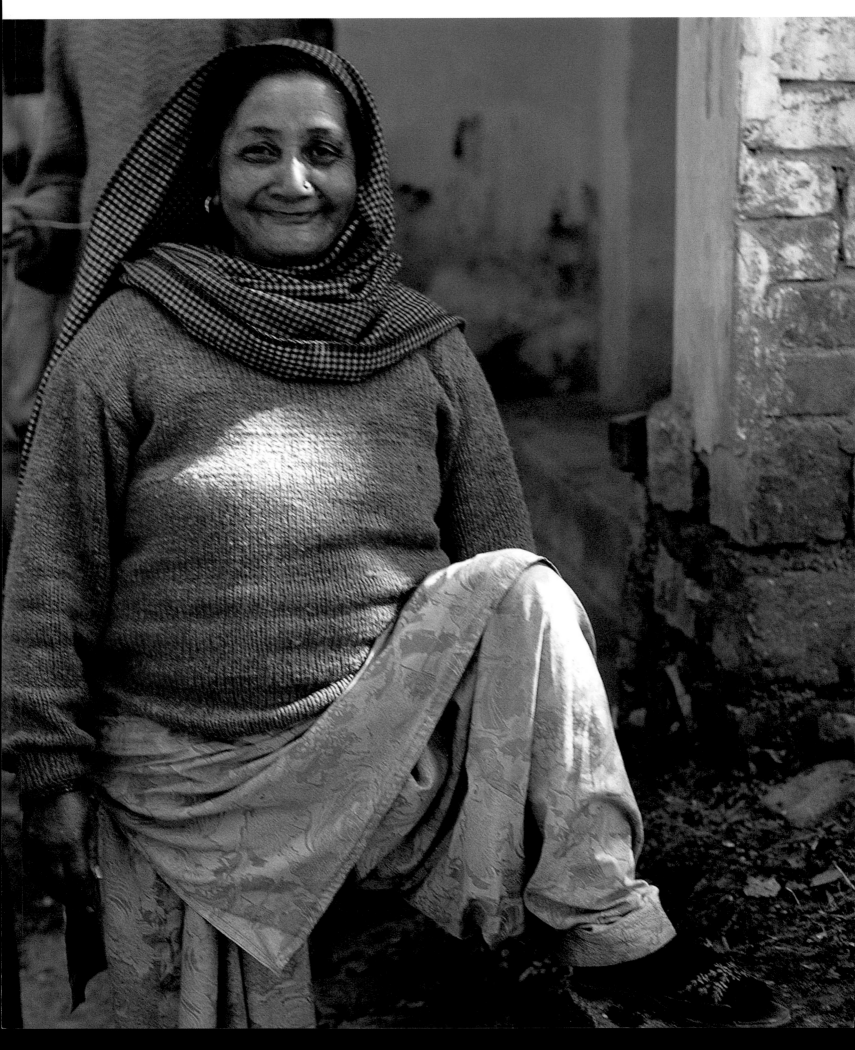

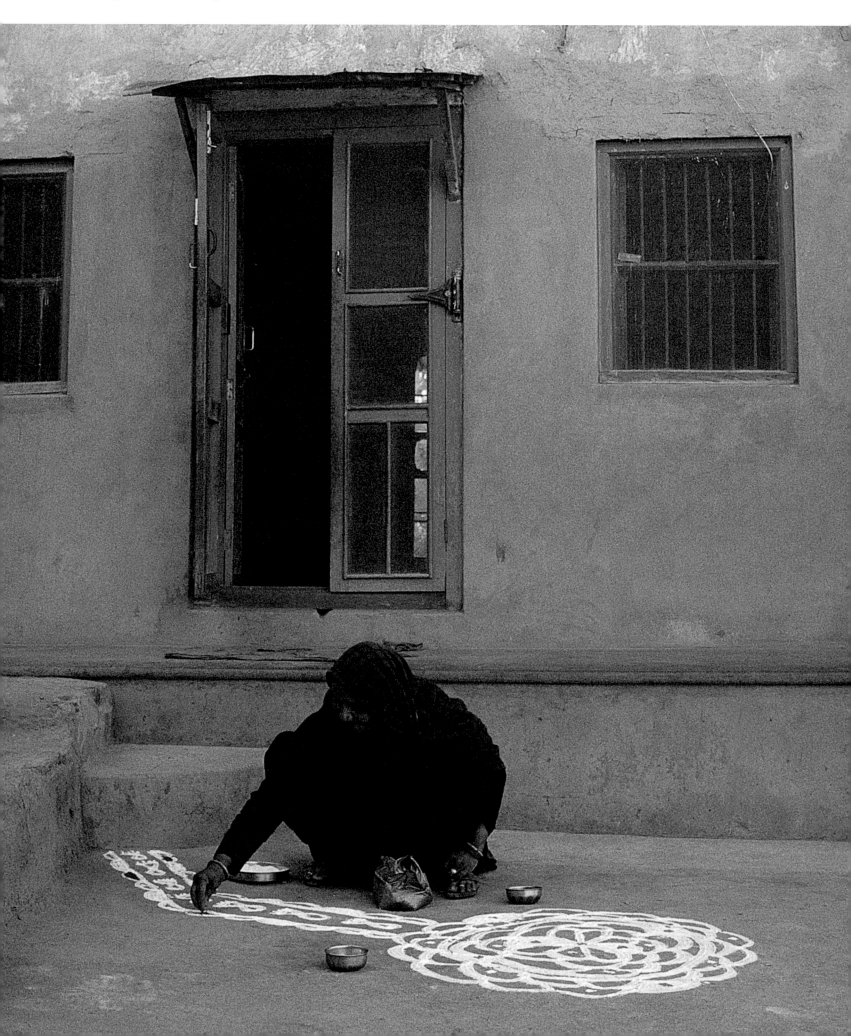

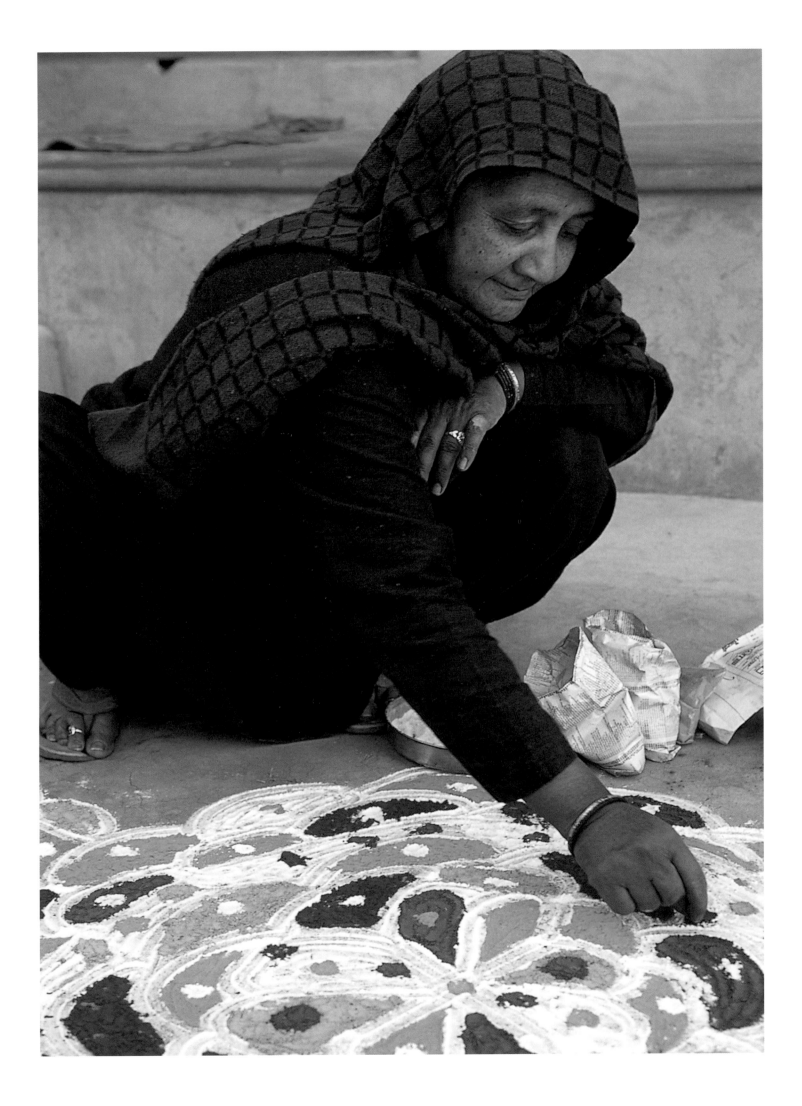

GANI DEVI

"It is my duty to get all my children married. Only then can I rest. So much effort goes into finding the right bride, to make sure that all will be well."

GANI DEVI IS JUST 46 YEARS OLD and she already has four growing grandchildren. Two live with her: Binu, who is seven, and little Pankaj, who is almost three. Gani Devi married Dulo Ram when she was 16 and he was 20. It is a good marriage, arranged in the traditional manner by both sets of parents. Gani Devi had not even met Dulo Ram until their wedding day, and yet, over the years, a deep and abiding love has developed. Her husband has been good to her; his rice and tea farming and the small sweet shop that he runs in the village have provided enough income to raise their four sons and one daughter. Their inherited wooden house is in good repair and its two floors have just enough room for everyone to sleep, although it's crowded when they are all together. Their eldest son lives at home and helps care for the family, while his wife aids Gani Devi with the cooking and the chores.

EVERY DAY, GANI DEVI GETS UP long before dawn to build a fire in the middle of her kitchen floor, brewing milk for tea and water for her family's baths. Soon, she is occupied with making breakfast, and shortly after that, she begins the elaborate process of creating meals for lunch and dinner. In between these tasks, she sweeps the entire house top to bottom, mends and washes the clothes, milks the cow, and tends the garden. It is rare that she finishes her daily tasks until late in the evening. Although this work pattern varies from family to family and region to region, it is basically the same for women everywhere in the subcontinent. Indian women work constantly and rarely have time to relax. In contrast, Indian men may work very hard at their jobs, but they come home to be waited on by their mothers, wives and daughters.

GANI DEVI'S DAUGHTER MARRIED A FEW YEARS AGO and, in customary fashion, moved away to her new in-laws' home. Here, in the little village of Nagri nestled in the Himalayan foothills of Himachal Pradesh, there was not enough employment or income available to support Gani Devi's burgeoning family. Of her three remaining sons, the youngest still lives at home, while two work as taxi drivers in the distant city of New Delhi. It is hard for these two middle sons to live in relative squalor in the overcrowded, polluted capital, but they have little choice and they approach their lives

PRECEDING PAGES, LEFT: Gani Devi is the mother of five adults and grandmother of four children.

RIGHT: Today, she is creating auspicious paintings to welcome her new daughter-in-law to her home. She begins by drawing a large lotus in her courtyard and a line of stylized footprints of the Goddess leading to the front door.

OPPOSITE: She finishes the lotus by filling in all the spaces with powdered pigments made from natural substances: sandalwood, henna and red and yellow ochre, among others.

145

GANI DEVI

with equanimity and good will. One has been married for four years and has two small children of his own.

GANI DEVI COMMENTS: "We have had several meetings with the astrologer and the *pujari* (priest). We must make sure that it is the right girl. Now we have found Sonu for Ranjan (her third son). Her father is also a Brahmin farmer living in a village about 50 kilometres (30 miles) from here. We have met her and I think she will be good for him." The two families have mutual friends who recommended the match. Both sets of parents corresponded through letters and then by phone calls. The marriage seemed desirable. Sonu's and Ranjan's horoscopes were compatible and the amount that her parents were willing to spend on their wedding and her dowry fit with Gani Devi's expectations. However, as this is modern India and hide-bound traditions have relaxed, Ranjan and Sonu have been allowed to meet—once. They were both shy and did not have much to say to one another, but both claimed that they liked the other's looks. It was enough—and the betrothal was confirmed. Indian society is endogamous, which means that according to age-old custom in most Indian subcultures, the bride always marries into a similar social order but leaves her parents' home to move to her husband's community. The marriage alliances of a typical Indian village reach communities in a circumference of 200 kilometres (125 miles). Among its other purposes, endogamy is an ancient means of preventing inbreeding.

NOW THE WEDDING IS JUST A FEW DAYS AWAY and Gani Devi is getting ready to receive the new bride into her home. Many preparations have to be made. She and Dulo Ram will vacate their own bedroom for the first weeks after the wedding. This room is freshly whitewashed. New posters of the Gods and Goddesses are attached to the walls. Gani Devi then meticulously paints the borders around the doorway with lotuses symbolic of Lakshmi's blessing, and in a corner of the room she paints a small shrine to ensure the sacredness of this new union. Her young granddaughter, Binu, helps her, handing her the brushes and carefully watching the painting technique. The grandmother remarks: "It is essential that Binu learn these customs so that when she is grown and a mother herself, she will be able to welcome her own daughter-in-law in the right way." Mothers have been teaching their daughters and granddaughters the fine arts of devotion in this fashion since the beginning of time. For many, these traditions encapsulate the continuity of feminine spirit and identity.

ABOVE: Gani Devi's neighbours spin goat hair before weaving it into the warm blankets and shawls that help protect the villagers from the heavy Himalayan winters.

BELOW: Each morning before dawn during the month of Chaitra (March–April), young pre-adolescent girls throughout Himachal Pradesh paint sacred *chowk* diagrams on the floors of their courtyards to honour the deities Shiva, Parvati, and Bastu. Binu, one of Gani Devi's granddaughters, is just finishing this morning's *chowk* as yesterday's fades away behind it.

146

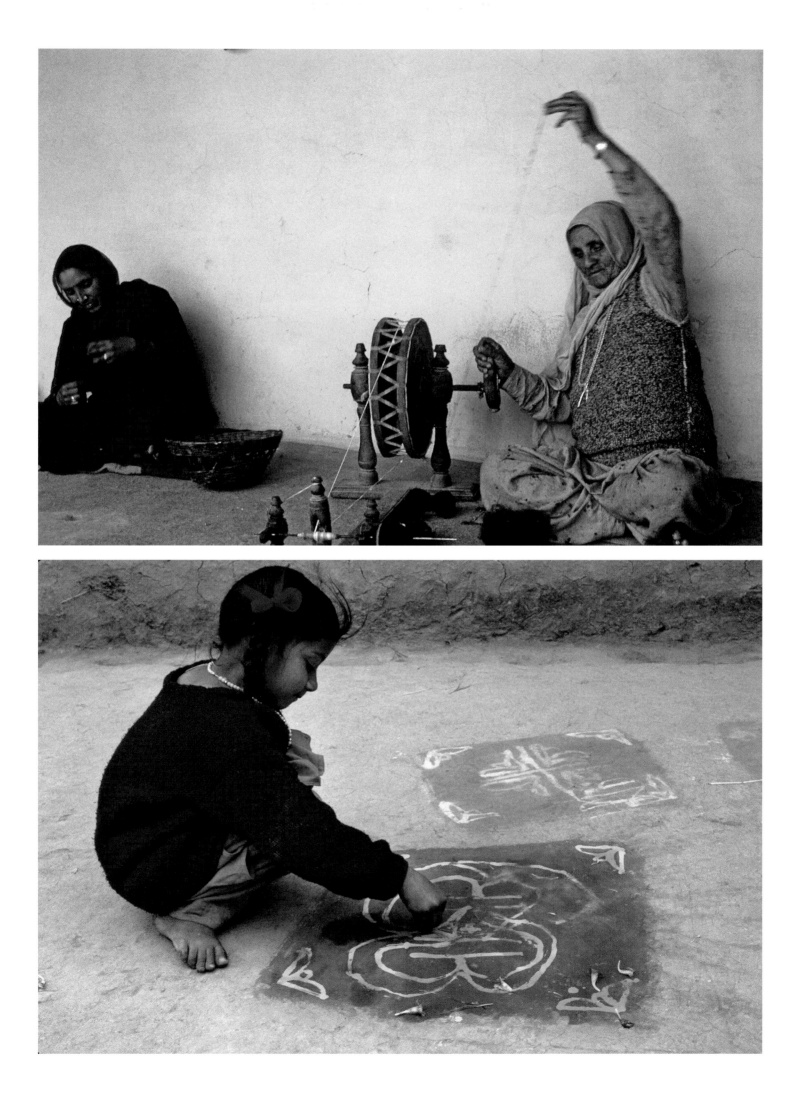

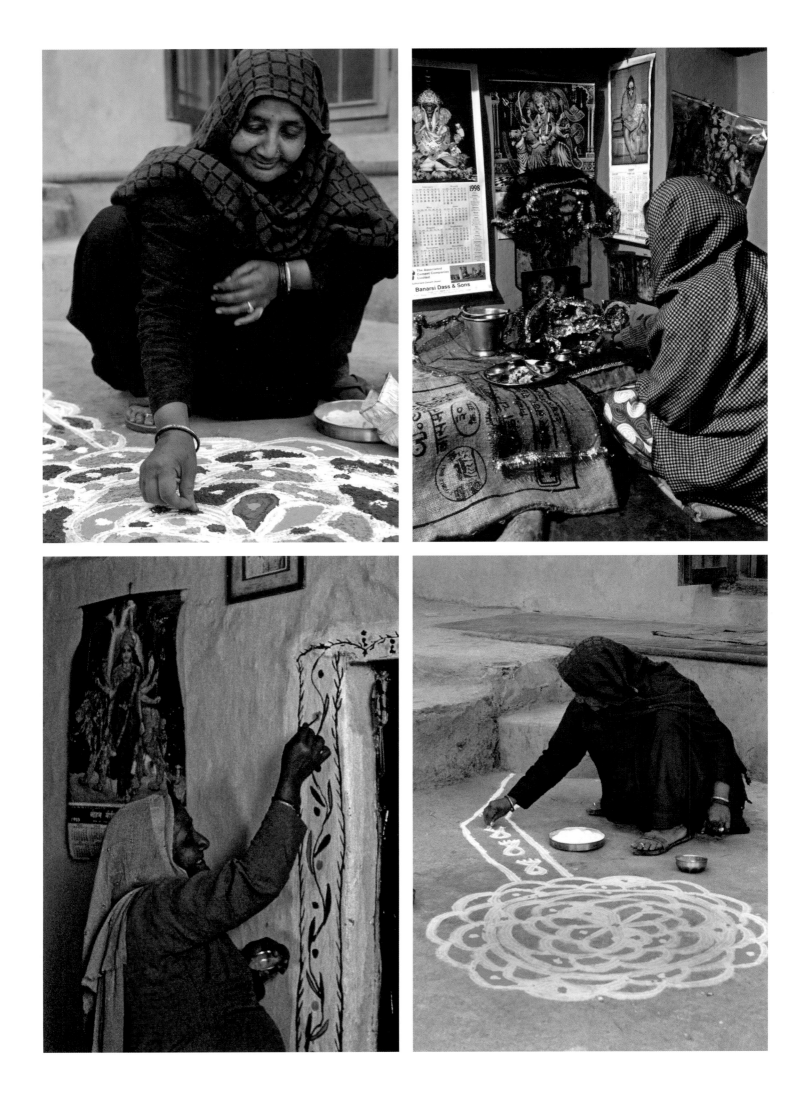

GANI DEVI

ON THE DAY OF THE WEDDING, Gani Devi rises long before dawn, first to bathe and dress and then to pray for two hours at her household shrine, imploring the host of divine beings to bless this new marriage and to fulfill it with healthy children. Then, as the sky begins to lighten, she washes the packed earth courtyard below the steps to the front door and begins to paint the last and most important auspicious symbol: an invitation to the Goddess Lakshmi to enter the home. First, she takes flour freshly milled from rice grown in Dulo Ram's paddy and draws a large lotus on the ground. From the edge of the lotus she applies two parallel lines about a foot apart and extending all the way to the bottom step. Within this channel she carefully draws the outline of footprints, one after another, joining the lotus to the house. Then, from a tray filled with bags and containers of powdered dyes, she begins to colour in the petals of the lotus: green henna, scarlet vermillion, yellow turmeric, all colours associated with the Goddess. The lotus, the primary symbol of Lakshmi, is now resplendent in brilliant hues. Finally, Gani Devi adds colour to each footprint and the painting is finished. In a short invocation, she prays that the Goddess will be present here in her home in Nagri and that the painted footprints will guide Her into the bedroom of the new couple, thereby ensuring their happiness and a fertile union.

THE PREPARATIONS ARE COMPLETE. Gani Devi climbs the stairs to the upper room of her house, rinses her hands, arms, face and feet and then unlocks the trunk containing her most precious possessions. Here are the carefully stored silk brocade tunic and pyjama sets popular in northwestern India and the gold jewellery that were part of her own dowry when she married Dulo Ram. Village life is mundane and arduous and the marriages of her children are among the few occasions when she can truly dress up. She lovingly fingers all the beautiful clothes and chooses a set that is bright red and heavily ornamented with gold lotuses. She puts rings on to her fingers and her toes and into her nose, and adds gold bangles to her wrists and a beautiful gold necklace to her neck. With her exquisite red chiffon scarf pulled fashionably over her head, she feels transformed. Dulo Ram, dressed in a long, embroidered white tunic, silk vest and bright yellow turban, is impatient to leave. Together with their sons, daughters-in-law, and grandchildren, they pack tightly into taxis to drive the hour and a half to Sonu's village for the two-day marriage celebrations. When they return, Ranjan and Sonu will accompany them as man and wife. Gani Devi is content in the knowledge that all the steps have been observed to make sure that this new relationship will be long-lasting and fruitful.

Besides painting the large lotus outside her front door, Gani Devi decorates all the interior doorways with paintings of vines and flowers. She then prays at her household shrine for the health and long, happy marriage of the newlyweds.

FOLLOWING PAGES: Gani Devi's small village of Nagri lies in the fertile Kangra Valley just at the foot of the western range of the Himalayas.

149

SAMABAI Rebuilding a New Life

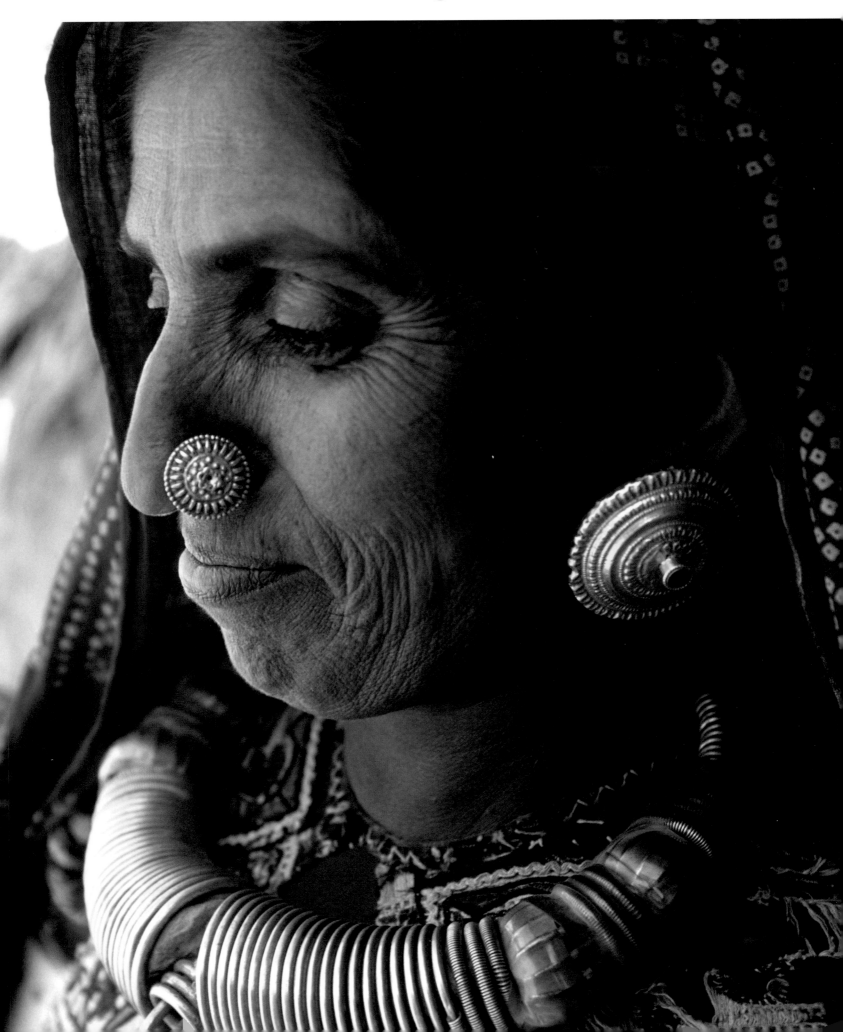

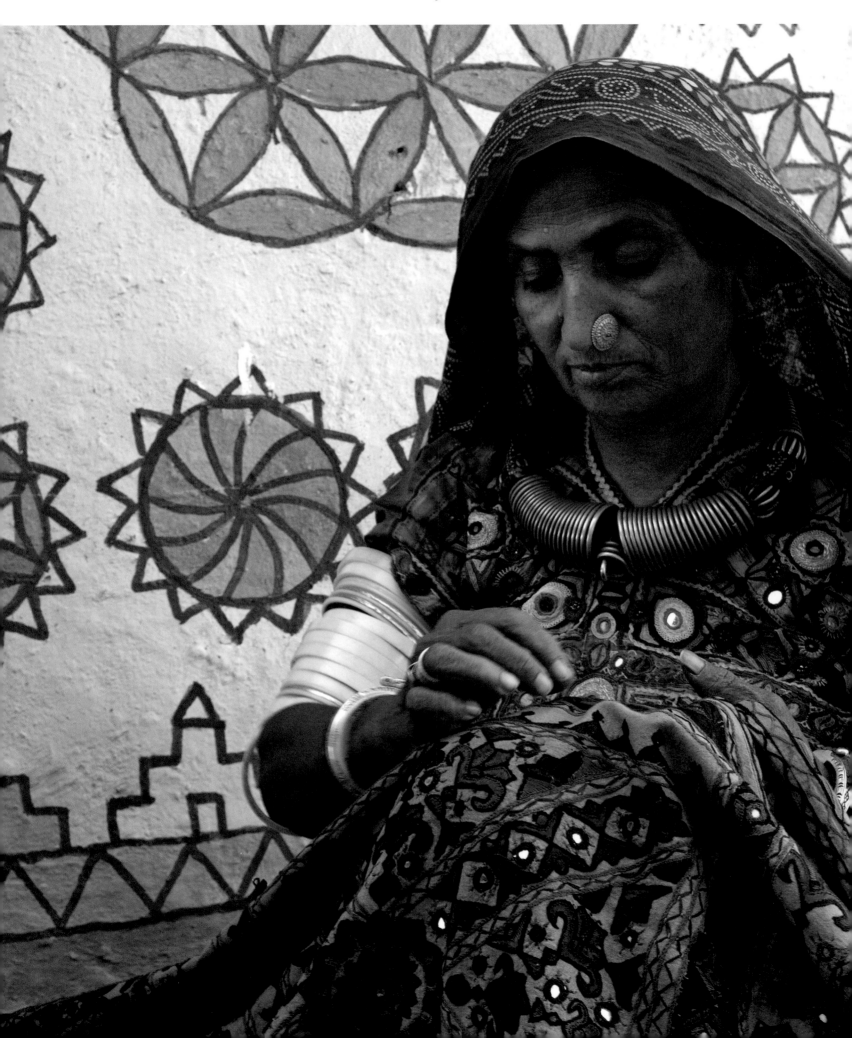

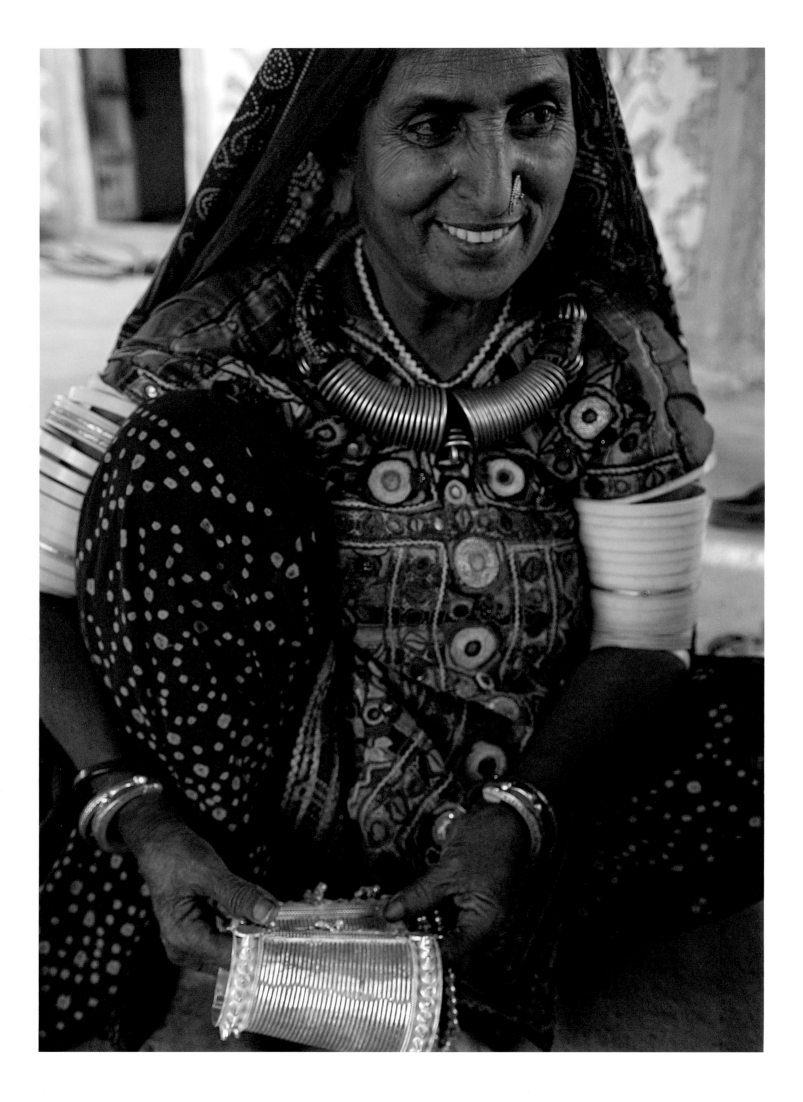

SAMABAI

"I was beginning to serve breakfast to my mother-in-law when the earthquake hit. Almost everyone else in the family was still asleep. First I heard a huge rumble and then everything began to shake. All my family started shouting: 'What is happening? What is this?' Some of my sons ran into the temple. My daughters were crying, some clinging to me. The huge noise would start and then stop and start again. All the houses began shaking and breaking apart. We all ran out into the desert and sat together while we watched everything fall down. Within minutes every house was completely destroyed. But, thanks to the Gods, none of us was hurt! The earthquakes continued for three days. We didn't eat. We had no food and no homes—nothing. We just sat in one place and prayed to Chamunda Mata, Rampa Pir and Ganapati (Ganesha), our family deities. When it seemed safe, we began sorting through the rubble for our belongings. Besides our buildings, we did not lose many possessions. After five days, we began receiving aid from Ahmedabad (the largest city in the state of Gujarat) and for one month some organizations provided cooked food and others, uncooked food. After that, the government gave us 2,000 rupees for food and then the Gandhi Ashram gave us money to buy the materials to rebuild our houses. God answered our prayers during the earthquake. We are grateful. There has not been a bad side to this."

PRECEDING PAGES, LEFT: Samabai always wears the heavy gold and silver jewellery she received as part of her wedding dowry.

RIGHT: Whenever she has any free time, away from her duties managing her large household, Samabai picks up a textile to embroider. Her talent, dedication and business acumen have resulted in a lucrative profession in textile production and dealing.

OPPOSITE: Samabai examines a new silver armband that she intends to present as a wedding gift to her youngest son's fiancée.

SAMABAI IS REFERRING TO the massive Gujarat earthquake of January 26, 2001, far stronger than the San Francisco earthquake a century ago or the one that struck the mountains of Pakistan in 2005. Its epicentre was in the district of Kachchh, just kilometres from Samabai's home. Thousands of houses were totally destroyed. Local and national government joined with numerous national and international aid organizations to help the survivors rebuild their lives. Originally, the houses in Kachchhi villages had packed-earth walls and timber-supported roofs. The style of architecture in each village was different, as was its ornamentation. After the earthquake, most houses were reconstructed using contemporary techniques intended to withstand future earthquakes. The result is a stylistic homogeneity where each brick and cement house and village is virtually indistinguishable and few exhibit distinct traditional variations. However, Samabai's community of Ludiya remains unique. Its reconstruction was sponsored by the Gandhi Ashram, whose founder, Mahatma Gandhi, advocated that a culture flourishes by maintaining its traditional craftsmanship.

155

SAMABAI

Thus Samabai's family and neighbours were encouraged to rebuild their homes exactly as they had always been. There is some rationality in that idea. No one was injured in Ludiya when their buildings fell down, but thousands died in Gujarat's urban centres when their brick and cement homes collapsed upon them. Ironically, Ludiya is now a model village in Kachchh, visited each week by scores of Indian and foreign tourists who want to observe a traditional community.

WHEN SAMABAI WAS YOUNG, her life was completely different. In the early 1950s, just after Indian Independence, the entire subcontinent was in turmoil. Before the British left, they had created an artificial boundary through Western India that bisected this Banni Region of Kachchh and forced its population into one of two separate and warring countries. Ostensibly, Muslims moved to join others of their religion in the new country of Pakistan, while all Hindus immigrated into the Republic of India. In Kachchh, although violent migrations occurred in both directions, the remaining Hindus and Muslims still coexist peacefully side-by-side as they have for millennia. But some religious friction was created after the earthquake, when Hindu fundamentalist politicians tried to give aid only to Hindus. These politicians believed that the animosity their gestures engendered would serve the anti-Muslim cause; luckily, their campaign was unsuccessful.

AS SAMABAI'S HINDU FAMILY had always lived on the Indian side of the new national border, they did not have to move. She grew up in a village not far from Ludiya in a family of the Suthar (carpenter) sub-caste. As is typical in India, her parents sought an alliance with a family of the same caste and occupation. At 16, Samabai married Khaju Kanya and moved to his village of Ludiya in the heart of the desert. Although Khaju and their three sons carve furniture, small woodcrafts and architectural elements, they are located at one of the lowest levels of the social strata. They have always been desperately poor. In this dry, hot, salty region there is almost no fertile land and the few vegetable crops are scanty. Only scrub brush and cacti surround the village, so wood, the basis of Khaju's livelihood, must be imported from hundreds of kilometres away. Until recently, it was a hand-to-mouth existence. But not now. Good fortune and Samabai's talented enterprise have changed the family's entire economy.

ABOVE: Samabai emotionally describes the impact of the 2001 Gujarat earthquake that totally destroyed her village. She and her family reconstructed their houses, seen behind her, using building techniques that have been passed down for centuries.

BELOW: Khaju Kanya, Samabai's husband, is a woodcarver as are all of her sons, but their products account for only a fraction of the income generated by Samabai's embroideries.

156

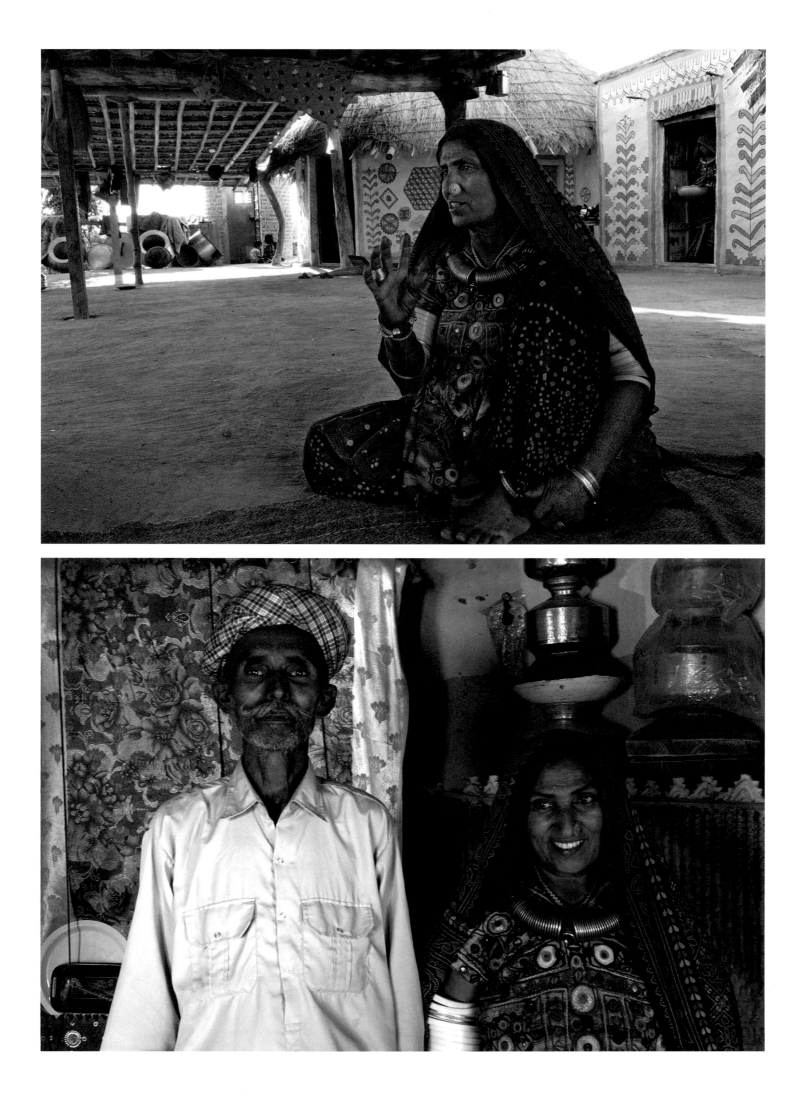

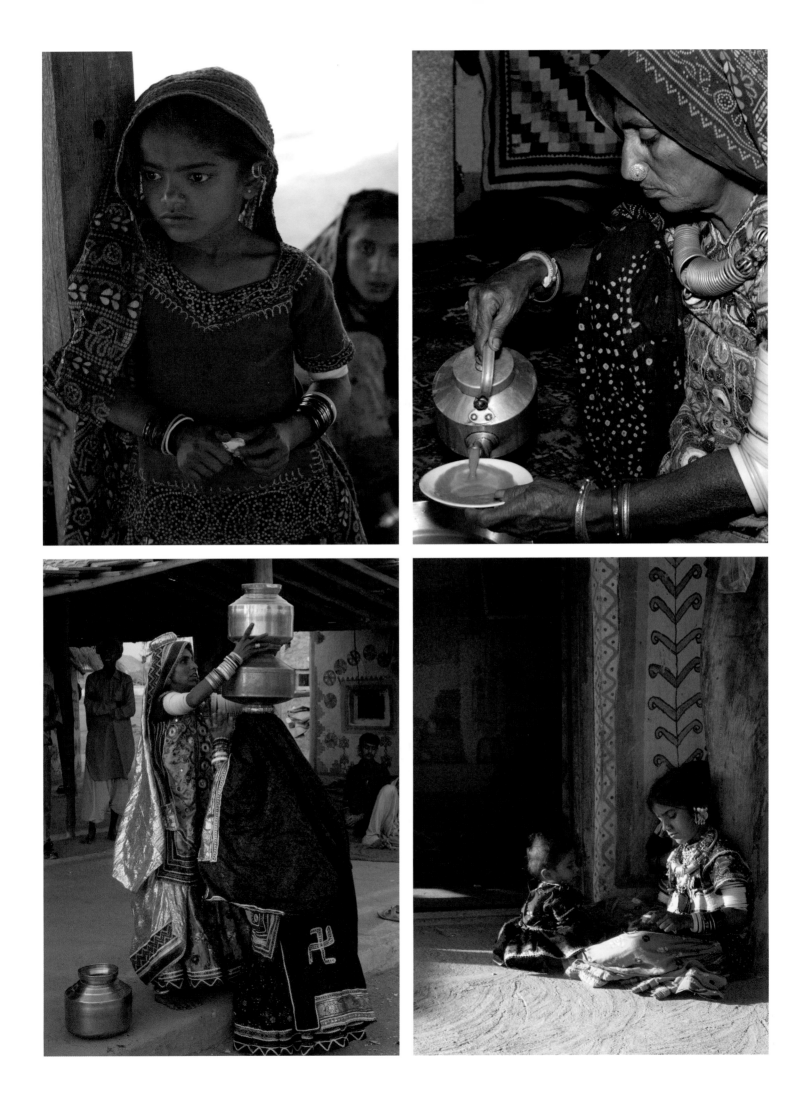

SAMABAI

KACHCHH IS A DRY, BLEAK DESERT that throughout history has been flooded annually by brackish tidal waters for as much as six months every year. Each small village, built on slightly higher land above the floods, was its own island. This isolation created a unique group of cultures whose artistic creativity has been unexcelled. Kachchhi embroiderers and block printers produced some of the finest textiles in history. The embroideries and appliqués of the Suthars are similar in style to those of the better-known Ahirs, or cowherds. Samabai's first memories are of her mother embroidering clothes. She comments: "Ma always had a needle with thread stuck into the hem of her skirt. Whenever she had a moment, she would pull out a piece of cloth and stitch. She taught all of us to create these designs. We used to make these embroideries only for ourselves and for our dowries, but now we make them to sell." In the late 1960s and 70s, Kachchhi textiles began to regain a broader popularity. First, older textiles were collected and sold; as these became scarce, entrepreneurs and non-governmental organizations encouraged the production of newly ornamented fabrics to meet the growing market demands (*see* Chandaben, pp. 52–65). The government paved and maintains good roads in the region, to provide rapid military access to the Pakistan border in case of attack. Consequently, Ludiya is no longer entirely isolated. With increasing regularity over the past few decades, dealers, collectors and tourists have visited the villages of Kachchh to look for crafts. Samabai was one of the first women to realize that her own talents were a profitable source of income.

DURING THE WET MONSOON MONTHS when flooding still swamps the area and tourism grinds to a halt, Samabai, her four daughters-in-law and six granddaughters are busy embroidering and appliquéing textiles. Their products (blouses, skirts, bags and quilts) are bright and beautifully ornamented, and the tourists love them. Samabai has a winning nature. She invites each visitor into her round, mud-walled home ornamented with mirror-inlaid bas-reliefs, offers them cups of sweet, milky tea, and pulls out stacks of textiles to spread at their feet. Her granddaughters are bold in their aggressive approach, attempting to pull each newcomer aside to sell anything they can: embroideries, small household articles, even the beaded chokers from their own necks. The result is that the women of Samabai's home bring in far more income than the men. This imbalance has completely restructured the position of women within the household and village. While throughout history the

Samabai's compound of four separate one-room houses contains the families of her three remaining sons. Her daughters-in-law and older granddaughters carry pots of water five times a day from the community well 150 metres (500 feet) away. Samabai's many young grandchildren demand a great deal of attention and she is grateful for the few times a day when she can stop for a cup of tea.

SAMABAI

women of Kachchh have lived in relative seclusion behind their veils, they are now recognized as the source of an improved economy and are beginning to have a political voice. The change is slow; gender roles have been entrenched here for centuries, but women are beginning to take more control. Certainly in Samabai's case, her husband Khaju, her three surviving sons (her eldest died in a car accident in 2005) and six grandsons treat her with respect and a certain awe. The men continue to carve wood and occasionally sell their crafts to tourists, but they generate only a fraction of the income produced by their women. Ironically, the men in many families in Kachchh now rely entirely upon their women to do all the work. Wives are expected to care for their children and conduct all the gruelling household tasks, and at the same time work fulltime to create marketable crafts, while their husbands drink, sleep and gamble.

SAMABAI IS A FIRM BELIEVER IN DIVINE GRACE. She acknowledges her gratitude to her deities with every transaction. She states: "The very first thing I did when we finished building my new home was to paint the walls with designs to our Goddess Lakshmi. It is Her kindness that gives us all these things. I must pray to Her. Each year for her *puja* I repaint my walls freshly. I hope these (patterns) will be pleasing to Her."

ALTHOUGH SAMABAI'S APPEARANCE and some of her customs beguile the observer into thinking of her as purely traditional, she is a savvy woman and familiar with the contemporary world. Her income has provided one of her sons with a television and another with a motorcycle and a cell phone. These modern-day items are cleverly hidden or underplayed when tourists come to visit the model village. Her youngest son is about to get married and, in choosing his new bride, an essential criterion was the girl's ability to embroider. The bride will join the rest of Samabai's extended family in their quest to improve their social and economic status. Samabai's granddaughters slip in and out of their veils easily, alternately bold and shy. But they are all determined to build a future where their own talent and ingenuity continue to bring them success.

Once each year, in preparation for the Diwali festival, Samabai and the other women in her family repaint the walls of their compound with traditional decorative designs that are reminiscent of the patterns employed in their embroideries.

FOLLOWING PAGES: Samabai never wears sandals or shoes and her feet are toughened by the rocky desert that surrounds their compound.

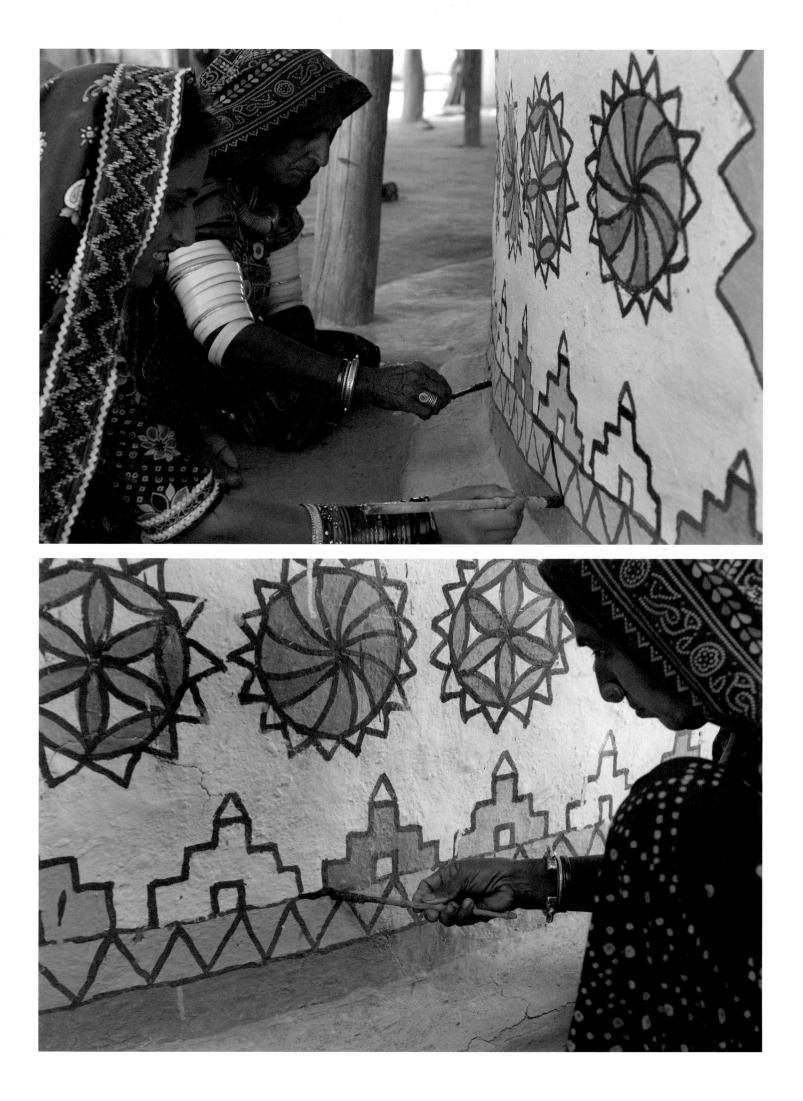

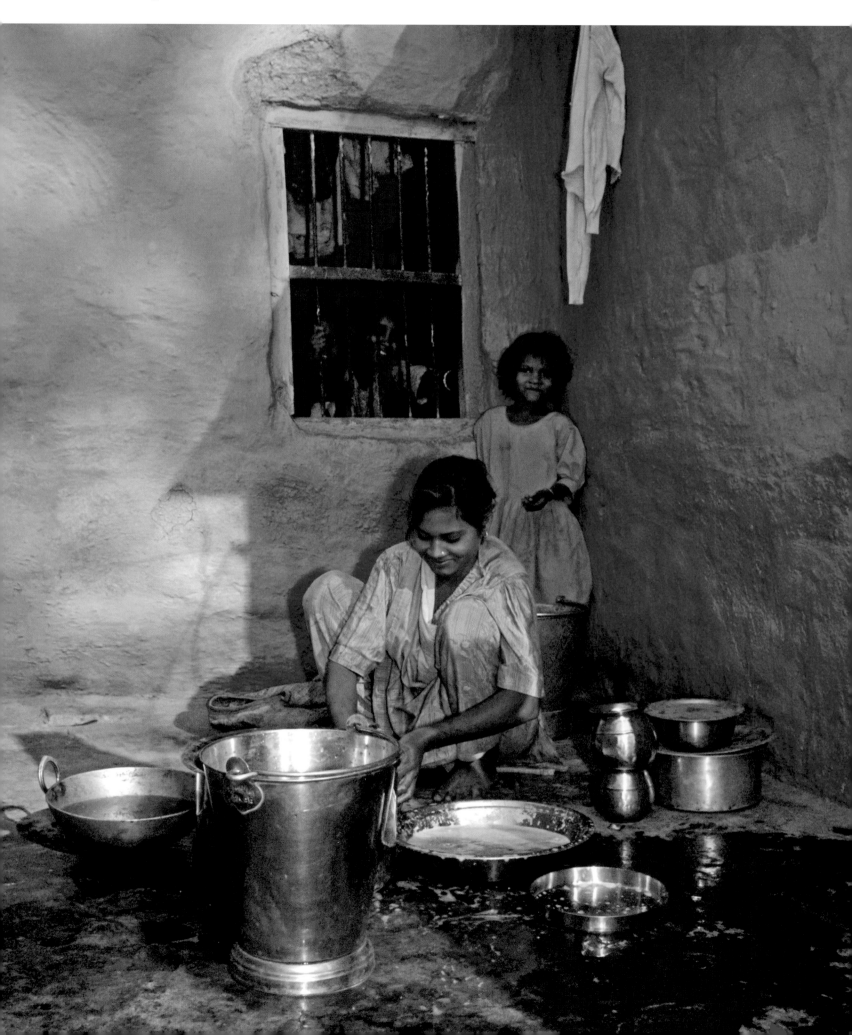

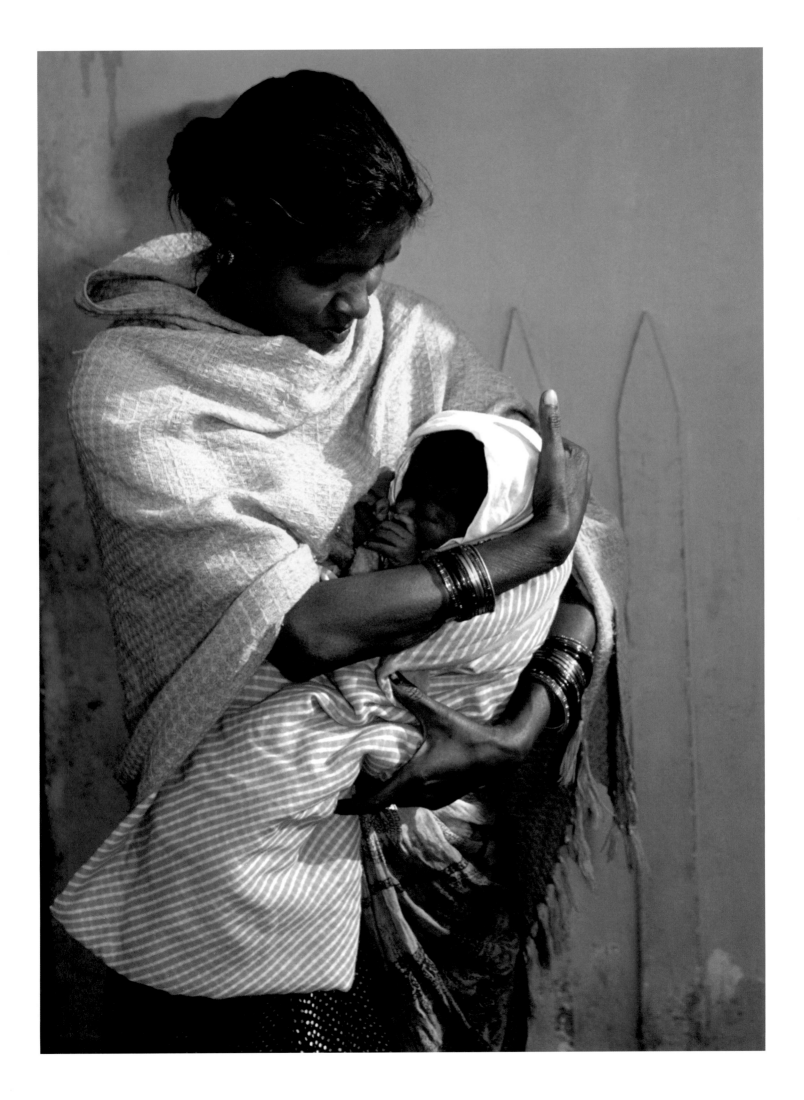

BIMLA

"Can I make a difference for my child? How can I make any changes? We are seen only this one way. We are mitti (mud), less than mitti. Even this beautiful baby is mitti to them. What can I do? It is my curse in this life."

IF BIMLA HAD BEEN BORN PRIOR TO 1951, she would have been labelled "untouchable" or "outcaste." Although Mahatma Gandhi renamed her people "Harijan," meaning "Children of God," and the Indian constitution decrees it illegal to discriminate against them based upon their heritage, they are effectively still on the lowest rung in the Indian social hierarchy. Bimla belongs to the hereditary sweepers' sub-caste: the Balmiki. According to tradition, her people swept houses, public buildings and homes, cleaned the foul open sewers, and disposed of garbage and unwanted refuse. Because these occupations put them in contact with potentially contagious diseases, they were considered polluted. People of higher castes eschewed them entirely, afraid that even standing too close to them would be dangerous. Historically, the lives of the Balmiki were untenable. Today, in the 21st century, they are better, but prejudice is still rife and day-to-day living is challenging.

ONLY TWO WEEKS AGO, Bimla gave birth to her first child, whom she named Leela. She cannot believe how beautiful her little girl is. Everything about Leela is precious. Of course, no one even considered the possibility of Bimla birthing in a hospital. Although admission to a maternity ward is technically possible, none of the Balmiki women in her community has attempted it. The red tape would be almost insurmountable, the expense unaffordable and the emotional atmosphere alien and disapproving. Instead, throughout the final days of her maternity, Bimla was closely attended by her mother- and sisters-in-law, and by their own Balmiki midwife. Although her labour was intense and painful, the close camaraderie with the other women had been nurturing. Together, they sang songs to Martha Mata, their community Goddess, and told *katha*s, the age-old stories that prepare a woman for this momentous occasion. According to custom, Bimla's husband, Shachin, had not been present. He had stayed with his close friends a few houses away and was only allowed to enter their home once the afterbirth had been disposed of and the entire house washed from top to bottom. She could tell from his expression that Shachin was proud of their little girl, but he admitted: "What can we do with a girl? How can we support her? She will only bring us expenses and then

PRECEDING PAGES: Bimla lives in the slums directly on the National Highway, on the outskirts of the sacred city of Varanasi. Everyone in their community belongs to the Scheduled Caste of sweepers (Balmiki), who remain ostracized and excluded by almost everyone in the castes above them.

OPPOSITE: Bimla has just given birth to her first child, a girl. She is justifiably afraid for her daughter's future.

167

BIMLA

we will have her dowry! Of course I love her, but if only she was a boy... Maybe our next child will be a boy, and his work and marriage can help with our costs with this Leela."

IN JUST A FEW DAYS Bimla will have to return to her job. She sweeps the floors of a nearby high school. Most of the children there have parents who are shopkeepers and businessmen. Although she generally cleans the classrooms in the evenings, whenever Bimla has contact with the students, they carefully avoid her, treating her with condescension. Bimla was never able to go to school and she is completely illiterate, but Shachin attended up until the fifth standard (grade) and can read and write. Bimla is determined that little Leela will go to school when she is old enough. National legislation now decrees that every Indian child is entitled to an education at least through elementary school. Although the enforcement of that law is uneven at best, there is now a small neighbourhood school near Kazakpura. Bimla knows the value of literacy and wants her children to have that advantage. It has certainly helped Shachin.

SHACHIN HAS CHALLENGED CONVENTION to become a bicycle *rickshawwallah* (driver). This profession puts him in constant contact with people of every caste and position. His job requires arduous work and a demanding schedule. He must leave home every morning by 4:30 in order to meet the early trains and be available for pilgrims who want to go to the sacred Ganges River. However, the traditional social hierarchy at the station prohibits Shachin from standing in queue for passenger arrivals, so he is forced to circle on the highway outside the station hoping to be hired by someone who is looking for a cheaper fare. Often, he has been threatened by his competitors and once he was badly beaten by a gang of station *rickshawwallah*s, but as this location is the best place for him to get clients, he persists. Shachin does not own his rickshaw. Few of his fellow *rickshawwallah*s do. He hires it from a local businessman to whom he pays a large percentage of his daily income. Nevertheless, Shachin is able to bring home enough money to help support Bimla and now little Leela.

ONE OF EVERY SIX INDIANS (16.44 per cent) is a member of what is euphemistically called the Scheduled Castes, the official term for the people who were traditionally outcaste, otherwise known as Dalits. During the past twenty years, the Indian Parliament has

Bimla's husband, Shachin, shown on the above left, drives a bicycle rickshaw. In common with all the other *rickshawwallah*s in that area, he decorates his vehicle with bright designs.

168

passed many laws that benefit the Scheduled Castes. Twenty-three per cent of all central and state government jobs are reserved for Scheduled Caste members, with the same percentage guaranteed for school and university admissions across the country. Only one person out of Kazakpura's Dalit population of 327 has been able to take advantage of these quotas. He graduated with a diploma from high school and is now employed as a servant to a factory owner. But in other communities throughout India, Scheduled Caste members are now serving as teachers, professors, airline officials, lawyers, judges, magistrates, political appointees, governors and even ministers of parliament. The tenth president of the Republic of India, KR Narayan, was a Dalit. The numbers of prominent Dalits are slight in proportion to the millions remaining disadvantaged, and few of the new professions are filled by women, but even that imbalance is slowly beginning to change. Mayawati, the present Chief Minister of the powerful North-Indian state of Uttar Pradesh (a position comparable to an American governor), is the first female Dalit in Indian history to reach this stature. Due to these new government quotas, a major backlash has been brewing among the higher castes for the past couple of decades. India's extreme overpopulation means that unemployment is rampant. Eligible higher caste applicants for employment positions believe that they are being rejected in favour of less qualified Scheduled Caste applicants. They resent being penalized for the prejudiced actions of their forebears. Riots have ensued in many parts of India. Societal tensions have increased accordingly.

BIMLA FEELS THAT HER OWN FUTURE IS UNSURE. The Balmiki have never had a fair chance. They have always been *pariah*s (a word appropriated to English from the name of another "untouchable" group). But she is determined that life will be different for Leela. She remarks: "When I was a girl, we had no possibilities. Everything and everyone was against us. Only our Goddess would listen. My mother and grandmother told me that our only hope was to serve as well as we could, to do our duty well. Only then we might be reborn into a better position in the next life. Only by being honest and working hard and not complaining in this life, could we hope... But I want my little Leela to have a chance. Already some (Scheduled Caste) people are getting strength. I hope Leela will go to school and learn and for her it will be better in this lifetime. I pray for this daily. With our Goddess's help, it will happen."

For Diwali, the Balmiki paint their small drab homes with bright blue, red ochre and white lime as a plea to the Goddess of Abundance and Prosperity: "Remember us!"

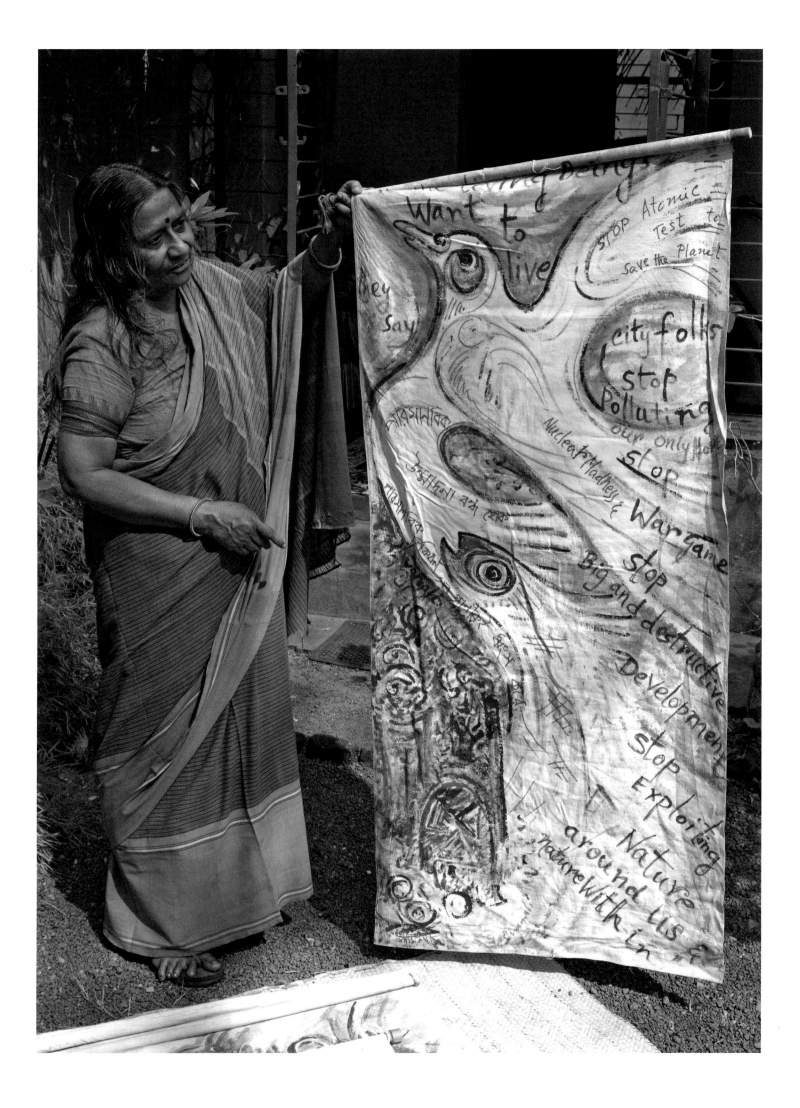

SHYAMALI

"People do not understand me. They think I want to be a protestor. I do not. I like to open discussions, to understand the interconnectedness of everything, to honour our responsibilities to the rest of existence."

SEATED ON A DIVAN IN HER LIVING ROOM, Shyamali Khastgir speaks passionately about her unusual life. Her home appears chaotic. Spread all around her are rolls of her paintings and cluttered piles of papers that represent her many interests and her history of social and political protest. Intermittently in her conversation, she shuffles through the jumbled stacks looking for a relevant article or letter. Above her, the walls are hung with framed paintings created by her well-known artist-father, Sudhir Khastgir, a member of the revered Bengal School of Art. In a country entrenched in ritual customs, Shyamali's family was far from normal. "My mother died when I was 10 months old. ...I grew up with my father's mother. I knew no religious practise. Until I was seven I had seen no rituals, no *murti* (images of deities) or *pranam* (hands folded in prayer)."

IN 1949, WHEN SHE WAS JUST NINE YEARS OLD, her father sent her to study at Santiniketan, the famous liberal arts school founded by Rabindranath Tagore, India's poet laureate and winner of the Nobel Prize for Literature. This progressive school was the intellectual heart of 20th-century India; it nurtured some of India's greatest minds, fostering some of its finest art, literature and philosophy. Her father had studied there. Shyamali spent most of her youth in Santiniketan and returned almost three decades ago to live there permanently. She remarks: "Growing up in Santiniketan, I have been exposed to these great, open minds, these people—(Ram Mohan) Roy and (Rabindranath) Tagore and others—who expressed an open interchange of ideas between themselves and other cultures."

RAISED IN A CREATIVE ENVIRONMENT and showing an artistic talent from early childhood, it was natural for Shyamali to follow her father's vocation. She studied and received her diploma in art at Santiniketan and lived there until her marriage, when she was 21. Tan Lee had been a young Chinese student at the school and his sister was one of Shyamali's best friends. Tagore had met Tan Lee's father in China and invited him to run his Department of Chinese and Buddhist Studies. After graduating from Santiniketan, Tan had studied town planning at the prestigious Indian Institute of Technology and then was hired by Shyamali's father to teach

SHYAMALI

architecture at his school in another state. Shyamali and Tan were naturally drawn together. She remarks: "I knew him and yet I didn't know him. I was naïve. I thought our marriage might be a way of bringing our two countries together."

AFTER THEIR WEDDING, they lived for six years in Kolkata, where Tan worked for the Calcutta Improvement Trust. In 1966, Shyamali gave birth to their only child, a son they named Ananda. The next year, Tan was invited to help plan a new industrial town, Kitimat, in northern British Columbia, and he moved there ahead of his young family. In 1968, they joined him. After growing up in tropical Bengal, living in Kitimat with its snowbound winters was an eye-opening experience. Shyamali believes it is significant that she "came to know the native people there. My son played with native children (Kwakiutl) and I met and became friends with their parents. Their thoughts and philosophy influenced me greatly. I was beginning to question many things, but had no real awareness yet." In 1971, the nuclear testing in nearby Amchitka Island, Alaska, alarmed Shyamali. She began reading everything she could about its environmental effects and gradually became involved with the peace movement and with the newly organized Greenpeace.

SHYAMALI'S FATHER HAD CONTRACTED Parkinson's disease in the early 1960s and his physical condition deteriorated rapidly while she was living abroad. Shyamali was clearly homesick and she wanted to expose her son to his heritage. So she took Ananda away to spend the school year in Santiniketan, living with Sudhir while Shyamali again became a student in the sculpture department. She states: "My father was a very anti-war person. We lived in an open house and many people came, although my father never visited other people. He wanted nothing to do with the military or with people who supported wars. At that time I didn't see the connection, but this is when I first began to think more and more about our responsibilities as human beings." Her father died shortly after she returned to the West, and Shyamali blamed herself for deserting him. Soon after, it became clear to her that her marriage had failed. Although unhappy, she was determined to remain married for Ananda's sake.

"IN 1976, WE MOVED TO VANCOUVER FOR TAN'S BUSINESS," she remarks. "My husband insisted on living in a luxury apartment building. I hated it. Tan Lee wanted to live in an exclusive, polished way that represented his position as a recognized architect. I could not live

CLOCKWISE FROM THE ABOVE LEFT: Shyamali shuffles through papers representing a lifetime of protests against weapons, war and environmental and social ills.

She is constantly experimenting with different artistic media. Here and in the bottom left corner, she paints on a woven mat.

Shyamali has sculpted marionettes that she animates in public to speak out against injustice. This one represents "Mother Earth."

176

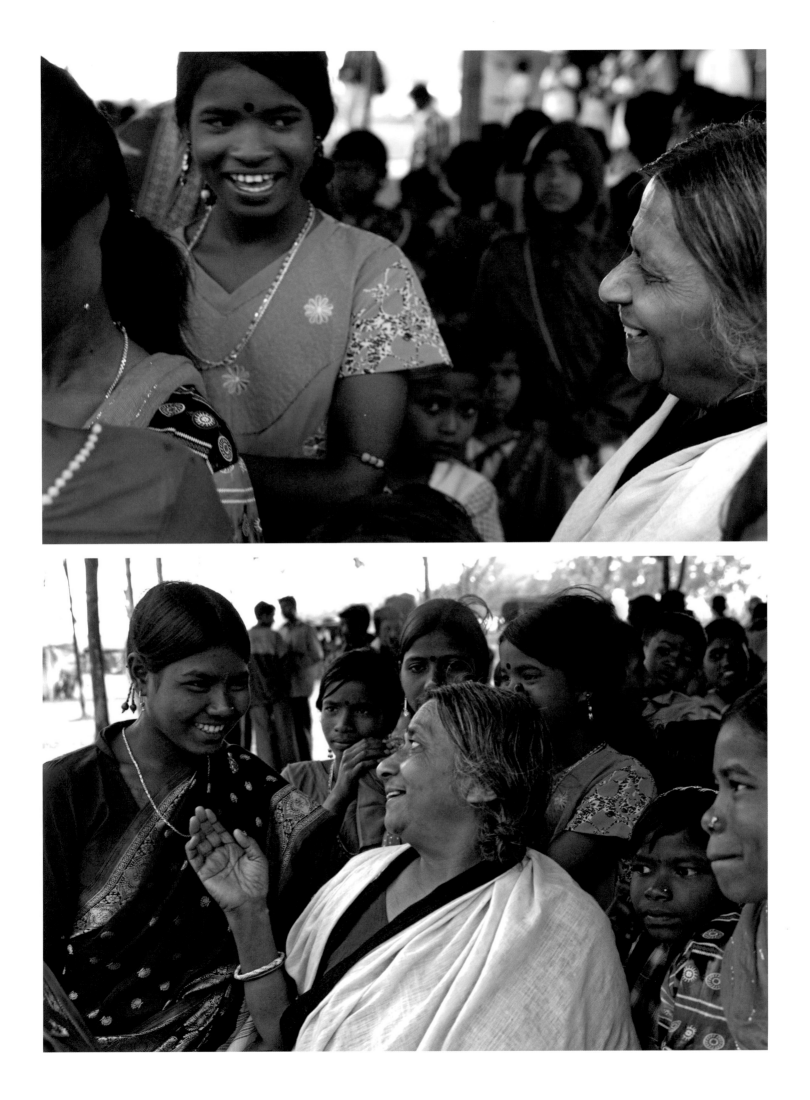

isolated from humanity like that. It was not me." Shyamali regularly attended the Unitarian Church in Vancouver, impressed by the congregation's social awareness. "I joined a non-violence workshop in the summer of 1977. I took my son to expose him. It was a very rewarding experience. Suddenly, I felt I was being given this big opportunity to begin to change the war machine. I wanted to do civil disobedience, to be arrested—to be able to go to court and say something publicly. I was first arrested with three other women for stopping traffic into a naval base where they were manufacturing Trident nuclear submarines. ...I was not political in that way, but in order to make my case against Trident, I became involved. The following year, at 12, my son wanted to get arrested at the Trident base and he was."

THEIR SHARPLY DIVERGING BELIEFS AND LIFESTYLES made Shyamali's relationship with Tan Lee more and more untenable. "I could no longer live in the guarded community my husband was part of. It made no sense. I decided to live alone. I have lived that way ever since, except for short periods living with my son." She moved into an artists' commune in a disused airplane hangar in Vancouver and began sculpting in clay and painting on cloth. After a few months, her son joined her. Shyamali supported the two of them by working for a private emergency health service aiding in family crises. "Finally," she states, "in 1979, I (was the defendant in) a very good trial about the Trilateral Commission (responsible for supporting Trident). I was able to prepare well. The Trilateral Commission was founded by David Rockefeller, and Jimmy Carter was a member. They had members in almost all the political parties. I subpoenaed Jimmy Carter, David Rockefeller and one of the Canadian ministers. I was questioning how the Commission was interfering with democracy in the US as well as in other countries. My trial was set for the anniversary of (the bombing of) Hiroshima and our judge was Japanese. I was so lucky. He allowed me to speak and say everything I wanted to say."

JUST PRIOR TO THE TRIAL, Ananda travelled to India to board first at Santiniketan and then at a progressive school in south India. Shyamali joined him a few months later and taught art in his school, travelling through India during holidays. "I wanted to tell people here about all this (belief in the social and environmental evil of nuclear armament). People were wondering why I had left a comfortable life in a conventional sense to live in a hangar and how

In recent years, Shyamali has become deeply involved with the plight of subsistence farmers, and particularly the many tribal people who live in her area. Here, she engages with girls at a tribal festival.

179

SHYAMALI

I could bear to send my son off to live without me." She then returned to Canada for a year and a half before realizing a dream she had cherished for years.

"IN THE SUMMER OF 1981, I went to Washington, DC, to get arrested." Shyamali explains: "I didn't know anyone there. I was guided to a community of creative non-violence working with street people (Jonah House). We would cook meals for over 300 people per day. I stayed with them throughout the summer months. They were inviting people to come get arrested at the White House by protesting armaments and war. We were praying on the front lawn of the White House and were asked to leave. I refused, so they dragged me to a police car. They would not let anyone pay my (bail) bond. I was put in jail for seven days. It was the great achievement of my life so far. They did not want to put someone with a sari in jail. …Once you get put in prison, you get to know other prisoners and hear their stories. It was a great and important education for me. …I was painting anti-war posters and hanging them. I had begun them earlier but I did quite a few there. No one else in our group was painting; not many artists joined us. By this time, I really realized that this is my special form of protest. It was a very good experience to be with this community for creative non-violence." She stayed in Washington for several months and was arrested four or five times, once at the Pentagon on Hiroshima Day. She then returned permanently to Santiniketan and since then has only travelled outside India once, visiting her son and his family in Canada, in 2003.

IN THE 26 YEARS SINCE HER RETURN, Shyamali has been untiring in her crusade against warfare, injustice and environmental destruction. She has been a vital activist against the building of dams on the Narmada River in central India that threaten millions of acres of fertile farmland and natural resources and the livelihoods of hundreds of thousands of people. She has marched to protest the second nuclear testing in Pokharan in Rajasthan's desert and the continuing war with Pakistan over Kashmir. She has applied her artistic talent more and more to painting what she calls her "posters": long cloth banners that blend images and words into evocative statements against social evils. After he finished school, her son, Ananda, moved back to British Columbia and joined the peace movement there. Proudly, she states: "He learned forestry working for the government and began his campaign to reforest Western Canada. He protested the logging of virgin forests. …He is

These details of four different "posters" focus on the messages that Shyamali tries to convey through her art.

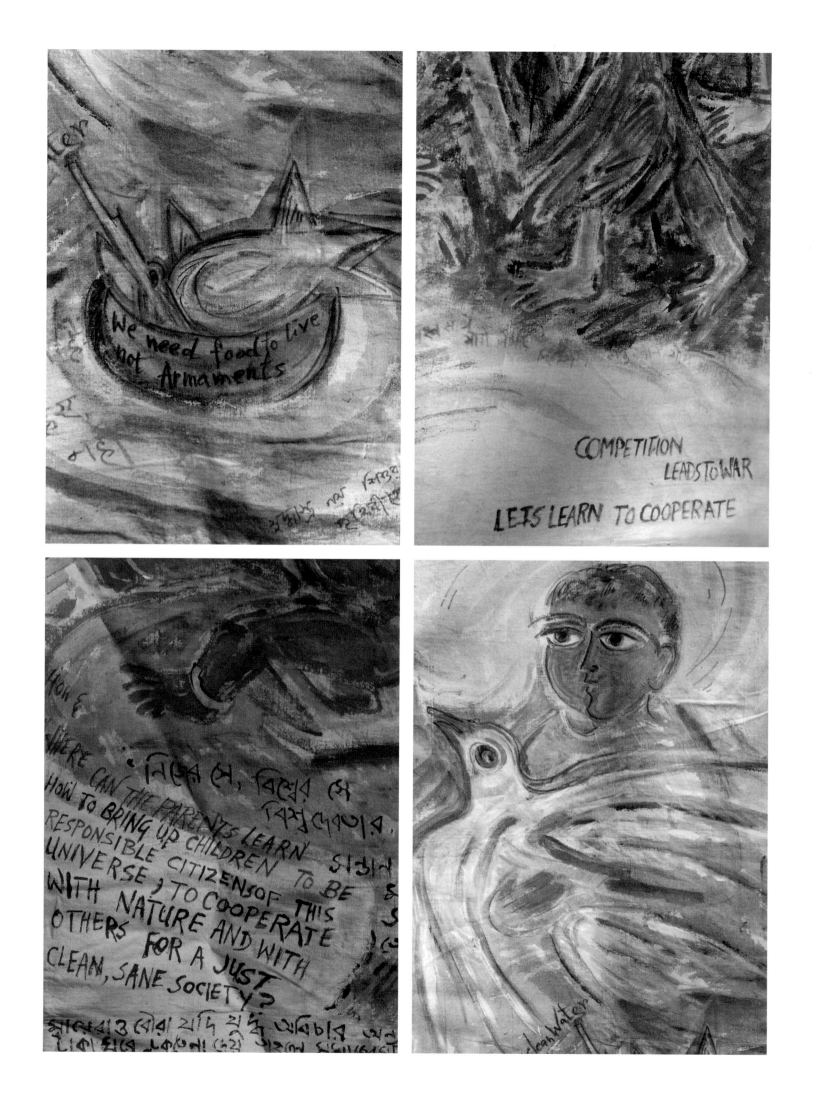

married and I have a grandson, also named Ananda, although I call him Tao. ...Now my son works for Greenpeace. So I guess his childhood exposure to peace activism and a non-competitive school life have had some influence upon him."

SHYAMALI BECAME GRADUALLY MORE AWARE of the dichotomy between the inherent self-reliance of rural people living in communities surrounding Santiniketan and their increasingly deprived condition. She resolved to try to make a difference. In response to the terrible floods and famine of 1995, she began working with others to encourage local villagers to dig deeper reservoirs near their homes, using the excavated earth to raise the level of their houses above the flood plain. She comments: "I really started believing that we can learn so much about survival from our rural people. How adaptable they are! They absorb so much and never complain. They have no freedoms and so much is imposed upon them in the name of big business and government. All over the world it is like this. The villagers are the ones who are feeding us. We cannot survive without them. But we are not giving them the credit they deserve. We do not acknowledge our debt or our responsibility. In a free country, they don't have a voice. Just now it seems that people everywhere think that they have no voice. Who will listen to them? Is this what we call a democracy?"

TODAY, SHYAMALI IS ATTENDING A TRIBAL FESTIVAL. Arthritis in her knees has grown worse in the last few years and she needs a ride to reach the remote village. There, she is welcomed excitedly by all the tribal villagers. She has helped them receive recognition from the local government, has worked to improve their living conditions, and is clearly beloved by them. While watching the games and dances of the children, she talks animatedly with tribal leaders, listening closely to their concerns and giving friendly, encouraging advice. Shyamali comments: "Living in Santiniketan, my self-imposed freedom is lost. I enjoy living quietly, but too often I am invited to do all these things and I cannot say no. It is like I live in this huge extended family... The reality (of the ways that humanity deals with suffering) is not very present when I am here (in Santiniketan). But when I go to a remote village and see the children being happy and playful in spite of the hard life, I feel a lot more optimistic and less afraid. We must develop creativity among the children and remind ourselves all the time that we are only part of the nature around us. We must not destroy it!"

LATER IN THE AFTERNOON, Shyamali visits a local arts fair where she hangs her provocative "posters" on a tree and pulls out well-sculpted marionettes with which to entice the crowds. One is a Native American chief, in whose voice she tells the story of a similar destruction of ancient lands and resources in a continent far away. The other is Mother Earth, who admonishes the crowd to start paying attention to the way in which they treat her children: her forests and rivers, her mountains and plains. Shyamali captivates her audience. She lives now as she has always lived: listening to her inner voice and acting with integrity to understand her interconnectedness with everything and to honour her responsibility to the rest of existence.

One of the proudest actions in Shyamali's life was her subpoena of Jimmy Carter and David Rockefeller, among others, for their involvement in the Trilateral Commission that supported the Trident nuclear submarine base near Seattle.

SONABAI Beautifying Her Isolation

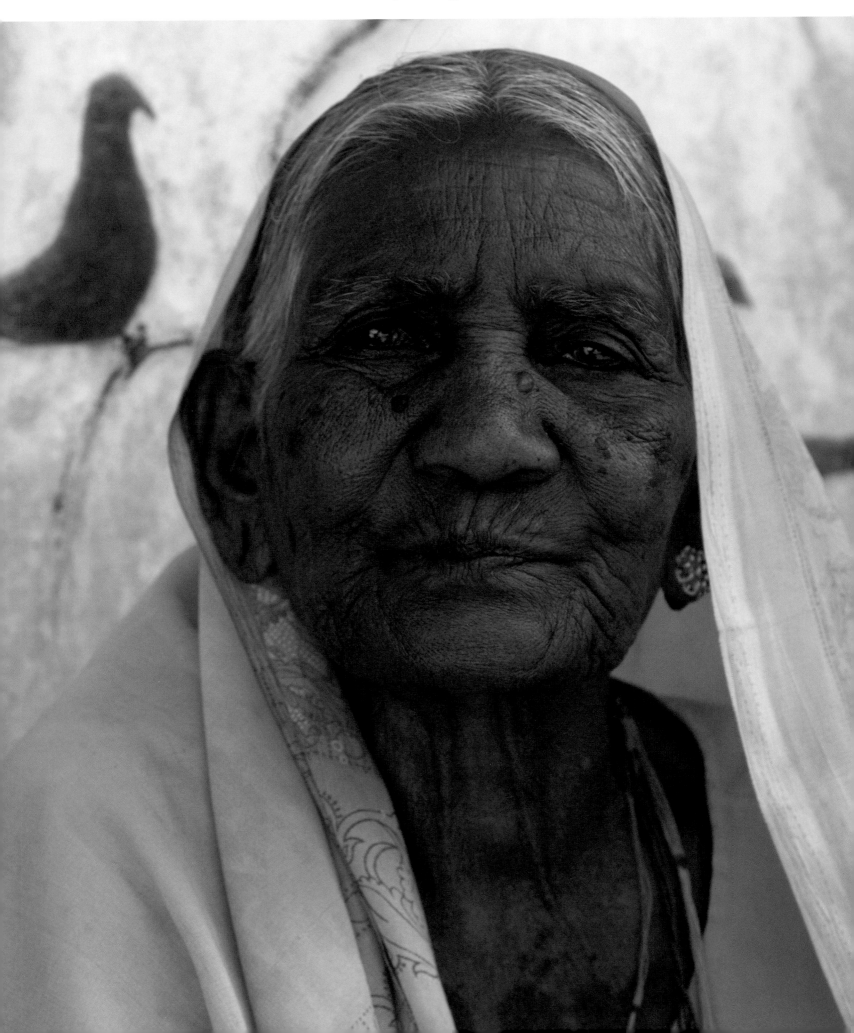

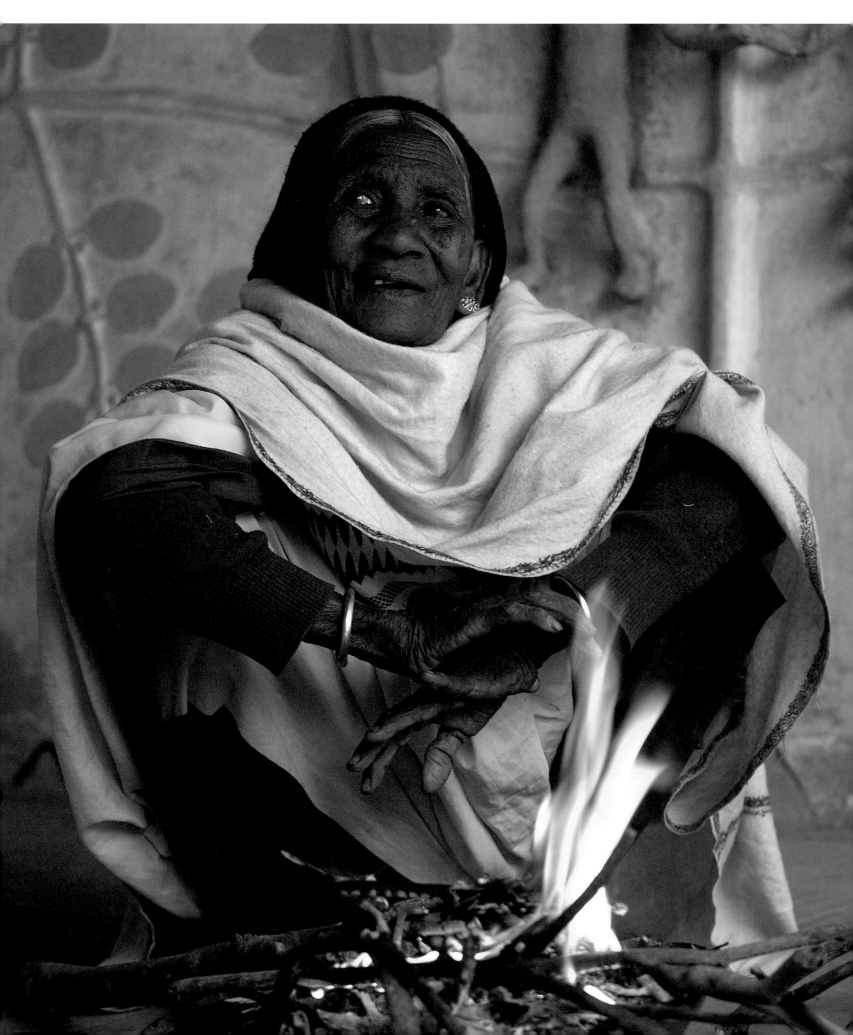

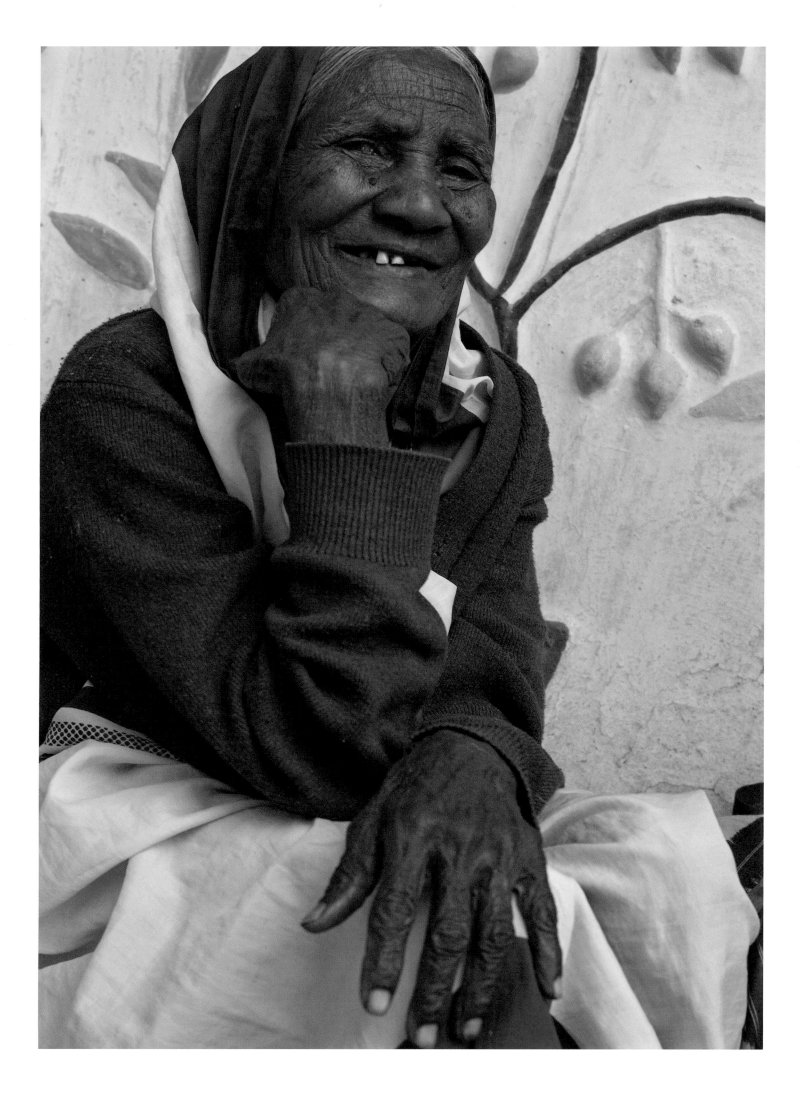

SONABAI

"When Babu, my son, was just three months old, my husband moved us to a new house. It was far outside the village, by itself in the fields. He did not want me to go outside, to meet anyone. I lived like that for many years."

SONABAI RAJAWAR LIVED IN TOTAL ISOLATION for 15 years, allowed to see only her young son and her husband. She had been raised as a child in the usual Indian large extended family with sisters and brothers, cousins, parents, aunts, uncles and grandparents all living in the same house. She played with her friends in the jungle surrounding her village; she visited the market with her mother and sisters; she enjoyed the many Hindu festivals that were celebrated each year. Her parents arranged for her to marry Holi Ram, a widower and farmer who was many years her senior. Sonabai states: "I was grown up, but I don't remember exactly how old, maybe 14 or 15, when we were married." For the first two years, the newlyweds lived in his elder brother's house with a large family of 13. As the youngest bride, she was required to do all the cooking and most of the chores. "We were crowded there, so when my husband said that we would move to our own house, I was happy. Then Holi Ram advised me not to go outside... It was very lonely, just Babu and I."

WHEN SONABAI WAS YOUNG, long before Indian Independence, all adult women in her community wore veils when they were in public. This symbol of modesty was a legacy of earlier Muslim influence throughout much of Northern and Central India. But the practise of *purdah* that forced Muslim women to live isolated from all males except those of their immediate families was never adopted by Hindus in the region where Sonabai lived. (In any case, Muslim women did not spend their lives alone, being surrounded by others of their own gender). Sonabai's situation was unique, the result of her husband's own peculiar psychosis. She remained within the walls of her home, able to experience the sun and the rain and to see the night sky only from the small square of her little interior courtyard. She had no one to talk to but her recalcitrant husband—no one to have fun with but her infant son.

"WHEN BABU WANTED TO PLAY, I had no toys for him," Sonabai says. "The house was new and there was clay lying around (from building the adobe walls). So I took some and made him some dolls. I found that I enjoyed making them and got the idea to put

PRECEDING PAGES, LEFT: Sonabai Rajawar lived in almost total isolation for the first 15 years of her marriage.

RIGHT: Now elderly, she reminisces about the hardship of her young married years and her unusual solution to her loneliness.

OPPOSITE: Kept within the confines of her remote rural house, she began to sculpt her walls with a variety of decorative forms.

187

SONABAI

some on my walls." Most human beings, when subjected to severe
isolation, are naturally depressed. If they are artists, they usually
express their moods darkly. But not Sonabai. Without any artistic
training and with no prototypes, Sonabai began to transform the
drab interior of her home, peopling her lonely world with
imagination and whimsy. The plan of her new house was typical of
the area and, indeed, much of traditional India. (A rectangular
central courtyard is encompassed by a veranda that leads into
various rooms: the kitchen, bedroom, storage rooms and barn). In
order to decorate her dwelling, Sonabai decided to fill in the spaces
between the supporting pillars of her veranda with latticework.
Although lattices (called *jali* in India) are common in Mughal and
Rajput monuments, none had ever been seen in Sonabai's
mountainous central Indian district. Sonabai is illiterate and was
never exposed to any books, postcards or prints. Her creative vision
came from within her own mind. Bamboo was plentiful in her
village, used for all sorts of construction and farming needs. In
order to create her *jali*, Sonabai shaved bamboo into strips, tied the
strips into circles and then bound the circles together to form a
grid. She fastened this grid between two pillars of her veranda and
then used clay dug right from the floor of her courtyard to cover
each bamboo strip. She remarks: "To entertain my son, I started
putting the dolls and animals I made for him in the *jali*. I liked this
look and so I began to make them part of the *jali*." The result was
an organic latticework that she decorated with birds, snakes and
monkeys, painting the entire structure with pigments made from
vegetables, leaves and minerals she had in her kitchen.

WHEN SHE HAD SURROUNDED HER COURTYARD with *jali*, Sonabai began
adding bas-relief sculptures to some of the flat walls. Throughout
that region, women are taught to sculpt their walls, particularly
those around their front doors. But the designs they use are limited
to simple repetitive patterns, usually geometric. Sonabai had been
raised in this same tradition. She grew up in a village just a few
miles away from Puhputra, and the front door and courtyard walls
of her family's home had the simple ornamentation that was
virtually interchangeable with all the other houses. Sonabai
invented another new style. She built up figures by using twisted
rice straw as a base and covering them with clay. She created pots
of flowers, vines, a tree filled with monkeys, and a baseboard
pattern of fishes, birds and deer. Squatting musicians peered down
from under the eaves and a blue Krishna played his flute in a tree,

On a base of wrapped straw, Sonabai plasters clay that she sculpts to form the figures of animals and humans. She imbeds unwrapped hemp rope into the heads of her figures to make hair. She wraps bamboo shavings into circles that, when tied side-by-side, become the basis of elaborately sculpted lattices.

188

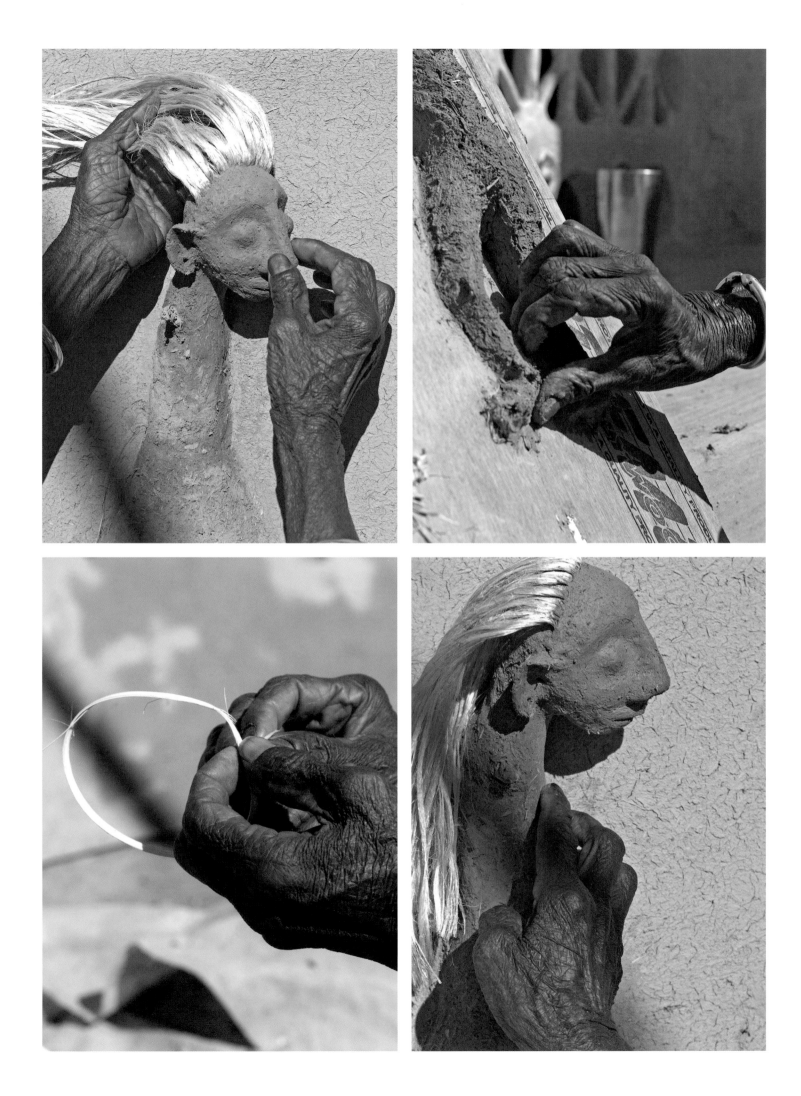

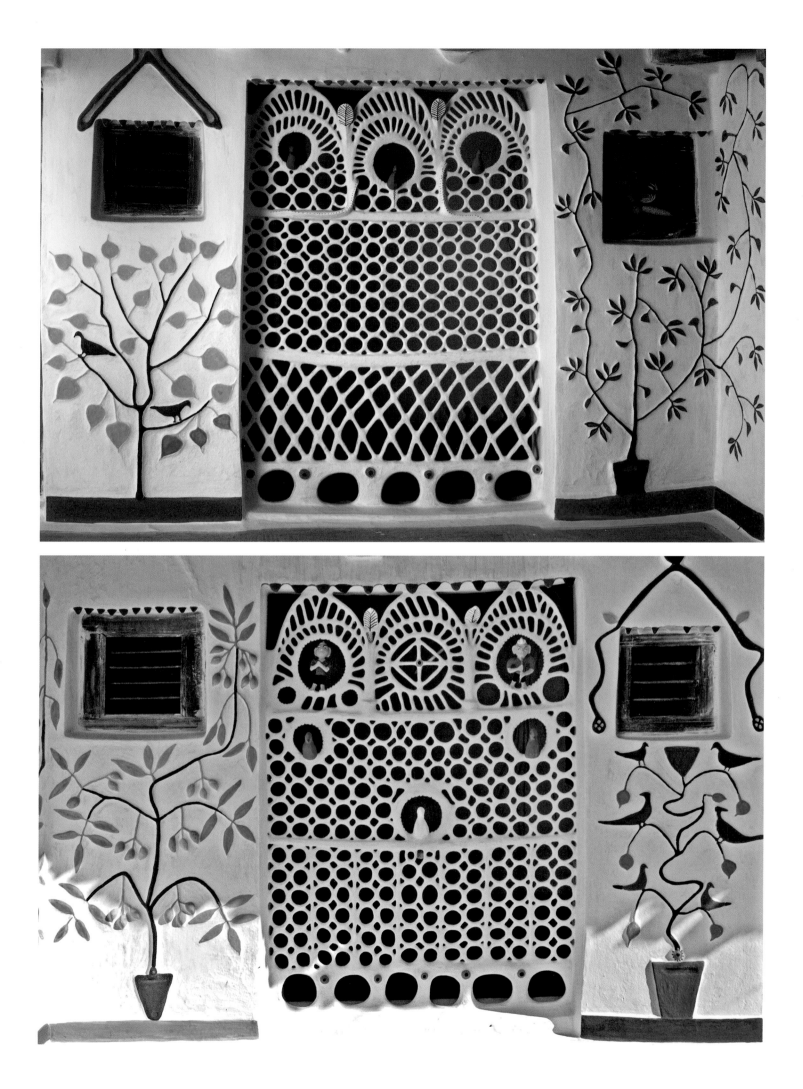

SONABAI

while maidens danced beneath. She even figured out how to make hair for her figures by untwisting hemp rope, sticking it into the wet clay, and then painting it with soot black when the clay was dry. The result of all her endeavours is an environment of colour, beauty and delight. Sonabai exhibits a natural sense of balance and form. Where another artist might cover every available inch with decoration, Sonabai instinctively understands the power of negative space. Although her home is filled with her art, it is not overpowering. She is truly a masterful artist.

WHEN ASKED HOW HOLI RAM, HER HUSBAND, responded to the transformation of their home, Sonabai states: "He really didn't notice. He didn't care what I did as long as I stayed inside and took care of the house and our son... I had many duties and had to prepare all the food. I could do these decorations when I had the time to."

FOR SOME REASON THAT SONABAI WILL NOT DISCLOSE, Holi Ram relinquished his demands of her solitude after 15 years, and gradually Sonabai was able to meet other villagers. A consequence of her enforced isolation, however, is that Sonabai is still very shy and withdrawn. She prefers to remain in her home with her family. But when her neighbours were allowed access to her house, they were amazed by the unusual decorations they found there. "People going by would stop and see my house. Other people would hear about it and, when they visited the village, would come see my house and praise my work." In the early 1980s, when Sonabai was already in her fifties, an innovative folk art museum was founded in Bhopal, at that time the capital city of their state. Scouts were sent to survey Central India and document all the arts and crafts that they found. In 1983, one such scout heard of Sonabai and visited her home. He was astounded by what he discovered and returned soon afterwards with his superiors from the museum and a professional photographer. Sonabai states: "They came here and wanted to take my walls. I told them that they are attached and cannot be moved, but they brought with them a large saw and took one of my *jali*s away with them. They also asked me to make other panels for them and returned for these some months later, when they were completed... When my husband understood that so many people were interested in my art and that there was money to be made, he was very excited. He encouraged Babu and me to make more pieces."

Two views of the inside walls of Sonabai's house portray her remarkable artistic embellishments. Sonabai was not trained as an artist: all of her creations were self-taught inspirations. Note the parrots, the winding serpents and the horn players that she has used to decorate the lattices that separate the pillars of her courtyard.

191

SONABAI

SONABAI'S PANELS AND *JALIS* startled the Indian art world with their innovation and received immediate critical acclaim. Remarkably, Sonabai was given the President's Award for Art (the Rashtrapati Purushkar) in 1985, one of the highest recognitions that any artist in India can receive! She was requested to come to Delhi to receive her honour, but Sonabai refused. She was a shy woman who had spent years in isolation. In the intervening years she had never even travelled the 25 kilometres (15 miles) to the nearest large town. Delhi is several hundred kilometres away and the award ceremony would entail large crowds and publicity. The trip seemed far too daunting to her. The President of India, however, would not accept Sonabai's refusal and he directed that the local district official command her presence in Delhi. Sonabai reluctantly acquiesced, travelling to the nation's capital with her son, Babu (Daroga Ram), who was in his thirties. "I had to accompany Mother; she would not go. Even after getting that letter we were afraid to go, but the District Magistrate… convinced us that we would have no difficulty or problems in Delhi… They showed us around Delhi, including the Crafts Museum and all the important sites in the city and important works of art. We stayed at the Lodhi Hotel (a fine establishment)."

SONABAI AND DAROGA RAM WERE RELIEVED to come home to Puhputra. "When I was in Delhi," she states, "I saw so many things and when I returned I started to use new colours in my work." Whereas the palette of Sonabai's work was previously natural vegetal and mineral colours, she now purchased poster paints in the market and her work became an explosion of bright colours. There was little call for her art in her farming village and Sonabai returned to her normal life of caring for her family. But just the next year she received another request. Sonabai was invited to San Diego, California, to demonstrate her art at an exhibition of Indian terracotta at Mingei International Museum. Again she tried to refuse, but the decision was taken out of her hands.

These are details of Sonabai's sculptures, clockwise from above left: participants in a harvest dance; a horn player; a monkey eating berries in a tree; and the God Krishna playing his flute.

IN APRIL, 1996, SONABAI AND HER SON boarded a jet bound for London and southern California! They travelled to San Diego with a facilitator/translator and a potter and his wife from Kachchh, Gujarat. For two months, the five Indians lived together in a modern tract house provided for them by the museum. Daroga Ram recalls how fascinating it was to shop at the local supermarket with such a huge selection of packaged food. Every day except Monday, Sonabai and her son went to the museum and, while in the public's

192

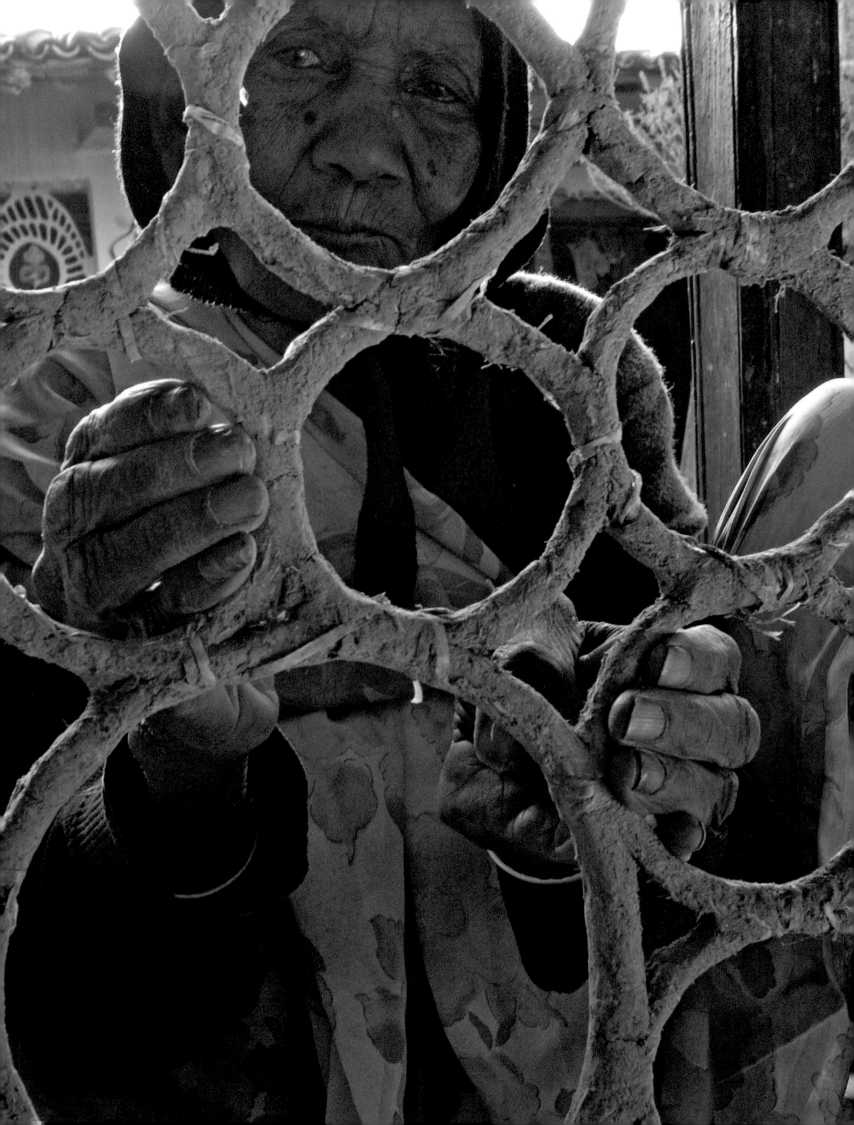

SONABAI

view, sculpted panels, *jali*s and figures. Sonabai records that many visitors intimidated her, but Daroga Ram enjoyed his interactions with them. On their free days, they were taken down to Tijuana and up to Disneyland; the latter was so completely alien to Sonabai that she no longer remembers it.

UPON THEIR RETURN HOME, Sonabai and Daroga Ram again gladly re-entered their world of farming, with occasional commissions for sculptures. In 1991 and 1996, the government awarded Sonabai stipends to teach her techniques to other artists. Most of these artists no longer practise her style, but several have continued to create innovative bas-reliefs and three-dimensional sculptures that derive from "the school of Sonabai." Sonabai, with Daroga Ram as her assistant, has returned to Delhi several times to sculpt for the National Crafts Museum and has travelled elsewhere in India for specific commissions. They have journeyed overseas one more time, in 1999, to exhibit their work in Queensland, Australia.

SONABAI IS NOW OLD. Her arthritis is bad and she seems to suffer from high blood pressure. Often, her thoughts are not clear and most days she just sits in the corner of her courtyard watching her grandchildren and great-grandson. Daroga Ram, other members of Sonabai's family, and several other artists in the area continue to produce art in the style she invented. Even though she never sought attention, Sonabai is aware of her artistic vision's remarkable effect. She states: "When I started I had no idea anyone would be interested in this. (Inspiration) just comes automatically to my mind; I don't know how exactly. It just comes. And then I sculpt… I do not know why so many people come to me, why they always want me to leave my home and travel. But they like my art and that makes me feel good." Through her initial determination to beautify her desolate existence, Sonabai Rajawar has created a legacy that has affected people throughout the world and is changing the lives and economy of many in her community.

Sonabai creates lattice by adding clay to a framework composed of circles made of bamboo strips.

FOLLOWING PAGES: Sonabai no longer lives in isolation. She dotes on her son's family that now lives with her. Here, she watches her youngest grandson, Pradeep, as he plays with a new toy.

195

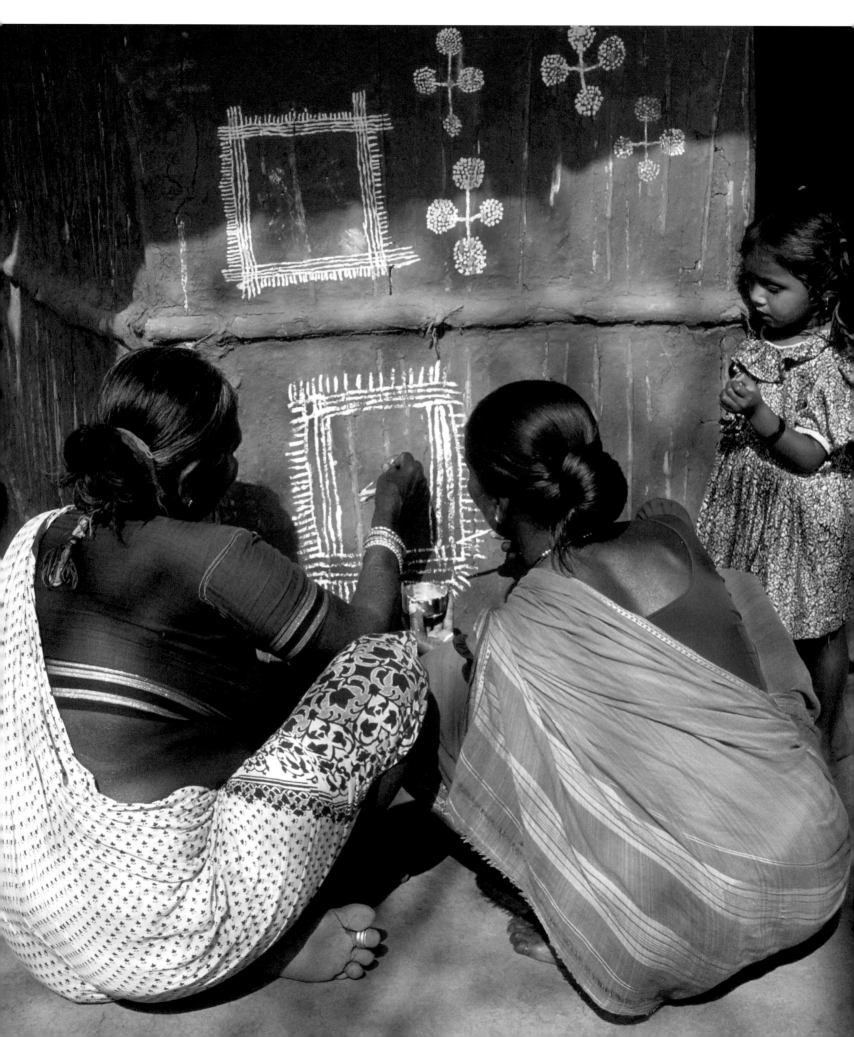

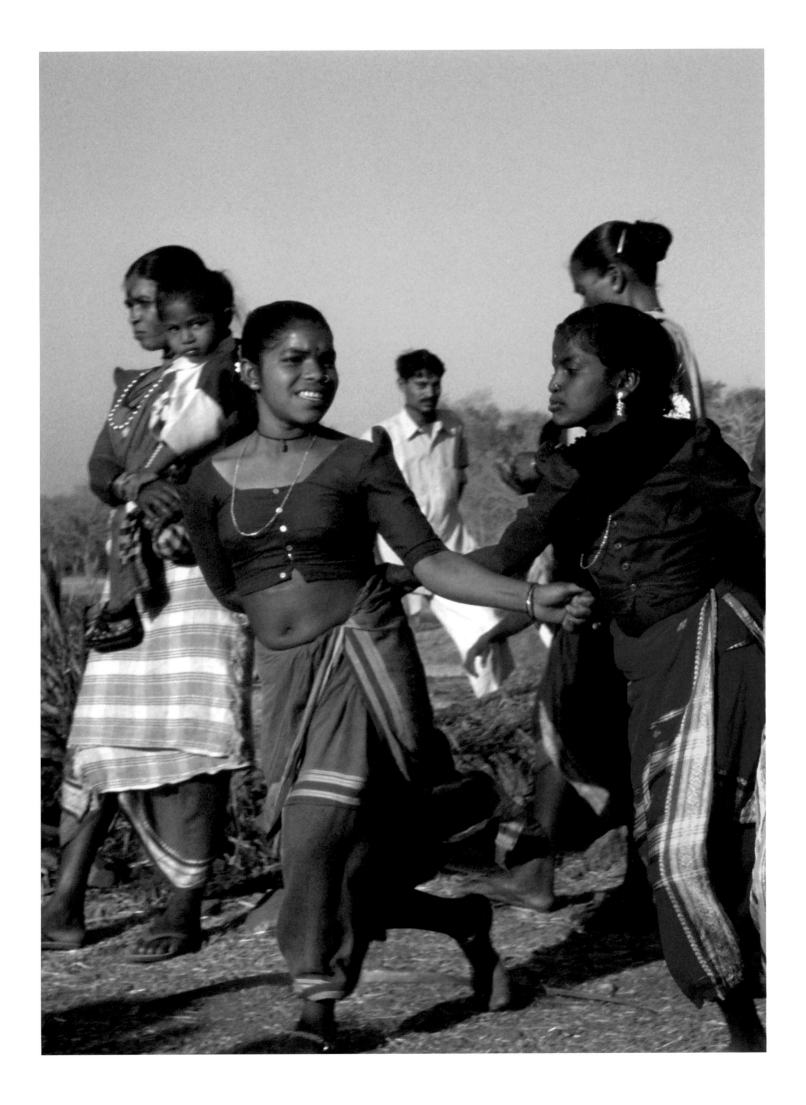

LARKU

"After this marriage, will Raghunath continue to treat me well? Will I be able to give him the son he wants? My mother, my father, so many people want this. How can we even feed a family with so much trouble around us? If I have a baby, will he even live?"

SO MANY QUESTIONS AND NO REAL ANSWERS. Larku is apprehensive. Frankly, she is scared. Around her, the wedding festivities are noisy and clamourous, as they have been for days. She wonders when it will all be over. Her future looms before her and holds innumerable unknowns, and yet she is so exhausted with the intense concentration of the past several days that she cannot think straight. She feels overwhelmed with fears.

FROM UNDER THE ELABORATE TINSEL and coloured paper veil that covers her face, Larku peers out into the crowd. This is the last time in her life that she will live in her parents' home. She feels some pangs of loss, although she also senses that she is lucky. Her groom Raghunath's house, into which they will move in just a few hours, is only on the other side of her small village. She has known him all her life. Some of her friends married men that they had hardly met and then had to move away to their husbands' villages. That situation is standard in most Indian communities, but Larku and Raghunath belong to the Warli, a tribe whose hereditary language, belief system, and social organization differ from those of mainstream Hindus. The tribal peoples of India (accounting for just eight per cent of the population) are direct descendants from India's earliest inhabitants and many, like the Warli, have remained isolated from the numerous invasions and cultural adaptations that have affected mainstream India for many millennia. Nevertheless, contemporary influences in the latter 20th century have created enormous changes among the Warli and, at a brief glance, they might seem no different from other farmers in coastal western India. It is only during the time of celebrations such as festivals or this marriage that the unique tribal ceremonies are obvious.

MANY TRIBAL CUSTOMS CONTRADICT the popular Indian norm. Some are illegal. Although Indian law states that it is unlawful for girls to marry before the age of 18 and boys before 21, Larku is only 14 and Raghunath is 18. This situation is not uncommon among the Warli and some girls marry even younger. When asked, Larku says shyly: "My father and mother have arranged it. I like him. It is my duty to marry." Years ago, the Warlis were matrilineal: property and

PRECEDING PAGES, LEFT: Larku is just 14 years old. It is her wedding day and she is terrified of what lies ahead.

RIGHT: Larku's mother and aunt are both *Savasini*s, women painters belonging to the Warli tribe who create the ritual marriage diagrams on household walls.

OPPOSITE: At Larku's wedding, her entire tribal village joins in several days of celebration, music and dance.

position were inherited through the female line. Although this social order has changed, men continue to pay a "bride price" (some money, livestock and desirable possessions). More common in India is the system of dowry, in which the family of the bride often goes into crippling debt in order to give the groom expensive presents and large sums of money. Warli women are still respected for their strength and forthrightness. It is common, however, for Warli men to have more than one wife, even though it is strictly illegal throughout India. Larku's own mother is the only wife of her father and Larku is not sure how she would feel if Raghunath took a second wife. Warli women are only allowed one husband, but separation and remarriage are easily arranged if the new man is willing to repay the first husband his "bride price."

THE ENTIRE WEDDING IS STILL GOVERNED by women's rituals. The function officially begins when selected women, known for their artistic skills, come to the bride's house to paint. These painters, called *Savasinis*, must be married themselves. The Warli believe that the symbols and images that they will paint on the walls have a sacred power that is too fertile for virgins and un-remarried widows to handle. Larku's own mother is a *Savasini*, and Larku has accompanied her all her life when she has gone to other homes to paint the ritual marriage designs. It looks so simple, but Larku does not yet know whether or not she will be a good painter herself. One of her unsettling questions is if, in the future, there will even be a demand for her to paint.

OVER THE PAST 30 YEARS, the entire position and status of *Savasinis* has changed among the Warli. The events that caused these changes are remarkable. In the early 1970s, a stranger photographed Warli marriage paintings and showed the pictures to art entrepreneurs in the national capital of New Delhi. The government-run Handicrafts and Handlooms Board then sent a representative to the Warli villages and asked some women to paint on paper. The results were considered so good that they were exhibited and publicized. Next, a travelling art patron noticed that one young Warli man, a farmer named Jivya Soma Mashe, had great talent. Jivya Soma was also given paper and paint. He rapidly developed his own distinct style of art based in part upon Warli women's traditional designs but enhanced by his own creative innovations. Where marriage paintings portrayed relatively rigid sacred motifs, such as tribal deities and symbols, Jivya Soma

Most of the paintings that the *Savasinis* make are very simple: squares that represent temples and various trees and flowers.

202

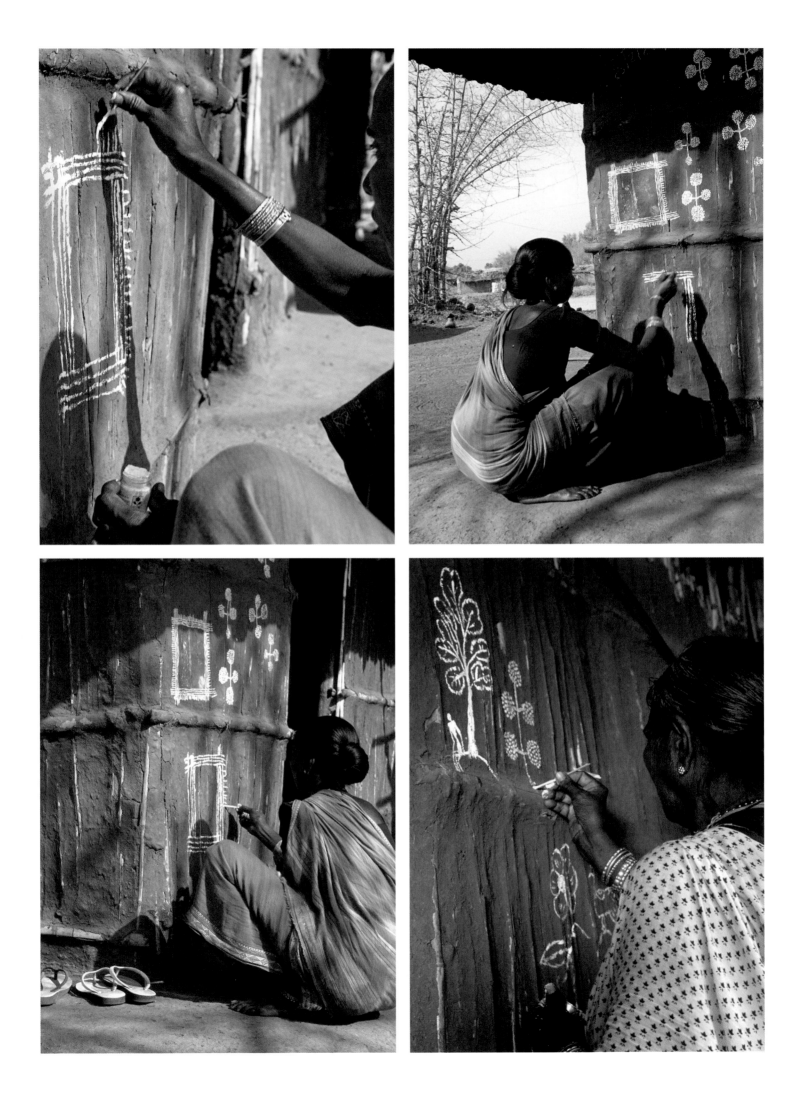

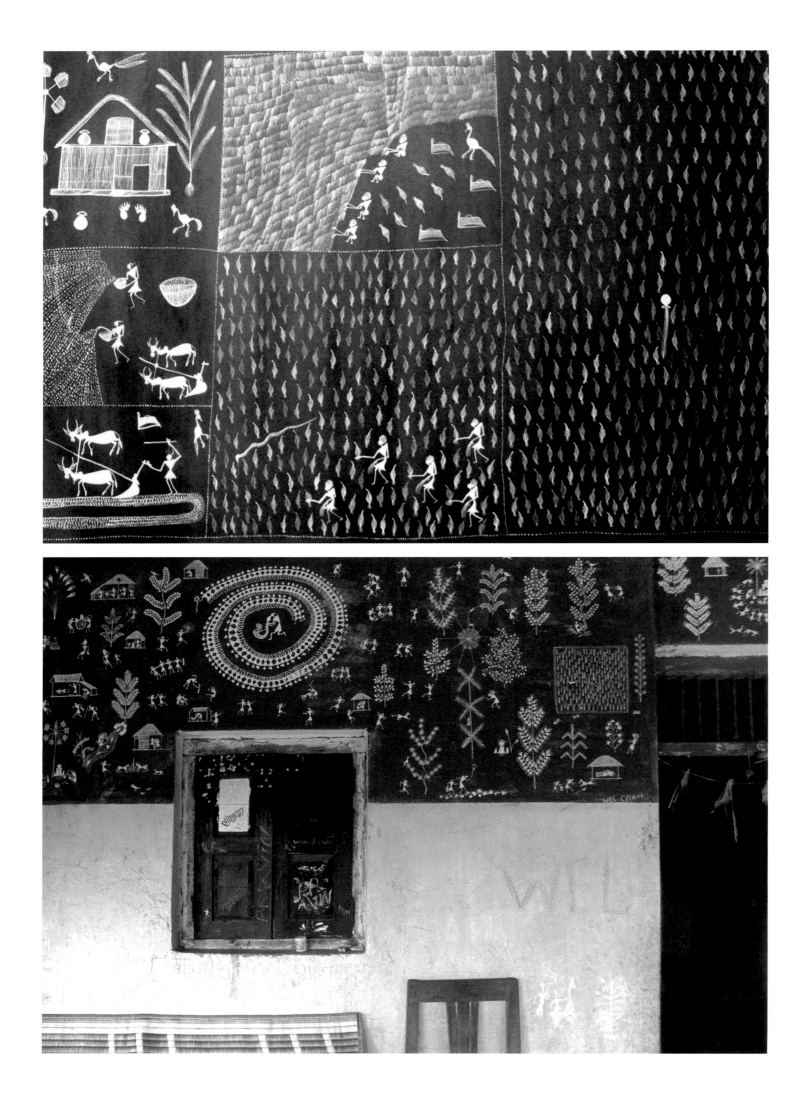

delighted in depicting his own conceptual genre scenes of farming, dancing, fishing, and households, all illustrated with abundant and luxurious plant and animal forms. He quickly developed into a brilliant artist whose paintings are sold throughout India and abroad. Jivya Soma Mashe single-handedly brought international attention to the Warli through his distinctive style of art that his sons, nephews and other male Warlis throughout the district also began to produce.

NO LONGER WERE THE WOMEN ARTISTS ASKED TO PAINT on paper. Now, this male-generated genre of painting is even affecting those created for Warli weddings. It is increasingly popular to ask male professional artists rather than traditional *Savasini*s to come to the marriage home to paint the walls. Ironically, these male painters need not be married themselves. Fewer and fewer women are learning to paint. Most defer to the men. Sami, a *Savasini*, commented: "These men are getting so much money for their paintings. This (income) has been changing many people's lives.

Jivya Soma is truly a fine folk painter and his work is deserving of praise. But the very existence of this male artistry threatens the future art of the *Savasini*'s.

OPPOSITE: Traditional paintings were solely the province of women. In the early 1970s, a male Warli, Jivya Soma Mashe, was given paper and paints and encouraged to develop his own style of art based upon the *Savasini* paintings. His artworks and those of other male Warlis have become popular throughout India. At the top is one of his paintings on paper, while below are the walls of Jivya Soma's own house.

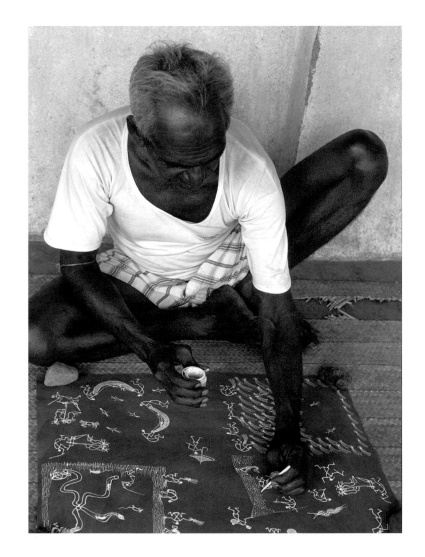

LARKU

They are very good at it. Why should we also paint any more when they are so good?" This tragic situation underlines a serious problem that is beginning to affect many Indian women. Either the men have grown to depend entirely upon their women's skills to provide their principal source of income, or they commandeer for themselves that which has been created naturally and lovingly by women, drawing credit to themselves and altering the production to meet the needs of a broader market. The patriarchal influence is so entrenched that women are taught to accept and even feel good about this transformation, losing in the process their own heritage and means of creative expression.

NEVERTHELESS, SOME OF THE *SAVASINIS* STILL PAINT for weddings. Larku's mother created the intricate ritual paintings for this special occasion. Using a crushed stick for a brush and rice paste as pigment, she drew the large square shrine to contain the image of Palaghata, the Warli Goddess of fertility and abundance. Inside this image she drew two representations of Panchashiriya, the male guardian deity astride his horse. Then she embellished these focal points with a few simple decorative touches. When she was finished, the *Dhavaleri* (the tribal priestess who is the principal officiant at all Warli marriages) began to conduct her ritual of consecration, singing the power of the Goddess and God into the paintings to be present in the ceremony and thereby blessing the new couple. Although the Warli rituals of marriage are not long, the entire community celebrates for days. It is a time of heavy drinking of locally-brewed palm toddy wine. A band of contemporary musicians has been hired to play dance music and everyone gets involved. Most join in the long snaking shuffle dance of the Warli, while some dance separately in the style of Bollywood musicals. The feasting and drinking are continuous and all the while Larku must stay dressed in her elaborate wedding costume and fringed veil. Raghunath is so drunk he can hardly stand or speak. She is overcome with questions: "How soon will it all be over? When can my new life finally begin?" Larku's shyness and youthful inexperience are stressed by her new role as a subservient wife. She has no voice and no real choices for her future. Until this point, her life was decided by her father. From now on, she is subject to her husband's whims. Larku hopes Raghunath will be good to her and not beat her in the manner of many husbands. She prays that she will soon have a son to make him happy, but even that thought fills her with dread.

ABOVE: Warli boys and girls join in a vigorous line dance after the wedding.

BELOW : Larku and Raghunath are seated during their marriage ceremony. Raghunath is very drunk.

FOLLOWING PAGES: This fine example of a *Savasini*'s art depicts a stylized temple. In its centre is Palaghata, the Warli Goddess of fertility and abundance.

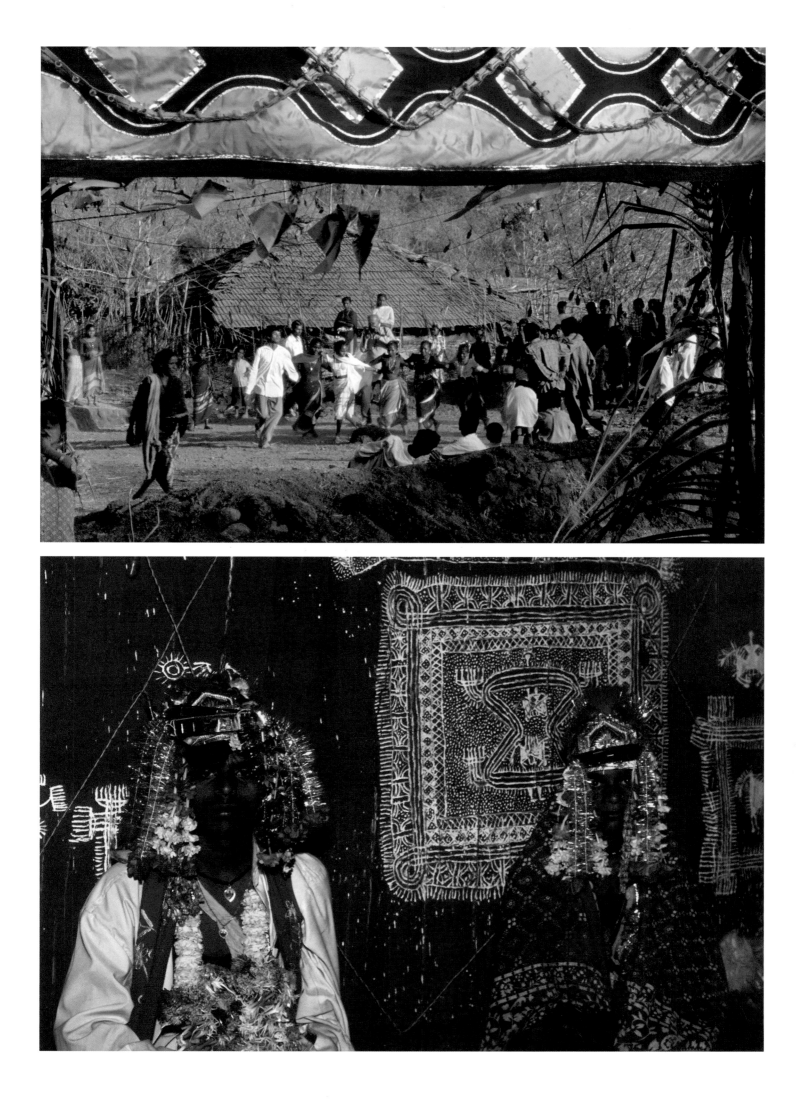

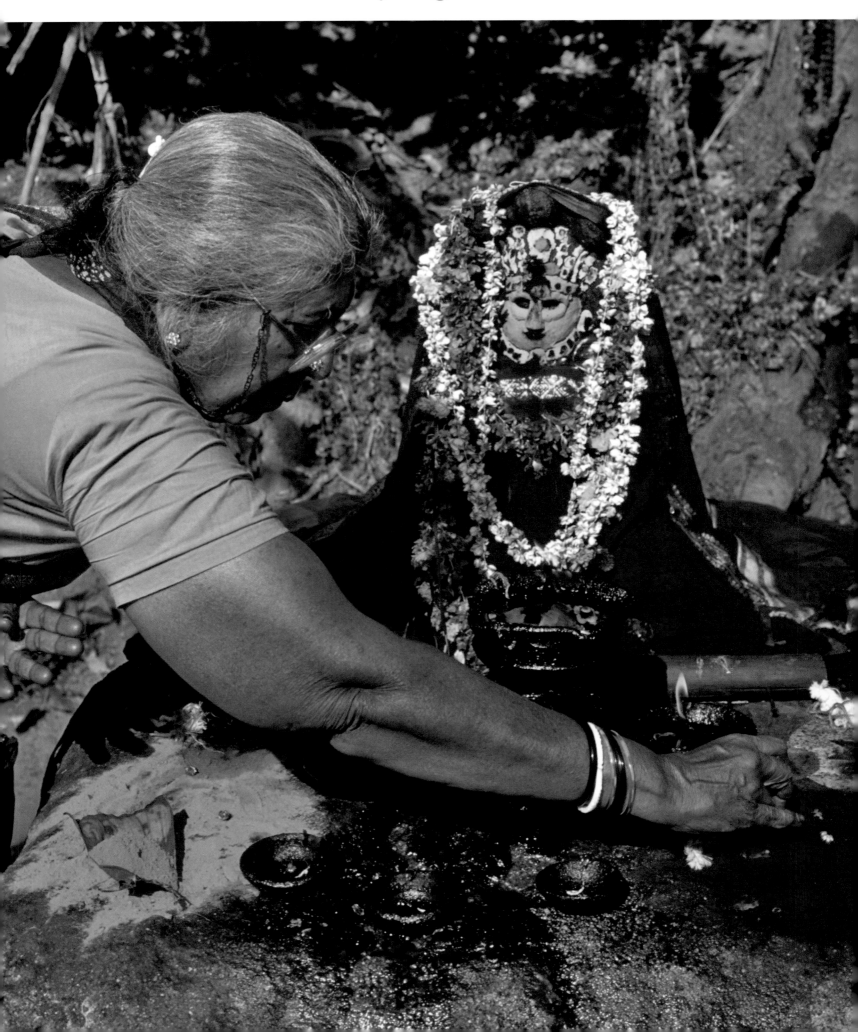

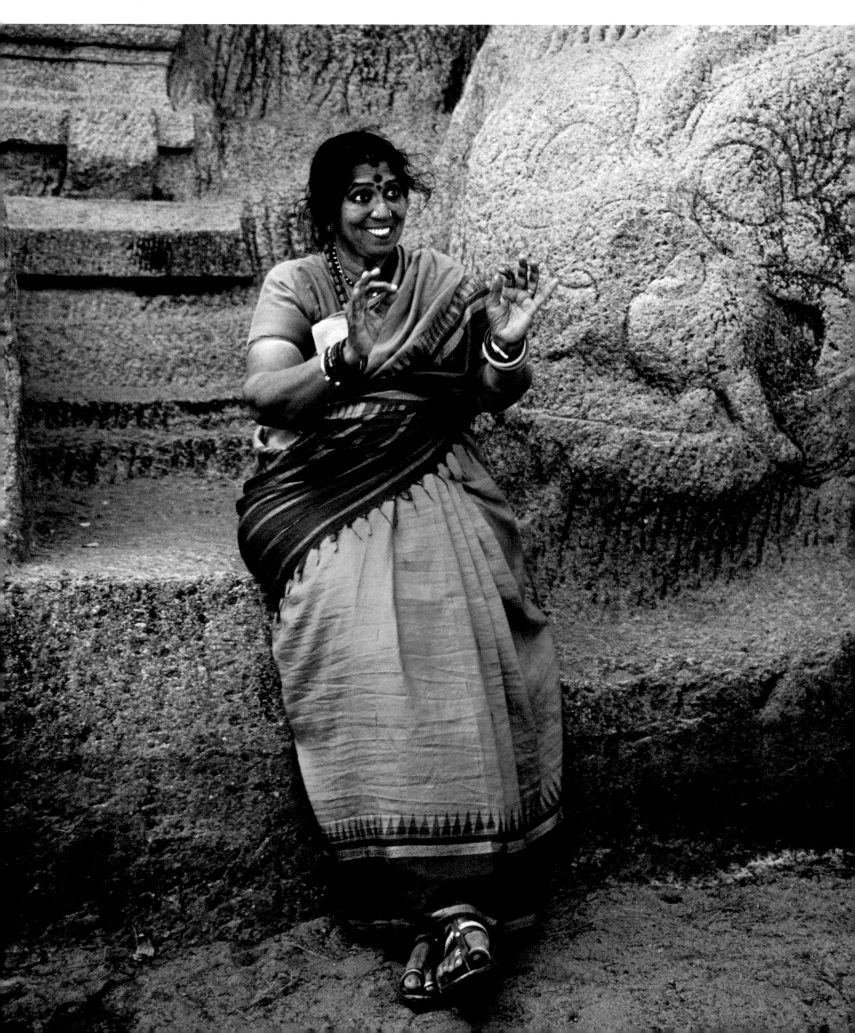

SUNITHI

"My puja (worship service) is my universe. My prayers give me balance and direction. It is my quiet time and whatever I am doing, however busy I am, I make sure that I have time to say my slokas (sacred verses). Even if I have to rise at 3:30 for an hour of prayers before an early morning departure, it is essential. Without it, my life would feel empty."

WHEREVER SHE TRAVELS, Sunithi carries her routine with her. Every morning, whether at home or on the road, she arises before the sun, drinks a cup of coffee, bathes, and dresses in a homespun sari (usually silk). She then marks her forehead and neck with vermillion to acknowledge her commitments to the chosen deity and sits down to pray for one solid hour. She recites a litany of prayers to those aspects of the Divine that she finds most compelling. Sunithi is very devout.

BY 6:45 THIS MORNING, she is reading the paper in a hotel restaurant as she waits for her tour to straggle out for breakfast. As her group members order and eat their bacon and eggs, Sunithi has another cup of coffee and entertains her guests with stories of Tamil domesticity. At 69, Sunithi Narayan is India's pre-eminent female tourist guide. Her international popularity is well deserved. Her knowledge of history, religion, culture and customs is consummate and her gifts for conveying that information captivating. Scholars from around the world seek her insights and advice. Foreign museums and university groups vie with one another to book her guiding services. She has received great acclaim for her lectures to professional audiences overseas. Sunithi seems indefatigable. She is a born teacher who radiates her fascination with and love for life.

AFTER BREAKFAST, the group of 17 late-middle-aged Americans gathers in a semicircle around the entrance to a small 9th-century granite temple. Sunithi has engaged the cooperation of a local priest to perform a *puja* to the supreme God Shiva. Many south Indian temples are closed to non-Hindus, and the tourists recognize how lucky they are to witness these rituals. As the priest lovingly washes the central image of the God, Sunithi draws a *kolam* (sacred design) with rice flour on the steps up into the sanctum. Then, while he dresses the stone icon with a white cloth and adorns it with flowers, she accompanies him by singing a hymn, her beautiful high voice echoing from the stone chamber.

PRECEDING PAGES, LEFT: Sunithi is deeply religious. Here she reaches in front of an icon of the Goddess Bhadra Devi to take some blessed vermillion for the dot on her forehead and the part in her hair.

RIGHT: Sunithi is a gifted storyteller who brings to life the tales and legends of Hindu Gods and Goddesses.

OPPOSITE: She is one of India's finest guides whose excitement with Indian history and culture is contagious.

213

SUNITHI

As the priest re-emerges, lights his flame and chants his prayers, Sunithi lucidly and gracefully describes each aspect of the ceremony as it takes place. The entire experience is enchanting.

A SHORT BUS RIDE DELIVERS THE GROUP to the edge of the monolithic stone monuments for which Mahabalipuram is so famous. Carved in the 7th century from a series of huge granite boulders, some of the monuments are caves transformed into pillared and ornamented temples. Others are free-standing buildings that have been literally chiselled down from top to bottom. Sunithi's favourite, where her listeners are now standing, is the sculpted hillside that is generally called "The Descent of the Ganges." Sunithi remembers coming here when she was just a teenager with her father, a teacher of English literature. At that time, there were no roads connecting the tiny village of Mahabalipuram to the metropolis of Chennai (previously Madras) where she still lives. Her father hired a boat to bring them overnight down the long inland canals and arranged for them to camp by firelight in the ancient caves. Now the site is one of India's most frequently visited tourist spots. Thousands arrive daily by bus, and the place is overrun with hawkers selling film, postcards and every imaginable craft.

FOR SUNITHI, THE MAGNIFICENT CARVINGS still hold an alluring charm. She enraptures her audience with her stories, explaining each subtle nuance of the remarkable sculptures with the tenderness of an old friend and the animation of a lover. The entire facade portrays scenes of the banks of the Ganges River, and Sunithi points out how Hindus bathe there and then pray to the sun. "Look at that man whose feet are immersed while he is facing the sun. Can you see that? And the other one who is just stepping out of the water. Look at the little bend of his knee as he finishes his ablutions. And the third one has a pitcher of water on his shoulder and a fourth man is ringing out his washed garment. Notice how the water thickens the base of the garment as gravity pulls it down. You can feel the weight of the water. Even today, if you go visit the Ganges in Varanasi, you'll see people like this washing and praying. In early times, along the banks, there were a number of *ashram*s (hermitages) in which the sages lived with their disciples. See that one sitting in meditation with his disciples at his feet? Whenever there are real saints, there is peace all around. Look at those deer lying there

Just before a Brahmin priest begins his worship of the God Shiva, Sunithi draws a simple *kolam* on the front step of this ancient temple.

214

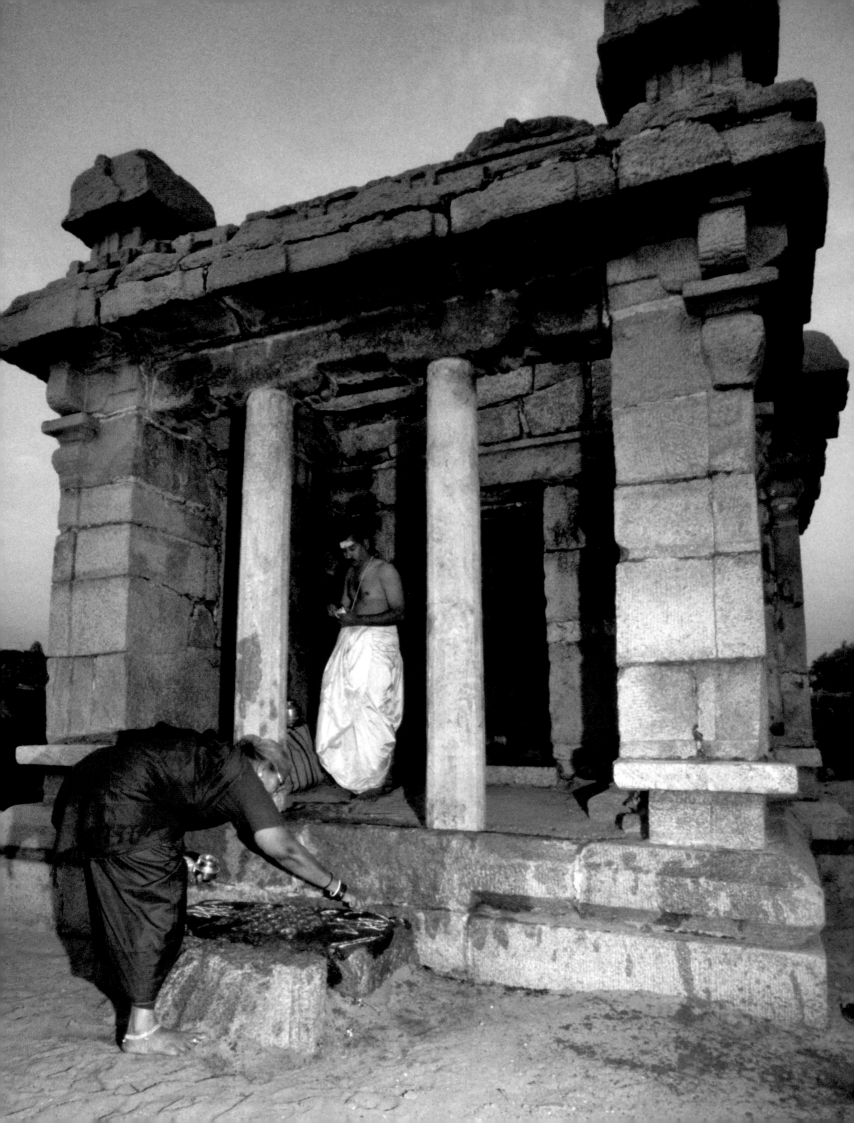

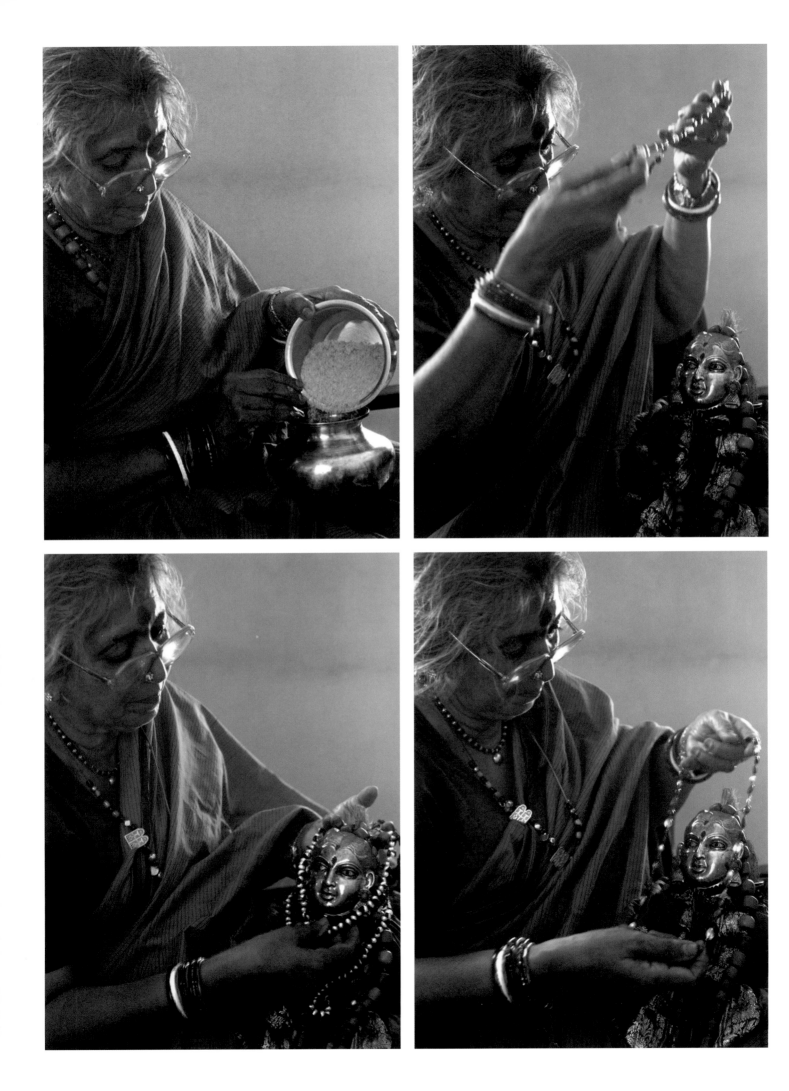

happily, one scratching his nose, while above them is a wild animal crouching. The artist is showing them living together in harmony... When we look at these beautifully-proportioned chiselled figures, it makes us wonder. Since these are our earliest examples of granite sculpture, how could these artists perfect the figures? It's a logical question. And the answer is that these artists were not novices. They were trained sculptors who worked on softer material with greater detail. So when they were commissioned to work on the hard granite, they eliminated all the decoration—and just the simple lines necessary to give a form to the figures were adapted." In this way, Sunithi excitedly draws the group's attention from one sculpture to the next, her words bringing the ancient stone to life.

NOW IT IS TIME TO CLIMB ON THE BUS for their last journey together. Two weeks of travel throughout Tamil Nadu with Sunithi are almost at an end. She is taking them to the airport in Chennai. The farewells are always as full of tears for Sunithi as they are for the tour members. She has a great capacity for deep empathy and builds relationships easily. Everyone on Sunithi's tours feels like her special friend. As the empty bus takes her into the city and back to her home, Sunithi has a chance to reflect on her life. It has been unusual, to say the least. She was born into a traditional Brahmin family. (Brahmins are the highest caste of priests and teachers and are particularly conservative in South India.) She was married at a young age to Krishna, a banker, and they had two children: a boy and a girl. But as much as Sunithi adored her family, she also loved three other things: learning, teaching and adventure. Sunithi broke with centuries of rigid tradition when, as a young housewife, she began training to be a government guide. Fifty years ago, Tamil Brahmin women did not work outside the home, did not converse with people of a lower caste (particularly foreigners) and did not travel without their husbands. Sunithi became India's first official female government guide and she excels at her work. She discovered that she had great acumen for learning and assimilating facts and she developed adept skills as a storyteller. She is still constantly learning new stories, new findings from research and new approaches to old material. She delights in enticing her clients into fresh points of view about India, particularly those jaded travellers who have stopped perceiving the beauty that surrounds them.

In preparation for worship of the Goddess Lakshmi in her own home, Sunithi first fills a silver vessel with rice and other offerings. She then puts a silver face of the Goddess on the neck of the pot, dresses Her in festive silk, and takes jewellery from her own neck to adorn the image.

217

SUNITHI

SUNITHI IS A MODERN URBAN WOMAN, a product of the 20th century, who is nevertheless immersed in her traditions. As soon as she reaches home, she drops off her suitcase and heads for her favourite neighbourhood spot: the Kapaleshwara Temple in Mylapore. During the past two weeks she has missed having her daily *darshan*s (moments of personal communion) with the holy icon of Shiva here. She loves all the activities and rituals of the temple. By participating in them, Sunithi feels linked to the countless generations of her ancestors who have worshipped here before her. She believes that her personal relationship with the divine underpins all her actions and decisions. In a life of travel and change, it is her primary foundation.

WITH HER *PUJA* COMPLETE, Sunithi exits through the enormous carved stone gateway of the temple and flags down an autorickshaw to take her home. Her husband, Krishna, now retired from the bank, has been taking care of things while she was away. He is remarkably supportive of her progressive choices and they have a warm and loving relationship. In a situation rare for an Indian male, Krishna often took care of their two children while Sunithi was travelling with her groups. She taught him to cook well and now that both of their offspring have moved away to raise children of their own, he is often home alone. They are glad to be reunited and Sunithi immediately begins to prepare an elaborate dinner for him. Back here, in their city home of almost 50 years, surrounded by the neighbours she knows so well, Sunithi is content. In her final act of the day, she lights a flame in her small kitchen shrine to thank the Gods for their many blessings to her.

Finally, Sunithi places garlands of flowers upon the Goddess before carrying Her to the shrine in the background to invoke and worship. All the while, her husband, Krishna, watches television in the background.

218

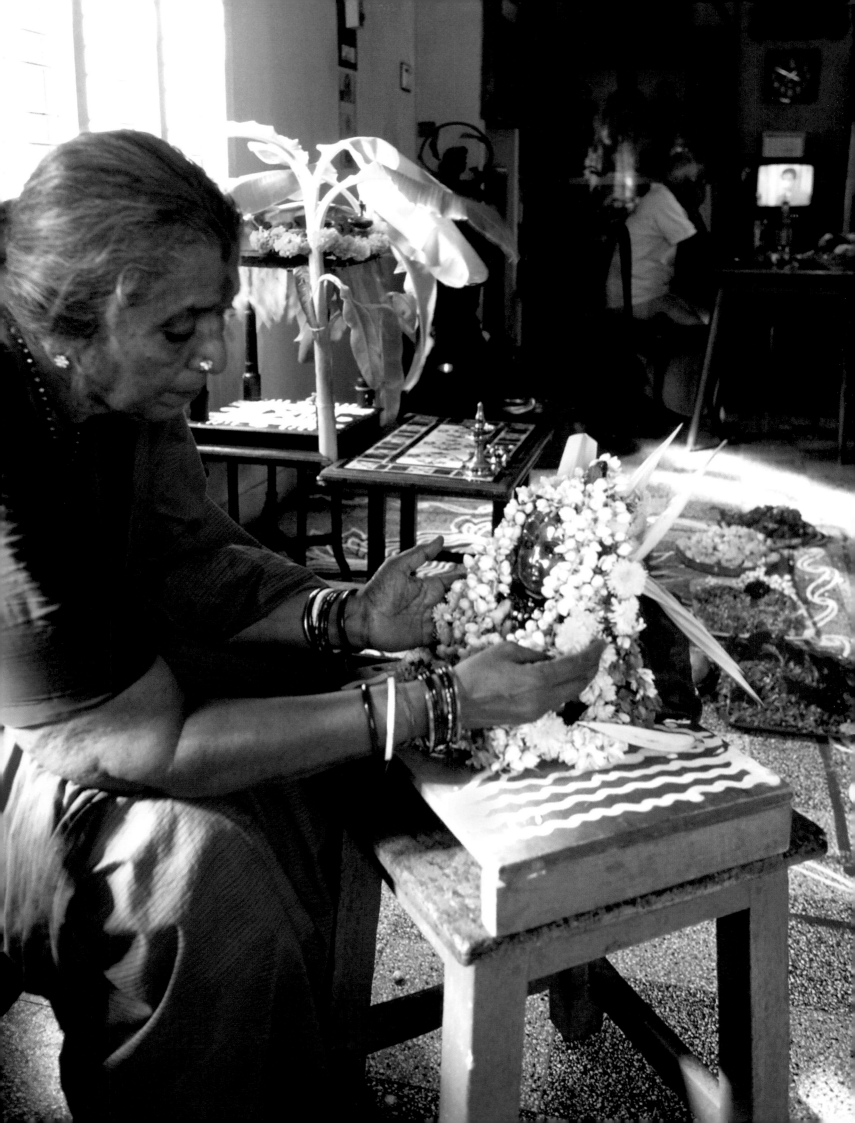

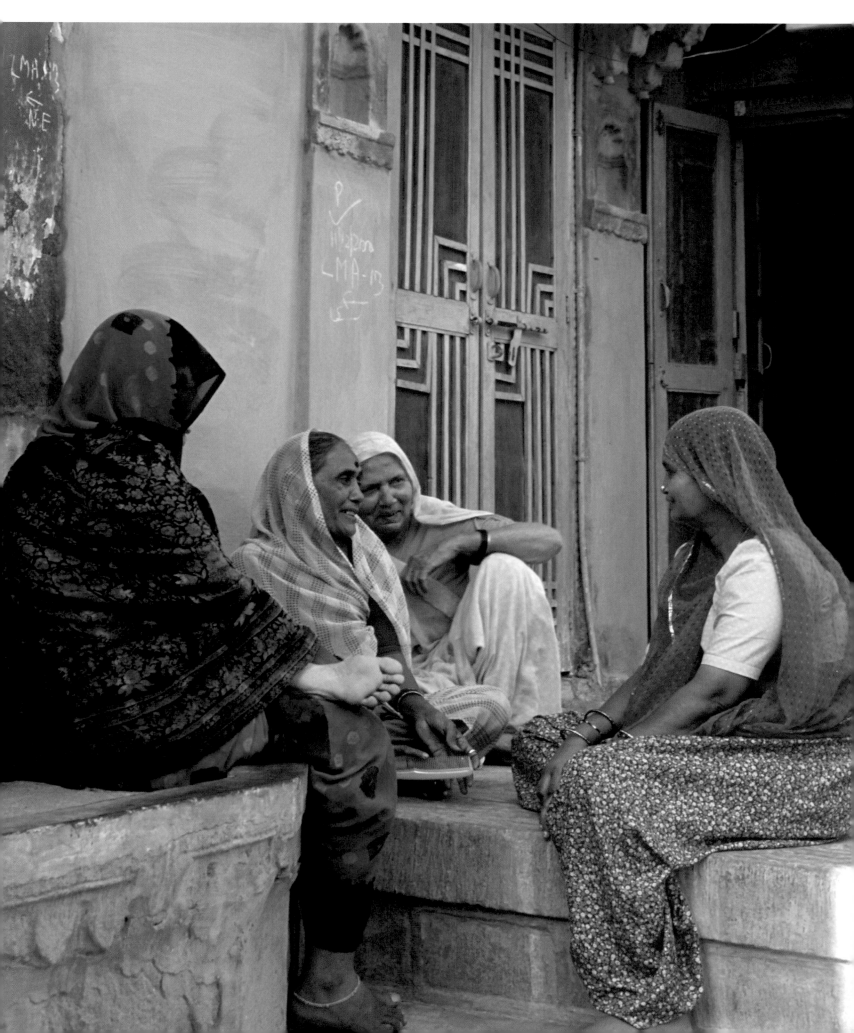

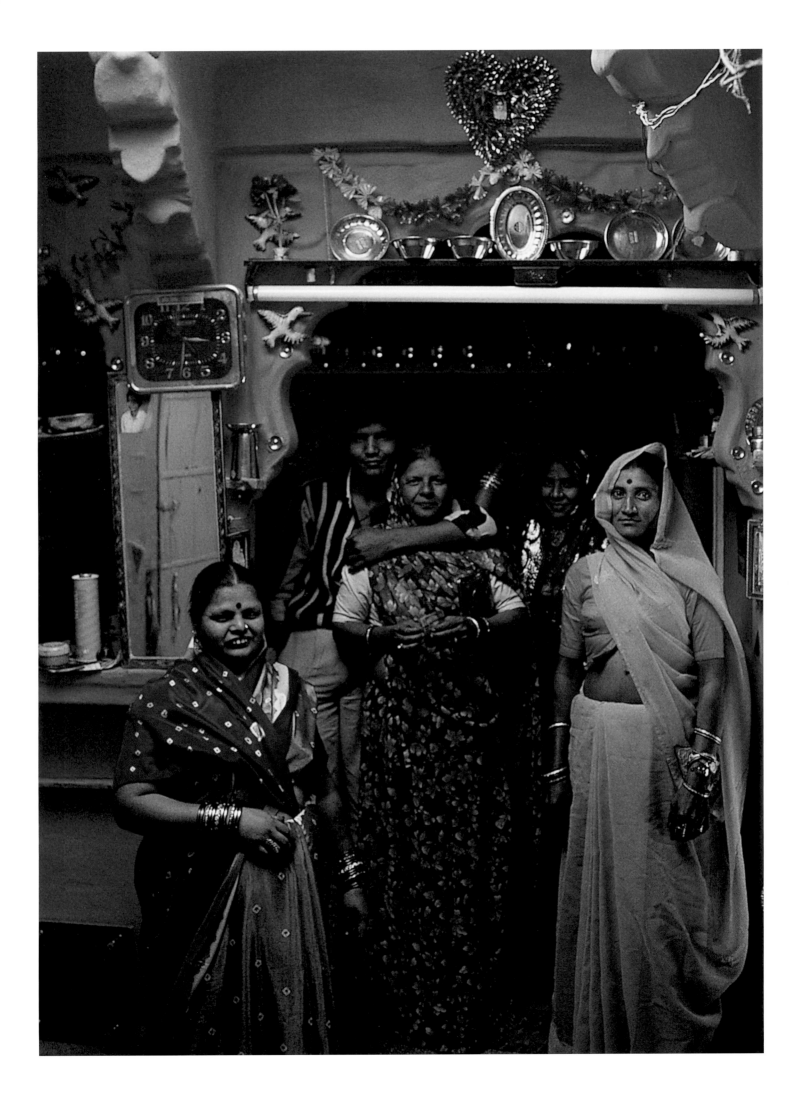

ROOPA

"I enjoy this Holi. The children are so happy. Everyone is. Everything is different for this one day. Look at those colours! It will take some time before things return to normal, but what fun it is today! And the afternoon bhajan, it should be good. Why don't you come along and see?"

THE CHILDREN HAVE AWAKENED HER EARLY this morning. Usually, Roopa is the first one in the household to get up, in the twilight before sunrise, to start the milk heating for tea and to cajole Arjun and little Mitra to arise. Now it is still very dark, but the two children can hardly contain their excitement, prodding her urgently to help them prepare for this special holiday. Today is Holi, the annual spring festival, a time of great frivolity and joy. Roopa gladly demurs to their requests, even though she knows that it will be some time before the full activities begin.

AS IS COMMON IN BRAHMPURI, a section of the western Indian city of Jodhpur, the entire house—inside and out—is decorated in bright primary blue. Up until 40 years ago, the walls of Brahmpuri houses were always painted white. Local legend states that decades ago one woman mixed too much blueing in with her whitewash and liked the effect. Her blue house provoked the envy of her neighbours and, one after the other, the colour of each home was changed. Although this story might contain some truth, it is also a fact that this particular shade of blue is a statement of Brahmin identity that proclaims the Hindu solidarity of this sector of the city. Along with her neighbours, Roopa painted all her walls a few months ago in preparation for another festival, Diwali. The house itself was built of local stone in the 18th century by the ancestors of Roopa's in-laws. It has been adapted and modernized during the past several decades to include running water, electricity, a modern kitchen, a television set, a telephone and even a computer.

AFTER RISING, WASHING AND DRESSING in clothes that she doesn't mind damaging, Roopa helps the children to fill with water two large plastic buckets and a couple of round brass pots. Then they sprinkle powdered dyes into each container, turning the water bright red, green, purple and blue. Finally, Arjun and Mitra fill large syringe-shaped pump tubes with the liquid (Arjun's red, Mitra's green). Admonished by Roopa not to spray inside, they rush up the stairs on to the roof terrace and animatedly begin to douse one another, and their mother, in colour.

PRECEDING PAGES, LEFT: Roopa, her son and a friend have all been sprayed with red and purple dyes during the spring festival of Holi.

RIGHT: Roopa, shown here wearing pink, meets regularly with her circle of women friends to discuss current events.

OPPOSITE: All the ancient stone buildings in this section of Jodhpur are painted primary blue, inside and out. Their architecture belies the fact that they are contemporary homes with televisions, VCRs, satellite dishes and computers.

ROOPA

HOLI IS A FESTIVAL when the normal customs of gender and societal restraints are relaxed. Women are more aggressive, children are demanding of their elders, subordinates are familiar and even commanding of their superiors, and everywhere the ingestion of cannabis and alcohol by adults is actively encouraged. While the children continue to cover themselves in their first layers of colour, Roopa descends to the kitchen to prepare their breakfast of tea, *rotis* (flat bread) and *aloo mutter* (potatoes and peas) and to awaken her husband, Dilip. Once he has bathed, she calls the children down and feeds all three, waiting to eat, as is the custom, until after they have finished. By this time it is light outside and already groups of children are beginning to assemble, cat-calling to one another to join in the fun. First Mitra and Arjun pull their father through the doorway and on to the street to spray him and then replenish their supply of coloured water before joining their young friends. Grinning in anticipation, Dilip stuffs a couple of bags of powdered dyes in his pockets and hurries to find his male buddies. Roopa, still dressed in her newly-hued cotton sari, carries a packet of brilliant green powder out into the street.

NORMALLY, LIFE IS RELATIVELY SUBDUED in the steep winding lanes lined with blue stone houses and arched doors and windows. Now, it is pandemonium. In a friendly, spontaneously joyous crowd, swarms of children are showering each other with colour. Men and women travel in separate groups, usually colouring only their own gender, although sometimes they intermix. In general, everyone is polite, even gentle with each other. The camaraderie of the community is tender and there is an atmosphere of tolerant good humour. Even the mischievous boy who runs along an adjacent rooftop to aim at unsuspecting grandmothers and lone passersby is benevolently excused.

ROOPA SEEKS OUT SEVERAL OF HER BEST FRIENDS. Some of the women live in adjacent houses and others live several streets away. The ritual is the same with each: first she sings out, "Happy Holi!" Then she asks if the friend wants to play, next she gives her a big, sustained hug, and finally she rubs her green powder over the other's hair, face, arms and legs. As each friend reciprocates in kind, Roopa is soon a patchwork of iridescent hues: her hair a mixture of pink, blue and green, her face streaked in red and her clothes a murky blend of the rainbow. She laughs so hard that she thinks she will burst.

Beginning early in the morning on Holi, Roopa's two children join their friends to douse each other in coloured dyes.

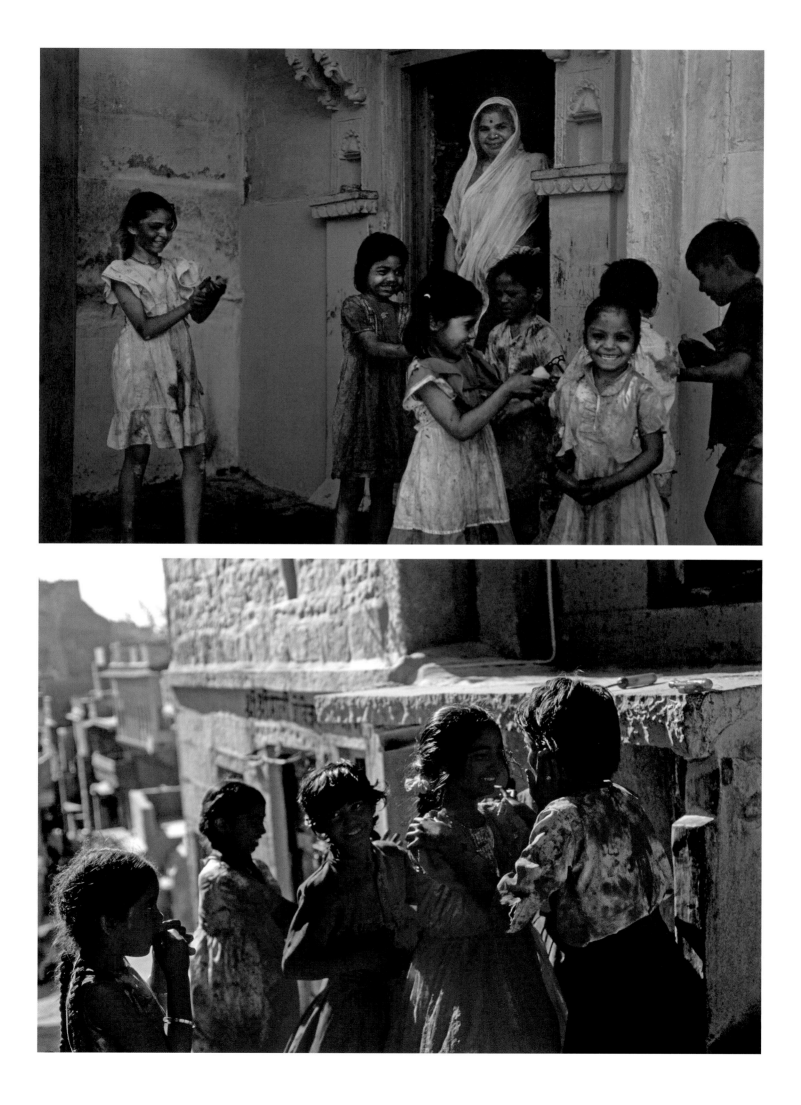

ROOPA

BY LATE MORNING, the frivolity begins to lessen. Everyone has already been coloured. Roopa returns to her house to bathe again and try to remove some of the dye. Even with assiduous scrubbing, it will take weeks before her hair and skin completely return to their natural state. Dilip comes back inebriated with *bhang* (a milk drink laced with hashish, specially prepared for this day.) He is jovial and tender towards her. He will sleep the afternoon away upstairs. The children will stay out most of the day with their friends, only returning to restock their supplies of dye.

ROOPA HAS BEEN LOOKING FORWARD to this afternoon all week. Although the legends and rituals surrounding Holi vary according to cultural tradition, Roopa and her family celebrate it in honour of Krishna, their favourite deity. Today, 12 women friends are coming over for a *bhajan*, a time of community hymn-singing. One brings a harmonium and another beats a small drum, while Roopa plays a tambourine. Together they sing songs written by some of India's best-loved poets—beautiful lyrics that praise Krishna and other Gods and Goddesses. Their heads sway as their feet and hands tap out the complex rhythms, their voices blending into crescendos of delight. For Roopa, this *bhajan* culminates a day of pure pleasure. As she says goodbye to her friends, she is ready to have a quiet evening with her family.

SO MANY THINGS HAVE CHANGED since Roopa was a child. Her own mother was raised behind the veil, in strict *purdah* (female segregation), never allowed to be seen by males outside the immediate family. The tradition of secluding females began in this area of India in the 12th century, influenced by the religious restrictions of the invading Muslims. The local Rajput culture has long been famous for its male-dominated chivalric society. Women traditionally worked hard too, but only within the confines of their homes. Although the 20th century brought new opportunities for them, it is still common everywhere in modern India for women to subjugate their own desires for those of their family. Women are extolled for their qualities of self-sacrifice. In times of poverty or great need, women typically go without food, medicines or comforts in deference to their husbands and male children.

ROOPA IS A CONTEMPORARY URBAN WOMAN. She attended high school and college before marrying Dilip, a boy that she had met in class. The only times she has worn a veil over her face were at her own

wedding and at various sacred rituals. Otherwise, she wears a chiffon scarf over her head, according to the current fashion. She considers herself her own woman, not her husband's chattel. Roopa uses her degree in education to teach primary school to neighbourhood children. She loves her work and the exposure it gives her to other families and to new ideas. She respects many of the traditions of her hereditary culture, but she also believes strongly in the right of women to participate in and even lead society. She states: "Our India is full of change. We are in a new century and a new millennium. We women no longer need to hide behind our veils. We are the strength of India and we are proving it in so many ways."

Once Roopa has bathed and changed later in the day, she joins her friends for an afternoon of hymns sung in praise of the deity, Lord Krishna.

FOLLOWING PAGES: Arjun and his friend stand on a roof to spray colours down onto passersby on the blue streets of Brahmpuri.

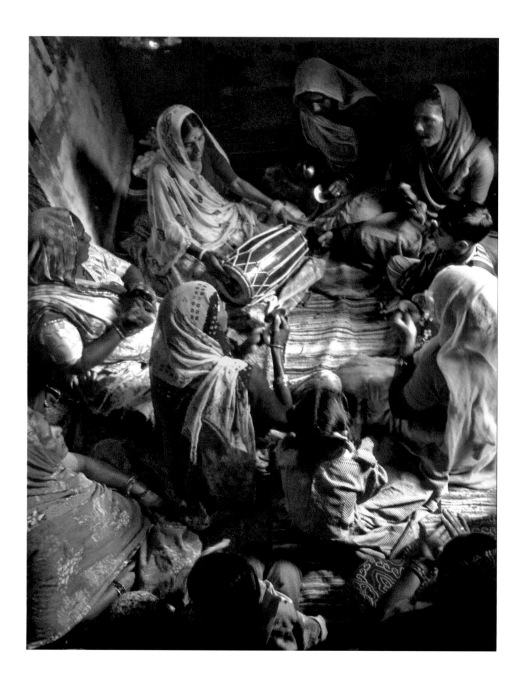

GIRIJA DEVI Managing the Family

GIRIJA DEVI

"It is not easy, running the household. There are so many responsibilities. But I have been trained for this my entire life. When I was just a young girl, my mother and grandmother taught me numbers by showing me how they kept the family accounts. They taught me reading and writing by making me recite the words of the many prayers and shlokas (sacred verses) used in our pujas (rituals of worship), and then by showing me the scriptures from which they came, requiring that I copy them out word for word."

WHILE OTHER CHILDREN PLAYED, little Girija Devi carefully ground spices and then was taught to blend them for her grandfather's various favourite dishes. Preparing the fire, learning the subtle arts of cooking, and cleaning the house were all essential parts of her education. She cared for the cows and water buffaloes, milked them daily, churned the milk for buttermilk and *ghee*, and learned the process of slowly condensing it to make the *malai* (cooked cream reduction) used for special sauces and sweets. By the time Girija was just 16, her parents had already betrothed her to Prashad, the eldest son of a landowner from another village, Singhpur. She met him first on their wedding day, when she left everything and everyone she had ever known to begin her new life as a bride in his mother's home. Forty-seven years later, she still lives in the same house—but now she is in charge.

WHEN SHE FIRST MOVED HERE AS A TEENAGE BRIDE, life seemed almost impossible. Not only did she have her new husband to get to know and learn to please, but she was introduced to an entire large extended family with 17 members living under the same roof! And to everyone she was a servant! She seemed to have no rights. Only the sweeper and the washerwoman, who came in from outside, were treated more roughly. Immediately upon her arrival she had to prove her merit by cooking for everyone, by cleaning up their messes, by washing the dishes and making their lives comfortable. Ruling everyone with an iron fist was Prashad's mother, the matriarch. She never smiled at Girija, never had a kind word for her, and never showed her any encouragement. Girija had no privacy whatsoever. She was always being watched and judged. The only time she had to herself was when everyone else was asleep, and then, curled up on her side in the room filled with other members of the family, she would softly, quietly, cry herself to sleep.

PRECEDING PAGES, LEFT: Girija Devi is the matriarch of her large extended family.

RIGHT: Her granddaughters join to draw elaborate *rangolis* (sacred designs) on a plinth in the courtyard of their house.

OPPOSITE: Aided by her grandchildren, Girija Devi shucks peas.

233

GIRIJA DEVI

HER POSITION BEGAN TO CHANGE when she had her first child, luckily a son. She had passed an important test and proved her essential fertility. The family line would continue. Rapidly, over the next several years, she bore four more sons and two daughters. They were such a joy to her and were an obvious source of pride for her parents-in-law. Gradually, she began to be treated with respect. As the wife of the matriarch's eldest son, she was now the second woman of the household. As Prashad's brothers began to marry, Girija had seniority: her sisters-in-law were secondary to her. She tried to make their lives easier than hers had been and even became close friends with one of the wives, but she always had to be conscious of her position and of the subtle diplomacies that kept the orders of succession appropriately defined. Then it was time to find husbands for her daughters and to arrange for their dowries. Luckily, her family essentially owned the entire village. Her husband and his brothers managed all the farmlands that surrounded it, the stone temple within it, and the huge annual festival that brought in pilgrims from hundreds of miles around. Even in drought years the family had enough. As her sons married and brought their wives into the large house, there was no longer room for Prashad's brothers and their families. Primogeniture governs the distribution of property in India. The secondary sons were forced to move into other houses in the village. Now only her parents-in-law were left and they were getting old. Shortly after Girija's first grandchild was born, Prashad's father died. His mother was now a widow, wearing the white garments of mourning, reduced to living in a small room by herself and no longer capable of voicing an opinion in household affairs. Thirty-six years after she first moved to Singhpur, Girija, now called by her proper name of Girija Devi, had become the matriarch.

LIFE IN AN EXTENDED INDIAN FAMILY IS COMPLEX. Almost all of Indian society is patriarchal and patrilineal: position and possessions pass from the eldest male to his eldest son. But the women of India have always been powerful. Hindu legends even record that the male Gods derive all their strength from the Goddess. Indians regularly state that the home is the centre of all society; in most cases, it is ruled by its dominant female, not by the man. Women make many of the major decisions for the family: they often choose whom their children will marry, and they usually govern the family finances. Girija Devi is definitely in charge. Without question, it has been a long upward battle to reach her present

The courtyard is the centre of all activity in the large house. In two of these photograph Girija Devi's granddaughters are engaged in painting. They are preparing the plinth beneath a planter that holds *tulsi*, a sacred basil bush. In the bottom right, Girija Devi and her daughters-in-law light incense and oil lamps and pray to the Goddess Lakshmi (incarnate within the *tulsi*) and to the God Vishnu (residing in the *salagrama*, or fossilized ammonite shell, at the base of the bush).

234

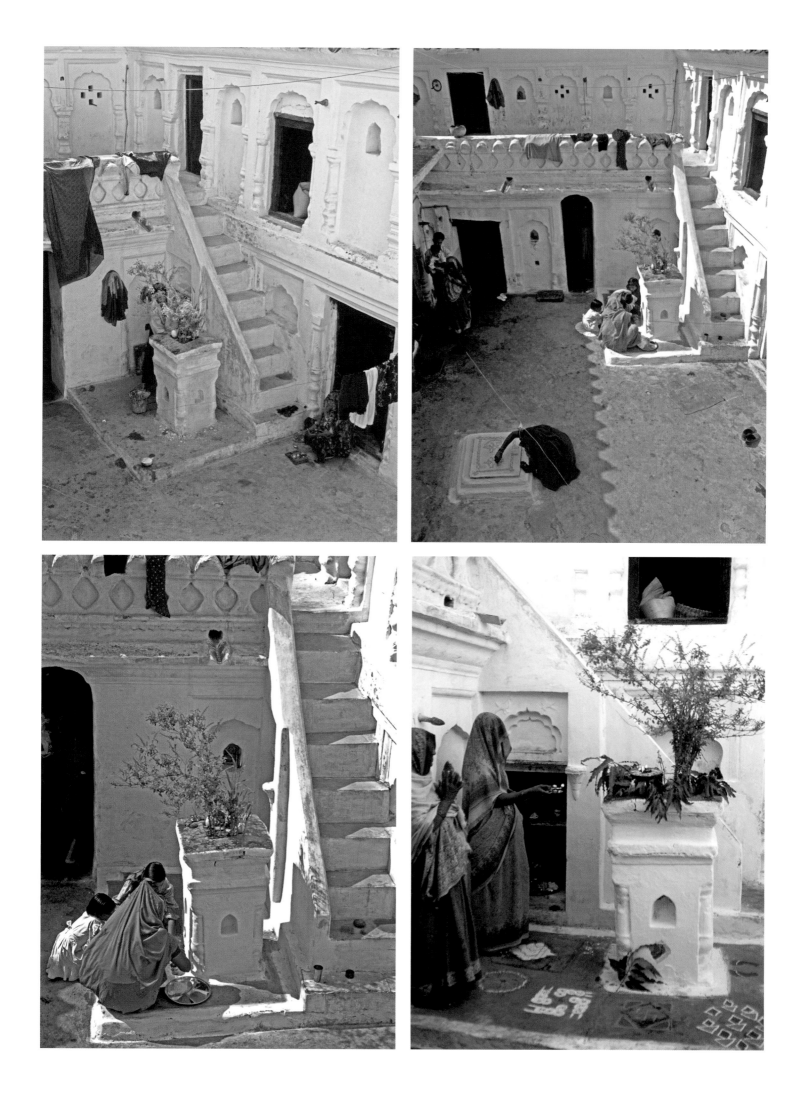

position, but now she rules the family. Not that her husband, Prashad, is ineffectual. Far from it: he is a strong-willed landowner, managing his farms with acuity and foresight, involved with village and district politics and influential in settling local disputes. But he respects his wife's insights into family matters. They discuss decisions between them and more often than not he acquiesces to her judgement.

NOW, FOUR OF GIRIJA DEVI'S SONS LIVE HERE in Singhpur with her. (One resides with his wife and family in the district headquarters of Chhattarpur). She rarely sees her daughters and their children. Living far away, they usually only visit once each year. But many of her grandchildren are here in the house with her and she loves interacting with them. Customs have greatly changed since she was a girl. They have a satellite dish, a television set, a VCR and even a computer with email! Their small village is far down a dirt road from the main highway, but it is hardly remote any more. Her granddaughters are interested in the latest fashions and in more modern marriages. Nevertheless, Girija Devi teaches them the old traditions. She comments: "I show them how to grind the spices and cook the way I was taught by my mother-in-law, recipes that have been passed down to me for generations in this family. They must never be forgotten!" The granddaughters milk the cows and churn by hand. She teaches them the intricate arts of sacred painting and of prayers to the household deities. "Each is learning the skills to run her own home when the time comes," Girija states. "Perhaps they will move far away to Delhi or Mumbai or Kolkata or even overseas—and in this modern world they may never have to run a household as large as this one, but still they should learn this management and responsibility." For Girija Devi, these qualities define the essential characteristics of a good woman.

Immersed in prayer, Girija Devi waves her offering plate in front of her deities.

FOLLOWING PAGES: As the major landowners of the village, the ancestors of Girija Devi's husband constructed a house intended to command the respect of the entire community. The ornamental architecture of this plastered brick structure is unique.

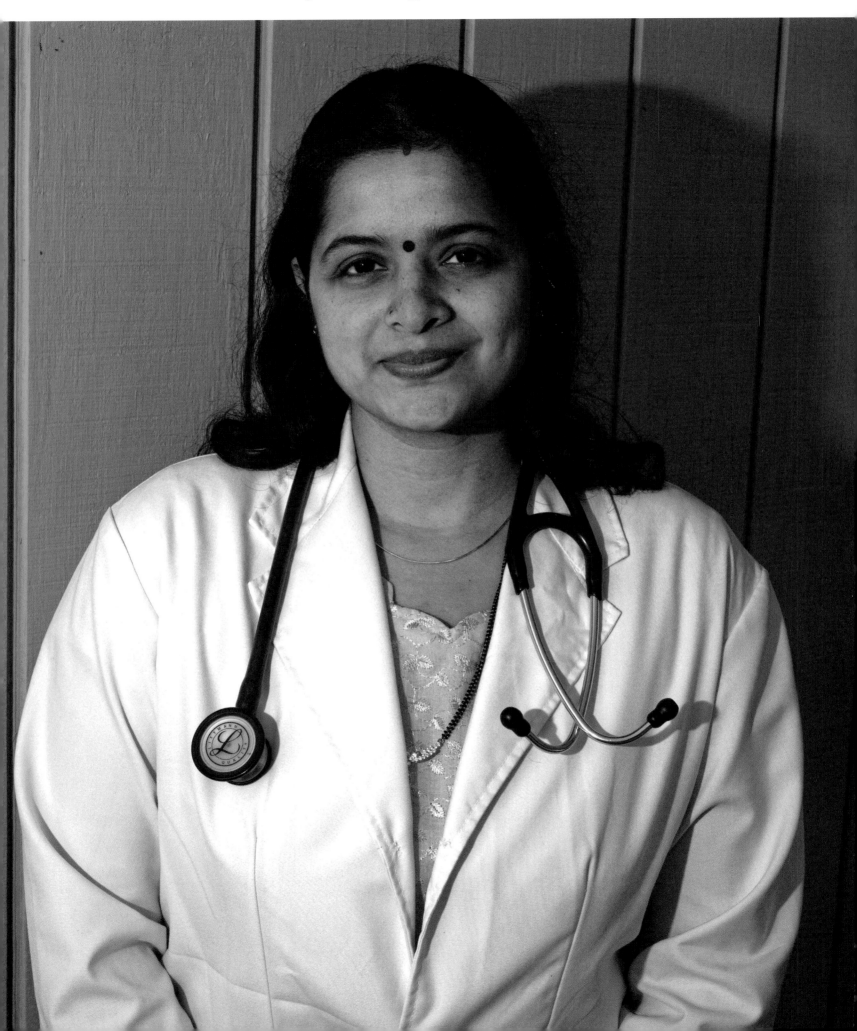

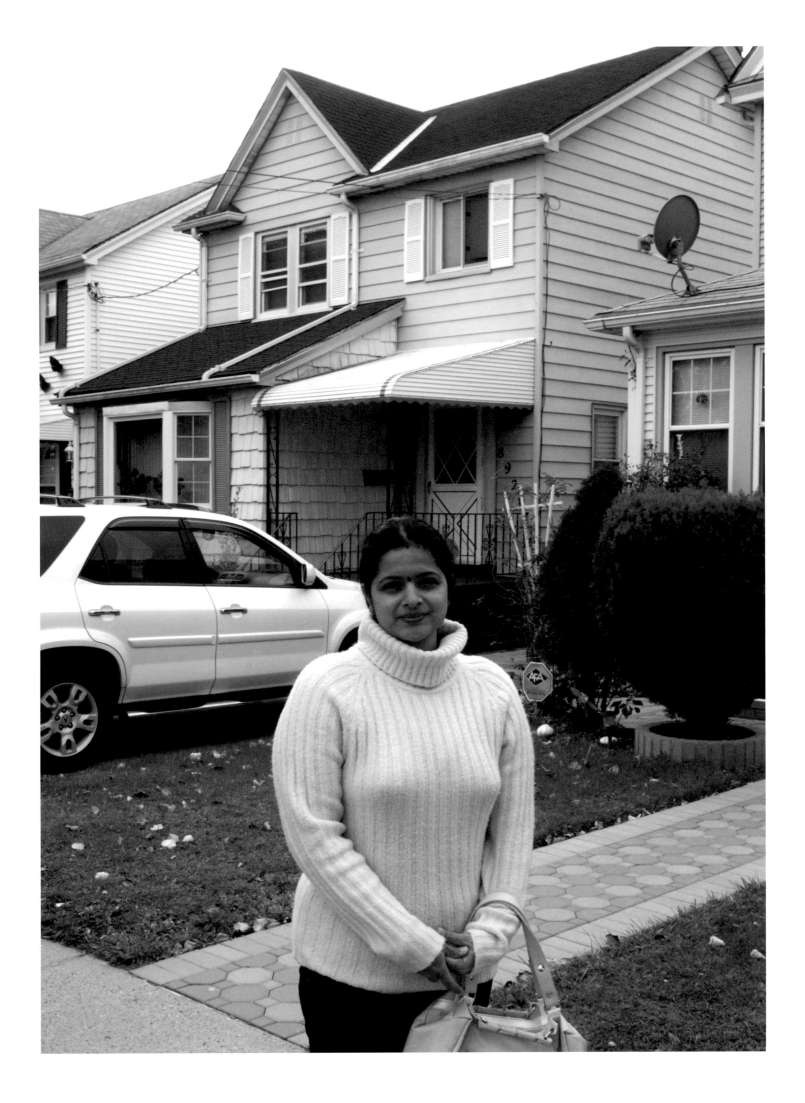

SWAYAM

"In olden days when my grandmother was ill, a doctor came to treat her at my house. I was a little girl of seven or eight. I just touched the stethoscope. My father said: 'Go... Go;' but I am a stubborn girl. I stayed and I made a decision then to be a doctor. At that time a doctor was considered to be like a God. Everyone was so excited about him coming. Something began blossoming in me."

SWAYAM PRABHA HAS ASSIDUOUSLY PURSUED HER GOAL ever since. She is now 28 years old, married and living with her husband in Queens, New York. Swayam's life has not been easy, and recently her challenges have multiplied. She is not yet certified as a physician but is still determined to become one.

SWAYAM GREW UP NEAR INDIA'S WESTERN TIP, in the city of Thiruvananthapuram (previously known as Trivandrum) in southern Kerala. Her father was a civil servant in the Department of Post and Telegraph. Although her mother was never employed outside the home, she is a strong woman descended from generations of strong women. Swayam is a member of the matrilineal Nayar caste, where possessions and position have been passed down from mother to daughter for generations. Although this tradition is deeply threatened in increasingly male-dominated contemporary Kerala, it is Swayam who has inherited the family property. Education is a priority in Kerala. Universities there teem with women and an emphasis is placed upon medical training. Kerala provides the majority of India's doctors and nurses. As a child, Swayam never told her parents of her decision to become a doctor, but she was aware that she needed good grades to be able to achieve her goal. "Many of the cream of our students went into medicine. So in every standard I applied myself diligently and made sure that I got good marks, concentrating as much as possible on biology." She was accepted into medical college in 1996, refusing an offer to study *Ayurveda* (the traditional medical science of India) in favour of allopathy (Western-style medicine.) It was while in college that she discovered the second most important influence in her life.

AS IS COMMON IN INDIA, Swayam's parents expected to arrange her marriage for her. In south India, preferred marriages are consanguineous, meaning that the couple is closely related. This custom ensures that beliefs, traditions and property are closely

243

SWAYAM

held within each family. Among Nayars, it is most common for a man to marry his mother's brother's daughter (but never the daughter of his father's brother). Swayam's parents were modern and encouraged Swayam to make friends from other castes, but they were not prepared for her serious interest in Vijay. She states: "In 1996, when I began medical school, I met Vijay. He was also studying to be a doctor. As our names were (alphabetically) close, we were automatically thrown together. Out of some 200 students, we spent most of our time near one another. As we lived in the same neighbourhood, we began walking to school together. There were always other students there. We were never alone, just the two of us, but gradually we realized our need for each other. Like magnets we always came together." But Swayam knew that no alliance was possible, particularly because Vijay's caste was lower than hers. His own parents had an intercaste marriage and so they encouraged the match; however, Swayam's parents, once they knew about her interest in Vijay, were opposed to it. "In my family," says Swayam, "Vijay is not accepted by everyone. Only after my father's untimely death in 1997, things changed. My mother's confidence was so shaken and there was an empty space in our lives... It hurt so deeply, and in that space I realized that humble and good Vijay was the man I wanted to spend my life with. I trusted him. So my love for him overcame my caste questions. At first my mother objected, but I told her: 'I can't go back. I love him. It is inside me. I am also in spirit a Nayar, but my heart is in such a state!'"

SWAYAM AND VIJAY KEPT THEIR LOVE A SECRET even from their close friends. Their medical courses were very demanding; they had little free time and they were never alone. Swayam's five-and-a-half years of study resulted in her Bachelor of Medicine and Bachelor of Surgery degrees in 2001, followed by an intense period of internship in neurological surgery and gynecology. She continued to work as an intern for a succession of fine doctors, broadening her knowledge and gaining valuable practical experience. In the meantime, Vijay was admitted to an MD course in Ahmedabad, in the northwestern Indian state of Gujarat, 1300 miles away. During the first three years that he lived there, they rarely saw one another. From the very beginning, Swayam comments, she told him: "It is so competitive and difficult to get into an MD course that you will impress my family and they will finally accept you." She blushingly confesses: "Actually, he became a doctor for me."

Swayam grew up in a suburb of Thiruvanathapuram (Trivandrum) in Kerala. As a descendant of matrilineal Nayars, she has inherited the old family *tarawad* (home) and was taught to observe sacred traditions such as creating *athapoovidals* (flower *kolams*) on special festival days.

244

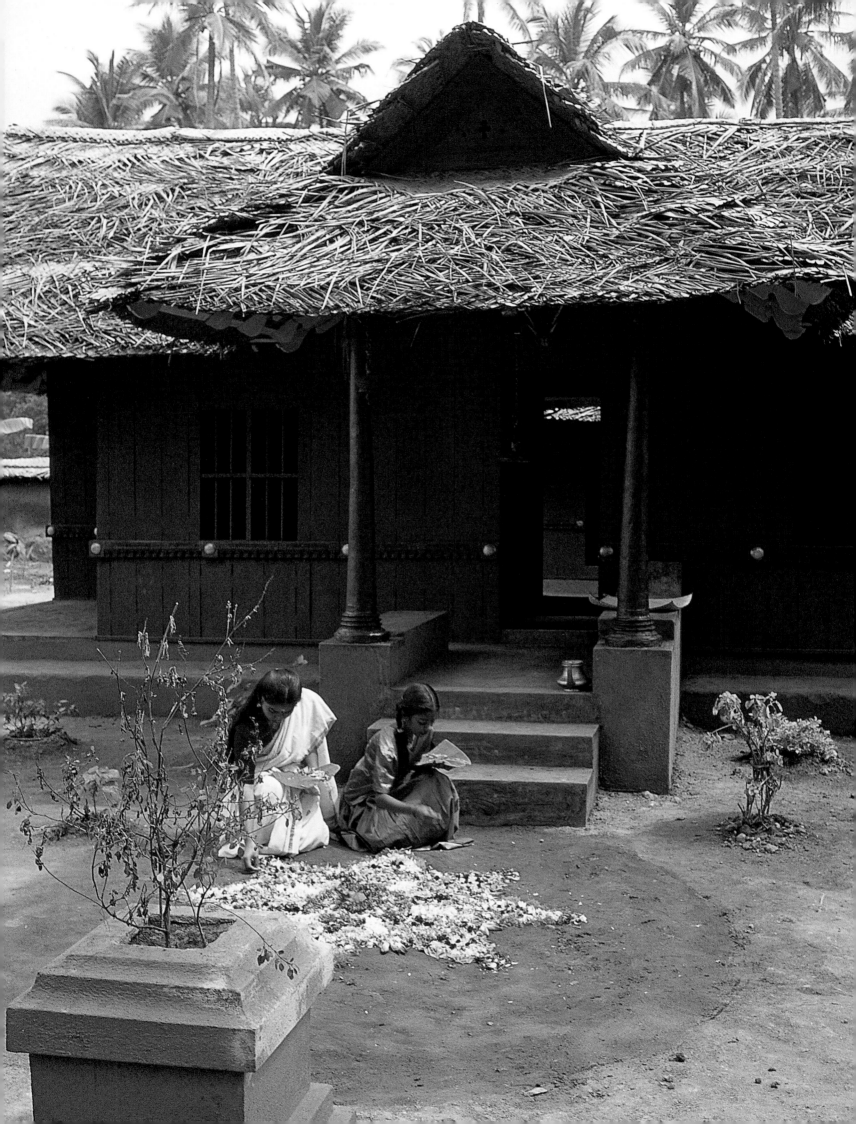

SWAYAM

IN TRUTH, VIJAY HAD ALWAYS WANTED TO BE A FILM DIRECTOR with hopes that he might improve the calibre of Bollywood films. But his own family opposed this profession and he realized that medicine would always provide him a steady income. He decided to sublimate his directorial ambitions until after he was a married doctor.

VIJAY PURCHASED A DIAMOND RING with his own hard-earned money and gave it to Swayam on September 5, 2004. It was a complete and thrilling surprise to her. (Engagement rings are a Western custom not observed in traditional India). They promised to marry exactly one year later and for the first time told a few close friends about their relationship. Their families made a public announcement two months before their wedding. One thousand four hundred guests joined them to celebrate the occasion. "It was my family's expense and we fed them all," Swayam remembers. "Even though it rained hard all day, it was a wonderful experience!" Immediately afterwards, the newly married couple travelled north to Ahmedabad in order for Vijay to finish his degree. It was the first time Swayam had ever left her home, and the stark contrast of the Gujarati culture impressed her. They lived there until Vijay officially became a medical doctor in May 2006.

FOR BOTH SWAYAM AND VIJAY, his new degree signaled the possibility to make the next important change in their lives. Qualified physicians are in such demand in India that they felt secure enough to gamble their immediate future. Swayam had yet to be accepted for her advanced medical training, but her internship qualified her for secure employment. They had inherited some money as wedding gifts and both had carefully saved their earnings. They seized the opportunity for Vijay to fulfill his dream and go to film school. Vijay believes that the best instruction for the kind of films he wants to make is in the United States and they had both wanted to live there. They had applied for and received Indian passports prior to Vijay's certification. Extensive internet searches of American film schools led them to an affordable, cutting-edge institution in rural Maine. The contrast of Maine's cold, rocky north eastern climate to the tropics of Kerala and the arid sandiness of Gujarat appealed to their sense of adventure. With Vijay's acceptance for a year's course at the school, they were able to obtain highly coveted visas and plan their trip to the United States.

ABOVE: In Queens, Swayam has learned to ride public transport to go to market and to the temple.

BELOW: She has a nourishing and supportive relationship with her husband, Vijay, who encourages her ongoing studies to be a certified doctor in the US.

247

SWAYAM

IN EARLY JULY, they flew to Maine carrying only a minimum of clothes, a laptop and film camera, small stores of treasured spices, and photographs of their families. They rented a simply furnished room in a farmhouse edged by forest. They could not afford a car, so they walked the long, rural roads to and from the market. Swayam remarked: "We eat very simply. Everything in the market is so expensive, I usually just make rice and dal (lentils). But it is so beautiful here! I love the clean streets and the clean air and everyone is so nice to us." Vijay began his classes immediately and was enthralled. With the other students he made several short, edited videos and found that he enjoyed writing scripts and directing the way they were cast and filmed. They both spent their nights intensely studying to take US medical residency exams. If they both passed, they would apply for visas that would allow them to work. Swayam could help support them during the years of film school and Vijay might be able to complement their income with a part-time job. They were just beginning to settle down contentedly into their new life when, in mid-August, disaster struck. With no warning, the film school announced bankruptcy and cancelled all future courses! They were forced to leave Maine within two months of their move!

INTERNET SEARCHES AND CONSULTATIONS with advisors at the school in Maine resulted in Vijay's application to and acceptance by the prestigious New York Film Academy. Vijay was even offered a small scholarship that would help offset the high tuition. By googling affordable accommodations, Vijay and Swayam were able to rent a small basement apartment in a house owned by a Sri Lankan family in Queens. When they moved in, they found it sparsely but adequately furnished. New York was so different from Maine, but Swayam accepted the change with typical alacrity. Immediately, they redoubled their preparation for medical residency exams. Shortly after they arrived, they celebrated their first anniversary by joining hundreds of other Keralites to celebrate the Onam festival at the local Ganesh Temple in Flushing. "It was so good to be there with all these people from my country. We had a great time, and I love the temple there. We go regularly now, especially when there is some special activity for Keralites. We are beginning to meet others. We have no relatives in the city and no other friends yet, but it is not lonely. We have each other and that is enough."

BUT THEIR CHALLENGES HAD JUST BEGUN. Soon after their move, Vijay was informed that his visa was not valid for the transfer to NYFA.

In front of a painted image of the God Ganapati (Ganesh) at the temple in Flushing, Swayam creates rice flour *kolams* and a beautiful large *athapoovidal*.

248

SWAYAM

If they wanted to remain in the US, their only choice was for him to forgo his long-held dreams of studying film and to try to get a well-paying medical residency at an American university. The competition is stiff and particularly difficult for a young doctor from India without a green card. He increased his efforts and passed his initial exams. Vijay is still interviewing for a position, with no idea whether or not he will find one. If not, they must return to India. If so, then it means a definite postponement of film school for at least eight years. Their difficulties were compounded when Swayam failed her practical exams for residency because her Kerala accent was so strong that her patients could not understand her. She now studies every spare minute, trying to improve her spoken English and hoping that she can pass the same tests in May and be eligible for residency herself. In the meantime, the young couple has no income and their stress is great. According to Swayam: "We have had a lot of disappointments since we have come to America. Just this past month has been so difficult! But we are healthy and my husband is with me—so I am happy. I need to improve my standard here (my work and my ability to communicate), but my faith is still strong." They use an internet phone to keep in almost daily touch with their families. With a web cam, they are even able to view their loved ones while they talk. "This bad period, this last month, I wanted to be with my mother," Swayam declares. "I miss her a lot. (Consequently) I do more *puja* (worship) and I call her. My mother has been very supportive."

SWAYAM AND VIJAY ENJOY LIVING IN QUEENS. When asked about how she feels in the city, she comments: "I feel safe on the street, on the bus, everywhere. People are people and I smile at everyone if they are okay, if they seem safe. It is a nice place… Today it is minus three degrees and I like it so much! I like the snow. I got so excited the first time I saw a snow shower. I had only read about them in books. It is so beautiful!"

AFTER A LIFETIME OF PREPARATION to be a doctor, Swayam continues to be unemployed. She is confident that she will pass her exams and be accepted into a residency programme even as she trusts in Vijay's own professional future. She draws on her strength as a Nayar, whose entire heritage has been defined by the acknowledged power of its women. Here, halfway around the world from her home and family, she is determined to succeed.

Despite the emotional struggle to adapt to her changes in fortune since moving to America, Swayam maintains a positive attitude.

251

JAMMU & KASHMIR

• Srinagar

Jhelum

• Jammu

■ Nagri

Chenab

HIMACHAL
PRADESH

• Simla

PUNJAB

• Chandigarh

UTTARANCHAL

• Dehradun

Sutlej

Gar

Sengge

H
I
M
A
L
A
Y
A

Brahmaputra

ARUNACHAL
PRADESH

• Itanagar

Sutlej

HARYANA

◉ New Delhi

Yamuna

Indus

Kanali

Ganges

UTTAR PRADESH

• Lucknow

SIKKIM

Gangtok

ASSAM

• Guwahati

NAGALAND

• Kohima

MEGHALAYA

• Shillong

• Jaisalmer

RAJASTHAN

• Jaipur

BIHAR

• Patna

■ Kazakpura

Ganges

Ganges

• Imphal

MANIPUR

■ Brahmpuri

• Agartala

TRIPURA

• Aizawl

MIZORAM

■ Begumpura

Chambal

JHARKHAND

■ Puhputra

• Ranchi

■ Santiniketan

■ Ludiya
■ Bhujodi

Gulf of Kachchh

• Gandhinagar

MADHYA PRADESH

• Bhopal

■ Singhpur

WEST
BENGAL

◉ Kolkata

I N D I A

Narmada

GUJARAT

*Gulf of
Khambhat*

CHHATTISGARH

• Raipur

ORISSA

• Bhubhaneshwar

■ Dhunlo

■ Bantaligram

■ Ambesari

MAHARASHTRA

◉ Mumbai

*Arabian

Sea*

• Hyderabad

Godavari

Krishna

Bay of Bengal

• Badami

ANDHRA
PRADESH

• Panaji

GOA

KARNATAKA

• Bangalore

■ Mylapore

◉ Chennai

A
N
D
A
M
A
N

A
N
D

N
I
C
O
B
A
R

I
S
L
A
N
D
S

• Port Blair

LAKSHADWEEP

Laccadive Sea

TAMIL NADU

KERALA

• Kochi

• Madurai

Thiruvananthapuram

Gulf of Mannar

Andaman Sea

I N D I A N O C E A N

GETTING THERE

MOST OF THE INDIVIDUALS PROFILED IN THIS BOOK have rights to privacy that must be protected. They were generous to allow their stories and photographs to be published but it would be inappropriate to invade their lives further.

However, the areas in which some of these women live welcome travellers and tourists. This section is designed to facilitate that travel. In recent years, tourist facilities have improved everywhere in India and it is possible to travel to even the most remote regions of the subcontinent. Women's craft cooperatives and empowerment organizations are established everywhere and many are rapidly gaining members and socio/political representation. Six regions in four Indian states are featured here as possible choices for viewing some examples of Indian women's traditional art. Contemporary art is displayed in galleries and museums in most urban centres.

There are many good travel agents and guides in India. Most focus their tours on palaces, temples, museums and urban centres. The author recommends two that are particularly experienced in tailoring tours to individuals' needs with an emphasis on out-of-the-way arts and crafts: Babu Mohapatra (www.innerindia.com) and Navin Pandey (www.gatikeventures.com). Whether or not you hire an agent, it is advisable to hire a private car and driver so that you can choose where to go and when to stop. Some of the finest art in India is found simply by driving on back roads and being observant.

RAJASTHAN

Sawai Madhopur, four hours by car south east of Jaipur, is near the famous Ranthambore National Park and tiger preserve. Accommodations are plentiful, some particularly fine. In preparation for many annual Hindu festivals, women throughout this region decorate the walls and floors of their homes with a variety of designs painted in pigments of white lime and red and yellow ochre (see *Lalita*, p. 42).

Brahmpuri, unofficially called "the Blue City," is a section of Jodhpur situated on the far side of Meherangarh Fort. Although the Fort is visited by thousands of tourists every day, few venture down into Brahmpuri. As long as visitors are quiet, courteous and thoughtful, they are welcome to climb the narrow hilly streets lined with bright blue stone houses, many of them with carved doorways and balconies. The festival of Holi, featured in the "Blue City" (see *Roopa*, p. 220) is a wonderful time to visit

GETTING THERE

Jodhpur (and other communities in Rajasthan) although visitors must be prepared to be covered in coloured dyes. A favourite hotel of the author's in Jodhpur is the Ajit Bhawan.

Jaisalmer, in the western Thar Desert not far from the Pakistan border, is a walled town featuring ancient carved golden stone buildings. Hotels, restaurants and tourist activities abound. *Indra* (p. 76), is one of the women artists working with Lugai for Lugai, a women's fair trade organization. Although most of these women are veiled and secluded, it is very valuable to visit their centre, Lok Kala Sagar Sansthan, on the outskirts of Jaisalmer (not far from Patwon-ki-Haveli, one of the merchant palaces most often visited by tourists). LKSS contains a folk museum and a literacy initiative, and offers frequent concerts of Merasi folk music. Also visit Asha Artists' Residence, where Merasi musicians and artists live, work, and run a Lugai for Lugai craft outlet. This colony is in Kanoi, a 45 minute drive from Jaisalmer on the road to the sand dunes of Sam, where many tourists go to ride camels and see the sunset.

GUJARAT

Shrujan is a non-profit organization that employs over 4000 women embroiderers in more than 60 villages in the district of Kachchh in the far western portion of the state. In Bhujodi, not far outside the district capitol of Bhuj, *Shrujan's* centre is well worth visiting (see *Chandaben*, p. 52). The women working with Shrujan use infinitesimally small stitches to embroider garments for the high-fashion trade as well as for furnishing fabrics. Selections of these items may be purchased there. The best accommodation in Bhuj is Hotel Prince.

Kala Raksha, in the village of Sumrasar, about half an hour's drive on the other side of Bhuj, is a women's craft cooperative that features folk textiles of superlative quality. The centre also contains a small crafts museum.

The village of Ludiya is 45 minutes further into the desert from Sumrasar. The painted mud walls of this tiny hamlet are some of the only examples of traditional architecture remaining after the massive Gujarat earthquake of 2001. Visitors are very welcome to visit Samabai's compound and to purchase the embroidered textiles that she and her family make (see *Samabai*, p. 152).

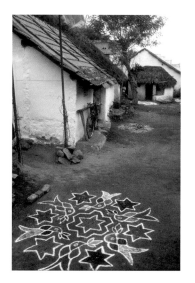

TAMIL NADU

Every day of the year except during the monsoons, women in more than a million homes in this state create *kolam*s (decorations on the ground outside their front doors with rice powder or ground stone powder) (see *Padma*, p. 86). The most elaborate and colourful *kolam*s are drawn during the months of December and January and are most easily found in the villages, towns and cities of southern Tamil Nadu. Most *kolam*s are trampled upon and wiped out before mid-morning. To see them when they are fresh, be prepared to arise long before dawn and drive either into the heart of old cities or into villages in the countryside. Then get out and walk. As long as visitors are courteous, they will be welcomed.

One of the best times to visit southern Tamil Nadu is during the four-day Pongal Festival in late January. At this time the *kolam*s are superb and the entire atmosphere is one of joyous celebration.

Unfortunately, Sunithi (p. 210) has passed away since writing her chapter. However, this state has many fine professionals who can help explain the intricacies of its fascinating history and cultures.

ORISSA

Bidulata (p. 116) lives in a village in rural Puri District. The women in this region paint the exterior walls of their homes in rice-paste designs for several festivals during each year. The largest number of paintings can be found between mid-November and mid-February. Look carefully at the houses alongside the road between Pipli and Konark or take the back road between Gop and Puri. The best hotels are in Bhubaneshwar and Puri. (The author's favourite is Hotel Mayfair in Puri).

While in this area, visit the craft village of Raghurajpur on the Puri-Pipli road. Choose from a variety of paintings on cloth, fine etchings on palm leaves, and folk sculptures, but beware of aggressive hawkers.

Dr Huyler's personal assistant, Babu Mohapatra, lives in Bhubaneshwar and can arrange excellent personalised craft tours (babu62@hotmail.com).

RESOURCES FOR ACTION

YOU CAN HELP TO SUPPORT INDIAN WOMEN'S EFFORTS to improve their own lives. Here are some strategies:

MAKE YOURSELF AS AWARE AS POSSIBLE of current conditions in India and the historical processes that have caused those conditions. One approach is to read some of the books listed in this publication's bibliography.

LOCATE AND PURCHASE handcrafted products made by women.

PATRONIZE RETAILERS who post the Fair Trade Federation symbol—and ask other outlets how much of the retail price goes to the producer.

GET INVOLVED WITH ORGANIZATIONS that lobby for international women's rights.

CONTRIBUTE TO INSTITUTIONS that help artisans buy raw materials and generate income—specifically micro-credit and craft-marketing organizations.

LEARN HOW international development and trade policies affect indigent women and, if you do not feel they are fair and effective, lobby the policy makers.

CONSIDER CONTACTING the following organizations, which are well-administered and work directly with some of the women featured in this book. All of the author's profits from this book are divided equally among them.

FOLK ARTS RAJASTHAN

Indra (p. 80), is a member of Lok Kala Sagar Sansthan, an Indian not-for-profit organization that includes a literacy programme for women, men and children and a women's fair trade crafts cooperative. Its mission is to empower the Merasi (musician) community of Jaisalmer District and to preserve traditional Rajasthani music, arts, and culture. The Merasi are a socially marginalized group of people who maintain an intact musical legacy 37 generations old. Folk Arts Rajasthan is a New York–based non-profit whose sole purpose is to empower LKSS initiatives.

www.folkartsrajasthan.org • Tel: 212-628-7210; Contact: Karen Lukas.
314 East 84th Street #11, New York, NY 10028. USA

SHRUJAN

Chandaben (p. 54) founded Shrujan, a non-profit that employs over 4000 women textile designers and embroiderers in villages throughout the impoverished desert region of Kachchh in Gujarat.

www.shrujan.org • Tel: 91-2832-240272 / 241903 / 394360; Fax: 91-2832-241902.
Behind GEB Sub-Station, Post Bhujodi, Bhuj, Kachchh 370 020. INDIA

KALA RAKSHA

A grassroots social enterprise dedicated to the preservation of traditional artisans in the desert region of Kachchh, Gujarat, KR provides workshops and cooperative outlets for village women who create traditional textiles in their homes, insisting on fair wages, providing preventive health care and basic education programmes.

www.kala-raksha.org • Tel: 91-2808-277237 / 91-2808-277238;
Fax: 91-2832-255500 / 91-2832-250410
Parkar Vas, Sumrasar Sheikh, Ta Bhuj, Kachchh, Gujarat 370 001. INDIA

SELF-EMPLOYED WOMEN'S ASSOCIATION (SEWA)

A truly remarkable achievement conceived and managed entirely by Indian women, SEWA is a non-profit organization benefiting 956,000 underprivileged women members spread over many Indian states, each of whom has her own bank account, health insurance and employment protection.

www.sewa.org • Tel: 91-79-25506444 / 25506477 / 25506441; Fax: 91-79-25506446
Opp. Victoria Garden, Bhadra, Ahmedabad, Gujarat 380 001. INDIA

THE EARTH AND GRASS WORKSHOP

Minhazz (p. 134) founded The Earth & Grass Workshop which works directly with crafts communities and traditional artists to preserve and promote diverse aspects of Indian art, craft and culture. She has also helped set up Delhi's first dedicated eco-shop The Bamboo Store.

www.minhazzmajumdar.org • Tel: 91-11-9818882553 / 29232186
S-203 Greater Kailash Part I, New Delhi 110 048. INDIA
The Bamboo Store, N-11 Rear Lane, N Block Market, Greater Kailash Part I, New Delhi 110 048. INDIA

THE GLOBAL FUND FOR WOMEN

The Global Fund for Women is an international network of women and men committed to a world of equality and social justice. GFA's purpose is the advocacy for and defense of women's rights worldwide.

www.globalfundforwomen.org • Tel: 415-202-7640; Fax: 415-202-8604
1375 Sutter Street, Suite 400, San Francisco, CA 94109. USA

WOMEN THRIVE WORLDWIDE

Women Thrive Worldwide advocates for international economic policies and human rights that support women worldwide in their actions to end poverty in their lives, communities and nations.

www.womenthrive.org • Tel: 202-884-8399; Fax: 202-884-8366
1825 Connecticut Avenue, NW, Suite 800, Washington, DC 20009. USA

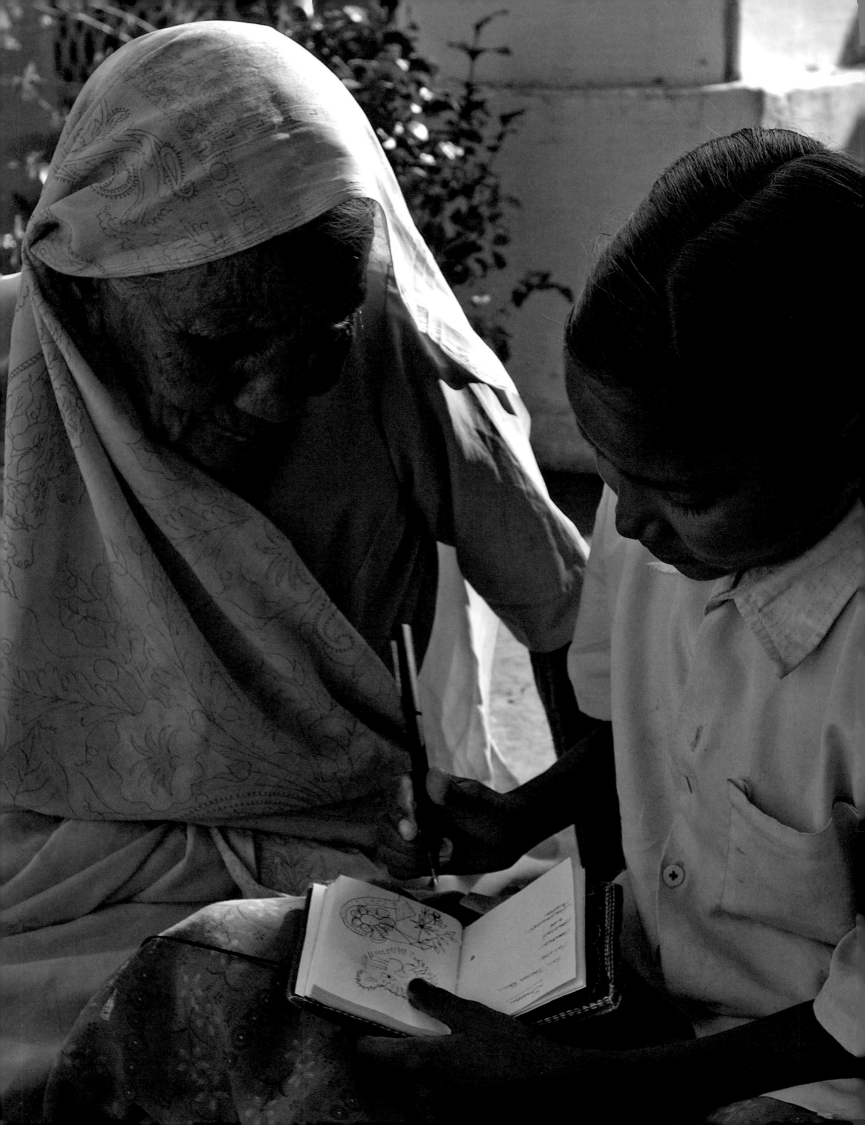

ACKNOWLEDGEMENTS

I have been gathering the material for this book in India for close to four decades. Thousands of kind people have helped me: opening the doors to their homes, inviting me in for cups of tea or for meals, sharing with me their lives and their thoughts. I have been welcomed as a member of many families from the far south to the distant north and from east to west. It is, indeed, humbling and I cannot begin to thank them all. I only hope that this book does justice to the trust they have given me.

Many individuals have significantly aided me in understanding the plight and strengths of Indian women. In my first years my mentors were Kamaladevi Chattopadhya, Rukmini Devi Arundale, Kamala Trilokekar, Padmasini, Mrs Ram Lal, Teni Sen Sawhney and Sushmita Tandan. In 1988, I first met Sunithi Narayan, who became the single most important influence on my work. She helped me break through the walls of my own bias and miscomprehension so that I could begin to perceive India more clearly. I wrote my chapter about Sunithi early in 2001, just before her unexpected death. As her entire spirit was engaged with life, I decided not to change the essence of Sunithi's story with this subsequent fact.

In September 2001, I submitted an earlier version of the manuscript and photographs for publication. The events of September 11 prohibited its imminent publication and the book was shelved for a few years. I am grateful to Judith Joseph for her help in preparing that earlier submission. When I reviewed the material in 2004, I realized that much of it was out of date, so I returned to India for three lengthy trips to gather new material. India is changing so rapidly that these new stories are essential ingredients for a broader comprehension of Indian womanhood. I am deeply grateful to the 21 women whom I have profiled here: Pushpa, Lalita, Chandaben, Savitri, Indra, Padma, Achamma, Kusima, Bidulata, Minhazz and Joba, Gani Devi, Samabai, Bimla, Shyamali, Sonabai, Larku, Sunithi, Roopa, Girija Devi and Swayam. Several have contravened ancient taboos against talking with a male outsider in order to tell me their stories. Many have overcome the confines of shyness. Some have become friends in the process. All have taken time from their busy days to open their hearts and their minds to me and I will be forever grateful to them and their families.

Two Indian men deserve particular thanks. Maheshwar (Babu) Mohapatra has served as my personal assistant in India for two decades, helping ease my access in difficult situations and to translate when I encountered a new dialect. Dr Jyotindra Jain is my closest professional colleague and I esteem his remarkable intellect and insights immeasurably.

Three lifelong mentors passed away during the years of this book's creation: Beatrice Wood, Andrée Schlemmer and my mother, Margaret Huyler. This work is infused with their spirits. Five American women have been my constant muses, challenging me to ruthlessly chip away at my male preconceptions and biases: Karen Lukas, Alev Croutier, Paola Gianturco, Alexandra Merrill and Becca Swan.

My assistant, Kathleen Brown, has been an invaluable help in putting this project together. In the several times we have travelled together in India, her natural warmth has aided me in my interviews. Without her tireless efforts to download and process my digital files both in India and in Maine, this book would not exist. Her creative input resonates in every chapter.

I am grateful to my publishers at Mapin: Bipin Shah and Mallika Sarabhai. Bipin has helped me in the last stages of putting this book together. If Mallika was not my publisher, I would easily have chosen her as one of the women to feature in *Daughters of India*. Her voice and her life's mission are an inspiration. Mallika's clear-sighted review of my text greatly improved the information I convey about Indian women. Thanks also to Diana Romany, Paulomi Shah and Sajeev Raghavan at Mapin. Joan Phaup of Camden, Maine, has conducted an excellent final edit. Thanks to Robert Abrams of Abbeville Press for co-publishing this book in the United States. Mingei International Museum of Folk Art in San Diego, California, has graciously hosted my exhibition about Sonabai (p. 184), entitled "Another Way of Seeing" (July 1, 2008–January 6, 2009).

Joseph Guglietti, the book's designer, is truly a maestro. I am privileged that he has designed three of my books. The graceful beauty of this publication is his art.

Finally, without the constant support, encouragement and feedback of my wife, Helene Wheeler Huyler, my life would be hapless and this book would not exist.

The photographs for chapters 2, 4, 6, 8, 11, 13, 16, 17, 18 & 19 were taken with Nikon F4 & F5 cameras using Fuji Velvia & Provia and Kodachrome 200. Chapters 1, 3, 5, 7, 10, 14, & 20 were taken with Nikon D100 & D2X digital cameras. Chapters 9, 12 & 15 are blends of both.

Four images in *Daughters of India* were graciously provided by other photographers: David Wright (p. 24 below) and author's portrait on back flap); David Berez (p. 77); and Barbara Goodbody (p. 211). The copyright for each of these images remains the property of its photographer.

BIBLIOGRAPHY

Archana. *The Language of Symbols*. Madras: Crafts Council of India, 1989.

Bose, Mandakranta, ed. *Faces of the Feminine in Ancient, Medieval, and Modern India*. New York: Oxford University Press, 2000.

Bumiller, Elisabeth. *May You Be the Mother of a Hundred Sons: A Journey among the Women of India*. New Delhi: Penguin Books, 1991.

Crill, Rosemary. *Indian Embroidery*. London: V & A Publications, 1999.

Crowell, Daniel W. *The SEWA Movement and Rural Development: The Banaskantha and Kutch Experience*. New Delhi: Sage Publications, 2003.

Datta, VN. Sati: *Widow Burning in India*. New Delhi: Manohar Publications, 1988.

Devi, Pria and Richard Kurin. *Aditi: The Living Arts of India*. Washington, DC: Smithsonian Institution Press, 1985.

Doniger, Wendy. *Splitting the Difference: Gender and Myth in Ancient Greece and India*. New Delhi: Oxford University Press, 1999.

Doshi, Saryu. *The Indian Woman*. New Delhi: The Department of Women and Child Development, 1987.

Fisher, Nora, ed. "To Adorn: At One with Life". *Mud, Mirror and Thread*. Santa Fe: Museum of New Mexico Press, 1993, pp. 16–45.

Frater, Judy. "Elements of Style: The Artisan Reflected in Embroideries of Western India." *Mud, Mirror and Thread*. Santa Fe: Museum of New Mexico Press, 1993. pp. 66–109.

———. *Threads of Identity: Dress and Embroideries of the Nomadic Rabaris*. Ahmedabad: Mapin Publishing, 2006.

Fruzzetti, Lina M. *The Gift of a Virgin: Women, Marriage and Ritual in a Bengali Society*. Delhi: Oxford University Press, 1990.

Ghosh, Pika with Meister, Michael W, ed. *Cooking for the Gods: The Art of Home Ritual in Bengal*. Newark: The Newark Museum, 1995.

Hardiman, David. *The Coming of the Devi: Adivasi Assertion in Western India*. Delhi: Oxford University Press, 1987.

Harding, Elizabeth U. *Kali: The Black Goddess of Dakshineswar*. York Beach, ME: Nicolas-Hays, Inc., 1993.

Hawley, John Stratton, ed. *Sati: The Blessing and the Curse: The Burning of Wives in India*. New York: Oxford University Press, 1994.

Holmstrom, Lakshmi. *The Inner Courtyard: Stories by Indian Women*. Kolkata: Rupa & Co., 1992.

Huyler, Stephen P. *Meeting God: Elements of Hindu Devotion*. New Haven, CT: Yale University Press, 1999.

———. *Painted Prayers: Women's Art in Village India*. New York: Rizzoli International, 1994.

———. *Village India*. New York: Harry N. Abrams, Inc., 1991.

———. "Creating Sacred Spaces: Women's Wall and Floor Decorations in Indian Homes." *Mud, Mirror and Thread*. Santa Fe: Museum of New Mexico Press, 1993, pp. 172–191.

Jacob, TG and P, Bandhu. *Reflections on the Caste Question: The Dalit Situation in South India*. Bangalore: NESA, 2002.

Jacobson, Doranne and Susan S Wadley. *Women in India: Two Perspectives*. New York: South Asia Books, 1999.

Jain, Jyotindra, ed. *Other Masters: Five Contemporary Folk and Tribal Artists of India*. New Delhi: Crafts Museum, 1998.

Karlekar, Malavika, ed. *Visualizing Indian Women: 1875–1947*. New Delhi: Oxford University Press, 2006.

Kinsley, David. *Hindu Goddesses: Visions of the Divine Feminine in the Hindu Religious Tradition*. Berkeley and Los Angeles: University of California Press, 1986.

Korom, Frank J. *Village of Painters: Narrative Scrolls from West Bengal*. Santa Fe: Museum of New Mexico Press, 2006.

Kramrisch, Stella. *Unknown India: Ritual Art in Tribe and Village*. Philadelphia: Philadelphia Museum of Art, 1968.

Kumar, Radha. *The History of Doing: An Illustrated Account of Movements for Women's Rights and Feminism in India, 1800–1990*. New Delhi: Verso, 1993.

Lal, Lakshmi, ed. *The Warlis: Tribal Paintings and Legends*. Mumbai: Chemould Publications, 1985.

Larkin, John and Bellman, Eric. "India's Poor Push Back as Nation Strives to Grow". *Wall Street Journal*: 3/17/06, p. 1, pp. 14–15.

Leslie, Julia, ed. *Roles and Rituals for Hindu Women*. London: Pinter Publishers; 1991.

Maloney, Clarence. *Peoples of South Asia*. New York: Holt, Reinhart and Winston, Inc., 1974.

Manna, Sibendu. *Mother Goddess Candi: Its Socio-Ritual Impact on the Folk Life*. Kolkata: Punthi Pustak International Booksellers & Publishers, 1993.

Manohar, Aashi, ed., and Shampa Shah. *Tribal Arts and Crafts of Madhya Pradesh*. Ahmedabad: Mapin Publishing, 1996.

McDaniel, June. *Making Virtuous Daughters and Wives: An Introduction to Women's Brata Rituals in Bengali Folk Religion*. Albany: State University of New York, 2003.

McGilvray, Dennis B. *Symbolic Heat: Gender, Health & Worship Among the Tamils of South India and Sri Lanka*. Boulder, CO: University of Colorado Museum, and Ahmedabad, India: Mapin Publishing, 1998.

Miller, Barbara Stoler, ed. *Exploring India's Sacred Art: Selected Writings of Stella Kramrisch*. Philadelphia: University of Pennsylvania Press, 1983.

Mitter, Partha. *Much Maligned Monsters: History of European Reactions to Indian Art*. Oxford: Oxford University Press, 1977.

Narayan, Sunithi L and Revathi Nagaswami. *Discover Sublime India: Handbook for Tourists*. Madras, India: Kartik Printers, 1986.

Panini, MN, ed. *From the Female Eye: Accounts of Women Fieldworkers Studying Their Own Communities*. Delhi: Hindusthan Publishing Corporation, 1991.

Patton, Laurie L, ed. *Jewels of Authority: Women and Textual Tradition in Hindu India*. New York: Oxford University Press, 2002.

Perdriolle, Herve. *Dialog: Richard Long & Jivya S. Mashe*. Ausstellung, Germany: Museum Kunst Palast, 2003.

Pintchman, Tracy. *The Rise of the Goddess in the Hindu Tradition*. Albany: State University of New York Press, 1994.

Puri, Jyoti. *Woman, Body, Desire in Post-Colonial India: Narratives of Gender and Sexuality*. New York: Routledge, 1999.

Raheja, Gloria Goodwin. *The Poison in the Gift: Ritual, Prestation, and the Dominant Caste in a North Indian Village*. Chicago: The University of Chicago Press, 1988.

Raju, Saraswati, Peter Atkins, Naresh Kumar, and Janet Townshend. *Atlas of Women and Men in India*. New Delhi: Kali for Women, 1999.

Sabavala, Radhika "Experiments in a Tradition: The Art of the Warlis". In *The Impulse to Adorn: Studies in Traditional Indian Architecture*. Edited by Jan Pieper and George Michell. Mumbai: Marg Publications, 1982, pp. 139–152.

Saksena, Jogendra. *Mandala: A Folk Art of Rajasthan*. New Delhi: Crafts Museum, 1985.

Sen, Anjali. *Santiniketan: The Making of Contextual Modernism*. New Delhi: National Gallery of Art, 1997.

Souza, Eunice de and Lindsay Pereira. *Women's Voices: Selections from Nineteenth and Early-Twentieth Century Indian Writing in English*. New Delhi: Oxford University Press, 2002.

Thirumaavalavan. *Talisman: Extreme Emotions of Dalit Liberation*. Kolkata: SAMYA, 2003.

Uberoi, Patricia, ed. *Family, Kinship and Marriage in India*. Delhi: Oxford University Press, 1993.

UNICEF. *Atlas of South Asian Children and Women*. Kathmandu: United Nations Children's Fund, 1996.

Wadley, Susan S, ed. *The Powers of Tamil Women*. Syracuse, NY: Syracuse University, 1980.

Wadley, Susan S. *Shakti: Power in the Conceptual Structure of Karimpur Religion*. Chicago Press: The University of Chicago, 1975.

Index

Page numbers in *italics* refer to illustrations.

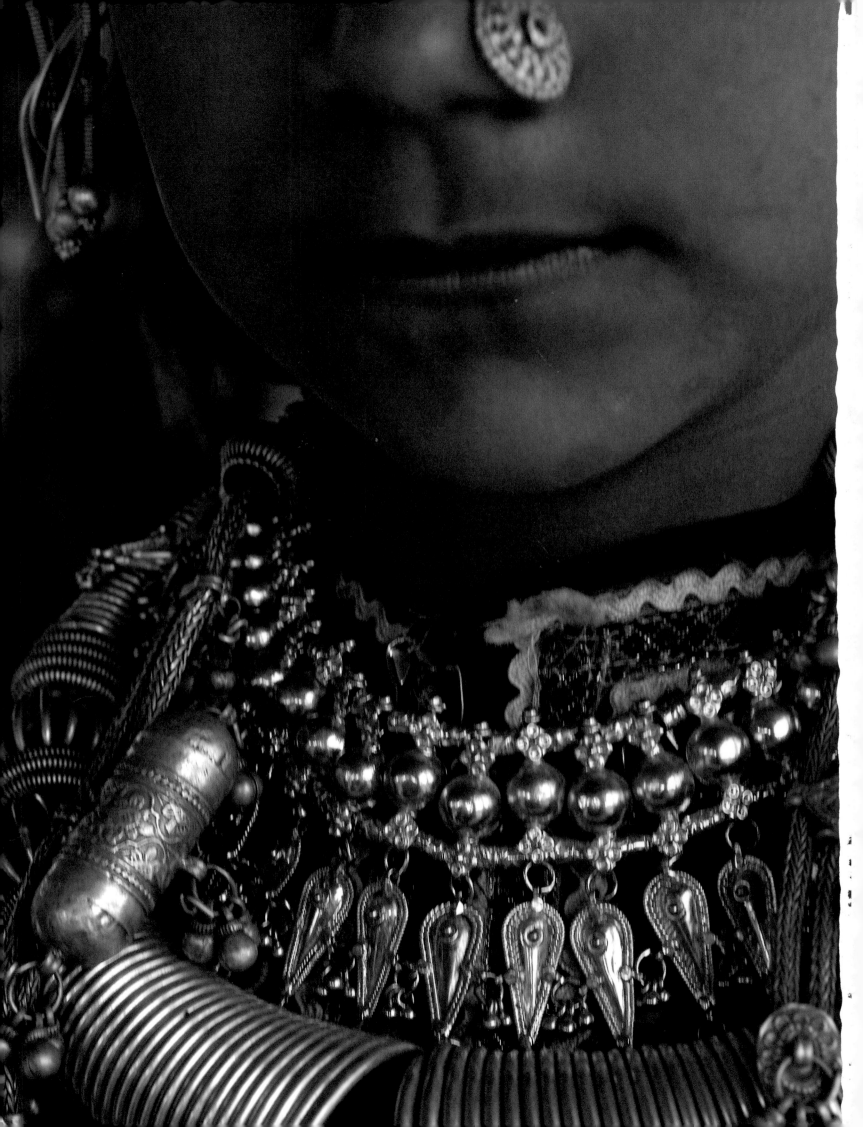